VILLAGERS

750 Years of Life in an
English Village

VILLAGERS

750 Years of Life in an
English Village

JAMES BROWN

AMBERLEY

First published 2011

Amberley Publishing
Cirencester Road, Chalford,
Stroud, Gloucestershire, GL6 8PE

www.amberley-books.com

British Library Cataloguing in Publication Data.
A catalogue record for this book is available from the British Library.

ISBN 978-1-4456-0347-6

Typeset in 10pt on 12pt Sabon.
Typesetting and Origination by Amberley Publishing.
Printed in the UK.

CONTENTS

AUTHOR'S NOTE

When I was a young man I wrote a book about my home village of Gamlingay. It was published in 1989 and called, after much deliberation and with startling originality, *Gamlingay*.

The book was the result of fourteen years' research. Having discovered everything there was to know about one village and told the world all about it, I thought I'd done with the subject. But old habits die hard and I confess I couldn't leave well alone.

Many readers took the trouble to write, often simply to congratulate me on the catchy title, but sometimes to pass on fresh information. The internet arrived and more records became available online. As time went on, other sources that were previously locked away in record repositories were made accessible.

It turned out I hadn't known the half of it, so twenty years on I decided there was nothing for it but to embark on a rewrite, combining the fresh material with the original text. It didn't quite work out as I'd imagined. Instead I ended up writing a new book, one that looks at the village from a different angle and contains little of the original text.

Today I'm not so conceited as to suppose this is the end of my research. There will be more to discover – there always is. But that, of course, is the fun of it.

INTRODUCTION

When the Domesday Book was written nine centuries ago, it listed over 13,000 villages. Almost all of them are still around today. For many hundreds of years after that first great tax-return was compiled the majority of English people lived in those villages, and a very large percentage of them worked the land. It's likely that the ancestors of even the most dedicated modern urban dweller once lived in a village. For most of us then, village history is *our* history, much more so than the story of battles, or the doings of kings and queens and politicians.

There are many ways to look at village history, but I've chosen to concentrate on one village and the people who have lived there during the last 750 years. In a sense, the story of one village is the story of them all. Of course, every village was and is unique – geography, landholding, local customs and the way the land was used have seen to that. Yet the life of a villager did not differ much from place to place, especially in the open-field villages of southern and eastern England where most of the population lived.

Despite what one writer called its 'romantic' name, the rather sprawling village of Gamlingay is not quaint or pretty or the birthplace of anyone famous (tourism isn't a major problem). You are unlikely to stumble on it by accident since it does not sit astride a main road, although its streets are as clogged with parked cars as anywhere else today. It's just an ordinary sort of place, tucked away in the south-western corner of Cambridgeshire, the parish boundary jutting pugnaciously into both Bedfordshire and the now-defunct county of Huntingdonshire.

Gamlingay has always been the largest village in west Cambridgeshire, but somehow it has never properly 'belonged' to the county. The Post Office recognises this geographical peculiarity by insisting that the postal address is 'Near Sandy, Bedfordshire', while the postcode directs mail to the regional centre still further away in Hertfordshire. Most modern guidebooks to Cambridgeshire fail to even mention Gamlingay. This odd invisibility is one of the factors that has helped to shape its history, and has left the village

with more in common with its neighbours in Bedfordshire than with the fat, prosperous villages closer to Cambridge.

Gamlingay also happens to be my home village. When I was growing up there it was still possible to say the village wasn't very different from its Victorian or even Stuart forbears. Links with the past were all around me, although I didn't notice them at the time. Later, when I'd grown up and moved away, questions about the village kept occurring to me. Why, for instance, was the muddy track along which we had raced our bikes called Park Lane? Why was there a ditch and a bank surrounding Gamlingay wood? Who had built New Road – and when was it 'new'?

Then, in 1975, I was idling away an afternoon in the splendid library in Newcastle-upon-Tyne when I found a history book that mentioned Gamlingay. I well remember the thrill of finding *my* village mentioned in a book. Hunting through the shelves turned up several more volumes that referred to it, and excitedly I took some photocopies. I may even have telephoned my somewhat mystified family and friends to tell them the news. Without realising it I was beginning what turned out to be a lifetime's quest.

One thing led to another, and to my immense surprise I discovered that a mass of information has survived about Gamlingay from the medieval and later periods (it must surely be one of the best-documented villages in England). Before long my desultory research became complete immersion. What those dusty, frustrating, sometimes impossible documents eventually told me became the basis of this book.

During all the years I've been researching the village I can justifiably lay claim to a mere trio of original discoveries. Trawling through the internet netted a sale catalogue, which provided hitherto unknown details about Gamlingay Park. Fieldwalking unearthed some flint tools, silent witnesses to Gamlingay's prehistoric past. And one day I happened to be flying over Gamlingay Heath at just about the only moment in all of history when a network of unsuspected crop-marks was briefly visible through a frazzled field of wheat during an early summer drought. Thank goodness I had my camera with me, because nobody had ever tried to grow wheat in that dry, sandy field before and probably never will again, if they have any sense.

For the rest, all the information I have used is freely available to anyone, although I must hastily point out that barely 1 or 2 per cent of what I painstakingly gathered actually appears in this book. After all, a book is meant to be read. Since those sources have been arbitrarily selected by the passage of time and then filtered through my interpretation of them, this can only be my version of the story of Gamlingay. You might well look at the same evidence and come to different conclusions. But then, all history is simply someone's version of what happened.

I say story deliberately because I'm not a historian and therefore what I've written is not a history, although I have tried to make it a true story, based on

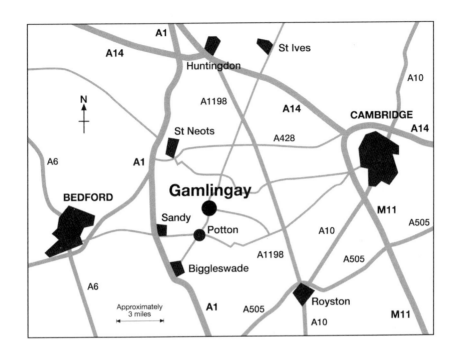

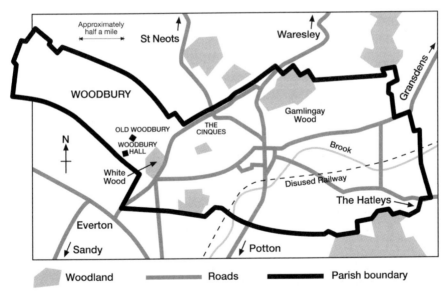

Simplified sketch maps of Gamlingay parish and the surrounding area. The ancient parish was the largest in West Cambridgeshire, comprising 4,460 acres and stretching some five miles from east to west. Woodbury was transferred to Bedfordshire in 1965.

the evidence I collected. Anyone who wishes to consult the original documents should be able to find them easily enough from the notes on sources at the end of the book. Occasionally I've had to speculate where the evidence is missing, vague or contradictory, but I hope I have made those occasions sufficiently obvious to my readers.

The story begins in 1279, with the medieval open-field village and ends with the village as it is today. For more than half of that long period of time the calendar year began officially on 25 March. Wherever possible I've changed those dates affected into modern ones. On the other hand, I have retained the original spellings used in the documents, partly because it would be difficult to decide on a standard form for many words, particularly field-names and surnames, but also because to modernise them would be to rob the documents of much of their charm. I have, though, used capital letters where I thought it would make them easier to understand. Punctuation is virtually non-existent in the original documents, so I've added it where necessary for the sake of clarity.

If there are errors in the text – and with so much translation and transcription over so many years there must be – then I apologise and freely admit that the guilt is entirely mine.

CHAPTER 1

THE SYSTEM

Indulge me for a moment and imagine you can travel back in time to the Gamlingay of 1279. Having got there, I think you will very quickly be on your way back again. You wouldn't want to live in Gamlingay in 1279 – or, come to that, in any of the countless villages like it scattered across southern and eastern England. It's not that 1279 is a particularly unpleasant time to be alive: I don't think you would want to live in Gamlingay at any time in the middle ages. You really wouldn't like it.

For a start, you won't be able to talk to anyone. It's not that the villagers are unfriendly or suspicious – although being villagers they are exactly that, of course, especially where outsiders are concerned. It's simply that they won't understand a word you say, and you won't understand them. You might recognise a word or two here and there, but that's about as far as it will go. Yet despite appearances, this is not a foreign land. It's medieval England, the people speak medieval English, and these folk are your ancestors.

Don't make the mistake of thinking the villagers are stupid, because they are not. They are just as intelligent as you are, although it's true to say they are ignorant, in the proper sense of the word. They don't really have a clue about why things happen as they do. They would not be much the wiser if they could read or write because nobody has much of an idea, not even the clever people who write books. This is why nearly everyone is deeply religious, yet at the same time incredibly superstitious.

You won't like the filth. It's everywhere, and you can't avoid it, as much a part of everyday life as the sun and rain. In winter, the village streets and roads are broad rivers of dirt with puddles and slithery mud up to your ankles, in summer rutted and potholed and baked hard. The dirt is carried into every home, the floors of which are in any case simply beaten earth. Nearly everyone works on the land, and bears the evidence on their dirt-encrusted clothes and shoes, and on their skin.

Water, and washing in it, is regarded with deep suspicion and rightly so. If I were you, I wouldn't drink any water. Virtually all village homes have a well in the yard, but just remember that most human excrement gets shovelled in a hole in the same yard, from where it can seep into the water supply. Please don't be tempted to cup your hands and scoop a mouthful of water from the village brook either, unless you are particularly keen on having an upset stomach. Gamlingay's brook is probably cleaner than most since it rises from a spring a couple of miles away, but two manorial estates back on to it and their waste – everything from animal entrails to the contents of the privy – gets thrown into it.

Neither the villagers nor anyone else know the medical reasons behind the vague and often fatal illnesses caused by drinking water, but they usually steer well clear of the stuff. Everyone drinks ale. It's easy enough to brew at home from the barley grown in the village fields and it's so weak you would have to drink an awful lot to make you tipsy.

Then there's the stench. The villagers are used to it, but I can assure you that your delicate twenty-first-century nostrils will wonder what has hit them when you get close to the houses. To be blunt, the village stinks. It's caused by countless odours combined in a nauseous cocktail, the chief of which is shit. There really is a lot of shit in a medieval village: ox shit, horse shit and cow shit; pig shit and sheep shit, rat, cat and dog shit; chicken shit, goose shit and of course the human variety. You will do well if you manage to avoid stepping in any of it.

Mingle in the fumes of the smoke drifting from the hearths, the aromas from the vegetables bubbling away in the pots hanging over them, the reek of dunghills, the whiff of rubbish in the yards and the smell emanating from the animals in the byres, then add the villagers' own personal fragrances – a dash of excrement and urine, filthy clothes, unwashed bodies and bad breath – and you will probably wish you had brought along a gas-mask.

If the filth and the stench and the water don't upset your delicate sensibilities then the food surely will. The hygenic preparation of food is a concept that lies far into the future. Everyone's staple food is coarse, leathery black bread, which is only palatable when dunked in pottage (a broth made of peas and beans, or any other vegetables readily to hand) and washed down with ale. This monotonous, woefully unbalanced diet brings with it a variety of health problems, though sometimes home-made cheese and butter are available, and eggs too, but meat is a rare treat for the average villager. Livestock is much too valuable to eat.

The accommodation on offer will come as a bit of a shock too. In Gamlingay most of the houses are contained within separate long, narrow plots of land running at right angles from the Cambridge to Bedford road and would be instantly condemned as hovels unfit for human occupation today. All are timber-framed with a wattle and daub infill, the daub being a mixture of clay

and straw with a large dollop of cow or horse dung to help it stick together. (I told you there was a lot of shit in a medieval village).

Most houses are separated into two rooms, one for sleeping in and the other a living room, and all are open to the beams in the roof. Unlike its modern counterpart, a stroppy child can't flounce upstairs and slam the bedroom door, because there's no stair and therefore no upstairs. The thatched roofs leak when it rains, and the thatch is home to numerous birds and rodents. There's no glass in the tiny windows, which are closed by the use of sliding wooden shutters. Furniture is mostly limited to home-made, bum-numbing benches or stools. Many houses have a byre close by where the family's animals live, although in some cases the byre is incorporated in the house itself.

The earth floor is sometimes covered with a layer of rushes, which soon gathers its own collection of detritus. On the floor in the middle of each living room is the hearth, the smoke from the open fire making its way out through a hole in the roof. When it gets dark the only light comes from the fire and a few smoky candles or rush-lights. Most people turn in early, passing the night on a bed made of planks and a mattress that's simply a bag filled with straw.

No villager ever sleeps alone, as the beds provide a warm and cosy home for that faithful companion of medieval man, the ubiquitous flea. Everyone carries lice around with them and companionable evenings are spent combing them out of each other's hair. If anyone goes outside at all after sunset, it's by moonlight or the light of a lantern or a flaming torch. The village is cloaked in a deep, impenetrable darkness full of threat and fear, pierced only by an occasional light at a window and the stars in the heavens. And when the cocks crow in the dawn of a new day, most folk are already up and about their business.

There's no privacy in a gloomy, smoke-filled medieval village house. All human activity is shared, and people grow up and grow old knowing at first hand the traumas of childbirth, the agonies of sickness and death, and (presumably) the felicities of sex. Outside the house are the outbuildings and the yard – the 'messuage' of legal documents. Even the poorest villager will keep a cow and maybe a sheep or two, and everyone has a vegetable patch where they grow the vegetables for the pottage pot.

Not surprisingly, sickness and death are common. Death is a constant and unavoidable companion to the living, a normal occurrence among people of all ages, not just the old. The average life expectancy is around thirty, although a few people do manage to survive to their three-score years and ten. Death comes in many ways: from disease and accident, during childbirth, and through neglect, poverty and pestilence. If the harvest fails, you can add starvation to that list.

Few people escape the loss of family members at regular intervals during their lives. The new-born and their mothers are most in danger, but it has been calculated that up to about a third of children don't make it into their early teens.

Since nobody knows much about the causes of disease, most of the remedies available (often from a village wise man or woman) are almost always entirely useless, the cure frequently being more dangerous than the malady.

The high mortality rate means that marriages tend not to last long, perhaps no more than twenty years at most. (It has been rather unkindly pointed out that modern divorce is merely a substitute for the premature death of one or other spouse.) In the past, a woman tied to a bullying husband or a man with a shrewish wife could console themselves with the thought that their unwanted partner might peg out at any time.

Because so many adults die young, a large proportion of children grow up as stepchildren after the surviving parent marries again. Today's concern over the numbers of children living in one-parent families or as stepchildren is in fact nothing new. In many ways it's a return to the past when it was almost the norm.

You won't spend long in medieval England before being brought face to face with The System. Few people can imagine an alternative and anyway, there isn't one on offer. Historians call it the feudal system, but feudal wasn't a word anyone used in the middle ages. Even today nobody really knows when or where feudalism came into being. There isn't even an accepted definition of 'feudalism'. The word itself was first coined in the seventeenth century to describe something that was already long out of date.

But if the concept is slippery to define, and medieval people themselves have never heard the word 'feudal', they know very well how The System works. In essence it's one of mutual interdependence, and by 1279, it has long-since been institutionalised in England.

In theory the king owns the whole country, which is great if you happen to be the king, but less appealing if you are one of the majority and therefore merely a peasant. The king has purchased the often-dubious loyalty of his family and his followers by granting them a large proportion of the country in return for certain obligations and services. For the great landowners, such as the earls, dukes and lords who attend the royal court, these obligations chiefly consist of providing the king with men and arms when required.

In their turn, these powerful men have given part of their holdings to lesser men, the knights and so forth, who provide men for their landlords' private armies as well as serving themselves. The knights lease most of their land to tenants, who in return pay rent and undertake services. Some of the land is given to the Church, which also lets most of it to tenants, who also pay rent and undertake services. We will see shortly what those services actually were, but for all levels of society, paying homage and swearing fealty symbolise their acceptance of the feudal deal.

The System is justified by pointing out to the broad mass of common people at the bottom of the heap that God has ordered society into those who labour, those who fight and those who pray – the three estates of medieval society.

Who are they to complain, for without such a system how can the powerful protect them, and the clergy look after their spiritual needs?

That's the theory. In reality, The System is much more complex and gradated than that, and changes over time as various economic and social pressures are brought to bear upon it, but it's a system that works, by and large, and has done so for as long as anyone can remember. What matters to most villagers is the fact that they owe obligations of one sort or another to someone further up the social pyramid.

By the latter part of the thirteenth century, The System has been in operation for such a long time that nobody is quite sure who owes what rents and services to whom, let alone by what right they are demanded. This bothers the king, so in 1279 an attempt is made to set down the facts, so far as they are discoverable, once and for all. The resulting documents are known as the Hundred Rolls, because the information was collected during enquiries held in the Hundred court. Think of them as a kind of updated and more detailed Domesday Survey although, unlike William the Conqueror's survey, the Hundred Rolls survive for only a few English counties.

Some have since been printed, although still in their original abbreviated Latin form (someone in the early nineteenth century with time on their hands designed a special font to replicate the shorthand marks used by medieval scribes). Luckily, the Cambridgeshire Rolls are among the printed ones, which means we can take a look at how The System works in practice in Gamlingay, and you now know why I chose to begin this story in 1279.

The first thing to note is that everyone has an official surname. Villagers had always had Christian names, of course, and they probably had surnames too, although since nobody bothered to record the names of ordinary villagers in any of the hundreds of documents that mention Gamlingay between the tenth century and the thirteenth century it's impossible to say for sure. The problems caused by half a dozen Johns or Simons in one village must soon have led to some form of distinguishing terminology, but not necessarily to a system of inherited surnames.

Even in 1279, surnames are still in a state of flux. Almost all of them seem to have originated in one of four ways: some are patronymics; some are based on a geographical location; others derive from an occupation; and some seem to have originated in a personal description. In Gamlingay, the derivations of Malin of the Church, William the Clerk, Simon of Tempsford and Cecilia the daughter of the smith, for instance, are obvious. Names based on occupations include Simon Baker, William Miller, John Tiler, Simon Carpenter and John Cook. Those reflecting an individual's appearance, perhaps in a humorous way, probably began as nicknames, like Agnes Red, Richard Prune, Philip Chikin and the unfortunate Custance Balde, although I admit John Human does puzzle me somewhat (and Oda Flie more than somewhat). And goodness only knows what Orabile de Hattele had done to get his name.

It is immediately obvious from the Rolls that Gamlingay, like everywhere else in the countryside, is unequally divided between the few who own the land and the many who do not. Owning land equals real wealth, because as everybody knows, they don't make it any more. Those who own large landholdings are universally known as 'lords', whether they are individuals or institutions, and their estates are known as manors – hence the title 'Lord of the Manor'.

Before we go any further, I have to point out that if you harbour any romantic ideas of what a lord of the manor was, now would be a good time to forget all about them. A manor is simply an estate or a farm, run like any other business to make a profit, and lords exploit them in every way they can. The most common method is to rent their land to the villagers, although generally a lord retains some of his land (known as 'demesne' land) to farm himself, or through a bailiff appointed to do the job for him.

In Gamlingay, Sir John Avenel and Merton College own two long-established manors within the village itself (hereinafter known as Avenel's and Merton manors). Sir Hugh de Babington owns the outlying manor of Woodbury. Merton College acquired its manor through its founder Walter de Merton in 1268 when he purchased it from William de Leicester, who chose to support Simon de Montfort's rebellion against Henry III and found himself on the losing side. It became part of the extensive College estates, and three-quarters of a millennium later Merton College still owns a sizeable portion of village land. The Abbot of Sawtry (a village south of Peterborough) holds a large block of land that becomes more important as time goes on, but which is never quite large enough to be a fully-fledged manor and is usually leased to a single tenant.

One of the ways that institutions such as the Church and Merton College can add extra bits and pieces of land and tenements to their holdings is by accepting gifts from the better-off villagers. The giving is unsurprisingly encouraged by the Church, which recommends it to its flock as a way of ensuring the future health of their souls. The charters recording these gifts survive in great numbers.

The tenants of these lords of the manor, the people who actually work the land, are divided into villeins and freemen. As their name suggests, freemen aren't subject to the rigid rules governing the lives of the villeins. They can, and frequently do, hold land from more than one lord, as well as indulging in a tangle of subletting among themselves.

Most of the lords' land is rented by free tenants. Avenel leases about 270 acres to forty-three free tenants, another forty-three hold about 350 acres from Merton College and nineteen hold around 115 acres from Babington.

It's a very different matter if you are born a villein. In medieval law, a villein belongs to his lord and all he is deemed to own is his belly. He's nothing more than a chattel, bound hand and foot to the manorial soil, a mere item which

can be sold along with the rest of a lord's estate. We may not like the idea of our ancestors being virtual slaves, but that is what in effect many of them were. Although there are subtle differences within the all-embracing term villein, each with a different name, they are all variations on the theme of bondage.

Gamlingay's villeins are subdivided into customary tenants and cottars. The cottars, named after the cots (cottages) they rent, form a pool of unpaid labour to do the hoeing, mowing, carting and harvesting when required. They have no land and survive as best they can, grazing a cow on the commons if they can afford one, and hiring themselves out when not working for their lord. Merton has no cottars, but there are nine on Woodbury manor and another nine on Avenel's.

The customary tenants get their name because the work they do for their lord in addition to paying rent is based on custom. They hold on average between six and ten acres each, which is barely enough land from which to scrape a living, but even so they are better off than the cottars. Avenel has eleven customary tenants holding 120 acres or so, and there are eight on the Woodbury estate holding around 65 acres, but there are none on Merton manor in 1279.

The fact that only thirty-seven tenants are unfree probably has more to do with the historical fact that Gamlingay had been, if only just, a part of pre-Conquest Danelaw, well known for its preponderance of free peasantry, than to any generosity on the part of its overlords.

In their matter-of-fact way, the Hundred Rolls spell out the services owed by the unfree to their lords. The tentacles of The System reach beyond their working obligations to touch every corner of their lives. Alexander de Wynepol is typical. Indeed, his obligations are specifically noted as being representative of another eight of Sir John Avenel's customary tenants.

Alexander rents a house, along with 12 acres of land, for which he pays four shillings a year. In addition, (and here's the catch) he has to work for nothing on Sir John's demesne land. He has to provide a man to cart hay, and owes a day's hoeing and a day's mowing with dinner provided, consisting of a wheatloaf, a piece of meat and a hunk of cheese, plus an allowance of fourpence a day for ale to swill it down. In autumn, he owes two of what are euphemistically called 'boon works', one with and one without food, when he will help to gather in the lord's harvest.

At the third boon that is called the Great Boon Reap he is to have for carting one loaf of wheat for every six bushels, and drink and cheese. He and one of his fellows are to have one piece of meat, and ale sufficient for the whole day.

The obligations vary from manor to manor. At Woodbury, William Abelot's duties as a customary tenant are to spend ten days weeding his lord's crops,

and at harvest (specified as between 1 August and Michaelmas) to do four days' boon-work without food. Some customary tenants do not pay rent, and their burden is more onerous. Geoffrey Le Ster holds a house and 6 acres of land from Sir John Avenel:

> He owes each week of the year two work-days whenever he must, and a day at hoeing and mowing and lifting hay and all the aforesaid boons as Alexander de Wynepol does, and is to have the same in all things as he does.

Quite apart from having to till someone else's land for two days a week, the problem with the boons demanded in autumn from Geoffrey Le Ster and the rest of the villeins is that at the very moment they are desperate to get in their own crops they are instead busily harvesting those of their lord.

Legal theory has it that the boons are undertaken simply out of love for the lord, but nobody is fooled by that. They do them because they must. How much the provision of food and drink lessens their feelings of frustration is debatable, but the contrast between the villeins' lot and that of the free peasants is particularly pointed during harvest.

To be fair, these demands may not be quite as burdensome as they appear. Services are not always exacted in full, and even if they are there's often a grown-up son living at home who can act as a stand-in. A day's ploughing or carting usually ends in the early afternoon when the tired oxen are put out to grass for the rest of the day, and a day-work probably ends around noon. If that doesn't sound too bad, remember the working day starts at dawn.

But the Hundred Rolls make it abundantly clear that exploiting the villeins (today we would call it 'maximising their profit potential') is not confined to simply working for their lord. The list of additional obligations attached to Alexander de Wynpol's name continues:

> He will be reeve at the lord's wish. He will not allow his daughter to marry without licence. He will give his best beast in lawful heriot. And he owes tallage to his lord at Michaelmas as the lord wishes.

A reeve is a kind of foreman, responsible for making sure his lord's orders are carried out. Fair enough. However, the reason a villein is not allowed to marry his daughter to another lord's man without licence has nothing to do with fairness – it's simply that the lord can charge him for the privilege. The fee is called merchet. In fact, much of the villeins' energy is spent in finding the means to pay for privileges like this. He has to pay the arbitrary tax called tallage each Michaelmas at the lord's will, come what may. He has to pay to leave the manor, pay if his son wishes to leave the manor, pay to inherit his holding, pay for not inheriting it, pay to grind his corn at the lord's mill and pay if he's caught not doing so.

Even when he dies he has not finished paying, or rather his family has not, since they are forced to hand over his best beast to his lord in what is known legally as heriot, but which probably seems more like daylight robbery to his bereaved family. And when he has finished forking out to his lord, there is always the Church. Tithes claim an annual tenth of a villein's income and are often bitterly resented, while his second-best beast, assuming he has one, is seized as mortuary in lieu of tithes the Church blithely assumes he has neglected to pay in his lifetime. Then there are mass pennies and church scot, fine-sounding names for taxes claimed from time to time by the Church, not to mention those taxes levied by royal command.

There are two avenues of escape from this oppression open to the discontented villein. He can quietly slip away in the middle of the night for the nearest town, and if he can remain there at large for a year and a day he's deemed to be a free man. His lord has four days in which to recapture him and bring him back to the manor, using force if necessary. After that, the lord must resort to the law to get his recalcitrant chattel back. It's a double-edged sword as far as the villein is concerned. Once he's left the village there is no way back.

The other way of escape is known as manumission. It's a polite-sounding name for buying yourself out of bondage, and a heavy fine is exacted in return for granting it. I haven't found a single instance of either manumission or escape from any Gamlingay manor. It must have happened, but Woodbury and Avenel manors had the unfree tenants and their manorial records have not survived.

The Rolls also tell us that rents are often paid either wholly or partly in kind. William de Welles pays 3s 7d a year for his house and land, and in addition has to find 'one pound of cumin and half a pound of pepper', scarce and costly commodities in medieval England. Adam son of Simon pays cash and one capon for his land and house, while Nigel de Mimmes pays for his two-acre croft by maintaining 'one candle before the altar of the Blessed Mary in Gamelinge, price 25d'. Occasionally there's a hint of humanity among the list of rents and services:

Alice de Scalare holds six acres of land from Merton and renders for it each year *one flowering rose*.

(By the way, don't be surprised by the variety of spellings of Gamlingay you will come across in this book. None of them are 'wrong', because there wasn't a 'right' way of spelling it until the Ordnance Survey officially froze all place-names. At one point, *The Guinness Book of Records* accepted my claim of a record for the village with well over 100 recorded variations of the name. It was soon beaten by a Welsh place-name with more consonants than you can shake a stick at.)

I must not give the impression that a villein's life is entirely one of endless drudgery and misery. Human beings have a way of making the best of their situation, especially if there doesn't seem to be an alternative, and anyway no system yet devised can prevent people from falling in love or taking simple pleasures.

One aspect of the village in 1279 that would probably appeal to you is the lack of noise. We live with the constant sound of technology – the hum of traffic, the whine of aircraft, the jangle of television and radio – and can only rarely escape it, but in medieval England the background to existence is essentially peaceful. The peasant working in the fields is accompanied by birdsong and the sighing of the wind, the creak of a cart and the occasional distant clang of the church bells. The loudest noise he's likely to hear is the crash of thunder overhead. At home there's the comforting sound of conversation or the crying of an infant, the crackle of the fire and the snuffles and grunts of his animals.

There is little doubt that the average villein had an infinitely better understanding and enjoyment of natural things – animals, birds, landscape, the slow turning of the seasons – than we are ever likely to have. Similarly, living in a society in which you know your obligations and have few responsibilities beyond living from day to day is an attractive one, no matter how unpalatable it actually was to many villeins at the time.

Over a long period more concrete compensations arise, which make the villein's lot a little less unhappy. Taxes and exactions slowly come to be fixed by 'the custom of the manor', and in general the lords find it in their interests to keep to it. Disputes are settled in the manor court by reference to custom. Fines for entering a holding are fixed by custom. Even the way the parish land is used is fixed by custom.

The trouble with following custom is that ideas become fixed too. Change can always be resisted by an appeal to custom. By 1279, management of the parish land has fossilised into the open-field system, which is also the practice over much of the midlands and south east of England. For arable purposes Gamlingay's land is split into three large fields, known sensibly enough as East, Middle and South. Each field is left to lie fallow in strict yearly rotation. Other than folding animals on the fields and using their dung as a fertiliser, this is the only reliable method anyone knows of returning fertility to the soil.

The two fields not lying fallow are cropped, one with winter-sown corn, mainly barley, and the other with spring-sown corn, beans, peas and so on. This method of revolving land use will continue for centuries, although there will be a move towards more compact holdings and a little Tudor enclosure to disrupt the endless cycle.

To make these huge, unhedged, prairie-like fields more manageable, they are divided into smaller units known as furlongs. Each man's holding is scattered within the furlongs in long thin strips, separated from his neighbours' strips by balks of unploughed land, or by hazel twigs stuck in the soil. At right angles

to the strips are the headlands where the plough can be turned, and which also provided access to the furlong.

What it boils down to is that someone like Alexander de Wynpol with his 12 acres of land actually has many strips spread out all over the parish. Efficient it isn't. Yet despite the obvious drawbacks of this unsophisticated system, it does ensure that everyone has a fair share of both good and bad land, which is probably how the idea originated in the distant past when the fields were cleared for cultivation. It also means that everyone holding land within a particular field or furlong is forced to grow the same crop as his neighbours. The field of winter-sown corn, for instance, can hardly contain anything else.

Growing the same crop as everyone else means enterprising peasants are unable to experiment with new techniques for producing better crops, nor try out new varieties. The conservatism of rural life – doing something the way it has always been done – precludes any real progress in agriculture until the seventeenth and eighteenth centuries.

Running alongside the village brook through most of the parish are the meadows, which are closed soon after Christmas and not opened again for grazing until the hay crop has been gathered in at the end of July. A man's share in the crop is determined by the size of his landholding in the open fields. Beyond the open fields, mainly to the north and west of the parish, are large areas of common or waste. Lying mostly on sandy soil, it's too difficult to cultivate using medieval techniques, and even modern farming methods have struggled to tame it.

Waste it may be, but like most of the resources in the parish it's not wasted. It provides rough grazing for pigs, sheep and cattle, timber for building, and is a valuable source of fuel. The right to graze animals on the common is zealously guarded, particularly by the poor, until Enclosure puts an end to it six centuries later.

The main area of woodland on the north-eastern edge of the parish is not available to most villagers, however. It may be called Gamlingay Wood, but it has long since been appropriated by the manors of Avenel and Merton. The wood is a renewable resource, carefully managed to produce a regular crop of timber from the trees and wood from the coppice stools or suckers. The timber is used for building, while the wood is used in a variety of ways: for fencing, wattles, and, of course, for fuel.

Gamlingay boasts two windmills. They are a relatively recent invention in 1279, and both stand on higher ground to the south of the village, inevitably named Mill Hill. One is owned by Merton College, the other by the Abbot of Sawtry. They make redundant the watermill on Sir John Avenel's manorial complex, which is probably why it is not mentioned in the Hundred Rolls.

Villeins are required to grind their corn at their lord's mill, even though they can do it more cheaply by using small hand-querns at home. Naturally, the lord takes a cut of the flour thus produced. For free tenants with more corn to

grind than the villeins, convenience often dictates that they also use the lord's mill.

The village supports a number of craftsmen – carpenters, blacksmiths, wheelwrights and so on – who could have been found in any English village until well into the twentieth century. It even manages to support a hermit, Brother William, for a few years after 1271. Most people are quite capable of making basic repairs to their tools and equipment, as well as undertaking the upkeep of their houses and outbuildings. As I've mentioned, nearly all the village buildings are thatched, and thatching is a skill many peasants learn when thatching stacks of hay or straw. It's only when the services of a master carpenter or a tiler are required that the village has to look outside its boundaries for help. Women learn the arts of spinning and weaving when they are girls, and make most of the clothing they and their menfolk wear.

The life of a peasant, whether villein or free – indeed, most of medieval life – is controlled by the seasons and the demands of growing enough food to live on. Medieval agriculture is essentially communal, because sharing the open fields and meadows makes it so. Everyone has to work together, driven on by the vagaries of the weather and the spectre of famine if they fail to get the crops harvested.

Everything they do is labour-intensive. Simply producing enough food involves large numbers of people expending an immense amount of muscle power. At harvest time, virtually every able-bodied man, woman and child in the village is needed to gather in the crops. Ploughing the land, sowing the seed, harvesting the corn, grinding it at the mill and baking the flour into bread is only made possible by the physical efforts of ordinary people, with a little assistance from horses and oxen and some rather primitive technology. When their priest tells them God has ordained that 'In the sweat of thy face shalt thou eat bread', it's a statement of fact they can readily identify with.

The year's work starts at Michaelmas (29 September), one of the four quarter days into which the calendar is divided, with winter ploughing and the sowing of barley, wheat and rye. Ploughing is an important skill, and 'God Speed The Plough' a heartfelt prayer. It's difficult, demanding work, especially for the ploughmen of Gamlingay who have to contend with the wet cloying clay which covers most of the open fields. Having once sunk up to my knees in that same clay as a child while crossing what used to be East Field, I have every sympathy with the ploughmen who did annual battle with it – my wellington boots are still in there somewhere.

A medieval plough is a clumsy, heavy wooden implement with an iron blade, which usually requires the combined strength of a team of up to eight oxen to draw it through the soil, although on lighter soils horses are able to manage the task. The oxen are driven by a boy armed with a goad, while the ploughman steers his plough as best he can. As they plod their weary way up and down the furlong, the plough slices the soil and rolls it towards the

centre of the strip, creating the characteristic ridge and furrow of the medieval landscape. The need to turn the plough on the headland at the end of each furrow produces the equally-characteristic reversed 'S' shape of the strip.

These wavy corrugations of ridge and furrow can still be seen all over the Midlands and East Anglia, preserved when the fields were converted to meadows and testament to the skill and effort of medieval ploughmen. None survives in Gamlingay, but in the adjoining parish of Waresley the grass outfield of the village cricket pitch is set on top of ridge and furrow, plainly visible when a ball alternately disappears and reappears as it speeds to the boundary.

When ploughing is finished, the field is sown. The seed is sown broadcast, from a basket held at waist level by a strap over the shoulder, onto the rough-ploughed land. Then it's buried by harrows, which are wooden frames with tines projecting into the soil, often weighted down with stones and dragged along by horses or oxen, although some people use a thorn bush or an osier hurdle instead.

The period after Michaelmas also sees the slaughter of those animals considered expendable, or which it isn't possible to feed throughout the winter. Butchering their animals means – for those who have them – the chance to eat fresh meat for once, and to salt and preserve what is not quickly consumed. Even into living memory this butchering time, particularly of the pigs most rural labourers have always managed to keep, was a highlight of the year, fondly recalled by those who witnessed it.

This hectic period of the farming year ends with the coming of Christmas, but after the twelve-day holiday is over there's plenty of other work to be done. Threshing the corn in the barns goes on all winter long, while outdoors there are fences to mend, ditches to clean and dung to be spread. By early spring work starts in the fields again: more ploughing, more sowing, this time of oats, barley, peas and beans, and more harrowing. The field left fallow also has to be ploughed, but no attempt will made to make productive use of it until much later in history.

As the days lengthen into June the villagers sharpen their scythes and begin haymaking, a task which takes until the end of July. By August the sickles are hard at work until the harvest is safely gathered in, then it's Michaelmas, and the relentless cycle starts again.

Unfortunately for the villagers, open-field agriculture is extremely inefficient. The net result is that at any one time, a third of Gamlingay's arable land is lying fallow, producing nothing, while the other two thirds is producing very poor yields. There is simply no room for error, ill luck or bad weather. It's high risk agriculture combined with low productivity. In a good year the villagers can produce enough food to feed themselves, but in a bad year the reality is that people starve. Ironically, the hardest time is just before the harvest, when the grain in the barns is running low.

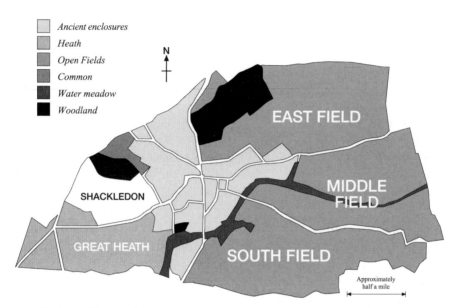

Sketch map of the village fields in 1279. The three great open fields remained virtually unchanged until the middle of the nineteenth century. Shackledon belonged to the Abbot of Sawtry. The manor of Woodbury is not shown.

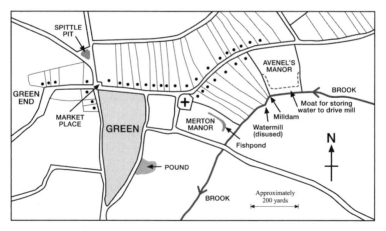

Conjectural map of the village in 1279.

The unavoidable comparison is that in many ways medieval Gamlingay is like a poor third-world village of today: just viable when the harvest is good and the weather clement, but when there's drought or a wet season and the harvest fails, it's a place of misery, starvation and death.

In the long run, establishing the custom of the manor will come to benefit the villagers more than it does the lords. For instance, once a rent is fixed it tends to stay fixed, sometimes for hundreds of years. Trusting to custom gives the villagers a solid, ultra-conservative framework in which to live. They know what's expected of them and the lord knows what he's due. This leads in turn to a distrust of change, especially in working practices, even when it's patently obvious that everyone will benefit. I once heard a foreigner remark 'do something the same way twice in England and they call it a tradition'. The origin of this truism lies buried deep in the heart of the medieval countryside, in the idea of the custom of the manor. Clinging to tradition is both a strength and a weakness of the English, as indeed it still is today.

According to the Hundred Rolls, Avenel, Babington and Merton College all claim 'view of frankpledge'. This fine-sounding if obscure term simply means that for most of their tenants they claim the right to dispense the law in all but major cases of crime, which are the responsibility of the hundred. The hundred is a Saxon subdivision of the shire into groups of parishes for the purposes of law and order, taxation and so forth. Gamlingay is in the hundred of Longstowe.

As well as frankpledge, the Gamlingay lords also claim 'assize of bread and ale', meaning that they control the weight and quality of those two staples of medieval diet, although 'nobody knows by what right they claim', as the Rolls put it. That legal nicety doesn't deter them because they go on dispensing their justice for centuries to come. The reason behind their apparently disinterested involvement with the law is money; in fining wrongdoers or in coming down hard on brewers of bad ale and sellers of underweight bread, they can put a little more cash in their manorial coffers.

Sir John Avenel also claims the right to hold a market in the village every Tuesday. It's a small market and will never amount to very much: a few itinerant traders and a villager or two with some surplus produce to sell. It brings a few more pennies to Sir John by way of tolls and doubtless the villagers enjoy the chance to gossip with their neighbours and friends, but to be a real success a market needs a strong and energetic lord behind it, qualities which Sir John Avenel and his descendants will never possess. His Tuesday market, like others, struggles on until the economic upheavals of the sixteenth century kill it off.

LIFE ON THE MANOR

People had, of course, been living in what came to be called Gamlingay on and off for thousands of years before the Hundred Rolls were written. Every autumn I used to walk the fields beside the village brook looking for medieval pottery, and often enough to keep me interested, I would find a sherd or two of broken pot or a chunk of roof tile lying on the newly-ploughed soil. One afternoon while shuffling along, eyes glued to the ground and trying to look as inconspicuous as possible, I accidentally kicked a lump of flint. It landed a yard or two in front of me, so I picked it up and examined it. I do believe I gave a gasp of astonishment when I realised that what I was holding was a hand-axe. I looked around me. There were pieces of flint everywhere. Hundreds of them. Why had I never noticed them before?

Thus was born Brown's First Law of Research, which states that you only find what you are looking for. From then on I could see nothing but flints. Most of them turned out to be merely small bits of flint left behind by whatever geological process it is that leaves small bits of flint behind, but now and again I would turn up another piece that had been worked by prehistoric man.

Within a few years I had gathered a large number of these worked flints, the bulk of them simply flakes created during the manufacture of artefacts like that hand-axe and the two beautifully-crafted arrowheads that were the pride of my collection. I assumed that since they all came from roughly the same area they must all be from the same period, whenever that was. Not a bit of it. Archaeologists I showed them to were able to say the flints dated variously from the Mesolithic to the Neolithic and into the Bronze Age. That's from roughly 10,000 years ago to about 2,500 years ago, an impressively vast length of time by any reckoning.

The trouble with pieces of flint is that they are, when you've admired the skill needed to produce them and marvelled that the point of an arrowhead worked into shape thousands of years ago is so sharp it could probably still kill someone today, simply pieces of flint. They don't tell us much about the people who made them – except that they were obviously expert at flint-knapping.

The same is true of the many crop-marks distributed all over the parish and visible only from the air. The squiggly lines could be Iron Age enclosures, the dark blobs might be pits, the parallel lines may be drove-roads, but until someone decides to excavate them it's a matter of guesswork when they were made, why they were made, and who made them.

Some of the people who left these faint traces were probably nomadic groups simply passing through the area. Others were almost certainly settlers who farmed the land alongside the brook or kept cattle on the Heath. Whoever they were, these folk were inconsiderate enough to leave next to nothing behind them, merely enough detritus to indicate that human beings had once been there.

During the centuries that the Romans occupied Britain there's no evidence that any of them ever set so much as a sandal on Gamlingay soil. This may well have been because much of it was still thickly wooded, which, if true, means the Saxons must have cleared most of the woodland and created the village.

The remains of a small Saxon settlement dating from between the fifth and eighth centuries, along with a nearby, later Christian Saxon cemetery, were discovered beside the village brook and excavated a few years ago in minute and forensic detail, and it's likely there are further Saxon remains buried beneath the present village. But while the archaeologists can say what crops they grew, the animals they kept and what they probably ate for lunch, they can't tell us the name of a single Saxon villager who lived there over a period of perhaps 400 years.

I saw the skeleton of one of these Saxon villagers still in his grave, and the thought crossed my mind that he may have been called Gamela, because the place-name experts seem to think Gamlingay is derived from someone of that name. It was sheer fancy on my part, of course – if there really was someone called Gamela he was probably one of the original pagan Saxons, and unlikely to be buried in a Christian grave.

Those place-name experts can't decide whether Gamlingay means 'the low-lying land of the people of Gamela' or 'the island of Gamela's people', which is rather contradictory of them. They base their conclusions in part on the first written record of the village in a charter dated to the 970s, which indicates that it's a well-established settlement and has gained its name by then, but not much else. Just over a century later, the Domesday Book reveals a few skimpy facts such as the number of ploughs there were and how much woodland there was, along with the names of the people who owned the village and what their holdings were worth.

Over the next 200 years, many charters and other records mention the village and sometimes the church, but like the Saxon charter and Domesday Book, they were not intended to provide future investigators with information. One set of records does tell us a little more about the village, but only in a negative sense: a number of beautifully written charters survive, dating from 1229 and 1230, which record small pieces of land being given away to the

monks in St Neots' monastery. These oddments of land belonged to a small hamlet, rather tamely called Newton, which was set up on Gamlingay Heath and failed to survive. Until the Hundred Rolls appear towards the end of the thirteenth century, then, all we really know is a little about a few landowners and the names of those who argued over the income from the church.

If the Hundred Rolls are the first documents to give us a glimpse of the medieval village, then from now on more and more documents survive to give us different perspectives on village life.

For the next 200 years, most of what I have to say will be based on the records of Merton College, the only Gamlingay manor for which records survive. That they have survived at all is a stroke of great good fortune. Had just one of the College librarians over the last five centuries decided to throw out the dusty and useless bundles of parchment cluttering his shelves, I should have lost my precious manor court rolls and bailiffs' accounts, and this chapter would have been very short indeed.

The main sources of evidence are the bailiffs' accounts and the manor court rolls. The bailiffs' accounts conveniently and coincidentally begin in 1279. Anyone who has ever done any book-keeping or had to produce a set of accounts is probably stifling a yawn at this point, but trust me, these accounts are actually interesting. No, honestly, they are, despite being written in Latin.

In fact, the first medieval document I ever attempted to read was one of Merton's bailiffs' accounts, and it made me laugh out loud. I had purchased four large rolls of microfilm containing all the Merton records for Gamlingay, but without a microfilm reader the only way I could view them was to slice off each frame, put it in a slide mount and project it on the kitchen wall. Eventually, I had well over twelve hundred slides, which gives you some idea of just how much information has survived.

I laughed not because the account was intrinsically funny, but because after looking at it for an hour or two I still couldn't decide which way up or even which way round it should be. It looked as if it was written in Sanskrit – in fact, so far as reading it was concerned it may as well have been written in Sanskrit.

But I am nothing if not dogged, and after about a week I could distinguish most of the letterforms and even make out some of the words. Unfortunately, few of the words made much sense because, as I soon discovered, they were written in a form of shorthand, with barely two words in ten spelled out in full. This was a blow, and immensely frustrating, but with the help of several books and by comparing my document with printed examples, I began to get to grips with the shorthand.

Eventually, the fact that medieval clerks used various signs of contraction to shorten words turned out to be an advantage. For instance, once you have discovered that 'ma' with a horizontal slash above it is a shortened version of *misericordia*, every time you see it thereafter you know what it means, and believe me, you see it many times because medieval clerks were very fond of the word.

Although I could now decode the words, I didn't know what they meant. Latin dictionaries and books on grammar were helpful (*misericordia* means 'mercy', incidentally), but classical Latin was of limited use for the simple reason that many of the things that medieval clerks were called upon to describe didn't exist when Latin was a living language. What were they to call a windmill, for instance? No Latin speaker had ever seen one, let alone given it a name.

Then I discovered that other people had met this problem, and some of them had been decent enough to compile dictionaries of medieval Latin words and write teach-yourself books to assist poor souls like me. One other major factor in my attempts to read and translate these rolls was that the clerks employed by Merton College to compile them were often as vague about the strict rules of Latin grammar as I am.

As for what the accounts have to tell us, before we look at them I must remind you that a manor was a business, run to make a profit. To that end, everything is recorded and accounted for, down to the last farthing (literally the last farthing), which is great news for me, but prevents me from printing even one of them in all their fantastic and meticulous detail.

I mentioned earlier that lords usually rented out a portion of their land and kept the rest – the demesne – for their own use. The College managed its manor and demesne through a bailiff, who had sole charge of day-to-day affairs, but who was responsible to the steward and ultimately to the Warden of the College himself. Merton manor was only one small part of the vast College estates spread over a wide area of south-east England, and the occasional appearance of the steward would have made the villagers aware that although their own horizons were limited in the main by the parish bounds, beyond the village lay a much wider world.

Merton's steward, as he criss-crossed the country, hurrying about his official business, called at Gamlingay several times a year to keep an eye on things and to hold the manor court. At the end of the thirteenth century the steward was a man called John de Seukeworth, and his account rolls give a glimpse of the sheer hard riding involved.

His itinerary from November 1300 until June 1301 reads Oxford – Huntingdonshire – Oxford – Cambridge – Northampton – Towcester – London – Basingstoke – Guildford – Gamlingay – Ware – Marlow – Newbury – Gamlingay – Wendover – Gamlingay – Cambridge – London, and many other places between. His hide must have been as tough as old leather.

It's my guess that John de Seukeworth became rather fed up with all the travelling involved in his job, because in 1302 he leased the manor in Gamlingay himself – 'farmed' was the legal term, from which the word farmer derives – and lived there until his death twelve years later, when the College reverted to its normal practice of managing the estate through a bailiff.

The bailiff ran the estate with the aid of his servants and his labourers, and it was he who had to face the auditors when they arrived to check his accounts on

their annual circuit of College property. If the bailiff had made a profit for his employers on the year's work he could face his inquisitors with equanimity, but if he'd made a loss he probably awaited them with some trepidation because he could be forced to make good the difference out of his own pocket. It's an interesting concept, and one which just might be worth reviving today.

It was the bailiff's duty to keep an accurate set of accounts, and he compiled them himself if he could read and write, or, if he couldn't, he hired a clerk to do it for him. They were written on narrow strips of parchment, sewn together to form one long roll, usually wound around a piece of wood for easy handling. Normally the accounts contain an entry recording the cost of this parchment, some of which was used by the manor court as well.

At the top of the roll the clerk entered the name of the bailiff and the year covered by the accounts, which usually ran from the July of one year to the July of the next. Then, after listing various arrears due from the previous year, the sources of revenue were noted: rents, profits from the manor court, money raised from the sale of stock, cereals, and so on, along with sundry items of other income. The revenue was added up, totalled, and then the expenses were listed and totalled, a balance drawn and the year's profit or loss declared. There is often an inventory tacked on to the end of the accounts listing the manorial stock, the corn remaining in the granary and the household goods and equipment.

The cluster of Merton's manorial buildings stood in a close next to the brook, facing on to the Hatley Road and only a few hundred yards downstream from Avenel's manor. I can say that with complete certainty because their later reincarnations were still there until about forty years ago, but it's the bailiffs' accounts that allow me to say with equal confidence that the entire medieval estate was surrounded by a clay wall covered with thatch. In the centre of it stood one of the largest and best-appointed houses in the entire village – the manor house, home of the bailiff.

It was surrounded by the sort of buildings familiar enough on farms until relatively recently – the tithe granary, the great granary, smaller barns, stabling for horses and oxen, hen-houses, pigsties, cowsheds, sheep-pens, dairy, dovecot (keeping doves was another manorial right), butchery and eventually a steeping-house and kiln, both for malt.

There was also a house for the manorial workers needed to run such a large establishment. They were known as the *famuli* – shepherd, cowherd, swineherd, gooseherd, carters, drovers, ploughman, dairymaid, etc. Close by the bailiff's house stood the kitchen, separated from it because of the risk of fire, and a kitchen garden full of herbs and vegetables. Furthest from the road was an L-shaped fishpond, stocked with carp and other edible freshwater fish. It's still there today, filled in and overgrown, one of the many enigmatic 'moats' marked on modern Ordnance Survey maps.

The bailiff's house was a typical medieval open-hall house, but larger and much better appointed than the average village home. The main room – the

hall – was open to the roof, but the two end sections were of two storeys. In common with the rest of the village houses, there was a hole in the roof above the hall through which the smoke from the central hearth escaped.

Plainly such an arrangement was not sufficiently refined for one of the bailiffs because in 1345/46 Richard de Bredon had three carpenters make a 'louvre on the camera'. 'Camera' in this sense means chamber, or house. The louvre was probably nothing more than a hole in the roof, but the next item in the accounts clarifies what I mean by refinement:

One barrel bought for the louvre – 4*d*.

It's not immediately obvious, but if you knock out the ends of a barrel you are left with something that resembles a chimney. Insert it in the hole in the roof and you have a rather superior adornment to your home.

Every year, money had to be spent on repairs to the bailiff's house. A few examples will give the general idea.

1330/31
Carpenter's wages making a new solar door and other necessary work for two days – 5*d*.
150 nails to fix the laths about the walls – 1½*d*.
Payment to one daubing the solar walls, 3*s* in part payment of 9*s* as agreed.
30 sheaves of rushes bought for the solar – 8*d*.
1332/33
One lock with a key for the new camera door – 3*d*.
1347/48
One carpenter hired for ten days making a vault in the solar, les steires, four gates and other necessary work ... 2*s* 6*d*.

A solar was an upstairs room, hence the need for stairs. We can get a good idea of what the bailiff's house was like inside from an inventory made in 1314 after the death of Merton's saddle-sore former steward, John de Seukeworth.

The inventory lets us take a stroll around the manorial complex in the company of the scribe who wrote it. He began, naturally enough, with the house itself, and with the most important part of it, the hall. It was furnished with a trestle table, a basin and ewer, a bench, a chair and two stools, because it was mainly used for the conduct of manorial business and for entertaining when required. This rather spartan room was where the manor court was held. No doubt the steward and his clerk spread their rolls of parchment on the trestle table while the rest of the court stood, sat on the floor or fought for the few seats available.

The pantry was also in the house, in the end section or service area. It contained more or less what you would expect a medieval pantry to contain. There were a couple of cloths, a bread-basket and a lamp; a few casks, some for wine and

some for salt; a flour-basket, and a chest made of fir and 'bound with iron'. There were also fourteen wooden cups for the manorial workers, and a flour-sieve.

In John de Seukeworth's private room – or rooms, since the items listed by the clerk were probably divided between his parlour (downstairs) and his solar (upstairs) – were his personal effects. The rooms were hung with tapestries and the floors strewn with rushes, and here he kept his most valued possessions, with a strong lock or two on the doors and chests to keep them safe. His clothes consisted of a silk shirt, a red cloak, a robe, corset and a russet tunic, presumably adorned with his 'gold clasp ornamented with silver pennies'. His three gold rings, four silver spoons and his mazer (a wooden drinking bowl) with a silver stand proclaimed his status as a wealthy man, while the knife and sword he carried would have deterred anyone from trying to steal them.

Old John also owned 'two books of romance', valued at three pence. These leather-bound, hand-written books were not romances in the modern sense, but stories of chivalry, and it is easy to imagine John de Seukeworth relaxing by his fireside with the candles flickering, enjoying those tales of knightly derring-do. It's a fair bet that other than the various service books and the Bible kept in the church, they were the only books in the village. It's intriguing that they are only valued at 3*d*, the same price as de Seukeworth's knife. I would imagine this is because despite the immense and painstaking labour involved in producing a book, there were simply not enough literate people in England to create a demand for second-hand volumes of romance.

After de Seukeworth's death, his goods were sold and the list of receipts tells us that the books did indeed make threepence each. It also tells us that his purse contained twopence halfpenny in cash, and that his worldly goods fetched a total of £2 6*s* 9¾*d*, which was passed to Merton, his former employers.

So much for the house. The inventory now takes us into the other buildings nearby. The dairy contained cheese-moulds and cloths, and three 14-foot-long shelves laden with ripening cheeses. The kitchen had an oven, a great brass cauldron, measures, brass bowls, chopping board, 'boket', plates, dishes, saucers and other paraphernalia.

Littered around the various granaries, barns, stables and suchlike were all the implements needed to run a farm. There were forks and spades, mattocks, pecks and scythes; there were ladders lying around for the unwary to trip over; and there were ploughs, harnesses for the horses and oxen, carts, horseshoes, nails, pans, cloths, axes, ropes – the detail is simply extraordinary. The scribe also noted the amount of grain left in the barns, which was not very much, since the inventory was compiled in June, just before the harvest got under way.

The manorial livestock isn't forgotten either. Eleven cows are listed, a careful distinction being made between those worth 7*s* each and those only worth 5*s*, plus two bulls, a young bull, three heifers and three calves. Almost 150 sheep and lambs are noted, along with three horses and nine oxen. Horses were more valuable than the workaday oxen – more than three times as valuable,

according to the inventory – and were used mainly for transport, while oxen were left to pull the great ploughs and the heavy carts. Three steers, forty pigs, a couple of sows and fifteen piglets complete the list of livestock.

This picture of a medieval farm would not be complete without some poultry clucking and flapping their way around the yard and, sure enough, they are listed too:

Three unmated geese
Thirteen goslings
One cock
Twelve chickens

In a later section of the inventory nine more goslings make an appearance, but then counting poultry always was a notoriously difficult business.

Running a manor farm involved making constant repairs to the outbuildings, and occasionally the construction of new ones. When Merton decided to build a new barn in 1358/59, a master carpenter called Geoffrey Silvestre was employed to do the work. It was a massive undertaking.

The new barn was over 50 yards long, half the length of a football pitch. To save money the Warden bought an old barn and had the timbers from it carted to Gamlingay and re-used, but even so the cost was enormous, as were the quantities of materials used: almost 9,000 nails, and no less than 36,000 tiles. Some of the expense was offset by payments in kind. Simon Selkman, who supplied the tiles, was paid 6 shillings a thousand but swapped a third of them for thirty cartloads of firewood, while Geoffrey Silvestre took a quarter of wheat and a quarter of malt in addition to presenting his bill for £6 13s 4d.

Most of the timber used around the manor came from Merton Wood. Dr Oliver Rackham, in his book *Trees and Woodland in the British Landscape*, estimated that at least 561 trees of various sizes were taken from Merton Wood between 1333 and 1337, an average of more than a hundred a year.

The timber was needed because there was always plenty of work for the carpenters, thatchers, tilers, plasterers and labourers to do. The following are a few extracts from the regular expenses, taken at random.

1281/82
Upkeep of ploughs:
Six pieces of iron bought – 18d.
Two-and-a-half sheaves of steel – 2s.
Four halters – 1d.
Carpenter repairing wood about the ploughs – 13½d.
The smith's wages – Michaelmas to Easter – 2s 2d.
Repairing one ploughshare – 1d.

Upkeep of carts:
One pair of wheels with an axle – 2s 2d.
Canvas bought to mend the cart collars – 2½d.
Fourscore and ten great nails – 10½d.
Four bands to go around the wheel-hubs – 1½d.
Oil and grease – 1d.
Repairs to three carts – 2d.

1326/27
Wages of a carpenter for removing one house from the vill to the manor, and rebuilding it there – 10s 6d by agreement.
For one to plaster and wattle and daub same house, and for roofing it – 6s 4d by agreement.
Wattling and roofing the steeping-house – 4s.
Thatching the tithe-barn – 18d.

1345/46
Two carpenters hired for eleven days to make a new beam for the kiln, a door and a stall for the stable, and making a stall and mending a stall and other work in the ox-house and barns – 4s 7d.

1358/59
Building a new kitchen: all carpentry work including studding and plastering the walls, and one man hired to tile the said kitchen ... 36s.

And then there was the mill. It stood on its mill-mound at the southern end of the village, and when it was working it must have been a splendid sight with its canvas-covered sails revolving in the breeze. When it wasn't working – which was quite often, in fact – the College must have cursed the new-fangled contraption.

Like all windmills until the invention of the smock-mill centuries later, Merton's mill was a post mill, a large, squarish wooden structure, balanced on a huge central post so it could be turned to face the wind. The post was supported on two massive beams laid horizontally in the form of a cross, with braces rising to the post from the outer ends of the four arms to give the structure some stability. Sometimes these 'cross-trees' simply lay on the ground, sometimes they were buried beneath the surface of the mill-mound. The sails were carried on four arms attached to an axle protruding from the body of the mill. As the sails turned, the axle rotated and, via a number of cogs and gears, drove the millstones which ground the corn.

The inherent weakness of the design lay in the fact that the axle was fixed at a right angle. The immense forces exerted when the mill was in full sail were sometimes too much for the structure to bear, and the axle broke or the mill toppled over. It took a long time for people to realise that if the axle was raked back from the horizontal the stresses were partially relieved.

So it is no surprise that the mill was a constant source of expense, or that Merton had to replace it every fifteen or twenty years. Building a new one was a major operation, which involved almost every able-bodied man the manor could muster. In 1341/42 Merton paid a penny halfpenny each to 251 men working to repair the mill-mound. This figure must include women and children too, and was probably considered to be part of the villeins' customary service; if not, I imagine they were 'expected' to lend a hand.

At the same time, the old mill had to be demolished and a new central post installed. The post was a massive piece of oak some 2 feet square and 20 feet long, weighing about 2 tons, which had to be securely fixed in order to take the weight of the mill structure. This is from 1295/96:

> Carpenter to make the new mill – 40s and a quarter of wheat.
> He and another carpenter for two days lifting the mill – 16d.
> Ten men to remove the old post from the ground – 20d.
> Fourteen men to ram in the new post and for other work about the mill
> – 2s 4d.

Between these frequent rebuildings, the mill required constant attention in the battle against the elements. Millstones wore out, joints gave way, sails ripped and axles broke, all of which were things the bailiff could reasonably put down to normal wear and tear. In 1303/04, however, neither wear and tear nor bad workmanship could be blamed:

> Making one new axle and placing it in Gamelyngey mill – 2s.
> Afterwards a great wind blew at night and broke and threw down two sailyards and the said new axle; therefore, for new sailyards and a new axle – 4s.

The friction caused by all the moving parts of the mill sometimes created sparks which in turn could set the mill ablaze, but in the one recorded instance when Merton's mill did catch fire, it seems the destruction was deliberate:

> 1340/41
> Sending a servant to Oxford in order to know what to do with the miller for burning the mill – 6d.

What the Warden said about his pyromaniac miller isn't recorded. Perhaps it's just as well, for millers were notoriously dishonest. A contemporary saying summing up popular opinion was 'An honest miller is like a golden thumb' – in other words, extremely rare.

Merton College was also rector of the church, and claimed the great tithes of the parish (the lesser tithes were claimed by the vicar). Great tithes included those of

hay, corn and wood, which is why the tithe barn in which they were stored often appears in the accounts. As rector the College was responsible for the upkeep of the chancel, while the rest of the church was repaired and renewed by the parishioners. The expenses involved are recorded in the accounts; here are a few of them.

1303/04
For a lamp to burn incense in, and for repairing vestments – 7¼d.
Lime bought, sand dug, and wages of workmen mending the chancel windows – 4½d.

1306/07
Glass for the chancel windows and the glazier's wages – 15d.
Book-binding – 4d.

1324
For bell-clappers and their carriage – 13d.
Carpenter making the celyng in the chancel, in part payment – 4s.
Repairing lead – 4d.

1334
Making a lock for the chancel door – 2d.

The church was one of the few buildings in the village, perhaps the only one, to have glazed windows. They must have been a tempting target for small boys, judging by the number of times they were mended.

One of the consequences of Merton claiming the right to dispense the law through their manor court was that they had to provide the well-known traditional instruments of punishment for minor offences: the ducking-stool (properly 'cucking-stool') for garrulous women, and the pillory and the tumbril. These are the only references to them I've found:

1298/99
Two carpenters making a byre, a pillory and a ducking-stool ... 8s.

1334
For the man who made le Thew and le Tumberell, 14d by agreement.

'Thew' seems to be another word for a ducking-stool. There was a darker side to the use of the ducking-stool: dunking a woman in (presumably) the murky waters of the manorial fishpond was a remnant of the earlier practice of trial by water. A tumbril was a dung cart with a backboard that could be let down to tip the contents out. Carting a miscreant around in a tumbril was meant to imply that he or she was no better than the usual contents. Standing in the

pillory – a wooden post driven into the ground with a framework for securing the offender's head and wrists – was, like the other punishments, intended to humiliate and embarrass wrongdoers in front of their fellow villagers rather than to do them any physical harm.

The accounts teem with so many unclassifiable items of manorial expenditure that the clerks often jumbled them all together under the heading of 'sundries'. Here are a few of them, quoted to illustrate the way even the smallest costs were noted down and accounted for:

1281/82
Grease and verdigris for the sheep-scab – 5d.
Leeks for pottage – 5d.
Three bushels of salt – 15d.

1288/89
Cleaning a ditch behind the garden, which was previously stopped up to the nuisance of the whole vill – 26d.

1298/89
Two servants hired to remove the timber from one old house blown down – 3d.
Making 36 hurdles for the fold – 7d.
Two pans of pike purchased – 1½d.

1326/27
723 faggots made at piecework in the lord's wood – 3s 6d.

1329/30
Castrating eight young pigs – 3d.
Digging a ditch at the head of le fyschpond – 3s 4d.

1333/34
Two pounds of candles bought for visiting the animals at night ... 4d.

1350/51
Three sykelis bought for reaping the lord's corn at harvest – 12d.
Paid to the king's clerk for le Asaye measure for the mill and the manorial bushel – 6d.

And so on. Finally, there is one further area of life in the middle ages illuminated by these accounts, and that's bribery. Bribery did more than just oil the wheels of society; for underpaid and overworked officials of the lower ranks bribes constituted a large part of their income, and higher officials could easily make

a fortune. There's an example of this in 1312/13, when John de Seukeworth (who knew how the system worked from his time as Merton's steward) gave half a quarter of oats worth 1s 3d to the mayor of Cambridge 'in order that he be favourable in taxing household goods'. Sometimes the bailiff was uncertain whether a bribe was required or not. This is William Cokinho in 1332/33:

> Servant carrying a letter to Oxford to ask Warden's advice about taking corn for the king's use ...

What Cokinho is referring to is the notorious system of purveyance, whereby the king's representatives were empowered to demand cheap food and goods for the royal household, a system that inevitably led to many disputes and much resentment. The necessary advice was evidently sent, because the next time the royal purveyors called at the manor there was no hesitation:

> 1334/35
> To the king's bailiff, 3s 4d for not taking corn for the king.

And 3s 4d became the standard bribe the king's purveyors could expect every time they knocked at the manorial gates.

I wish I could tell you how these accounts, in all their incredible detail, were actually compiled. Did the bailiff keep notes on scraps of parchment and write them up at the year's end? Or did he and the reeve bring out their tally sticks, check the notches cut in convenient beams in the granaries and barns, and strain their memories to recall the income and expenditure for the year? It beats me. But I can tell you how much the clerks who usually wrote up the accounts on behalf of the bailiff received for their trouble, because the amount is diligently recorded every year: anything from 2 to 8s per account.

Apart from two short periods when it was leased, Merton manor was run by a bailiff until the early 1360s. From then on, the estate was permanently leased to a farmer and the accounts are replaced by a short and rather dry recital of virtually fixed annual expenses on the estate. So long as he paid his rent, the College, naturally enough, didn't need to know all the details of the farmer's business.

Each year the bailiff's accounts contain a record of the profits of the manor courts, usually amounting to a few shillings from each sitting. The court was held by the steward of Merton when he called in at Gamlingay on his circuit of College manors. In his saddlebags were the court rolls on which the proceedings of past courts were written, needed when it came to establishing the all-important custom of the manor if any disputes arose, as they frequently did. When the steward arrived to lodge at the bailiff's house, he expected to be entertained in style – no pottage or black rye-bread for him. During one visit in 1333/34 the steward consumed bread, ale, beef, mutton, mustard, six capons and a piglet, while his horse dined on a bushel of oats.

Courts were held regularly from at least 1279, but the court rolls themselves only survive from 1340, although they do not run continuously. Like the bailiff's accounts, court rolls were written in heavily abbreviated dog-Latin. The first batch to survive span the years 1340 to 1355 (significant years, as we shall see), and they will be the ones to concern us here.

The court sat in the bailiff's hall. It was packed with tenants, known collectively and revealingly as the *homage*, anxious to see the day's business concluded. While the jury was being sworn in, the clerk was busy noting down the details of date and place of the court, sometimes finding an idle moment to embellish the capital letters.

Dating an event was not straightforward in the middle ages. Dates were related to the nearest religious festival, often a saint's day, while the year was always noted by the regnal year of the current monarch. To take an example at random, the clerk noted one court as held on the 'Friday next after the Feast of St Botulph in the seventeenth year of the reign of King Edward III.' In order to work out the actual date you need to know that the seventeenth year of Edward III's reign ran from 25 January 1343 to 24 January 1344, and that St Botulph was celebrated each year on the 17 June. You then need to consult the calendar for 1343, which shows that 17 June fell on a Tuesday, before you can say the court was held on Friday 20 June 1343.

After this complicated exercise, the clerk then entered the names of the jury, followed by those who sent their excuses for non-attendance and a stand-in (known as an *essoin*) to take their place. He also noted the names of those who simply didn't turn up and the twopence or threepence they were fined for their dilatoriness. After these formalities, the court settled down to business.

In fact, there should have been two courts: a court leet, whose main function was to oversee law and order, and a court baron, mostly concerned with land tenure, but over the years things had become rather relaxed and the courts combined. The court had the power to fine or even imprison wrongdoers, who were all at the mercy of the lord: each case ends with the sonorous words 'therefore he (or she) is in mercy'.

The clerk seems to have entered the cases in the order in which they were heard, but reading a series of court rolls covering a long period of time soon reveals that certain types of cases crop up with monotonous regularity. The records of well over a hundred courts survive between 1340 and the early sixteenth century, and at each court entries like the following ones appear:

1346
The jury present that William Warde, fined 8*d*, John Reve, 2*d*, Alan Basse, 8*d*, John Basse, 8*d*, Walter the clerk, 4*d*, Robert Yarker, 3*d*, Henry Wolf, 8*d*, William Sped, 1*d*, John Warde, 6*d*, William Cord, 3*d*, Emma Sped, 8*d*, and John le Rede, 4*d*, are brewers who sold ale contrary to the assize. And that Rose Speed, fined 1*d*, did likewise.

The jury present that John Basse, fined 4*d*, and Alice Sentere, fined 2*d*, are bakers who sold contrary to the assize.

The manorial officers, whose job it was to enforce the statutory regulations concerning the price and quality of the ale sold in the village, as well as to check that the measures used conformed to the law, were called aletasters. Brewers fixed the traditional ale-stake at the front of their dwelling when they wished them to call. Working in pairs, the aletasters had the task of sampling the new brew of each alehouse, and it will come as no surprise to learn that the post of aletaster was a very popular one indeed. Once secured, the job was often clung to with a tenacity that death alone could break, yet the following is almost as frequent an entry as the list of offenders against the assize:

1340
John le Rede, fined 2*d*, and Alan atte Hoo, fined 2*d*, are aletasters and did not do their duty.

Continual presentation for not doing their duty doesn't seem to have deterred these public-spirited men. Forking out a few pennies in fines was a small price to pay for the free ale they consumed at each brew. Neither do the fines the brewers paid seem to have made much difference to the quality of the drink they produced (the same can be said of the bakers and their bread). The same people appear again and again before the court, continually being fined and continually transgressing.

In reality the fines had long since become a sort of licence-fee, and nobody pretended they were anything else. So long as they paid up, the village bakers and brewers could continue to trade. Those who really did produce undrinkable ale or inedible bread would soon discover they had no customers. Occasionally you find a glimpse of compassion from the steward among the repetitive list of fines, as in these entries from 1340:

Presented that Godwyne (pardoned because he is a pauper) and Christian Malyn (fined 2*d*) are regrators of ale who sold contrary to the assize. Likewise Alan Basse baked bread and sold it contrary to the assize. Pardoned because he is old.

Another regular feature of court business was the transfer and inheritance of land and houses, and nearly all the rolls contain items like this:

1346
John Rykyld ... came and showed that he holds of the lord one house with a croft adjacent and one-and-a-half acres of land by right of his wife, for services of 15*d* per year, homage, fealty and suit of court.

Attendance at court ('suit of court') could count as one of a villein's day-works. Disputes sometimes arose from these land and house transfers, and the jury would be asked to settle the matter by referring to the time-honoured custom of the manor. In 1344, they were told that Alan atte Hoo, the aletaster mentioned above, who held a house and ten acres of land in bondage tenure, had died:

> and the whole homage swear that by the custom of the manor his wife should hold the property for the term of her life without paying the entry fine. And she gives in heriot one heifer worth 3s.

A year after being allowed to take over her husband's property without paying the entry fine, Alan atte Hoo's widow appeared before the court again.

> Alice, late the wife of Alan atte Hoo, committed Letherwyt. Fined 2s.

Letherwyt (or lairwite) was incontinence, or in plain English, illicit sex. On the face of it, it seems strange that Merton College should fret about one of its female tenants enjoying the pleasures of sex, yet judging by the heavy fine the court imposed it seems the College strongly disapproved.

But, as usual in manorial affairs, practical economics was at the root of the matter. The clue lies in the fact that Alice held her late husband's property in bondage tenure, which made her legally a chattel of the College and her lovemaking very much their business. If she became pregnant she would be unable to perform her manorial services, and that would never do. Alice chose to ignore the implied warning issued by the court (or followed her natural desires, if you prefer) and the following year the court dealt with her again.

> 1346
> Alice, late the wife of Alan atte Hoo, committed Letherwyt with William Norys junior. Therefore it is ordered to seize the whole tenement which Alice holds from the lord in bondage.

She lost her land and home because it was a condition of her right to hold them that she remained unmarried and chaste. Alice atte Hoo's case is the only one recorded in the entire manor court-rolls, but before we give too much credit to Merton for not pursuing other women in the same circumstances, it's as well to bear in mind that the 'crime' of letherwyt only applied to bond women and at any given moment few of the College's tenants were unfree.

Money, of course, was the reason why lords held courts. There was a profit to be made from justice, as another Alice – Alice Basse – discovered in 1340. The previous court had been informed that Alice was to be seized because her father was dead and she was under age, 'that is, under eleven years'. Soon after,

Merton College reached an arrangement with one of the villagers regarding the young orphan's future.

> It was ordered at the previous court to seize into the lord's hands Alice the daughter of William Basse, along with a house and croft, because she is under age. And now comes John the son of Walter who gives the lord 13s 4d as a dowry. Pledge the bailiff.

Since Alice was a minor, Merton were entitled to play the part of surrogate father and pocket the dowry. Child marriages were relatively rare, but not unknown in medieval England. We'll never know, but let's hope her husband-to-be was simply interested in her property.

If those two cases are unique in the Merton court rolls, the following are anything but, since most courts contain something similar:

> 1347
> Andrew Russell is placed in the tithing of Alan Melleward and sworn.
> Robert the son of William Norys is placed in the tithing of William Chyken and sworn.
> John Cokerel has remained in the lord's fee for a year and more and is not in a tithing. Fined 1d.

When a boy reached the age of twelve he was enrolled in a tithing, a group of households (nominally ten, hence the name) under the watchful eye of a chief tithingman. Similarly, any newcomer to the village was expected to join his local tithing. It was the chief tithingmen who usually formed the jury of the court, and they were held responsible for the good behaviour of their tithings. It was an ancient method of keeping the peace, and failing to enrol in one produced a few more pennies towards the profits of the court.

The manor court dealt with many petty transgressions, but theft was a rarity. Cases like this are few and far between:

> 1346
> John Latewys stole corn at night. Fined 10d.

My guess is that in a close-knit community, the chances of getting away with it were small; or it may be that the victim and his friends exacted their own form of punishment without recourse to the manor court, because in most of the recorded cases the victim was the College itself.

> 1346
> John le Rede took a cart to fetch his grain in on six occasions without licence from the bailiff. Fined 12d.

And he took the lord's plough without licence to plough his land. Fined
12*d*.
And he depastured the lord's pasture with his beasts. Fined 12*d*.

Some entries are more cryptic. In 1347, Alice Draper was fined 3*d* for
'damaging the lord's estate'. How did she damage the lord's estate? We aren't
told, but presumably it was by letting her cattle roam unchecked, because
wandering animals were a perennial problem. Any that were found at large
within the manor boundaries were claimed by the lord as 'waifs and strays',
and so you find occasionally, as in 1353, the jury saying that 'one horse weyf
came into the lord's demesne and is valued at 12*d*'. Another little mystery
there: why was the horse only worth a shilling? It should have been valued at
fifteen or twenty times as much. Perhaps a shilling was the fine the owner had
to pay to get his horse back, because, of course, pay a fine he must. If nobody
claimed the animal it became College property.

Many historians see the thirteenth and early fourteenth centuries as a watershed
in both manorial and medieval prosperity. An increasing population during the
thirteenth century led to pressure for more land to be brought under cultivation.
It was this pressure that was responsible for the attempt to found the small
settlement of Newton on Gamlingay Heath, a project that had failed by 1230.

Larger markets combined with a servile workforce brought increased
wealth to the owners of land. But the decline from this peak of prosperity was
already under way during the first half of the fourteenth century, as attested
by twelve men of Gamlingay in 1340, who swore on their oaths before the
commissioners assessing a tax known as a 'ninth' that:

> 440 acres of land have lain uncultivated because of the destitution and
> poverty of the tenants. 1,200 sheep belonging to outsiders used to be
> stocked and folded in the vill, but because of divers taxes and tallages
> which came to pass these sheep were removed, so that none now fold
> sheep in the vill, to the evident decline of the King's "ninth".

It might be that these Gamlingay men were merely doing what farmers have
always done by pleading poverty when faced with a demand for money, but
even so it clearly demonstrates that stagnation had set in. And to make matters
worse – very, very much worse – a shuddering blow was about to fall on the
village and its inhabitants.

If you visit Gamlingay church today you can find, if you know where to look,
the words *mors comparat umbre, que semper sequitur corpus* carved on one
of the massive piers in a large, unmistakably medieval hand. It means 'Death is
like a shadow, which always follows a body'. Surely created by a priest, if my
hunch is correct it's the only memorial in the village to the visitation of the one
epidemic of the middle ages that everyone has heard about: the Black Death.

Oddly enough, like the word 'feudal', 'Black Death' wasn't a term that was used at the time. Contemporaries called it the Pestilence.

It's pretty well established that the first and most devastating of the many pestilences or plagues to infect England arrived from the continent via the South Coast ports late in 1348. We now know the disease was carried by rat fleas, and in medieval England rats were everywhere. They infested the filthy hovels of the village and the congested streets of the town. In cold winters rats are dormant creatures, but unfortunately the winter that followed the plague's arrival was unseasonably mild, the rats remained active and the disease spread quickly from place to place.

Those of you who are squeamish might prefer to skip the next few paragraphs, because there's no getting away from the fact that the plague was spectacularly unpleasant.

It came in three different forms, all of them nasty. The most common was bubonic plague. You got the bubonic version through being infected by a flea bite, which after about six days turned into a blackish pustule. In response the lymph nodes swelled as the body tried to fight the infection, and it's these swellings, known as buboes, that give this form of the disease its name. Eventually purplish blotches appeared, caused by haemorrhaging under the skin, and the disease overwhelmed the nervous system. The good news for anyone who had the bubonic version was that half the sufferers made a full recovery. The bad news was that the other half did not.

Sometimes the infection moved into the victim's lungs, and this virulent pneumonic form was doubly dangerous – to the sufferer, who experienced extreme fever and coughed up blood, and to anyone nearby, who was at risk of infection by the airborne transmission of the bacteria. If you did get pneumonic plague, I'm afraid the chances of survival were much worse than if you had the bubonic variety. It was virtually certain you were going to die.

Yet even these odds were better than those on offer if you contracted the third form, called septicaemic plague. If you got that, you were definitely going to die. Thankfully, the very nature of septicaemic plague meant it was also very rare, because the bacteria that got into the bloodstream killed the victim within hours, usually before it could be transmitted to anyone else.

At the time, people had no idea how the plague spread. Put yourself in their place for a moment – would you have made the connection between an everyday occurrence like a flea bite and getting the plague? It took modern science to solve the mystery. To medieval people, the plague was simply a terrifying and seemingly random killer, and neither the English nor anyone else were equipped – medically or psychologically – to deal it.

The tide of death lapped into Cambridgeshire around April 1349, as the spring-sown crops were pushing through the soil and the buds were unfurling. Many of the crops would go unharvested that autumn as village after village succumbed to the spread of the disease. We can only guess at the effect that

news of the approaching menace brought to those villages in its path. No doubt the villagers prayed long and hard that it would not strike them. Some parishes, like Elsworth and Great Shelford, seem to have escaped the disaster completely. Others, like Gamlingay, were not so lucky.

Apart from that carved message to posterity in the village church, which bears no date, the other evidence I can present comes from the manorial records. For instance, I mentioned that aletasters held on to their jobs year after year. During 1349 and 1350 no less than three new ones were elected, and at two courts only one aletaster served instead of the normal two. This was unusual, to say the least.

It was also unusual to have three vicars in a single year, but Robert Godewyn, who had served in the parish for ten years, was replaced in April 1349 by Thomas Amys, who was himself succeeded by John Chiken in the December.

I've also said that bakers and brewers tend to appear on every court roll. Making due allowance for those noted as having died, there are twenty-six of them mentioned between 1344 and 1348. Only seven appear again between 1349 and 1355, when the rolls temporarily cease. Some 73 per cent are never heard of again.

If you do the same calculation with individuals mentioned in the rolls, ignoring the ones who died prior to 1348, then 112 people are named, but only 30 are recorded again after 1349, which by coincidence also gives us a disappearance rate of 73 per cent. When you look at the seventy-six different surnames mentioned before the Black Death, only thirty-two occur afterwards, which implies that 58 per cent of village families were simply wiped out.

There is still stronger evidence to be found in the manorial records. Unfortunately, the bailiff's accounts for the years immediately after the Black Death are in a poor state of preservation, thus confirming Brown's Second Law of Research, that the more important a document is, the more difficult it will be to read. Even so, it's clear that some kind of catastrophe has occurred. The 1349/50 accounts mention unpaid rents, that nothing was received from the windmill in either money or corn, record cottages and land 'in the lord's hands this year' and write off more than £3 in 'decayed rents'.

The following year's accounts tell a similar story: rents not paid, land lying vacant and that the court held before Christmas 1350 raised nothing at all for the College coffers because nobody had any money.

The court rolls normally have one or two entries each session recording land and property transfers. The first court to be held after the arrival of the plague, that of 9 July 1349, is filled with entries about property transfers, purchases of land and orders to distrain new landholders. The court held on 6 November 1349 is even more emphatic: twenty-three separate entries dealing with land and property. This is a typical one, from the July court.

Agnes Pope came and did fealty, and acknowledged that she holds from the lord half an acre in le forthend following the death of her husband

Richard Pope ... for services of 1½d per annum. And she holds half an acre in the same place following the death of her sister Alice for services of 1d per annum and two appearances at court. Ordered to distrain Agnes to pay the entry-fine on the half an acre she holds following the death of her sister Alice.

Margaret, the wife of Henry Rykyld, comes to claim Henry's house and land because he is dead. So is William Henry. Margaret King, widow, claims a croft and two acres on behalf of her fatherless child. Thomas Basse, who held a house and nine acres of land, is dead – and so on. In 1352, three years after the event, you can still see the shadow of the Black Death hanging over entries like 'ordered to seize the late James Douglas's cottage for lack of a tenant'.

I think you will agree that this is convincing evidence of the arrival and effects of the Black Death on the tenants of Merton manor. From its appearance in April 1349 until the cold weather set in during December, the disease ravaged the parish, killing large numbers of men, women and children in a particularly horrific and painful way.

How many villagers perished is impossible to say. Disappearing from the records is no proof of death, and taken in the context of what happened to the rest of England my percentages seem too high. In the panic and confusion that followed in the wake of the Black Death it's likely that many people took the opportunity to leave the village and start a new life somewhere else.

Despite the fact that my calculations refer only to Merton manor, a large proportion of villagers probably made an appearance sooner or later in the College records. Besides, it is inconceivable that the tenants of Merton suffered in isolation. I reckon about half of the entire population of Gamlingay were killed by the plague during the terrible year of 1349. Over England as a whole, it's thought that about a third of the population died.

Set out in cold type like that, it's easy to overlook what it must have meant to have half the village wiped out in a matter of months. Yet we cannot really begin to imagine what it was like as the village choked with the stench of rotting corpses and echoed with the agonised cries of the dying, as the crops and livestock went untended and babies and children followed their parents to the grave, because nothing like it has ever happened in England since. It was quite simply the biggest disaster this country has ever experienced. The sense of fear and utter hopelessness must have been overwhelming. But the human spirit and the desire for life are very strong in all of us, and people did survive the trauma of losing their family and friends, although at what cost to their state of mind we can only guess.

The after-effects of this catastrophe are still argued over by historians, but the indisputable facts are that the survivors demanded – and got – a higher wage for their labour, prices of agricultural produce fell and there was a general movement to accelerate the process of exchanging manorial services for rents and wages, which eventually led to the end of the feudal system.

On Merton manor, the Black Death ensured that in the long run the manor was not profitable as a bailiff-run farm. After the next outbreak of plague, in 1361 (about which there is not one scrap of evidence in the Gamlingay records), the College leased it permanently to farmers. Commuting services for rents and wages would not have affected Merton unduly with its free tenantry, but must have concerned the Woodbury and Avenel manors, both of which relied heavily on villein labour.

Given that the plague was a great disaster for the village, it's astonishing how quickly it recovered. Few tenements remained empty for long. The court rolls and bailiffs' accounts for the following years show the speed with which things returned to something approaching normality. Looked at from the brutal view of economics, England just before the Black Death was a vastly overpopulated country and could stand a large decrease in numbers without too much land going out of cultivation. The survivors simply took on more land. Other holdings had probably had too many people working them anyway.

The most violent shock, however, was undoubtedly psychological. The Church was central to village life and its teaching coloured every villager's view of the world, yet God had apparently allowed this indiscriminate slaughter to happen to the faithful. Questions were asked, and belief in the ultimate goodness of God was badly shaken. If even the clergy were victims of the plague, then there must be something very wrong with the Church. This suspicion was intensified by the actions of many priests during the crisis, who simply panicked and fled, leaving their parishioners without the support of the Church when they needed it most.

There's a hint that this may have happened in Gamlingay. John Baxter, the rector, was granted a dispensation by the Church in August 1349 after being found guilty of simony. Simony usually referred to the buying or selling of ecclesiastical preferments. Did the previous incumbent sell the rectorship to Baxter because he wanted to get as far away from the carnage as he could?

Strangely enough, the Church soon recovered its lost prestige. As the Black Death faded into memory the Church gained a new vitality that was to explode into the religious fervour of the following century, when hundreds of parish churches were wholly rebuilt and thousands of chantries and parish guilds were established.

Eventually everyday life settled down once again to the pattern of the seasons, although some of the rules had changed forever. On one level I don't suppose the people had much choice. After the dead had been buried and mourned, there were still crops to grow, cows to milk, mouths to feed. People remarried and children were born. Life goes on.

And yet, reaching out to us across the centuries is that simple, heartfelt message to posterity cut into the fabric of the church itself: 'Death is like a shadow, which always follows a body'. So far as I can discover it is not a direct quotation, but whoever it was who took out his knife six and a half centuries ago created a fitting epitaph to Richard Pope, Henry Rykyld, Thomas Basse and all the other villagers who perished.

CHAPTER 3

THE CHURCH

Brown's Second Law of Research, that important documents are almost invariably illegible, is confirmed by two documents that ought to cast some light on Avenel's manor during the middle ages. (By the way, the following few paragraphs also demonstrate Brown's Third Law of Research, that family history is rarely very interesting unless it's your own, but they do contain information that's pertinent to this story.)

Back in 1279, the manor of Avenel's belonged to Sir John Avenel. From him it passed to his son William, who died in 1331, leaving the manor to his son, another John. This Sir John fought with Edward III in France during the Hundred Years' War and died in Brittany in 1359. When a man who was a direct tenant of the crown died, an *inquisition post mortem* was held to establish what lands he held and who was to succeed him. This was done by convening a local jury and holding an inquiry. The inquisitions held after the deaths of William and his son John should, therefore, provide some much-needed information about Avenel's manor – if only you could read them.

Even the little that is legible amply demonstrates that the Avenels were not the most enterprising of families. The first inquisition (1331) mentions the market, which ultimately failed because the Avenels didn't push it hard enough, and that their manor court brings in a profit of two shillings a year. Compare this sum to Merton's court, which in 1333 brought the College 14s 3d profit from the two courts held that year.

We also learn that Avenel's now possesses its own windmill: Sawtry and Merton both had windmills half a century earlier. The second inquisition (1359) looks as if some clumsy clerk has upended an inkhorn over it, but at least we do learn that the manor possessed two dovecotes worth 4s 6d, and that the windmill was worth 10s a year. Merton leased their mill for twice that amount.

Meanwhile, the estate passed to yet another John Avenel. From him, in 1383, it went to Robert Avenel, who was the last of the line as things turned out. He married Gillian, the daughter of Sir Robert Bealknap, and died without

leaving an heir. Given the complexity of feudal relationships and the prize at stake you can imagine what happened next. A clutch of claimants to the estate appeared, with the Courteney family eventually emerging as victors from the legal tussles that followed.

They promptly cashed in their winnings and sold the manor to a man with the unlikely name of Sir Baldwin St George. He owned, and lived in, the neighbouring village of Hatley St George, which took its name from his family. After his death in 1425, Avenel's passed through several generations of St Georges until it reached Sir Richard St George, who died in 1485. His son and heir, Thomas, was a minor at the time of his father's death, which meant the St George estate, including Avenel's, was to be held in trust by an appointee until Thomas could inherit it. In practice it was up for grabs and it was safely pouched by the Archbishop of York, who was able to pocket the profits.

When the time came to inherit the family fortune, Thomas had to prove he was of age. This was actually quite a difficult thing to do in medieval England. There were no such things as birth certificates, no requirement for a parish to keep a register of births, marriages and deaths until 1538, and no instruction for the details to be kept in a book until the end of the sixteenth century.

The only way Thomas could prove his age was to gather villagers who could remember his birth and christening, and bring them before an inquisition. He claimed he was born and baptised 'at Gamlyngey on the Feast of the Nativity of St John the Baptist' in the eleventh year of the reign of Edward IV (29 August 1471), and his witnesses backed him up.

Peter Semer told the inquisition he himself had been born and baptised on the same day as Thomas. Another witness remembered that his brother 'celebrated his first mass that day in Gamelyngey church'. Robert Payn had good reason to recall that particular day, since it was also the day his father died. William Emlaunt swore he saw one of the godfathers 'give the sayd Thomas Seyngeorge a silver cup' after the baptism. Their statements were accepted and Thomas St George became the lord of Avenel's manor, as well as much else besides. This is not the last time we shall meet Thomas St George; the next time will be when he's an old man of sixty.

Woodbury manor was in the hands of Sir Hugh de Babington in 1279. It remained in the Babington family until the male line ran out of steam in 1501 and the manor passed into the female line through Audrey Delves. As with Avenel's there are virtually no surviving documents from Woodbury, not even an ink-stained inquisition post-mortem. But it's reasonable to assume that manorial business ran along much the same lines at Woodbury and on Avenel's as it did on Merton manor.

The Merton manor court rolls, those faithful mirrors of villagers' failings, resume in 1386 after a break of thirty years. On the surface manorial life continued much as it had done, unruffled and changeless. The manorial rule-breakers paid their fines and the property transfers were recorded for posterity by the clerk. You would never guess from the rolls that just five years

earlier south-east England had been convulsed by the Peasants' Revolt and the crackdown that followed its failure. There was considerable unrest in this corner of Cambridgeshire at the time, but as far as Gamlingay is concerned there's no evidence to suggest the village was involved in any way – not the slightest hint of riot, nor the faintest whiff of burning.

But if you look beneath the surface, there's a change in the tone of the rolls from now on. The changes brought about by the Black Death and the Peasants Revolt have done for the old manorial system of services, heriots, merchet and the rest. Lords may have liked to think the old ways were still in operation, but the fact is that rude reality kept intruding.

When the rolls begin again, the court is preoccupied with enforcing agricultural discipline and what it sees as the proper management of village affairs. It wouldn't have been necessary in the days of the rigid yet more community-minded manor of a hundred, or even fifty, years before, and it heralds a shift in the attitude of ordinary folk and their relationship with the manor.

If you read a century or two's worth of court rolls, you can't help but notice that the court's priorities are always subtly changing. Successive courts will often have dozens of cases of a similar nature. Villagers will be hectored and threatened and fined for not cleaning their ditches properly, or else an upsurge in assaults will preoccupy the court. At the end of the fourteenth century and the beginning of the fifteenth, the steward and his clerks were being bored to distraction by the endless pleas of debt they were forced to hear, although I feel it's kinder not to test your patience by quoting any of them.

Trespass is another offence that appears again and again in this period. At least the clerk was kept amused by the effort of spelling the many field names involved in the presentments.

> 1408
> John Holewyn for trespass in the corn and pasture at le milledam. Fined 10*d*.

> 1409
> Henry Basse trespassed in Myllecroft with his sheep. Fined 4*d*.
> William Warde and John Peverell for trespass in le lays in le cornefeld. Fined 2*d* each.

There's a simple explanation for the rise in the number of trespass cases. It was due to the appointment of a manorial official called a hayward. His job was to supervise the fences and enclosures, which were supposed to prevent livestock straying, to look after the common stock and to impound stray beasts. Any animals found wandering about were locked up in the village pound until their contrite owners had paid the appropriate fine, but, as always throughout history, some people were less inclined than others to play by the rules.

1408
John Smith broke the lord's fold and took away his beasts contrary to the lord's wish. Fined 6*d*.

1417
William Warde, servant of John Fisher, broke the lord's pound and removed a horse taken for trespass in the lord's corn. Fined 2*s*.

I haven't the slightest doubt that William Warde was acting under orders from his master. To the Fishers, rules were only there to be broken. They were a provocative, troublesome family who took perverse pleasure in thumbing their noses at manorial authority through most of the fifteenth century. They were always being fined and admonished for one misdemeanour after another, and just as often they ignored both. The attitude they typified slowly became more widespread and symptomatic of England as a whole. This is a selection of cases concerning the family over a period of seventeen years:

1408
Hugo Fyssher owes suit of court – defaulted – fined 2*d*.
His servant Walter not in tithing. Hugo Fyssher fined 2*d*.
Reginald Fysshere – trespass – horses in lord's corn and pasture. Fined 3*d*. Also geese in lord's corn. Fined 2*d*.
Thomas Fyssher – trespass – horses in lord's corn. Fined 4*d*.

1409
Reginald Fyscher distrained – plea of debt.
Thomas Fyscher – trespass – lord's wood on four occasions. Fined 12*d*.
Reginald Fyscher – trespass – pigs and animals in lord's wood and meadow. Fined 6*d*.

1413
Hugo Fyscher has died and his wife has his tenement. Ordered to distrain her to swear fealty to the lord for the services owed.
William Fyscher broke the pound. Fined 4*d*. And he trespassed in the lord's corn. Fined 4*d*.
John Fyscher not in tithing. Fined 3*d*. Also trespass – farmer's corn twice. Fined 4*d*.
On the orders of Thomas Fyscher, his servant John placed horses in the farmer's pasture, broke the pound, and trespassed in the farmer's corn. Thomas fined 12*d*.

1414
Thomas and John Fysshere fined 2*d* each for default.

Thomas Fyssher trespassed seven times in the lord's wood with his animals. Fined 2s 4d. Also trespassed in the lord's rye. Fined 2d. And in the lord's meadow. Fined 3d.

1422
Agnes Fissher did not send for the aletasters. Fined 4d.

1425
John Fissher has built a road across the lord's meadow to his house over the brook in le brokende. Must amend it before All Saint's day on pain of fine of 3s 4d.

That's just a selection remember. I have a certain grudging admiration for the way the Fishers flouted authority, but I also have sympathy with the poor officials who had to try and deal with them. The Fishers and hundreds of other families like them all over England were asserting their independence and individuality, and in doing so were hastening the end of the middle ages. In a century or two they would be commemorated and sentimentalised as the yeomen of England, but I don't suppose that either they or the people who got in their way saw it quite like that at the time.

Perhaps as a result of this new attitude, the court was now having to deal regularly with another type of dispute. The strips that made up the furlongs, and in turn the open fields, were only separated from each other by easily portable boundary marks, and they were a sore temptation to less scrupulous villagers. An extra foot or two of soil pinched from the edge of your neighbours' strip might easily go unnoticed. A couple of examples will suffice to show what was going on:

1414
Thomas Scot encroached on William Chastelet's land in length 4 perches and in width 2 feet. Fined 2s, and ordered to amend it before the next court on pain of 10s.

1422
John Welised senior encroached on the lord's land with a hedge one furlong in length and 2 feet and more in width. Ordered to remove it before the next court on pain of 10s.

Occasionally the court ordered a new tenant to undertake some building work as a condition of tenure. When Nicholas Wryght took over a house with a garden and five acres in 1417, he was told to build a two-roomed cottage next to it or face a fine of 20 shillings if he didn't do it by Michaelmas. The task was made easier by the College's gift of timber 'for splints and wattles or corbels'

and a payment of 23s 4d. This combination of stick and carrot must mean that either Wryght had some relatives or servants he couldn't house (in which case that was his problem, surely?), or the dwelling he was about to take over was on the verge of collapse. Given the state of some of the village buildings at the time, it's more than likely the house was in ruins. Orders like this are not infrequent:

1391
Geoffrey Skynner has not repaired his house called le bakhous. Fined 2d. Ordered to repair it before the next court on pain of 15d.

1412
John Ives was ordered at the last court to repair his ruinous tenement on pain of forfeit of 6s 8d. He has not done so; therefore the bailiff is ordered to levy the penalty.

As time went on this sorry state of affairs got worse rather than better, as we shall see.

Wood, for both firewood and building purposes, was becoming scarce. The growing pressure on this resource is reflected in the many fines the court levied for removing faggots and bundles of firewood from the College wood, and for breaking hedges and fences for the same purpose. The very fact that it had to repeatedly issue such warnings and penalties simply proves how ineffective the court was in stopping the practice. This is from 1417:

William Fouler cut down five elms worth 3s 4d on a close called Kechelscroft without licence from the lord. Therefore it is ordered to distrain him before the next court to answer the lord for the trespass.

The villagers might have thought that the woods and hedgerows were a communal asset to be used freely by all and sundry, but the deep ditch and earth wood bank which surrounded the wood (and still does today) argued differently. In 1424 the wooden bridge spanning the brook below Mill Hill was falling down, and the village asked the Warden of the College for help with some timber to repair it. He granted the request, saying they could have

nine oak trees called Wranglonns *growing in the ditches outside their wood*, on condition that the township shall not hereafter claim that the Warden and Scholars should contribute to the repair of the said bridge.

The Warden was being less than magnanimous. The rare and obscure word 'wranglands', or alternatively 'wranlons', is defined in the *Oxford English Dictionary* as 'crooked or misgrown trees that will never become timber'. This grant of some relatively worthless oaks served to further emphasise to the

villagers that the wood belonged to the College, and that the bridge was the villagers' problem.

Village life in the middle ages may have revolved around the seasons and the demands of agriculture, but it was regulated by the Church. From the meagre documentary evidence about Gamlingay church at this period you would think the only thing anyone was concerned about was who should get their hands on the church's income. But when dealing with the church we need not rely solely on documents because the building itself is still there, waiting to reveal at least some of its secrets.

Gamlingay church manages to look both graceful and solid: 'fair large and Comely', as the antiquarian William Cole described it in the eighteenth century. Like many English churches, Gamlingay's is a conglomerate of different styles and periods. The earliest surviving parts were built in the thirteenth and fourteenth centuries with local brown fieldstones rubbed round and smooth by glaciers thousands of years ago, and rough-hewn blocks of carstone. The enormous bowl-like depression left when the carstone was quarried saw later service as the village butts, later still as the village pound, and today is a children's play area.

In a sense you are closer to the people of the past when sitting quietly in a parish church than almost anywhere else, for the very stones seem to speak to you if you care to listen. You are sitting, remember, in what was until the middle of the sixteenth century a Catholic church. Within the chancel the various services were said, sung or chanted in Latin every day for hundreds of years.

The clergy who took part in these services were expected to stand throughout, and the choir-stalls installed in the 1440s include a typically medieval compromise between strict compliance with tradition and everyday practicality. Each stall contains a small seat that folded up when the clergy stood, with a sort of perch on the underside, which they could rest on during the chanting of the Offices but still appear to be standing. This concession to aching calves and sore feet was considered to be an act of mercy, and as you will remember, the Latin for mercy is *misericordia*, which gave the perch its name: a misericord.

Misericords were usually decorated on the underside by a wood carver, and the results are one of the glories of English medieval churches, albeit one that was for clerical eyes only. The carvers' work seldom bears much discernible relation to Church teaching, and whoever was employed to embellish the misericords in Gamlingay church couldn't be bothered with it either, creating a demon's head, an ape, grapes in vine leaves and a crouching man with what looks like the weight of the world on his shoulders. The little handgrips between the seats were worked into an angel, a mitred bishop and a variety of fantastic animals. Tucked away for the last five and a half centuries, the misericords remain almost as fresh as the day they were carved, but the handgrips on the stalls have been rubbed smooth and polished by the natural greases of countless hands over the centuries.

The stonemasons joined in the fun on the exterior of the church with their open-jawed gargoyles. I'm particularly fond of a marvellous dog, lolling on

his back and leering at the world through his hind legs. This is vernacular art in a religious setting, an illuminating insight into the fears and obsessions, as well as the sense of humour, of medieval people.

In 1464, a couple of decades after the stalls had been fitted, Walter Taylard (another Merton steward, and a rich landowner in his own right) made his will and asked to be buried in the little chapel of St Katherine, 'newly built by me'. Having forked out for the chapel, he and his wife not unnaturally thought they had proprietorial rights. His wife carved the words *hic est sedes Margarete Taylard* ('this is the seat of Margaret Taylard') in tiny script on a pillar next to the chapel, where it can still be seen today. The message is clear enough; how she expected ordinary villagers to understand her Latin isn't so obvious.

Margaret outlived her husband by seven years, and as you would expect she was buried beside him in St Katherine's chapel. In common with much of the priesthood and the wealthier laity, the couple had a commemorative brass made, set upon 'a faire marble stone' according to John Layer, who saw it a century and a half later. We'll have to take his word for it as it's no longer there. Layer, incidentally, also liked the church, describing it as 'a very hanesome faire large church' and Gamlingay itself as large and well-built, spoiling the effect somewhat by adding 'for a Countrie towne'.

The religious revival in the fifteenth century resulted in a more substantial and ornate church, but the work came to an end around the time John Alcock, the Bishop of Ely and twice Lord Chancellor of England, visited the parish in 1490. He came to consecrate a brand-new great bell, a small bell, and two new altars, and left behind a modest prayer he'd composed for the faithful to utter each time the small bell was rung: 'God have mercy of John Busshop of Ely that halowede the Altares and Bellys.' Then he was off to oversee his plans to suppress the Benedictine nunnery in Cambridge and found Jesus College in its place.

Nowadays we're used to Anglican churches with plain whitewashed walls and neat rows of pews, but the interior of the medieval church was very different. There were no seats for the congregation, or very few until the sixteenth century. People plonked themselves down on the rush-strewn floor of the nave or lounged against the pillars, watching and listening to what must have seemed an interminable service in unfathomable Latin. Margaret Taylard, of course, must have had a seat to deposit her expensively-clothed backside on, or the message she carved in the pillar makes no sense.

If she, who knew Latin, found the service dull enough to take out her knife to while away the time, then so did many others, as shown by the indescribable and often indecipherable mass of graffiti on most of the pillars – *hic est sedes* and *mors comparat umbre* among them.

Those who had forgotten their knives could gaze at the colourfully-painted statues of angels and saints, or the equally colourful wall paintings, illuminated by the light falling through the gaudy stained-glass windows and the many candles burning in the church. What the wall paintings looked like

is a mystery because all that remains in Gamlingay is a smudge or two of red ochre, but lurid – not to say horrific – biblical scenes such as the Mouth of Hell and the Day of Judgement were popular elsewhere.

The average villagers' understanding of the teachings of the Church came from a combination of these vivid images and whatever simple instruction the clergy could give them. Medieval priests, especially in rural parishes, were often barely literate themselves and couldn't teach their flock much beyond the basics of this kind of comic-strip Christianity. Attending the church was what mattered; whether the villagers understood what was going on was largely immaterial.

Mass was celebrated at the high altar in the chancel. The villagers in the nave could only crane their necks for a glimpse of the mysterious happenings because they were separated from the action in the chancel by a rood screen. There were additional side altars dotted around the villagers' side of the screen where a shortened form of the Mass, known as a 'low' Mass, was also celebrated. There was one such altar in the Taylard's chapel of St Katherine. The chapel itself was also painted, presumably with an image of the saint and her emblem of the wheel, and there was a squint through the thick wall to allow the Taylards to see through to the action at the high altar (the squint is still there today).

Somewhere in the church was an altar dedicated to the Trinity, maintained by the guild of the Trinity. Numerous candles or torches (made of thick, plaited wicks) burned at the altars and before the images around the building. Evidence from the Gamlingay wills made before the Reformation shows that some of these lights were maintained by the villagers themselves, such as the rail light and the ploughlight.

Easter was a major event. On Good Friday there was the popular ceremony of 'creeping to the cross', when the parishioners went down on their knees and shuffled over to a cross (either the altar cross or one kept for the purpose) and kissed it. When everyone had done so, the cross and the consecrated host were placed in a wooden coffer or chest known as the 'sepulchre'. From Good Friday until Easter Sunday lights burned before the sepulchre and a continuous watch was kept over it. This hugely enjoyable ritual was one of the targets of later reformers, who thought it had more to do with superstition than religion. Perhaps they had a point.

The church really was the hub of village social life, which was dictated by the Church calendar with its daily pattern of worship and the yearly round of festivals and saints' days. The local saint's feast-day was celebrated with much enthusiasm and church ales possibly more enthusiastically. Held within the church itself, they were an alcoholic equivalent of a church bazaar. The holy days of the Church calendar were the villagers' holidays, which is where the word comes from, of course. Gamlingay church possessed no fewer than eight banners, which were held aloft in the many processions required by ritual. One of the most important was the yearly Rogation or Gangtide procession.

These annual perambulations made their way right round the parish boundary and had a two-fold purpose. The first was purely religious: the priest, leading crowds of people carrying banners, handbells and the parish cross as they chanted the litany of the saints, blessed the growing crops and prayed for good weather. The second was eminently practical: the procession halted at various places marked by crosses – Gilbert Cross on the southern boundary with Potton, and Gamlingay Cross on the eastern boundary with Great Gransden for instance – and prominent local landmarks such as Chapel Corner and Harborowe Bush, to demarcate the parish boundaries. The procession was also known as 'beating the bounds', and in an age largely without maps it served to ensure that knowledge of the parish boundaries would be passed on from generation to generation.

The church was also the parish strongroom, parish storehouse, parish armoury and frequently did service as a reliable place to conduct business transactions. People thought that promises made within the church were less likely to be broken than those made elsewhere. This folk-custom lived on for a long time. As late as 1645, Christopher Mead stipulated that some money he bequeathed to his son should be handed over in the south porch.

The church bells also played a part in village life, signalling the celebration of the different rites to the villagers scattered in the fields, and tolling the dead to their last resting-place in the churchyard. They were also rung to signal an alarm and, curiously, during thunderstorms. Medieval folk held that thunder was the voice of the devil, and believed that ringing the bells – representing the voice of God – would drive the storm away. Given that a thunderstorm will always either drift away or dissipate, nature invariably confirmed their belief in the efficacy of the bells.

From time to time, Gamlingay church played its role as a place of sanctuary for criminals on the run. In 1260, for instance, Henry le Norys, outlawed for theft, was arrested in the village but escaped to the church. The blame fell on his fellow villagers. As the Cambridge Assize rolls of that year noted, 'He was in the tithing of Odo Est of Gamnegeye, therefore in mercy. And judgement of escape on the vill.' There was a forty-day time limit on sanctuary and when Norys reached it he took advantage of a peculiarly English custom available to fugitives. He was allowed to confess his crime to the coroner and 'abjure the realm'. In effect this was banishment forever from the kingdom. Donning the sackcloth garment of a pilgrim, the criminal set out barefoot and bareheaded, carrying a white wooden cross, and made his way to the port designated for embarkation, there to take the first ship available. (When a Bedfordshire man took sanctuary in Gamlingay after a murder in 1342, he was ordered to leave via Portsmouth.) If no ship was available, he had to wade out up to his knees in the sea at each tide to show his willingness to go.

Assuming the criminal didn't simply dump the cross, change his clothes and stroll into the distance at the first opportunity – in which case he was then an outlaw – abjuring the realm was a cheap and simple way of ridding the country

of its thieves and murderers. But what on earth must the rest of Europe have thought about having the dregs of England dumped on their doorstep?

The church also played, as it still does, a central part in the three main ceremonial rites most people undergo: baptism, marriage and burial. Little documentary evidence survives from the middle ages for the first two in Gamlingay, although the solid thirteenth-century baptismal font, with a piece or two of an earlier one incorporated in it, silently proclaims its part in village life through the centuries.

Death is a different matter. Visible signs of death are everywhere: indented slabs of stone, their brasses long gone, memorial tablets, medieval stone coffin-lids, and most obvious of all, the churchyard. I don't mean the crosses and gravestones, which date from a later period, but the fact that on the south side of the church the churchyard stands 3 or 4 feet higher than the surrounding land. Those who died in the bosom of the church were laid to rest there and it is, quite simply, full to overflowing with the mouldering bones of long-dead villagers. In contrast, the dark, north side of the churchyard was associated with the Devil, and was reserved for the interment of felons, unbaptised babies and (with permission) suicides.

At the same time as the revival of the Church was taking place after the Black Death, there grew up an organisation whose nearest modern equivalent would be the Friendly Society. For the outlay of a penny or two a week, the thousands of guilds which sprang up all over the country provided mutual protection against old age, infirmity and poverty. At the same time the guild member could be sure of a good funeral, and that masses would be said on the anniversary of his death.

The guild of the Trinity in Gamlingay was founded in the late fifteenth century and employed its own brotherhood priest, owned a guildhall, a malt-mill, cottages and at least sixty acres of land, all gifts given piecemeal over the years. Virtually every pre-Reformation will includes one or more bequests to the guild – or the brotherhood, or fraternity, as it was also known.

The Acts of Parliament suppressing the guilds were passed in 1546, and this is what the guild of the Trinity possessed in terms of domestic equipment at about that date:

> 2 brasse pottes; one brasse panne; one trevett of Iron; one dosen of pewter platters; 8 disshes; 6 sawsers; 3 towelles.

The whole lot was valued at a pound. The villagers had had plenty of warning that the guilds were about to be suppressed, and ample time to spirit away most of its moveable possessions long before the commissioners came knocking on the door. The guildhall and everything else was confiscated and sold, and the priest given a pension of 96s. The passing of the guild caused a certain amount of hardship to the villagers and brought little benefit – either in terms of money or prestige – to the king.

CHAPTER 4

THE END OF THE MIDDLE AGES

From the 1450s onwards England was embroiled in civil war – the Wars of the Roses that every schoolchild learns about, or used to learn about. The dynastic warfare left no visible mark on the village or its records. So far as I'm aware, only one Gamlingay man was involved in the sporadic conflicts. He was William Aydrop, who had fought with the Duke of Exeter, and he and another combatant were accused in the court of Chancery of menacing William Hunt, who had served with the Earl of Warwick. They 'talke and rayle daly' and 'manasse and threte', Hunt claimed, wherever 'he ride or goo'.

Judging by the village documents from this period, it's difficult to escape the conclusion that while their lords and masters had taken their collective eyes off the ball, the common people were relishing their unaccustomed freedom by abusing it. The art of behaving selfishly reached new heights.

Some people took the opportunities on offer and prospered under these new conditions. Low rents and the chance to farm more productively by combining strips of land into compact blocks set these villagers on the way to becoming yeoman farmers. Many who were less fortunate lost the ability to claw some kind of independent living from the soil and slid to the bottom of the heap to become landless labourers, wherein lay the seeds of the problem of the poor that was to plague successive centuries.

But to really get on, it was usually necessary to leave the village and head for London. Robert Otewy did it at some point in the first decade or so of the fifteenth century. His parents were brewers, regularly coughing up their pennies in fines for baking and brewing, so you won't be taken aback if I tell you Robert described himself as a brewer in his will of 1443. He really had made a success of his new life in the capital, and was able to leave his son a considerable inheritance: a thriving business, fine clothes and silks, a lump sum in cash and bits and pieces of gold and silver. He had not forgotten where he came from, though, remembering his family back in the village with various bequests, as well as giving a large donation of £5 to the upkeep of Gamlingay church and another £5 to the poor of the parish.

His example may well have inspired another young man from Gamlingay who was drawn to seek his fortune in the capital, one who succeeded beyond the wildest dreams of the average villager. He was the son of Joan and John Purchase, and they christened him William. No doubt the Purchases knew all about the success of Robert Otewy from his proud parents (whether they wanted to or not, unless parents have changed considerably since the middle ages).

They were not a wealthy couple. Joan was fined as an alewife, which is not how wealthy villagers made their money. Since William doesn't appear in the village records at any stage during his long life, it's possible that he went – or was sent – to London before he was twelve, because he ought to have been recorded in the manor court rolls as joining a tithing. It's equally possible that Robert Otewy (or his son) were involved in some way, perhaps by giving him a roof over his head when arrived in the city.

When William Purchase makes his first appearance in the national records in 1455 he is living in London, and clearly a grown man. He appears because he and another man were granted letters of attorney to act on behalf of two brothers called Geoffrey and Thomas Boleyn. If the name Boleyn rings a bell, that's because Geoffrey Boleyn was Anne Boleyn's grandfather. Originally from Norfolk, Boleyn was a London mercer, which means he was a merchant who traded in fine cloths, silks and so on. I must leave the obvious question – how did the son of a Gamlingay peasant and an alewife come to be a confidante of Geoffrey Boleyn? – hanging in the air, because frankly I have no idea.

By 1463 Purchase was working as a tailor, trusted enough by someone in authority to be sent with others to arrest three Genoese merchants for an unspecified offence and take them before the king in Chancery. Geoffrey Boleyn may well have been behind it because we can take it as read that he trusted Purchase, otherwise he wouldn't have made him one of the executors of his will, which he did that same year. More importantly for Purchase's future career, Boleyn was also a confederate of John Norlong, another London mercer. Purchase probably knew these men through trading with them (tailors need cloth to work with, after all), but he seems to have had a special relationship with John Norlong.

The year 1466 was the turning-point in Purchase's life. He began it as a tailor and ended it having taken the first steps along the road to riches and power. John Norlong died early in the year at the age of forty, and Purchase was one of the executors of Norlong's estate. In his will Norlong tells us that he thought his wife Margaret was pregnant with their first child, as indeed she was. As a young widow with money and a money-making business, Margaret would have had no difficulty in finding a new husband, but she didn't in fact look very far for one. Within a few months of her husband's death Margaret Norlong became Margaret Purchase, and William took over her late husband's business in St Lawrence Old Jewry, just off Cheapside. I'm pretty sure that for

Purchase the marriage was primarily a business deal. Marriages usually were when property was involved, and on the few occasions he mentions his wife there's no warmth or affection in his words, not even the conventional terms of endearment.

Shortly after his marriage, he bought his way into the Mercers' Company. This not only allowed him to trade in cloth, it opened up many opportunities for personal advancement. The Mercers were the foremost livery company and prominent in the government of the City of London, a position which made them a force to be reckoned with in national politics. Opportunity had knocked for Purchase, and he grabbed his chance with both hands. Almost overnight he became a man with a position in the City, and he settled down with his wife and stepdaughter to do what he was really good at: making money.

Purchase had an obvious talent for it and we find him busily employed in trade during the next few years, his activities occasionally noted in the Mercers' court and in the national records, depositing a bond here, chasing up a debt there. Fundamentally, his business was that of a middleman, buying wool and cloth from the graziers and clothiers who formed the backbone of the medieval English economy and exporting it to the Continent in the ships that crowded into the port of London, taking in return rich silks and other expensive cloth to sell to his customers in the capital. For instance, between April and September 1481 he sent no less than 2,910 yards of English woollen broadcloth (which was between one and a half and two yards wide) and a piece of double worsted to the great Brabant fairs held in the Netherlands and Belgium. So successful was he that within a few short years of setting up as a mercer, he was selling cloth of Arras to King Edward IV, who ran up a large debt of £465 and paid it by excusing Purchase from paying customs and other taxes for four years.

Successful businessmen make enemies. One easy way to make them was to be an executor of an estate, as Purchase was of John Norlong. A dispute arose over a bequest to the wife of Michael Dennys, and according to Purchase the irate Dennys assaulted him in his own parish and 'holde hym there in prison by 2 owres'.

After thirteen years Purchase wanted a break from the hustle and bustle of commerce. The most popular way to get away from it all in medieval England was to go on a pilgrimage, which neatly combined a holiday with the chance to earn some credit for your soul in the afterlife. There was a choice of destinations for the pilgrim, including Walsingham and Canterbury, but if you were able to afford it there were places further afield to tempt the traveller, such as Rome or Jerusalem or Santiago Compostella. Purchase chose the latter, and in the early spring of 1479 he set off for Plymouth, intending to take a ship to Santiago in northern Spain and visit its famous shrine of St James. He reached Exeter, but on arriving in the city he was promptly arrested. He had

either forgotten or did not know that Michael Dennys had relations in the West Country. Despite his protestations that it was 'pure malice and untrouth ymagend by the said mighell denys', and that he was 'grevosly vexid' by the whole affair, he was compelled to put up surety for his release.

I don't know whether Purchase ever made it Spain, but Dennys had certainly spoiled his holiday. Purchase, though, was not a man to cross, and when he got back to London he had Dennys arrested and hauled before the Mayor and Aldermen. Now it was Dennys's turn to complain, citing the unfair advantage that the 'favour might and power that he hathe in london' gave Purchase.

That power came from Purchase's growing ambition, both within the Mercers' Company and in the City itself. He was made one of the Wardens of the Mercers' Company. He became Auditor of the City of London, then Chamberlain, and the next two decades are largely a record of his steady promotion within the City. He was elected one of the Aldermen (to be an Alderman you had to prove you were worth at least £1,000) and was Sheriff in 1492/93.

Although much of his energy was spent on official business, he made sure he had enough time to make himself a very rich man, investing his money in two Norfolk manors, a mill and sundry properties in and around London. Some of that wealth may have come from dodgy dealings in his official position as Chamberlain, a post he held for eight years, because in 1490 Purchase was bound in the sum of £1,000, which may indicate some official disquiet at his activities. If he did abuse his position, he would have shrugged his shoulders and argued he was only doing what everyone else did. Nothing was going to stop his inexorable rise. In October 1497 he reached the top of the tree when he was elected Mayor of London for the year.

What happened during his year of office is recorded in *The Great Chronicle of London*. One of his first duties, after hosting the new Mayor's annual junket for 1,000 guests, was to meet and greet King Henry VII on his return from the West Country after quashing the rebellion led by Perkin Warbeck. The king stepped off his barge at Westminster Bridge

> ... where the mayer standing wythyn the paleys with his brethir the aldyrmen, and a grete numbyr of the Cityzins In ordere along westmystyr halle In theyr best lyvereys, Receyvid his grace with a short propocicion to hym made by the Recorder of the good exploit of his Journay and subduing of his Rebellis.

At Christmas 1497 the king's palace at Sheen was burned to the ground; in May 1498 Purchase attended a solemn mass at St Paul's to mark the death of the French king; from Easter until August there was a drought, when 'grasse encreasid not', which doubled the price of hay.

The explorer John Cabot was also in town, persuading the king and the city's merchants to bankroll his trip to Newfoundland and Nova Scotia.

Purchase may well have been one the investors, but as far as anyone knew Cabot had taken the ships and provisions and disappeared off the edge of the world, for in 'this mayris time Retourned noo tydyngis'. There would be none: Cabot was never heard of again.

The major legacy of Purchase's time as Mayor was his order that the gardens in Moorfields, just outside the City walls, 'be made playne ground' as John Stowe put it in his *Survey of London*, to which a later antiquary added 'then to the great pleasure, since to the greater profit of the City'.

When his year as Mayor came to an end in October 1498, Purchase more or less retired. At the end of 1502 he was excused his official duties because of his 'grete age and ffebylnesse' and died in the spring of 1503. Margaret outlasted her second husband, living until 1511.

He may have been old and feeble, but his mind was still razor-sharp when he made his lengthy and detailed will, truly a wondrous document that makes it clear he was, in today's terms, a multi-millionaire. The arrangements for his sumptuous funeral in the church of St Lawrence Old Jewry opposite the Guildhall matched his status, with twenty poor men paid to carry the torches that followed his body to the church and another four paid to hold burning tapers to 'brenne about my body' during the service.

There were many bequests to the poor and numerous instructions to his executors, including one to buy some woollen cloth to make gowns for the poor:

> whether it be blake clothe or musterdwillers ... of 3 yerds a pece for 12 men and 12 women, price of every yerde of the saide clothe 2s 4d or litell [more] or litell lesse as it wolle falle.

There speaks a businessman. He left large sums of money to the universities in Oxford and Cambridge, to friaries, convents, churches and fraternities in and around London, to hospitals, lazarhouses and 'pouer prisoners' locked up in London's jails (he knew what it was like to be arrested), and to the Guildhall for a new kitchen.

It might have been different if he'd had an heir to leave his fortune to, but he mentions no surviving children, and Margaret only mentions her daughter in her will. Perhaps they had no children together, or if they did, outlived them. He made sure Margaret was well provided for, including fifty pounds' worth of 'plate of myne of goldsmythes werke'.

All in all, he gave away in cash alone around £1,000, the bulk of it in charitable works for the good of his soul, as well as disposing of his properties in London and his Norfolk manors. Perhaps I'm reading too much into it, but there does seem to be a guilty conscience at work in the amazing number of bequests Purchase made to earn some kind of credit with his Maker.

In his last days he was worried about having large amounts of cash and valuables left around the house at his death, because in a codicil to the will he

asked for all his 'money plate or Juelles' to be put into a chest 'with foundry lokke theruppon', and placed in the hospital of St Thomas for safekeeping.

But there's something missing from his will that really should be there. It was normal practice to leave a bequest to the parish church of the village or town where you were born, much as Robert Otewy had done six decades earlier. Purchase left money to both the churches and highways of nearby Waresley and Eltisley, but nothing to Gamlingay. Perhaps he simply forgot.

There's not much left of the London he knew. The Great Fire of London in 1666 destroyed the city Purchase was familiar with, including his house in Lawrence Lane (now a back alley between offices, mostly used for parking dustbins) and the church of St Lawrence Old Jewry where he was buried. If Purchase's bones did manage to survive incineration, they were vaporised when the rebuilt church was flattened by a German bomb during the Second World War.

The choice of one his executors hints at another aspect of Purchase's life beyond the world of commerce. He appointed William Grocyn, a Greek scholar, leading light of the English Renaissance and friend of many other luminaries of the period. It's possible that through Grocyn, Purchase met Erasmus, who was in England in 1499. He certainly rubbed shoulders with kings and ministers, but within the mercers he must have known William Caxton, who was their representative in Bruges early in Purchase's career before he turned to printing. The father of John Colet, Dean of St Pauls and an eminent scholar, was a fellow mercer and Mayor of London. Purchase may well have known the young Thomas More, whose father was also a leading mercer, but here we are entering the realms of speculation and, like William Purchase himself, we've come a long way from Gamlingay.

If Purchase is an example of what a man could achieve by leaving the village, back in Gamlingay the concern with self-interest, coupled with the violent nature of some of the men who were scrambling out of the old villein class, is reflected in the manor court rolls. They run virtually continuously from 1461 until 1499, with four rolls surviving from the early sixteenth century plus a handful from the court of the honour of Boulogne, which for a few years was held on the same day as Merton's court. In the weird and wonderful world of feudal sub-letting, the honour of Boulogne was part of the Royal landholdings and in effect the overlord of Gamlingay's manors. Before you ask, I have no idea why these stray Boulogne records should be filed alongside those of Merton's court.

We saw the decline of the communal village earlier in the century when families like the Fishers dominated the court's activities, but now the Fishers were respectable folk, established members of the village hierarchy. Paradoxically, they had risen to a position where they now sat in judgement on those people trying to emulate them. I should imagine they were suitably indignant at the way some of them went about it. There are few as unforgiving as a reformed sinner.

Might was right, as it usually is. It was a dangerous age, when everyone carried a knife, if only to eat their food with, and the only way to settle an argument, it seems, was to resort to violence. This selection of cases heard by the Boulogne court illustrates what I mean.

John Warde, plowghwrite, assaulted William Ongear with a stick called a lever worth a halfpenny and drew his blood, contrary to the king's peace. Fined 4d.
Thomas Taylor, fined 6d, assaulted Northerne Johnson, fined 2d, with a stick and drew his blood.
Ralph Weyber assaulted Robert [blank] with a pothanger. Fined 2d.
The same Robert assaulted the said Ralph and struck him with a jar, throwing it at his head.
Philip Thesler assaulted William Paule, firing an arrow at him. Fined 4d.
John Birt assaulted Agnes Wache and struck her in the face with his hand. Fined 6d.
Robert Fuller assaulted Thomas Holme's servant by throwing a stone at him and drew his blood. Fined 6d.

It's reminiscent of a lot of rowdy children in the school playground. In a way these fifteenth-century villagers *were* acting like children, newly released from the restrictions of the past and yet to learn that freedom brings responsibilities. These incidents reflect the general atmosphere of lawlessness in the country at the time and none are particularly serious, unless it was your head that came into contact with a flying pothanger.

The village constables were supposed to deal with such sporadic outbreaks of petty violence, but it was a difficult task at the best of times. When real violence flared it was also a thankless one, as William Burley, the constable, discovered.

On the morning of 8 May 1492, Thomas Russell was making his way to the manor court when he was set upon by Edward Langton and a band of his servants. Why Russell was ambushed in cold blood is a mystery, but there may have been some sort of inter-manorial dispute behind it – Langton farmed the Sawtry estate at Shackledon. Whatever the reason, it's clear that Langton was taking no chances. He and his men fell upon their victim with 'six sticks and knives and an unlawful bandog', and as the court heard

assaulted Thomas Russhell within the bounds and limits of this lordship, and then and there beat him and wounded him, badly cutting him and drawing his blood contrary to the king's peace.

'Bandog' implies some sort of hunting dog, probably a mastiff. If the phrase 'bounds and limits of this lordship' means that this premeditated attack took

place within the manorial gates, which I think it does, then Langton must have felt really sure of himself.

The constable, William Burley, probably witnessed the bloody assault as he was one of the jurors and would have been at the court early to be sworn in. I doubt very much if he lifted a finger to protect Russell. It would have taken a lot of courage to plunge into the middle of a group of men and a vicious dog attacking a defenceless man, but the court obviously felt that Burley should have done something, because the clerk has written in the margin beside the record of this case that 'John Fox is elected constable instead of William Burley and is sworn'. Possibly it was easier for the court to blame the constable than to examine their own consciences. Poor William Burley! I feel sorry for him, especially considering the stew his son was to get into forty years later when faced with a similar predicament.

Langton, meanwhile, was fined the hefty sum of 5s and his servants 20d, although whether his servants were fined individually or collectively I can't say. I'm pretty sure the fines were not paid – at least, there seems to be no record of them being paid – but in the end there was little the court could do about it.

Much of the violence could be blamed on the influence of the alcohol served in the village alehouses. There were as many as ever: nine alewives were fined in 1487 and seven in 1495, for example. Some establishments had developed into something a little closer to the modern-day public house, and three of them had acquired names.

They had always had names, of course: 'Mother Basse's place' or 'Spede's house' or something similar; but from now on The Cock in Church Street, The Falcon at the crossroads, and The Swan are mentioned. The Cock, first noted in a deed dating from 1445, is still going strong today in a later Elizabethan house on the same site. I'm intrigued by the fact that a rental from around 1490 mentions the *signum de le cokke* and the *signum de le Swan*. These are early references to inn-signs, which were not to become fashionable for another 200 years. Their owners must have been trendsetters. The owner of The Falcon (a converted farmhouse known during most of the middle ages as 'Whitehall') was none other than William Burley, erstwhile constable.

At least one of the innkeepers believed in providing entertainment as well as alcohol for his customers, as this next quotation illustrates. It also illustrates in passing another of the difficulties to be found with medieval documents, as well as part of their appeal.

Any entry in the court rolls containing unfamiliar words always caught my eye because it was likely to be out of the ordinary. This one had several, and took two long evenings and a fruitless visit to Cambridge library to untangle. The stumbling block was the word *ospitmanus*, used to describe William Gosson. It didn't exist. I thought perhaps I'd misread it, but every combination I tried drew a blank. On the point of giving up in sheer frustration, inspiration

finally arrived. I looked up *hospitmanus* and there it was – an innkeeper. Maybe the clerk who wrote it was a Cockney.

1475
William Gosson, innkeeper, aided by various people played unlawful games and sports, namely football, tennis and tables, on feast-days and at other illegal times. Fined 6*d*.

'Tables' was originally a Roman board-game and resembled backgammon, using dice and counters which the players moved around the board. It was much in vogue with the upper classes throughout the middle ages. Tennis was the 'real' variety, and could be played at a basic level by simply stringing a net across a suitable open space. If no racquets were available, you could use the palms of your hands instead. Football was played by hordes of people, had no rules, was often brutal and dangerous and was frequently banned by the authorities.

Another illegal way of enjoying yourself (and let's face it, most ways of enjoying yourself were illegal), as well as providing food for the cooking pot, was to indulge in a spot of poaching. A couple of examples among many will do. William Rede was fined fourpence in 1471 for taking rabbits and hares 'with greyhounds and other animals', while in 1489 the court heard that Richard Frances, Thomas Derlyng, William Burley and Richard Aythorpe were 'common poachers who do not hold land and tenements worth more than 40*s*, and own greyhounds and hunt by scent'. In fairness, I must point out that William Burley wasn't the village constable at the time.

Note the financial restrictions on keeping greyhounds and hunting: you either had to own property worth forty shillings a year for taxation purposes or goods worth £5 in order to indulge man's innate instinct to hunt. This ensured, as it was meant to, that taking game remained 'hunting' for the well-to-do and 'poaching' for everybody else.

Living in a small community (small in modern terms: there were never more than about 300 villagers in Gamlingay during the middle ages) offered people with a keen interest in their neighbours' business many opportunities to amuse themselves. With no street lighting, easy access to the village tofts and crofts and thin wattle walls, it was simplicity itself to spend the long winter evenings happily listening to private conversations. Not for nothing was this pastime called eavesdropping. Traditionally, of course, it was the womenfolk who were supposed to indulge in it. All the stranger, then, that this is the only case of its kind in the court records:

1461
The jury say that Thomas Jervis is a common 'evisdropper', hiding at night by the tenants' houses. He listens to what the tenants say in their

houses and repeats it all in suspect speech contrary to the law of the land. Fined *6d.*

And what was Thomas Jervis's wife doing while her husband was out at night gathering gossip? She had found her own way of passing the time:

Rose his wife furtively took 'Otemele and flowir' from William Baldry's goods after the feast of the Nativity last. Fined *6d.*

I mentioned before that theft was a much rarer occurrence in the medieval village than you might have imagined. Major cases of theft would have been heard in a higher court anyway, but for what they are worth, here are the only other cases from this period recorded in the rolls:

1463
Isabella Sprottele stole corn from the tenant's sheaves during last harvest. Fined *6d.*

1494
John Wolff unjustly took a calfskin and a piece of clout-leather from an unknown man. Fined *12d.*

Many of the entries on the rolls are the familiar routine stuff of earlier courts, but occasionally there's a new twist to an old theme. Plenty of people were still being presented for gathering firewood from the hedges and woods, but John Dalton went a step further when he and his servant 'stripped the trees called "crabtres" in the lord's wood' in the autumn of 1463. And someone in authority decided to clamp down on the village butchers in the early sixteenth century, because alongside the usual fines for the bakers and brewers there are several examples like this:

1508
William Smith and John Calnersley sold tainted and unhealthy meat. Fined *1d* each.

Waifs and strays were still a problem, but now there's a clear statement of the custom of the manor when an animal was found wandering in the fields.

1511
One calf called 'A Cow calfe' and coloured 'reddefleckyd' came within the lord's land as a stray after Michaelmas last, and was proclaimed in the marketplace and in the church as the custom is for a year and a day. Therefore the lord has seized it. Worth *3s.*

These proclamations are the only times the market place is mentioned in the rolls. And having said earlier that millers were notoriously dishonest, here is a surprising and unique entry, from the rolls of 1508:

Richard Hanbery holds the mill and took excessive profit. Fined 2*d*.

The surprise being, of course, that the case *is* unique.

Meanwhile, the village was falling to pieces. To give you an example, in 1487 the court instructed John and Robert Warde to 'repair their tenements sufficiently in all things before Michaelmas'. This order was greeted with blank indifference. The order was repeated in 1490, when it was specified that the timber and thatch needed repair. The Wardes were given until the following Easter to make it good or face a fine of ten shillings. Four years later, the instructions were repeated. Yet again they were ignored. The following year they were told to make good the wood, thatch and plaster or the bailiff would have to do it. Nothing was done, of course, and the order was repeated in 1496. The following court increased the penalty to twenty shillings and dropped the idea of the bailiff doing the work. Then the case quietly slips from the records, *nine years* after it was first raised.

Houses and barns were coming to the end of their useful lives, and nobody was prepared to lift a finger. The attitude of people like the Wardes and others is partly explained by the fact that they were, absurdly, sitting in judgement upon themselves. Oh, they would happily sit on the jury and piously order other people (and themselves) to make the necessary repairs, but immediately the court was finished they would adjourn to the nearest alehouse and promptly forget all about it.

The College itself was just as bad. As far back as 1451 the jury had listed many defects around Merton manor – stables defective, sheep-cote in bad repair, hogs' cote 'totally decayed' and the dovecote 'has windows broken in many places by the wind'. They cheerfully suggested that the new tenant should make the repairs.

By 1491 even the room the jury sat in was tumbling down and well-nigh derelict. An inventory was taken that year, when Thomas Bird took over the lease of the manor farm, and is brief in the extreme. There wasn't much to write about: £10's worth of stock, bits and pieces of husbandry hardware, but significantly only one plough. The scribe also noted a trestle table, three forms, four bedboards, the only cooking utensils being a spit and an iron pot. The manor house was more like a hovel. It was a situation that didn't exactly inspire a respect for authority. And what did people do when the repairs couldn't be put off any longer and building work simply had to be done?

1486
Each person who has made lime for their houses in the king's highway shall make adequate repair on pain of 3*s* 4*d* before Pentecost next.

Most villagers considered the road that ran past their house and yard to be their own personal property and thought nothing of burning lime on it, digging holes in it and removing sand from it. Some went to the opposite extreme and left obstructions on it:

> 1485
> Thomas Jenkyn fined 3s 4d for placing stones and sand in the king's highway ...

Jenkyn was almost certainly rebuilding his house. What could be more natural than to block the road with his building materials? Also 'natural' was the obstruction noted in 1487, when John Cler was ordered to 'carry his dung from the king's highway to his gate on pain of 12d'.

The court spent much of its time during this period repeatedly issuing regulations concerning the government of parish resources. This kind of thing:

> Nobody shall put or pasture his sheep or horses in le litilfenne from the feast of the Annunciation of the Blessed Virgin Mary until Michaelmas on pain of 6s 8d.
> The lord and all free tenants of this manor who are copyholders shall clean that part of le comon brok where it abuts on their land ... pain of 6s 8d.
> Ordered that no baker or alewife cut down lez Bromes or hethe on the common except one cartload a year on pain of 6s 8d.
> Nobody shall keep his sheep or pigs on their own, but shall put them in le Flok, on pain of 3s 4d.

I'm afraid it was all just so much hot air. The tenants who so conscientiously repeated these sensible rules and regulations were the same ones who broke them, the same ones who were fined and the same ones who didn't pay up.

The end of the middle ages is traditionally seen as occurring on 22 August 1485, when Henry Tudor is supposed to have plucked Richard III's crown from a thorn bush at Bosworth Field and placed it on his own head. Henry's victory certainly ushered in an era of stability and firm government, although the transformation from medieval to Tudor is more apparent with hindsight than it was at the time, especially in the rural villages of England. But stability, particularly financial stability, brought with it the opportunity to plan for the future, and before we leave this period I ought to mention the two buildings that did get rebuilt at this time, and which still ornament the village today.

Both were College properties, and both were leased in turn by an energetic tenant called Thomas Bird. He first appears in the records in 1475 as the lessee of Whitehall, the farm-cum-pub which stood at the crossroads, but he soon

took on the rectory, standing just to the east of the church. If what we have seen of the rest of the village is anything to go by, the rectory was probably falling down when Bird took it over, because he built a new timber-framed one in its place, with a magnificent open hall and a cross-wing at the south end. The stains left by the smoke as it curled up from the hearth in the hall and out through the roof are still plainly visible today.

In 1491 Bird leased Merton Manor Farm, which was all but uninhabitable. He built a new Manor Farm, also with an open hall and a cross-wing. In both cases, later building and modern restoration have combined to give us the finest secular buildings in the village. They stand as monuments to Thomas Bird, one of the new breed of men, thrusting, ambitious and dynamic, who would consign the middle ages to history. The Tudors have arrived.

SUCHE ANGRE AND FURYE

Village life may have looked outwardly serene, but there were always tensions and passions bubbling away like a pottage pot simmering over a fire. There were rumours, intrigue, gossip, vendettas, cliques and alliances – there always have been, and probably always will be in village life.

They sometimes boiled over into the outbreaks of petty violence reported to the manor court, and were the inevitable result of people living and working cheek-by-jowl with their neighbours in a rather isolated village. Some of them developed into full-blown feuds. No doubt there were many causes – arguments among neighbours, disputes over land, a grudge over an inheritance, family rows, marital infidelities, and so on – but the situation in Gamlingay was aggravated by an odd aspect of the justice system.

The parish boundaries butt up against Huntingdonshire to the north and Bedfordshire to the west and south. I said Gamlingay was isolated, but I didn't mean geographically. It was isolated in the sense that if there was trouble in the village, help with law enforcement could only come from the Cambridgeshire authorities, usually the nearest Justice of the Peace. The justices over the border in Bedfordshire and Huntingdonshire had no jurisdiction in Gamlingay.

None of this would have mattered very much if there had been a Justice of the Peace – or any other figure of authority – actually living in the village, but after the passing of the Avenels there was no man of substance living there until the early eighteenth century. Merton manor was farmed, Woodbury and Shackledon in the hands of absentees, and Avenels belonged to Thomas St George, who lived a couple of miles away in Hatley St George. The main responsibility for keeping the peace rested on the shoulders of the village constables, appointed by the villagers through the manor court, and we saw in the last chapter how ineffective they could be.

One of these pent-up village feuds burst into brief but bitterly violent life on a wet Sunday morning in the early March of 1532. Although the eruption only lasted a few hours, it created enough incidents to keep those who witnessed it in anecdotes for the rest of their lives.

Let me introduce you to the chief actor in this little drama played out on the village stage – Edward Slade. The Slade family had held land and houses in Gamlingay from the early fifteenth century. Edward was born around 1485, the son of William Slade, a lawyer, who paid for a commemorative brass to be laid in Gamlingay church recording the death of his wife Eleanor in 1506 and 'the said William who died 15—' The blank dates were never filled in, for William Slade remarried and moved to Bedfordshire.

His son described himself as a gentleman, but anyone less gentle than Edward Slade is hard to imagine. He was arrogant and strutting, grasping and cruel, volatile and brutal, a real Tudor bully with a fiery temper. It's a combination that's intimidating at best and positively dangerous at worst. Men like Edward Slade often achieved great things in times of war or national crisis, but in times of peace and in a rural setting they were a menace to anyone who crossed them.

Slade's idea of fun was to carry on a number of feuds for year after year, and to revel in the litigation that inevitably followed. I've been unable to get to the bottom of his dispute with Richard Clark, who farmed Merton Manor, but his feud with John Basse began in about 1518 and stemmed from Basse's refusal to complete the sale of some land in Gamlingay under the terms of a will. Both men claimed title to the land and the argument reached the court of Chancery.

The other leading actor in the drama actually was a Justice of the Peace. Thomas Chicheley esquire owned a large estate at Wimpole, and was married to the sister of one of the heirs of Thomas St George. Like most people who had any dealings with Edward Slade, Chicheley bore a massive grudge against him.

This one had its roots in the marriage around 1512 of George St George, the palindromic eldest son and heir of Thomas St George. His chosen bride (or the one that was chosen for him) was Jane Mordaunt. With no idea of the consequences, his father Thomas innocently gave the newlyweds a handsome wedding gift in the form of a joint life interest in great chunks of land and property, including the manors of Tadlow, Papworth Everard and almost certainly Avenel's in Gamlingay. Unfortunately for all concerned, George very soon died, before there were any children from the marriage. His widow Jane then unwisely chose Edward Slade as her second husband, probably by 1514, because he was appointed one the Justices of the Assize for Norfolk that year, alongside Jane's father William Mordaunt in what seems to have been blatant nepotism. Slade must therefore have had some training in the law, which explains his litigious nature.

The grudge between Chicheley and Slade arose because both men hoped for a share of the inheritance when Thomas St George died. Slade claimed Chicheley 'always supported and mayntened dyvers injuries and wrongs' against him due to his wife's connection with Thomas St George. I'm sure Chicheley would have said much the same about Edward Slade.

Slade and his wife Jane began their life together in the manor house at Tadlow. Slade had the house rebuilt, but unluckily, and no doubt to everyone's amusement, it fell down and had to be moved to another site. It didn't take long for the local gentry to begin to resent the presence of Edward Slade in the social circles of west Cambridgeshire, resentment which came to a head in 1522, when they drove him from his manor house in Tadlow with threats and violence. Needless to say, one of the gentlemen who took part in the expulsion was Thomas Chicheley.

Ten years on, Slade was living in Avenel's manor house in Gamlingay when another storm broke over his head. To say he was unpopular with his fellow villagers would be like saying the Black Death was merely a mild dose of flu. They loathed the man. They later claimed he stole a field of wheat from Widow Goores and two crops of peas from John Basse, that he 'mayhemmed' Richard Clark, killed several people's pigs and when Mistress Barker tried to save her pig from his clutches, it was said that he clouted her across the hand with a mole-spade so hard that she was unable to move it 'soo wele as she myght before'. Thomas Ratford had a bullock stolen, a man called Trollop lost his hay when Slade broke open a barn door and threw the contents in the yard, and the village constable, John Burley, was set upon when he tried to prevent Slade and his cronies stealing the tithes from the tithe barn. Slade took a flock of sheep belonging to William Malden and held it to ransom for 20s, and his servants turned the corn out of John Hedding's cart. It was claimed that most of the village went 'dayly in daynger of ther bodyes' because of Edward Slade. He was a black-hearted scoundrel, little better than a bandit – if you believe it all. These villagers were justifying their actions in a court of law, and they may just have been protesting too much.

What finally sparked all this resentment into flame was yet another assault, perpetrated on John Basse by one of Slade's servants. Basse responded by asking the constable to arrest Slade and obtain sureties that he and his servant would keep the peace. Slade himself thought Basse was put up to it by Richard Clark ('for suche malice and evyll will as he do also bear') and, of course, Thomas Chicheley. Perhaps he was right, or it may be that both Basse and Burley saw it as a golden opportunity to take revenge on Slade. As constable, Burley may also have thought it was a chance to make amends for his father William's dismissal from the post, forty years earlier. He probably believed that since nearly everyone in the village was thoroughly fed up with Slade, they would like to see him taken down a peg or two and support their elected constable.

But John Burley made a big mistake in trying to arrest Slade while he was hearing mass in the church. He obviously hadn't learned from the experience of the king's bailiff, who had attempted a similar arrest two years before. On that occasion Slade's servants had kept the chapel door shut until their master had made his escape.

From this point on, there are more than two dozen accounts of what happened. None of these eye-witness statements tell exactly the same story and some of them vary wildly, which only goes to show that the truth, whatever else it might be, is a highly subjective matter. In this case it all depended upon which side of the argument you were on, but the main events are clear enough.

The sacring bell had just been rung to alert the congregation that the host was about to be elevated in the chancel in what was, literally, the high point of the Mass. At precisely this moment, Slade was on his knees in the chapel of St Katherine engaged in private prayer, and he looked up to follow the ceremony through the Taylard's spyhole in the wall. The vicar, Thomas Pekket, raised the host for the villagers in the nave to see. He was about to bless the chalice when Burley, with supreme mistiming worthy of a Basil Fawlty, entered the church and tried to arrest Slade.

Slade swore that Burley simply came up to him, more or less unannounced and without showing his warrant, and 'maliciously brake his girdell & pulled his wodeknyfe from him, shethe and all' as it hung by his side. Burley vehemently denied doing any such thing. A scuffle broke out, but who struck the first blow is a matter of dispute. Slade, 'in a great furye', said forcibly that if anyone laid hands on him then he would give as good as he got. There was some pushing and shoving, then Burley was cuffed on the ear and hit in the mouth so that 'he did spett blood', before Slade grabbed a staff and started whacking the constable with it. Burley claimed Slade then pulled out his wood-knife, which justified Burley in punching him 'on the Ere with his ffyst'. Before the brawl could develop further the two protagonists were pulled apart, 'before the Crucyfix', no less.

William Bramswell then stepped forward into the limelight. I can imagine him holding up his hand for attention and clearing his throat before saying mildly, 'John Burley, I pray you be content and make no further besynes, for we will wytnes that you have arrested hym.' It was a pretty speech, but a waste of breath as nobody else seems to have heard it in all the commotion. Slade's version of events has it that he offered to find surety and that the constable agreed, whereupon both men calmly joined everyone else in taking holy bread before the congregation quietly dispersed, 'every man home to his owen house for their dyner'.

Burley, on the other hand, adamantly denied surety had been offered. Others merely said Slade left the church and went home. Slade's story of a happy ending sounds dubious at best, but he was no doubt correct when he said the scuffle was 'to the grete troble of the preste then beyng at masse'. Meanwhile, the rest of the congregation, whom Slade rather cuttingly described as 'light persones', had been enjoying the spectacle of an officer of the law and a gentleman fighting in their midst during divine service, and were excitedly discussing the dramatic events. As William Myddelton testified, there was 'moche busynes, some spake of the oon parte and some on the other'.

The scene now shifts outside the church. The bruised and bleeding constable, with 'a hurte upon his litle fynger' and his feathers of authority well and truly disarranged, was approached by Slade's friend John Bridges, who offered to put up surety for Slade. Burley refused the offer, claiming that he had no authority to accept.

The constable was in a difficult position. A failed arrest would make him look a fool, yet if he tried to arrest Slade on his home ground it seemed likely there would be further bloodshed. At the same time, he was responsible for law and order in the parish and could hardly go home for lunch as if nothing had happened. He took the only other course open to him, and sent to the nearest Justice of the Peace for help. The nearest one was none other than Thomas Chicheley.

When Burley's messenger arrived at Wimpole with the plea for assistance, Chicheley dispatched a couple of his men to ascertain the facts of the matter. It was only when they failed to return in good time that he wearily pulled on his boots, mounted his horse, called four of his men to join him (ten or eleven, according to Slade) and set off for Gamlingay. The first thing he did on arrival was to head for The Cock, where he could down some ale while listening to the constable's tale of woe. The second was to call for most of the men of the village to join him. Chicheley then sent two of Slade's friends, John Bridges and Stephen Butler, to Slade to request the pleasure of his company. 'Sent' is perhaps not the right word. Neither is 'request'. The hapless pair were informed they would end up in Cambridge Castle if they didn't do as they were told. The reply they brought back from Edward Slade was entirely predictable: he refused.

At this point Chicheley decided to go home and make the most of what was left of his Sunday, but as he was leaving the villagers came to him, crying that if he went then they were going with him, adding that they 'knewe well murdre was lyke to ensue, and manslawter' if he didn't stay. At least, that was how Thomas Chicheley justified what happened next.

He sent the messengers back to Slade to tell him that if he refused to come as ordered, he would take him as a rebel and 'pulle the tyles over his hede', a phrase which sounds much more like the authentic Chicheley than the reluctant participant we have seen so far. The two wretched messengers returned, unable to find Slade. Someone then claimed to have seen him going into his house carrying a bow and arrows. On hearing this, Chicheley's patience snapped. Gathering Bridges, Butler, Burley and the rest of the village men, who were by now armed with swords, bucklers and bills, Chicheley led his motley band down Church Street and round to Avenel's, which lay on the outskirts of the village. Most of the men with him were probably glad of the chance to settle some old scores.

The sight of the mob bearing down on him obviously frightened Slade, who, whatever else he might have been, was no coward. In his own words, he was 'in grete feer and dout of his lyfe' when he saw Chicheley and his men in 'suche angre and fury'. He hastily ordered the doors to be shut, and only now (he said)

took a bow and some arrows, and rushed to an upstairs window overlooking the yard. One of his servants also grabbed a bow and ran to a window.

Chicheley, with an angry crowd at his back and Slade peering down at him, told his men to pull down the fence surrounding the manor house. It was quickly flattened and the crowd surged forward into the courtyard. Slade and his servant responded by loosing a few arrows in their direction, 'only to fear them & not to hurt them'. If that really was their intention, they didn't succeed. As one witness put it, 'the master as the man shott arrowes out at the wyndowes … and struke Chicheley his servant throwe the knee'. Slade was to claim rather weakly that he only fired one arrow without a head on it, thereby putting the blame for the injury squarely on the shoulders of his own servant.

Having lost his patience half an hour before, Chicheley now lost his temper. He bawled 'break down the doors' or something like it, because everyone who was there agrees that some of the mob got hold of a large post and ran with it at the hall doors. This improvised battering-ram quickly smashed a way in to the house. Now Chicheley was faced with another problem: how to get the pair out of their respective rooms. Typically, his response was to yell 'down with the dores, down with the dores' and to call for 'Gune powder, and sayd they wold burne Slade out of the house'. The problem of finding a supply of gunpowder did not arise, for in the excitement that followed the inner chamber doors were forced open, and 'oon of them ther brake all in peces'. It did not take long to find and capture Slade and his anonymous servant, Slade complaining that it was done with 'grete vyolence' and that he was dragged from his chamber by the mob, 'some by the leggs and some by the armes'. Despite claims to the contrary, it's quite clear that once in Chicheley's hands the two prisoners were roughly treated.

> as soone as Chicheley hadde Slade, he causyd hym mayntenant to be ledde to the stokks and throwe a myre by the waye, and ther kept hym fast lokkyd

Slade was to state later that while he was being dragged through the mud a little over £7 in gold and silver was stolen from him. If indeed the money was taken, I would suggest it was buying round after round of ale for his conquerors, by now safely out of the rain in the warm and convivial atmosphere of The Cock.

Slade's mud-spattered state was not improved by the weather that Sunday in March. William Myddelton tells us 'it rayned a lytyll, soft pase'. Slade, of course, disagreed, saying that it 'reyned very sore the seid mydlent Sunday'.

The troublesome pair were left to cool off in the stocks for an hour, 'in the reyne, all wete and cold' as Slade complained afterwards. Then they were put on a horse and sent with an escort towards Cambridge Castle. They reached Caxton that evening, where Slade was incarcerated for the night. The next morning he was taken to Cambridge Castle where

... they brought hym befor Mr Sutton, beyng Justice of the Peace, wher
he found suertes and so was set at large.

And so Edward Slade, battered, bruised, muddied and no doubt as defiant as
ever, went home to his wife and children, to nourish his hatred of the men who
had bested him.

That bitterness resulted in the case Slade brought against Chicheley, Burley
and fifteen villagers in the Court of Star Chamber. In retaliation, Burley and
some of the villagers brought a counter action against Slade. Other village men
were dragged into the dispute to give evidence on one side or the other. We
aren't told the outcome of either case, which is unfortunate, to say the least.
You can feel the burning indignation of Slade, Butler and Bridges at the rough
handling they received. You can see the angelic expressions on the defendants'
faces as they denied the allegations to a man. You can follow the action through
all its stages, making due allowance for bias and contradictions in the evidence,
but, maddeningly, the result of the case is not given. Nevertheless, I think it's
safe to say Slade lost – eventually. Against him were the sworn testimonies of
twenty-two respectable men, including a Justice of the Peace and a constable.
For him were a few friends willing to attest to his heavy-handed treatment, but
unwilling to swear that the arrest was unjustified. What happened to Edward
Slade was probably seen by the court as a rough-and-ready form of justice.

And then he disappears completely from the village records. Although he
had effectively been driven out of Gamlingay, the courts continued to hear
from Edward Slade. In the next few years he was engaged in a dispute with
Thomas St George, who accused Slade of waste and destruction in the manors
of Tadlow and Papworth Everard. At the same time Slade was pursuing
Thomas Chicheley for jury-packing in an action for slander.

The trail of documents leads to Northamptonshire at the time of the land
sales which followed Henry VIII's dissolution of the monasteries. Slade knew
a property bandwagon when he saw one and promptly leapt on it, buying or
leasing four houses and over 300 acres of land in the little village of Rushton,
a few miles north of Kettering.

He spent the rest of his life in Rushton with Jane and at least seven of their
children, probably in the house he owned known as Huntingdon Hall, a
name that would have appealed to someone who was always keen to let the
world know he was a gentleman. No doubt he bowed low to his powerful
neighbours, the Treshams at Rushton Hall, but he still enjoyed annoying his
lesser neighbours because one of them took him to court for chopping down a
hedge between their two properties.

Slade made his will at the end of July 1546. The ink was scarcely dry when
he died, just over a week later. The following day he was buried in the chancel
of Rushton All Saints. He left everything to Jane during her lifetime, then to
his only son John, who was nineteen. John had obviously inherited some of his

father's less attractive traits, because Slade warned him warned not to 'medle nor mynister duryng the lyff of mye sayd wyff hys mother'. Officialdom's final dealing with Edward Slade came at Northampton in October 1546, when an inquisition was held to record the property he owned at his death. His wife enjoyed nine years of what I trust were peace and quiet before she followed her husband to the grave. After his mother died, John Slade married a Widow Taylard, thus neatly reviving the Gamlingay connection through the descendants of the Walter and Margaret Taylard we met in the last chapter.

One of Edward Slade's great-grandsons through his daughter was William Leete, who left England for America in 1639 and eventually became the Governor of the New Haven Colony (1661–65), then Governor of Connecticut (1676–83). A respected figure in the early history of the United States, he at least seems to have been a well-liked man.

Let's return to that damp and dismal Sunday in March 1532 and listen to some of the evidence given by those on the periphery of events. Where had John Basse got to, he who began the whole business by asking the constable to arrest Slade? The poor man had been taken ill and missed the drama,

> ... for somoche as he was not present, but was at home in his own howse, being very evyll at ease and sickely.

Or to put it another way, he'd kept his head down when he knew trouble was brewing. Thomas St George was asked to give evidence as well, but he was in his own parish church at the time and therefore couldn't comment on what had happened. Besides, he said, he too was 'acrasyd of a Surfett the day menconned'. There was a lot of it about.

The last word must go to the vicar, Thomas Pekket, an old man of fifty-eight. Despite the evidence that he was disturbed by the fighting going on as he raised the host, like the three wise monkeys he saw nothing, heard nothing, and was saying nothing:

> afor the sayd arrest, and afor any suche busynes, this deponent hadde sayd masse and was gone in visitacon, so that he can not depose in it.
>
> Mr Chicheley came to the town when this deponent was at evynsong, and there this deponent contynuyd tyll they hadde arrestyd Slade, and can not depose in the mater further, for he was not among them, nor dyd see any of the demeanour ...

Man of God he may have been, but despite his protestations Thomas Pekket *was* there and could hardly have missed what was going on. Like many people that day, he would have to live with his conscience.

NOTHINGE IS SO SURE AS DEATHE

By 1500, more people than ever before owned property and possessions, and with this increase in personal wealth came concern about what would happen to it after they died. The solution was to leave a will, and from about this date that's exactly what the better-off villagers began to do.

Please don't think I'm morbid, but I like wills. They are some of the most revealing, as well as the most personal, of all documents. They give you a glimpse of the lives and individual characters of people in a way that few sources can match. If you are lucky enough to be able to handle an original Tudor will it's easy to imagine it being written at the testator's bedside five centuries ago, for the paper looks new and the ink remarkably fresh, while the frequent crossings-out and insertions indicate the changes of mind and mental turmoil of someone trying to sort out the final reckonings of a lifetime.

Most wills are in English, and in the 'secretary' script of the time. Many of those that survive are copies of original wills, bound in large leather volumes and kept as a record of the granting of probate by the Church when the will was proved. You don't need me to tell you that a fee had to be paid for proving a will.

The wills made by the men and women of Gamlingay are in two separate repositories: those proved in the Archdeacon's court and the Consistory court are in Cambridgeshire Archives, while those proved in the Prerogative Court of Canterbury are kept in The National Archives at Kew. In total I have copies of 181 Gamlingay wills from the period 1464 to 1650, although of these only three pre-date 1500. The forty-six made before 1552 will concern us here.

For anyone interested in why the wills are not simply kept in one place, it's all down to the way the Church was organised. Gamlingay came under the jurisdiction of the Archdeacon, but when his court was in recess for six weeks each year the Consistory Court took on the job of proving the villagers' wills and retained the copies among its own records. If, as often happened, someone owned property in Gamlingay (in the Diocese of Ely) and

two miles away in Potton (in the Diocese of Lincoln), their will would have to be proved in the Prerogative Court of Canterbury. This was because there was a potential conflict over who should get the probate fee, and to avoid an unseemly argument the Archbishop of Canterbury stepped in and claimed the cash.

Strictly speaking, a will should dispose of real estate and a testament should cover the distribution of personal belongings, but few people bothered with such fine distinctions. All wills start with a preamble and since we've already met him in the last chapter, that of John Basse will do as well as any to give the general idea:

> In the name of God amen, The 11th daye of maye the yere of owre lorde God 1534, I John Basse the elder of Gamlingay in the diocess of Ely, beyng hole of mynd and of perfytte remembrance, feryng the incerten houre of dethe, make and orden thys my testament and last wyll in maner and forme folowyng.

Deciding when to make a will depended upon the individual and how they viewed their prospects of longevity. Some were written what the testator obviously hoped would be many years before the end came, although as John Sylbarne rightly pointed out in 1546, 'nothinge is so sure as deathe and nothynge so uncertaine to man as the owre of deathe'. Others left it to the last possible moment, when they were lying on their deathbed. Thomas Huckle in 1543 was more concerned that his wife might 'dye upon this syknes' than with the fact that he himself was close to death, while Richard Clark in 1552 was obviously ill when he made his will, saying 'yf I dye at this tyme I forgeve Robert Myddleton all that he owethe me when yt ys countyd and reckonede'.

After the preamble the testator made his first bequest. This is typical of most, from John Nicholas in 1538:

> I bequeath my sowle to God allmyghtie, to our blessid ladie saynt marie and to all the hollie companie of hevyn, and my bodie to be buryed within the parishe churche yarde of gamlyngay.

You might assume this indicates a pious, deeply-felt religious sentiment, and no doubt it often did, but after reading twenty or thirty wills with almost identical wording you can take it that more often than not it is simply a matter of form.

There was a pecking order in death as well as in life. Those who could afford it were buried within the church itself, while the rest made do with the churchyard as their last resting place. William Wentworth, a man of substantial means who had married the widow Lady Margaret St George, asked in 1497 to be buried by the tomb of 'Le Avenellis in le Crosse Aley'.

Others less wealthy (and less grand) who were nonetheless interred inside the church include two farmers of Merton manor, Thomas Bird (1505, 'besyde my father and my mother of the northe syde') and Richard Clark (1552, 'in the mydell allye'). William Malden in 1550 decreed that his body be 'buryed in the churche porche of the sowght syde', a resting place half way between the common herd heaped together in the churchyard and the upper ranks of society buried within the church, presumably a station he thought he occupied in life as well as in death.

Most corpses were interred within a day or two of death, mainly for reasons of hygiene, and in a 'winding sheet' or shroud, not a coffin. Individual coffins were a rarity until the seventeenth century. Most parishes had their own re-usable coffin available for the corpse to rest in during the burial service, and also a bier or hearse – a wooden frame with handles – on which the coffin was placed. The service might take place inside the church or beside the freshly-dug grave, accompanied by the doleful tolling of the bells. Death could be an expensive business, but most folk were glad to bear the cost for the sake of a good funeral. John Basse's will reveals the typical funeral expenses from this period: 4*d* each to the parson and vicar to say the dirige and mass, 2*d* to the parish clerk, a penny to the sexton for digging his grave, 7*d* as an offering and 8*d* to the bell-ringers, plus another 2*d* to provide a wax light 'to brene about the hersse'.

Throughout their lives people were indoctrinated by the Church that if, in the happy event they were destined for Heaven, their soul would hang around near their corpse for thirty days after they died (the 'trigintal' period) before it went to Purgatory. During its period of detention in Purgatory their soul would suffer ghastly torments in proportion to the sins they had committed during their lives, until it was thoroughly purged and could proceed to Heaven. Everyone was, of course, considered a sinner to some degree, and no Heaven-bound soul could escape the Purgatorial waiting room.

For most people this was a terrifying prospect, although not nearly as terrifying as the alternative. Fortunately, doctrine also had it that there were ways you could shorten the length and lessen the intensity of the suffering your soul would endure there. You could earn remission by undertaking acts of charity and religious good works while you were still alive, while the prayers offered by your family and the community on your behalf after your death could also earn you some credit while you were in Purgatory.

Many testators' bequests reflect a lifetime's fretting about the well-being of their souls. There was nearly always a payment for masses to be sung during that first month after death when the soul was still loitering close by, and another for more masses on the anniversary (the 'obit') of the testator's demise. Thousands of priests thus sang their hearts out for the dead and made a comfortable living while doing so. In his will John Basse asked William Burley, a friar of the Augustinian order in Cambridge, to sing thirty masses for

his soul, while some of the money he gave the guild of the Trinity was to be used to pray for:

> my soull, the soull of Amy my wyff, the soull of John Bass my father and also hys wyff, the soull of Henry Bass my grandfather and his wyff and all chrysten souls.

Basse was a prudent, cautious man – witness his timely confinement, 'evyll at ease and sickely', during the Chicheley-Slade affair. He could read the signs of coming change better than his fellow villagers. His gift to the parish guild was a conventional bequest, but he added that the money would go to the church and parish instead if

> the forseyd guyld be not mayntened, and that a priest do not contynew in service ther to synge for the brethren and systren, as doth nowe at thys present tyme and season …

It was to be more than a decade before Basse's fears were justified and the parish guilds suppressed. Occasionally, payments were made to a priest with no strings attached, presumably out of simple gratitude, such as when Edward Hitt in 1546 left 8*d* to 'my ghostly fathere', the word 'ghostly' in this context meaning 'spiritual'.

There are many bequests based on the custom that some portion of an estate should go to the parish church. They came under the general heading of religious good works, and as such could help the soul of the giver on its way. Mortuary payments were a thing of the past, but almost all testators left money to the high altar for tithes they were presumed to have forgotten, and most followed with a donation to the upkeep of the bells. That's not to say that people did not leave money to the church of their own free will, because they often did. Donations in cash or kind were made for candlesticks, tapers, torches, wax, painting the image of St Katherine and so forth. Joan Golde gave a silver spoon to the guild priest, and in 1497 William Wentworth passed to the curate his best horse, complete with collar and bridle attached. William Fox left £4 in 1522 to buy a cope, and William Goodday 'the logges that lye in burtons yarde to the reparacyons of the churche gates where nede is'.

Charitable acts could also assist the soul. Thomas Ancten in 1532 left the churchwardens eight of his cows to let out to poor men for a shilling each per year. In addition, he gave his executors a logistical nightmare by requesting that during each Lent for six years after his death they should purchase

> oon barrell of White herynge and oon kade of Red herring, the same to be delte every Fryday, to eche of the pour people two White herryngs and oon Red …

A cade was a barrel of herrings containing about 700 fish (red herrings were smoked and white herrings pickled in brine, incidentally). His executors must have turned cartwheels of joy at the prospect of handing out vast quantities of fish every Friday in Lent. If every poor person was to get three fish, there were either an awful lot of poor in the parish or Ancten was using the word 'poor' in a spiritual sense to include all the villagers. But then, a man who could afford to leave two silver candlesticks worth the enormous sum of £10 to the church might easily look upon the rest of the parish as 'poor'. More often the poor simply received a penny or two each as a funeral dole.

> Robert Barford: 'I gyve to the poore folke to be delte amonge them 3s at my buryall day.'
> John Nicholas: 'to all the poore people within the towne of Gamlyngay havynge no plowghe 2d.'
> Elizabeth Whiting: 'to distribute amongst the pore folks in Gamlingay one Come of malte.'

Another common type of charitable bequest reflects a perennial problem. The village roads and the bridges that carried them over the brook were the responsibility of the parish, which naturally meant that nothing was spent on them until it could be put off no longer. The roads were used as dumping grounds or served as quarries, and the bridges were left until they were about to fall down or had actually crashed into the muddy water beneath. In effect it was left to individuals to sort out, and because he mentions both, this is Thomas Ancten again:

> to the reparacon of the bridge called mille bridge, and mending the high way in Gamlingay – 13s 4d.

Most of the people who made wills were men, at least in the first half of the sixteenth century, and this tends to give rather a one-sided view of life. Few women made wills because the husband had usually settled all the financial arrangements in his will for a period long after his wife's lifetime. A wife who died before her husband had no need to make a will because anything she owned at her marriage automatically belonged to her husband. The only spinster's will from this period is that of Katherine Bures, who described herself as a 'gentlewooman' and left everything she had to 'Mystreis Audrye Sengeorge, because I have found her goodd and trustie to me'.

After the health of his soul, the first concern of a married man was for the welfare of his wife and children. It was customary for a woman who brought her own possessions with her when she was wed to be given them back in her husband's will. John Nicholas, representing the view of many men, dismissed these domestic goods as 'trasshe of howsolde'. This clause in Richard Clark's

will is similar to many, although it contains a cash bonus his wife probably did not expect:

> I bequeathe to my wyff all suche goodes and cattale [chattels] as she had when I fyrst maryed her, or to the number and valew of them, and £5 besydes …

Behind these arrangements lies a hidden tangle of bargains entered into at the time of marriage. These were the dowry (the money or property the wife brought with her to the marriage), the 'portion' (the share of an inheritable estate), and the jointure, which was the part of the estate reserved for the wife if she was widowed.

To men like Richard Clark and others like him, marriage had little or nothing to do with affection – it was primarily a business deal. Yet such marriages usually worked. The main consideration after the financial arrangements had been sorted out was to produce an heir and continue the family line, but most people were not so desperate as to marry someone they didn't think they could grow to like, or even love. Besides, with no divorce possible, they were stuck with each other and had to make the best of it.

Although in Richard Clark's case the marriage failed to produce any children, his widow had nothing to worry about financially with a husband rich enough to leave three houses, cash bequests of about £160, a hundred sheep and much else besides. She was given:

> my howse for her to dwell in that joynes next to the parsonage, with the close and 10 acres of Lande, untyll Clement Bygrave be 20 yeres of age, yf she lyve so longeth …

As a well-endowed widow (in the material sense) she would not have wanted for another husband, if indeed she wanted one. It was more difficult for less well-off men to provide for their widow and children. Their wills often include convoluted plans containing phrases like 'if this should happen' or 'if it happens that', plans that were either ignored, or failed to take all possible outcomes into consideration, or were so confused in their meaning that the lawyers must have rubbed their hands with glee and dreamed of lengthy court cases and extortionate fees.

The erstwhile constable, John Burley, solved the problem simply enough when he made his will in 1545 by leaving to his wife Margaret 'my house that I nowe dwell in called the Fawcon for terme of her lyffe'. In a rather more long-winded way Thomas Ratford, owner of The Cock, gave his wife all 'Inward Stuff perteynyng to howsold' with instructions to 'bake and brue and Sell other vyttells to her awne use and profytt'. Nicholas Ancten deserves a good mark from posterity for giving his wife 'free dwelling' in his house for the rest of her life, and an extra one for defining it so pleasantly:

she to have the houses and gardyn plott which I dwell in myselfe, and so
to have free goyng and comyng therto, both for hirself and hir frendes.

He further provided for her by telling his son to pay her 13s 4d a year, to till
and compost five acres of land out of his own pocket, give her some 'pasteryng
and Wynter pastering' for a cow, and take her a load of firewood each year.

The good Nicholas apart, many men attached strict conditions to whatever
they deigned to give to their wives. Richard Berry in 1526, for instance, left
his wife all his land and in the same breath warned her to 'mak no wast apon
the saym'. Gifts like this were normally for the widow's lifetime only, the
husband usually providing for the bequest to revert to his heir or another of
his children when they came of age. Afterwards, unless they remarried, most
widows were considered to have the right to a room and board for life in the
house of their eldest child. However sick in body the husband happened to be,
he nearly always had at least half his mind on the possibility that his widow
would indeed marry again.

The will of a splendidly neurotic man called William Whiting, who died in
1552, is an extreme example of a man attempting to exercise his patriarchal
authority from beyond the grave. His mother Elizabeth knew what kind of man
he was. In her own will she evidently anticipated trouble between William and
his brother John, whom she had made her executor, for she warned William
that if he sued or troubled John for anything other than what he'd been given,
or interfered in the execution of the will, then his bequests were to be 'voyde
and of nowe effeckt'.

When William came to make his own will, he left the lease of his farm to his
wife and expected her to remain a widow until their son was 20 years old. But
if she remarried, she was to give back the estate in exactly the same condition
as she found it, down to the last acre of wheat, the last pewter plate, and the
last chicken running about in the yard. Her magnanimous husband decreed
that she could have £20 if she did remarry, along with the gift of two pairs
of sheets and 'her rayment that belongeth to her backe, and go her waye'.
Furthermore, if she mistreated their daughter Joan, 'I wyll her part be made
out £10 and shee to be taken a waye from here.'

And what do you think William Whiting did after this display of mistrust
and suspicion? He appointed his wife to be an executor of his will.

The underlying reason for this dictatorial attitude (and William Whiting
was by no means the only one) wasn't the fear that their children might be
ill-treated by a stepfather, although this was always a possibility. Rather it
was the desire to keep the estate together as a going concern for the son to
inherit. But what never seems to have entered their minds is how a widow
with young children to bring up (in Whiting's case, five) could possibly look
after the wheat, the rye and the barley, the cattle, horses, poultry and the rest
without remarrying.

Not all men were unreasonable, and some showed a much better appreciation of the difficulties their widows would have to face. William Fox, definitely 'hooll of mynde' as he said in 1522, took a much more commonsense approach:

> … if it forton [fortune] Johan my wif to mary herafter then I will that the man that schall marie hire shall put in sufficient Suirtie as shalbe thought necessarie … for the full Redilivering of such mony and goods as I have bequeathed to John Foxe my son.

The provisions made for children are as varied as the people who made them. Robert Blokke in 1549, for example, left his 'poore childerne eche of them £4 a pece and a cowe bullocke apece' as well as '4 sheep a pece of the parcell of shepe that be at Potton'. Sheep were a major source of wealth in the early sixteenth century, and even the poorest villager normally had two or three to his name. You would doze off long before you had finished counting the sheep, lambs, hoggets and so forth mentioned in these wills. In an age when cash was in short supply people tended to measure their wealth in terms of the goods and chattels they owned, and used sheep as a kind of currency.

It was usually the eldest son who inherited the bulk of an estate, normally consisting of the main dwelling house and the lion's share of the land. Where the testator was a craftsman or in some form of trade he frequently bequeathed his working tools and equipment to his eldest son, although even the most dedicated artisan was also a part-time farmer holding a few acres of land that he used to augment his income. Robert Myddelton received his father's 'curreyng geyre' in 1548, as well as his 'gryndyng stone with all thyngs perteynyng unto it'. At least some of Robert's work after his father's death was going to consist of dressing and colouring pieces of tanned leather, because that's what a currier did. John Burley of The Falcon left his son

> a ledde, a mashe fatt, an yeldynge fatt, all the boltynge arks, my pott whele and pott bords.

Leads, mash vats and yielding vats were all brewing vessels; boulting arks were troughs where flour was sifted from bran. Young Thomas Burley was going to have to bake and brew in order to make his living. The reference to the pot-wheel is a little puzzling. Perhaps The Falcon attracted rowdy customers who smashed a lot of ale jugs, or maybe John Burley added to his income by making and selling pots to his fellow villagers.

When he made his will in 1537, William Goodday was faced with the problem of what to do about his young son Gregory, his only child. Gregory's mother was dead, and his father soon would be. Typically, an orphaned child would be dumped on a handy relative and given some kind of bequest to cover

the cost of bringing him up or to see him apprenticed. William Goodday was not typical. All his goods were carefully parcelled out to friends and relatives (and how poignant it must have been to give away his wife's best apron, the only remembrance he had of her apart from the child). But his overriding concern was not with his soul or self-pity or regrets, but with the welfare of his son.

> I bequethe to Gregory Goodday my son £4 in Anngells [gold coins], which sume of £4 I will shall remayne in the hands of my brother Thomas Goodday, he to occupye the saide sume to his avauntaige so that he fynde my foresaide sonne Gregory Goodday at schole to lerne to play at orgyns …

This was a novel solution to the problem of an orphaned child. Maybe young Gregory had already shown some sort of musical ability that his proud father wanted to nurture. As this is the only instance from this period of a man actually wishing to encourage his son's gifts rather than dictate the course of his life for him, I would love to know what happened to Gregory Goodday. Did he ever learn to 'play at orgyns'?

As well as his son, William Goodday also had his own aged mother to worry about. He was determined that at the very least she would have a decent burial, giving ten shillings from the sale of some wood to his brother so he could 'brynge my mother to erthe when it shall please God to call for her'.

Younger sons and daughters were usually given second-best treatment, which was probably inevitable. Men were unwilling to break up their holdings by dividing them among their sons, so the younger boys had to make their own way in the world, assisted by as much help as their parents could afford after setting up their heir. This often meant the younger children having to make do with little more than a few sheep and as much spare cash as could be found. Even Clement Whiting, whose thoroughly unpleasant but well-off father we have already met, could only expect £10 in cash plus a couple of oxen, a horse, a cow 'next the beste' and 'my thyrde fetherbede'.

Unmarried daughters on the other hand were provided with what was intended to be a tempting dowry, often just a straightforward cash payment, as in the case of Thomas Hawse in 1549:

> I geve also to Kateryne my daughter 40s to be payde heyre att the daye of hayre maryage.

Similar arrangements were made for his other two unmarried girls. More often than not the age at which a bequest was to be paid was specified. In the case of boys it was generally a year or two later than for girls. George Brockewell's will is typical of many: he left a generous lump sum to his daughter Audrey

'if she lyve to the aige of 18 yeres, or ells at the day of her mariage'. Many fathers obviously expected their daughters to be married before they reached eighteen

Some men were in the awkward position of having pregnant wives while they themselves were dying. Apart from the fact that they would not live to see their child, there were somewhat complicated arrangements to be made for its care. One example – a straightforward one – will do:

> If my wyfe be with chylde I geve to the chylde 40s, and if shee be note with chylde then I gyve the 40s to Tyme and Brygett my chyldern ...

Thus spoke Rafe Bell from his death-bed on Monday 22 August 1552. He was never to know whether his wife really was pregnant, and neither will we.

During the first half of the sixteenth century houses were gradually becoming more comfortable – in some cases positively luxurious – when compared with their medieval predecessors. At the very bottom end of the scale nothing much had changed, and even moderate houses were still small and retained the characteristic medieval open hall layout. Those houses described as 'Tudor cottages' in today's estate agents' catalogues are in fact usually substantial yeoman farmers' houses. Few, if any, genuine cottages survive from the Tudor period – they were much too flimsy.

In the houses of the will-making class the hall was still the most important room, often containing the table. Many were the heavy oak trestle tables of the type in use throughout the middle ages, from which the table-board could be removed for storage along with the trestles when not in use, like 'the table in the hall with the trestelle' Thomas Huckle left to his wife. Newer designs of furniture made by joiners were slowly coming into fashion, such as the 'folte [folding] table in the halle at the cocke', as Thomas Ratford described his. Folding tables were either early forms of drop-leaf tables, or had a top that could be folded back on itself to lay flat. Chairs were rare enough to be considered status symbols, being reserved for the head of the household and sometimes his wife or an important guest. We still talk today of taking the chair at a meeting and defer to the chairman. Everyone else sat on stools or forms. The stool was also slowly evolving from those made by carpenters from boards nailed together into 'joined' stools with four legs.

Walls were often decorated with painted cloths called hangings, descendants of medieval tapestries, which must have brought some welcome gaiety to the sombre rooms. Katherine Ratford evidently thought so because she had them in both the parlour and the hall of her house at Brook End in 1545. Some people employed itinerant artists to decorate their walls, as can still be seen today in what was the Tudor rectory, where vestiges of early sixteenth century wall-paintings have been uncovered. Hangings had one advantage over painting on plaster; they could be taken down when their owner moved home.

Beds were treasured family possessions, passed on from generation to generation. John Burley left both his daughters a feather bed and another to his granddaughter, while we have already seen that Clement Whiting received his father's third-best bed. Almost as prized as the beds themselves was their accompanying 'furniture', as William Malden made plain when he left his son

> all bedsteds, tables and formes, bedhangyngs, hawlyngs and coveryngs, with my best fetherbedde with all therto belongynge exceptynge … one matteres, one coverlet and 2 payre of shetts …

William Goodday left to Isobel Brockewell with obvious pride, 'my best fyne shette wrawght with sylke, and the pyllow with the bere wrawght with sylke', which was luxury indeed.

Apart from beds and tables there was little other furniture. Clothes were sometimes kept in a press, an early form of wardrobe, but more usually in sturdy oak chests or coffers along with other household goods. Surprisingly, the early wills contain few references to these everyday objects, perhaps because they were everyday items and thus overlooked. Many chests were painted, frequently red, as in Thomas Pekket's 'grete Redde chest', but Katherine Ratford's 'redde sprewce forcer with all that is in hit' may have been covered in red leather. A forcer was a strongbox, and they were normally leather-covered, bound with iron and fitted with a lock to keep the contents safe. Hers was probably made in the Baltic – spruce was a corruption of Pruce, or Prussia, from where many such chests and coffers were imported.

Household utensils of one sort or another are recorded: 'my grettest brasse potte and a panne of brasse', a 'lyttell posnett with a handle' and 'pewtre dysshes and platters with all maner of lattyn vessell' are all mentioned by John Nicholas. Silver appears occasionally, usually as spoons. Richard Clark had seventeen, all of which were given to relatives and friends. Apart from the pair of silver candlesticks Thomas Ancten gave to the church, you have to go back to Margaret Taylard's Latin will of 1475 to find any really substantial silver: 'one silver bowl with its cover', 'one silver salt with its cover', 'a coral rosary with the silver gilt paternoster' (a special bead) and six silver spoons. She also had a gold ring, which she gave to her sister Elizabeth Bonyface, who was a nun.

One of Margaret Taylard's daughters received what she called her 'better clothes' and her 'best belt of gilt', but surprisingly perhaps, men seem more concerned with their clothes than women. This may because there are more male testators, or perhaps because a set of clothes tended to be handed down from father to son as a kind of heirloom.

Robert Barford died a bachelor in 1546, leaving 'a grene coote and a violet coote of my fathers' to one of his friends, but where did the gown and the petticoat which he gave to his sister-in-law and sister respectively come from?

Or, for that matter, the two kirtles he left? Presumably from his mother, although why he and not the women in the family got them in the first place isn't clear, and it's probably kinder not to speculate. Andrew Brockwell made a distinction between his best clothes – 'my best cote, my best dublett, my best cappe' – which went to his brother and the working clothes he passed on to his servant. Robert Alryche left William Jarvis the younger 'my Russet cote, because he shalbe good to my wyfe', and future researchers to ponder on exactly what he meant.

What a gorgeous sight these men must have made in their Sunday best. Richard Clark, proud as a peacock no doubt, wearing his russet gown 'furrede with lambe' and his best jacket and a worsted doublet as he sat down in the hall at Merton Manor Farm to eat with his 'sylver spones' is easy to picture. It's also easy to imagine the mess his clothes got into as he picked his way through the mud and manure in the farmyard, and the curses of his wife when she came to clean them. Some of his less-well-off contemporaries were also clothes-conscious. William Lawe with his 'chamlet Jakett', Rafe Bell fetchingly attired in doublet and 'payre of hosen' and even Thomas Ancten, resplendent in his 'gowne furred with fox', were all sixteenth-century followers of fashion.

Of the other types of bequests, mostly of a small and inconsequential nature, two are worthy of mention. Timber was becoming scarce by the Tudor period, and with scarcity came a rise in value. It's specifically noted in only two wills. Thomas Huckle, obviously a carpenter or wheelwright, left his 'tooles and tymbre' to his son, while William Goodday bequeathed 'all my tymbre in my house to repayre the same … and allso a pece of tymbre lyeinge in Burtons yarde to make a kyrble for the well'.

Servants were occasionally remembered, but not often. Two examples: Richard Clark remembered his ex-servant Elizabeth, who 'now dwellethe with Robert Bycley', with the gift of 40s, and in a typically blunt phrase, sour, dictatorial William Whiting left a combe of barley to each of his three servants on condition they 'tarrye tyll Mychaellmas'.

When the testator had decided who should or should not benefit from his estate, he then had to consider the problem of whom he could trust to see that his wishes were carried out. There were usually two executors, often his wife and son, but sometimes close friends or the parish priest. Most testators appointed a supervisor, or overseer, to keep an eye on the executors, and this position was normally filled by a trusted friend or relative. It was customary to give the overseer a small token of appreciation for undertaking what could turn out to be a difficult task, requiring diplomacy and tact. Thomas Golde in 1538 appointed Thomas Basse to be the supervisor of his will, 'so yt be done and fullfylled accordynge as my will, and so to have for his labor and paynes takynge 3s 4d.' And however charitable Thomas Ancten may have been he was no fool when it came to business. His overseer was left in no doubt why he had been appointed. He chose

my frende John Carleton, gentilman, to whom for his kyndenes and diligence here in to be shewed, and for the love I bere to him and Antony his sonne, I have solde all my londes and leasses for yeres in the said Towne and parishe of Gamlingay for lesse money then I myght have had of a nother man by £16 13s 4d.

And under no circumstances was John Carleton getting a fee.

Having ensured the health of their soul and sorted out their bequests, all that was left for the scrivener to do was write down the names of those present as witnesses, get them to sign, or those who were illiterate to make their mark, and the will was finished. The scrivener must frequently have been a priest since few of the villagers could do anything more than scratch down their names, but with an annoying sense of modesty he usually hides his identity behind the phrase 'with other'. And with that the testator freed himself from earthly care, and was ready to meet his Maker.

The funeral service that inevitably followed was undertaken, of course, by the parish priest, and the wills of three of Gamlingay's clergymen survive from this period: Nicholas Consannt (1519), Thomas Pekket (1542) and John Holder (1544).

Holder succeeded Consannt as rector, while Pekket held the more humble post of vicar. We met Thomas Pekket in the last chapter during the Slade affair, when he claimed he was about his duties and missed all the excitement. Reading these wills it's obvious that Pekket was less well off than his clerical brothers, who, apart from their social and educational advantages, also benefited from having the great tithes of their parishioners each year, while the vicar had to make do with the small tithes. You could say that Consannt and Holder lived in a similar style to one of the wealthier farmers of the village, while Pekket's lifestyle was more like one of the village husbandmen.

Each of them naturally asked to be buried in the chancel, and each left the customary bequests to the church fabric and the parish poor. Holder gave his white vestment, surplice and mass books too, saying they should be used on 'everye solempne feaste and noe other wyse'. Pekket and Consannt both left money for yearly obits. In fact, Consannt's is the only one of the villagers' wills to reveal what was involved in keeping a yearly obit. The anniversary of his death was to be marked by three priests and the clerk saying the dirige and singing the mass as the great bell was rung. After that the sexton was to 'goo aboute the towne with the bell', reminiscent of a town-crier, then a few pennies were doled out to the poor.

Compared to the majority of their parishioners, all three priests lived comfortably enough. Nicholas Consannt was the richest of them; he owned land in Kent, which probably helped to fund his life of comparative luxury. He ate his meals at a 'great foldynge table' in the hall off his pewter platters, using his pewter dishes and saucers (kept, no doubt, on the 'foldyng cupbord' in his

parlour) and his silver spoons as required. Afterwards, as he sat by his fireside, he could dip into his collection of books for an hour's contemplative reading, the firelight dancing off the gold ring on his finger, before retiring to lay his clerical rump on one of the three featherbeds he owned and his tonsured head on one of the bolsters that went with them.

Each of the beds was equally well-appointed, with two pairs of sheets, a pair of blankets and a coverlet to keep him cosy during the longest winter night. When he rose in the morning, he could choose from the three gowns he owned, the best of them 'furred with Shanks', a kind of fur obtained from the legs of kids, goats or sheep.

But it's his reading habits that make Nicholas Consannt really intriguing. He left most of his library to Merton College, where he'd been educated. His copy of the Bible went to a friend and he gave three books to the vicar of Potton. One of them was a book of St Augustine's sermons, another a volume called *Polyanthea*, which was a collection of quotations from Greek and Latin.

The third book he left to the vicar of Potton was called *Malleus Maleficarum*, a notorious treatise on witchcraft first published in Germany in 1486. The title translates as 'The Hammer of Witches', and it was full of handy hints on how to recognise a witch, how to get rid of one, and how to extract a confession (a red-hot iron was best, apparently). To modern eyes it's a ragbag of misogyny and superstition, but it was an indispensable guide for the Inquisitors of late medieval Europe. It came into renewed prominence as the witch-finders' handbook during the witch-hunts of the later sixteenth and seventeenth centuries, but in England in 1519 *Malleus Maleficarum* was a rare book. So why did Consannt need a copy of the classic text on witchcraft? Did he suspect there were witches in the village? If there was anyone in Gamlingay during his rectorship who was thought to be in league with Satan, none was ever prosecuted for it. Perhaps Consannt's copy was kept for purely intellectual purposes, something to mull over with his friend the vicar of Potton while passing an hour or two in idle speculation. Perhaps there was a more sinister reason for Consannt having the book, but if there was one, I haven't found it.

Consannt's successor as rector, John Holder, lived in a less ostentatious style, possibly because the Reformation was under way and it was dangerous to flaunt the wealth of the Church. It's only a matter of degree, though, because Holder likewise ate with a silver spoon, wore a gold ring and passed the long evenings with his books for company – mostly religious commentaries. Tired after a day riding his bay horse round the village, he had a choice of three flock beds to sleep in, and if he woke in the night no doubt he made use of his 'closse chayer'. It was a very important item of furniture. Many folk made do with an everyday chamberpot, but the rector's close chair was a more impressive object – an early example of a commode – which is why it was singled out for special mention. It would have been his servant John's task to empty it each morning. Maybe that's why he was remembered with tenpence-worth of

affection by his master. Whether John remembered his master with as much affection is another matter.

Like seemingly every other man in the parish, clerical or lay, Holder was inordinately fond of his clothes, leaving among other items four doublets, a neckerchief, a 'clothe frock lyned with sattin of Cypres' and 'best blacke gowne lined with Chamblett'. The most unusual bequest in Holder's will was to his supervisor, who received '2 ladders, a long pycheffork, and an awngell in golde'. Presumably Randall Borowes, the man he asked to oversee his will, had expressed an overwhelming desire for the ladders and the pitchfork.

The last of this trio of clerical wills is that of the vicar, Thomas Pekket. He was an old man of sixty-eight when he died in 1542. He too was better-off in material terms than many of his parishioners. Robert Parson, the priest employed by the guild of the Trinity in Gamlingay, was given one of his best gowns 'for the grete peyns that he hathe taken with me in tymys past'. It's tempting to imagine the two of them discussing the upheavals in the Church and the thorny issues of the day. Pekket had lived long enough to remember the Wars of the Roses, so perhaps he wasn't greatly surprised that change was in the air again – change that would eventually sweep away the old Catholic faith and almost everything that went with it.

VEHEMENT SUSPICION

During the three decades following Henry VIII's break with Rome in 1532, the state threw off the colourful vestments of Catholicism and clothed itself in the more sombre hues of Protestantism. Under Henry and his successor Edward VI, the Church was reformed in a series of unprecedented upheavals. Much of the physical damage inflicted on churches at this time has been wrongly blamed on Oliver Cromwell and the Puritans of a century later, but I'm afraid that's how it goes with history. The short-lived reign of Mary which followed saw the old religion partially restored, then, after the accession of Elizabeth in 1558, a settlement was eventually imposed which saw the confirmation of most of the earlier reforms.

At the end of it all, parishioners up and down England had lost most of what had sustained the medieval Church: images and icons, processions and pilgrimages, guilds, chantries, monasteries, altars and candles, holy days, most of the Latin, obits, Purgatory and the Pope. Masses were sung no more in Gamlingay church and people no longer left money in their wills to the guild of the Trinity or for the saying of obits. Some of the magic had gone from villagers' lives. Painted statues of saints and colourful wall paintings were out, whitewash and simplicity was in.

To posterity, the Reformation marks a revolution, but there's no way of knowing what the villagers themselves thought of the changes at the time. It was not, in any case, an overnight revolution, and it took almost forty years before the country could truly call itself Protestant. Maybe the changes didn't seem so radical while they were happening. There was uncertainty, it's true, as shown by the preambles to the wills and the ifs-and-buts attached to some of the bequests, but it's equally true that the villagers seem to have obeyed the flood of orders and injunctions from the government and the Church. You would have needed to be pretty dense to be unaware that it was dangerous to oppose the orthodoxy of the day, and while religion still played as big a part in their lives as it had for their ancestors, most people were still equally

preoccupied with the business of feeding, clothing and housing themselves. Perhaps the fact that the new Church of England allowed some of the old practices to continue, such as the churching of women, the Rogationtide processions and Church Ales, smoothed the way to acceptance. By 1580, only the old could remember the traditional Catholic religion in all its late medieval glory, now gone forever.

There was another way in which the village was changed by the Reformation. The confiscations of Church property by the state were followed by the biggest boom in the land market the country had ever seen. The spoils of pillaging were sold off to the highest bidders, and millions of acres acquired new owners. In Gamlingay, the Sawtry Abbey estate, the land of St Neots' monastery, the guildhall and small parcels of land belonging to the guild, as well as sundry plots belonging to other religious foundations, were put up for sale. Among the purchasers were up-and-coming yeoman families in the village – the Apthorpes and the Russells, for instance – and no doubt it helped them in their remorseless climb up the social ladder. In all probability they would have scrambled their way up soon enough anyway. The sales simply speeded the process up a bit. It also gave the owners of these estates a vested interest in maintaining the new order.

When people decide to change any institution they feel has outlived its usefulness, there's often a temptation to shove it too far in the opposite direction. So it was with the Church. Rigid Protestants now held sway, and in their concern for the moral welfare of their flock they sometimes moved effortlessly from the merely ridiculous to the plain daft. In attempting to impose their version of morality on the nation, neighbour was encouraged to spy on neighbour and pass on what was often no more than village tittle-tattle, half-truth and rumour to the churchwardens. They in turn passed on the gossip to Church officials, who elevated it to the status of evidence. Before very long the Church courts were full to overflowing with the victims of scandalised rumour-mongers.

The Church held courts because it exercised jurisdiction over probate, as we've seen, over marriage and divorce, offences against Church laws and spiritual matters generally, including the dodgy area of morality. Offenders in Gamlingay, both real and imagined, were reported by the churchwardens to the Archdeacon during his parochial visits. If possible they were based on fact, but presentments could be based on common fame (rumour) and vehement suspicion. Cases arising from them were heard in Cambridge. The court usually imposed some form of penance or a fine or simply a warning on those found guilty. Much of the court's time was taken up with cases of what moralists thought of as sexual aberrations. The following presentments by the Gamlingay churchwardens will make it clear why the Church courts were known throughout the land as the 'Bawdy Courts'. They are taken from the Ely diocesan records and cover the period from 1569–1615:

Margaret Warren: 'for absentinge hir sellf from hir husband, he being very syck'.

James Meade: 'for scoldinge'.

John Wrighte: 'begatte his woman sarvante with childe'.

Joan Chadler: 'late servante to John Wrighte of Gamlingaye, she is with childe unlawfully begotten by the sayd John Wrighte'.

Katherine Radcliffe: 'hathe ben in our towne above the space of A monethe and have not come to the Churche'.

John Wilson: 'for lyving suspiciouslye with An Remson, beinge unmaried'.

Mary Wake: 'for scolldinge'.

Christopher Mead and his wife: 'for incontinencie before mariage'.

John Bretherton: 'vehemently suspected to have comitted fornication before mariage'.

John Robinson: 'for useinge himselfe disorderly in the time of comon prayres, in that he did laughe and kicke with his legges'.

The churchwardens: 'for that the Towne commandments be decayed'.

John Goodin and Lucy Robinson: 'for beinge marryed uppon Tewsday in Whitsun weeke last, marryeinge tyme then beinge oute'.

William Harper and Christian Ratford: 'they were married together upon the 12th day of Februarye 1614 being the Sunday after Sextuagesima Sunday'.

John Cockerell: 'for not receivinge the Communion at Easter 1615'.

Edward Lee, rector: 'he is not resided upon the Parsonage'.

Thomas Cater, curate: 'whether he be licensed or noe we cannott tell'.

Owen Easement and Mary his wife: 'for incontinencie before mariage'.

In the medieval village, gossips who spread such stuff were lucky if they escaped a good soaking in the manorial fishpond. Now they had their chance to tell tales about their fellow villagers under a cloak of authorised respectability. You can almost hear the tut-tutting in the background when Thomas Condall was hauled before the court in 1576 and charged that 'the common fame ys that he shoulde be noughte with Agnes Ludloe, alias Trewelove, his Auntes daughter'.

The inference of the phrase 'be nought with' is that he was sleeping with his cousin Agnes, a charge he stoutly denied, saying that he'd been out of the area on his master's business and was about to go again, thinking it would be 'aboute Sturbrydge Fayre or Michelmas next before he come home againe'. Quite what that had to do with anything isn't obvious, but this rather feeble defence was swallowed by the court. The ploughwright Bonyface Wragge was charged the same year with refusing to pay the fine for not attending church and for having 'kepte men in his howse in tyme of service'. Wragge's response both admits the charge and misses the point with almost the same dexterity as

Thomas Condall, stating 'they were his verye frends and strangers that came to make merrye there with him'.

Where some form of penance was ordered by the court, it usually involved the guilty person being exposed to public ridicule, in much the same way as the stocks, pillory, tumbril and ducking-stool had been used in the middle ages. Penance didn't work particularly well in practice, but it must have been a humiliating experience all the same. Margaret Person was found guilty of disturbing the holy service and ordered to go on her knees in the aisle after the gospel reading and in a loud voice say

> Good people, I do acknowledge and confesse that I have mysused and muche unreverently behaved my self in this holy place at the tyme of devyne service, to the great offence of allmighty God and evell example of you all.

Another village woman ordered to do penance was Ann Robinson, wife of the John Robinson mentioned above, who found the church services so funny. In June 1611, she was found guilty of slandering Steven Apthorpe and made to confess as much before the entire congregation. Steven Apthorpe had been a churchwarden the year before and one of his duties was to levy the church rate. Ann Robinson admitted that she had injured and defamed him when she had boasted:

> the sayed Steven Apethorpe would have had me to be his whore, and that iff I would have lett him have had his minde off me, he would never have asked my husband his church dewes ...

She was, she went on, 'most hartely sory and desire him to for give me'. There's no record to say whether Steven Apthorpe did forgive her, nor whether her husband found his wife's confession at all amusing.

The penalty for fornication was designed to be as humiliating as possible. Thomas Kendricke, found guilty of the offence in 1570, was given the standard punishment for such a crime. He was forced to stand

> 3 severall Sundays or holydays in a white shete and a wand in his hand, in the church porch there from the second peale to morninge prayre untill the readinge of the second lesson, and then the vicar to fetche him in with the Psalme of Miserere in Englishe.

Entering the church dressed in penitent's garb as the vicar intoned the Psalm of Miserere (which asks God, among other things, to 'blot out my transgressions' and 'wash me thoroughly from mine iniquity, and cleanse me from my sin') while his fellow villagers sniggered or stared sternly at him must have

given Thomas Kendricke food for thought at the very least. The shaming of Kendricke may well have given other members of the congregation something to think about too.

With the Puritans in charge and ever anxious to meddle in the lives of their neighbours, there were plenty of opportunities for people to cast stones at their fellow villagers. But it's no coincidence that very few members of the gentry or the upper classes were ever carted off to the ecclesiastical courts. They were too powerful or well-connected for the Archdeacon to cross. Either that or they led blameless lives.

As we're in confessional mode, I too have a confession to make. I freely admit I enjoyed sitting in a quiet corner of Cambridge University Library, searching through the records of the Bawdy Court and wondering what juicy tit-bits I would find next. As the sun fell across the desk (my neighbour was engrossed in a stack of Charles Darwin's original notebooks, I noticed) I opened a small, slim volume listing people who had been excommunicated in Cambridgeshire between 1577 and 1584. As you would expect, the punishment of excommunication was reserved for those who were found guilty of grave offences, but oddly enough it was also handed out to people who simply failed to turn up for a hearing. Within that little book I found the following matter-of-fact details of an extraordinary triple excommunication in Gamlingay from 1582:

Thomas Upchurche: 'hathe married another mans wife'.
Edward Scayles: 'for selling of his sayd wief (viz. Issabell Bowers) to Thomas Upchurche for 16s.'
Issabell Bowers for the same reason.

The vicar, Thomas Huckle, was also implicated, presumably for carrying out the marriage. Huckle was suspended, but a marginal note indicates he had died before the court had considered the case.

Those few lines immediately raise a host of questions. I haven't come across another case like it from this period, although I do know of two betrothed Essex women who were sold at around this time. Their combined valuation didn't match that of twenty-three-year-old Isabel Bowers, and even she was only considered to be worth about the same as a second-rate horse. Wife-sales were recorded in the eighteenth and nineteenth centuries (the last one as recently as 1887), and Thomas Hardy wrote his classic *The Mayor of Casterbridge* around a wife-sale, but it was a much older practice than that, dating back to the middle ages.

The problem facing partners who couldn't get on was that there was no possibility of divorce. The Church would occasionally sanction separation, but an Act of Parliament was required for divorce, and only the very rich could afford that solution to their marital difficulties. Among the poor it

was relatively easy to simply run away and never be heard of again. Another alternative was to commit bigamy, which also appears to have been relatively common among the poor. The other way out of an unsatisfactory marriage was the unofficial folk-custom of divorce by mutual consent via a wife-sale. Popular opinion had it that each party was free to remarry afterwards. The law saw things differently.

Before the 1754 Marriage Act laid down rules much as we have them today, getting married was a rather complicated business involving five separate stages. First there was the contract between the respective families concerning the dowry and other financial matters. When everyone was satisfied with the arrangements, the couple exchanged verbal promises (they 'plighted their troth', and were therefore 'betrothed'). It was this stage that constituted legal marriage. Then followed the proclamation of the banns in church, after which the Church gave its formal blessing to the union at the wedding ceremony. In the sixteenth century the Church was attempting to have this fourth stage recognised as the lawful moment of marriage.

The fifth stage was the consummation, which in the Church's ideal world was supposed to follow the wedding ceremony, but after plighting their troths many couples simply headed straight for the bedroom. They were legally married, so why wait? The Church didn't agree, which is why Owen Easement, Christopher Mead and their respective wives were cited for incontinency before marriage, and why so many women were pregnant when they got round to making their vows in church.

In a nutshell, exchanging words along the lines of 'I take thee for my wife/ husband' before witnesses was enough to constitute a legal marriage, but the Church would not accept that the couple were joined in holy union. In 1570, William Flynte and Matilda Waythman from Gamlingay appeared before the court for precisely this reason. They were presented because 'they beinge sewer together will not marrye'. 'Sewer' is an obsolete form of the word 'sure', and means the couple were betrothed. This was not good enough for the Church authorities, who wanted them married in church.

To add to the confusion, the Church specified certain times of the year when marriages could not be conducted, mainly connected to the religious calendar (although this could be circumvented by purchasing a licence). This is why the Goodins and the Harpers were presented for getting married outside the prescribed periods. There were other prohibitions on marriage, including a ban on marrying any of a number of close relations. These were listed on a printed sheet known as a 'Marriage Table' that was supposed to be displayed in every church. In 1579, the churchwardens were themselves presented because the 'table of degreasse of matrimonye are wanting'. A mere twenty years later the churchwardens got round to buying one.

Returning to Edward Scayles and Isabel Bowers, I think we can assume they had plighted their troths but hadn't proclaimed the banns or undergone a

wedding ceremony in church. This would explain why Isabel Bowers was not referred to as Isabel Scayles. It's clear that the couple didn't get on and used the folk-custom of a wife sale to solve their difficulties. It was all highly suspect in the Church's view, hence their excommunication. All I can add is that so far as the records show, Edward Scayles is never heard of again. Thomas Upchurche and Isabel Bowers did remain in the village, although I don't think they ever lived together. There's a later case from the Church court records of 1601 concerning Isabel Bowers, when she was presented in her maiden name 'for havinge a childe by Richard Brite, as she sayeth'.

Another who fell foul of the Church courts in the second half of the sixteenth century was John Russell. In gathering the raw material for this book I've come across many people I would like to have met, some I wouldn't want to bump into on a dark night, and a few I would have avoided during daylight. But it's hard not to like John Russell. He was astute, kind-hearted, and had that roguish Elizabethan rough-and-tumble attitude to life which characterised some of his more illustrious contemporaries. His family was one of the foremost in the village from the middle of the fifteenth century until the early seventeenth century, gaining considerable wealth and some powerful enemies along the way – remember Thomas Russell, attacked by Edward Langton and his mastiff in 1492.

John Russell modestly described himself as a husbandman in his will, but the evidence it contains points to a higher position in the village hierarchy: he owned a mill, an inn, three houses and land and sheep in Gamlingay and Waresley. He also possessed a fatal attraction for women – or perhaps it was the other way round. Russell had married Joan Parson, a widow, by 1559 at the latest, because according to the Patent Rolls of that year she was pardoned for certain unspecified crimes at a cost to her purse of 26s 8d. Dozens of other people were pardoned at the same time, which probably means she was a Catholic. Whatever material benefits she may have brought with her, Mrs Russell presented her new husband with a ready-made family – five girls and three boys from her first marriage.

Goodness only knows what she thought when her husband made a string of appearances in the Bawdy Court. Over a period of some eighteen months he was linked with at least three lovers, but because the court records rarely allow you to follow a case through from beginning to end it's difficult to untangle the skein of relationships and jealousies involved, let alone the crabbed legal Latin shorthand they're written in. Things do become a little clearer when Katherine Nelson was presented on 25 May 1569 because she 'did sclander John Russell and Agnes Ward togither'. Having seen the kind of village gossip regularly reported to the court, it's not difficult to work out what the slander was. Agnes Ward swore her innocence with the aid of several of her friends and was let off. But they say there's no smoke without fire, and a month later Russell himself was presented. This time the reason couldn't be clearer:

he was taken in bedd with Elizabethe Anderson, and there so taken by
Martyn Kevell, William Kevell and Robert Pygot.

You can easily imagine the scene: the horrified trio come upon the unsuspecting
lovers in flagrante, and as good Protestants with suitably stiff moral backbones,
they rush off to tell their sordid tale to the outraged churchwardens. But I don't
think it was quite as straightforward as that. A mere two days later, Martin
Kevell was presented because he had 'committed fornicacion with Elizabethe
Anderson'. Several other possible scenarios now emerge, one of which is that
Russell got his revenge by reporting Kevell to the authorities. Joan Russell
probably exacted her own form of revenge on her erring husband when she
discovered what had been going on.

Elizabeth Anderson was ordered to do the usual penance in church. She may
simply have been very liberal with her sexual favours, but my guess is that she
was one of the village prostitutes. Whether I'm right or not, the next woman
linked with John Russell in the church courts certainly was a prostitute. In
1570 he was presented 'uppon a sclander therove the Towne, of hordam with
Sybbyll Carton', which was put more plainly when the presentation was
repeated later on: 'that he comytted whoredome with Sybill Carton'. Russell
was ordered to purge himself 'twelve-handed': that is, to find five people plus
himself to swear his innocence, which he would have had little trouble doing.

Sybil Carton on the other hand was found guilty, and before long found
herself standing in the church porch 'in a white shete, barefaced, with a white
wand in hir hand three severall Sundays', and so forth. It's a prime example
of how taking action on moral grounds could lead to an absurd injustice. If
Russell was innocent of the crime of purchasing sex from Sybil Carton, how
could she be found guilty of providing it?

The experience seems to have changed John Russell, because he was not
presented again. It might be that he was more careful afterwards where he
bedded his lovers, if he had any. Or perhaps his experiences (or his wife's
reaction) put him off for good.

Russell died in 1588, the year of the Spanish Armada. His will, now in the
National Archives, paints him as a man of his times and a lover of life. Judging
from the first bequest, he could be both kind and generous:

> I doe give to William Randall, alias Russell, *whiche I have brought upp
> of a childe*, three roodes of Land att millbridge in Gamlingaye whiche
> the windmill doethe stand uppon and the windmill withe all manner of
> implements therunto belonginge ...

William Randall, otherwise Russell, may have been an orphan he'd taken
responsibility for raising, or perhaps he was the result of an earlier liaison
with one of the accommodating village women. We'll never know. But as

well as women, Russell also enjoyed more than the occasional sup of ale. The following bequest is typical of the man and shows he was quite capable of combining a solemn Church ritual with an irreverent booze-up. To Thomas and John Bestow he left

> my house at milbridge and the grounde inclosed wherin the howse doethe stand, payinge yearly thre shillings fower pence *to be bestowed on a drinkinge* at Gangtide under the banck in Potton waye, nere unto the house.

The tired and thirsty villagers taking part in the long Rogationtide or Gangtide procession must have looked forward to John Russell's thoughtful 'drinkinge' when they reached the Mill Bridge. I should imagine the name of their benefactor was well toasted each year.

John Russell left no children of his own – legitimate ones, anyway – and the gift of a house to his step-grandson and the numerous small bequests to his step-children and step-grandchildren are further evidence of his generous nature.

Every lover of good ale must dream of owning his own pub. John Russell achieved that dream as owner of The Cock. He left it to his nephew Thomas Russell on the understanding that 20s would be spent on the poor in Gamlingay at Christmas and Easter each year, with a similar provision for the poor of neighbouring Waresley. He really did like to liven up religious occasions. John Russell also asked his nephew to provide for a 'memoriall to be paynted and sett upp on the howse ende of the Cock, to continue in Gamlingaye for ever', but unless my eyes deceive me Thomas conveniently overlooked this when his uncle was dead. Perhaps the emblems moulded into the exterior plasterwork of The Cock and coyly described by the Royal Commission on Historical Monuments as 'convivial', is that memorial. And a rather appropriate one it would be.

At the end of John Russell's will is a list of debts owed to him. It shows he had that nose for business which every successful Elizabethan needed. Even when he lay dying John Russell knew exactly what was owed to him, by whom and for what. Of the thirteen debtors he lists, owing sums between 18d and over £10, no fewer than ten seem to be straight cash loans. I like to think of John Russell ending his days by lending some of his spare cash to his needy neighbours and friends. In truth, I just like John Russell.

FINERY AND FEATHERBEDS

Now that we've returned to the subject of wills, we may as well stay with them and look at the surviving ones from the second half of the Tudor century.

One obvious difference from the earlier wills is that preambles no longer refer to the Blessed Virgin Mary and there are fewer references to the holy company of heaven than before. From mid-century onwards, the standard phrase in use speaks of the testator's confidence in salvation 'through my Saviour and Redeemer Jesus Christ'. Hidden behind that change of wording lies the Reformation.

Another difference is that people are wealthier than their fathers and grandfathers and tend to measure their substance in cash, rather than by the sheep and suchlike so frequently used before. Mary Ratford (1576) was typical of the transition when she left her brothers 'twoo shepe and twentie shillings in money', and her mother-in-law 'fyve shepe, one Calf and tenne shillings'. Gold, scarcely mentioned before, is coming into circulation among the better-off villagers. William Farye, who described himself as a 'yeoman, Crased in bodye', gave the vicar 'three Gynniers of goulde inclosed in one' in 1595. It's a mystifying bequest because it was to be another seventy years before the first guinea was minted. Perhaps Farye was thinking of 'guilders'. The vicar wouldn't have minded what they were – gold was gold, no matter what shape or form it came in.

Sometimes it came in the shape of a ring. The giving of rings at a funeral as a remembrance of the deceased was quite common among the wealthier classes. In his will of 1593, John Massye left to his 'good maister' Richard Tramton 'two Angels of goulde to make a goulde ringe, and to my Mistress his wyef likewise two Angels of gould'.

Almost every will mentions the poor. Giving to the poor was recommended by the state, but this probably carried less weight than the fact that their rising numbers was becoming more and more of a problem in village and town alike. Most bequests simply lump the poor together as – well, 'the poor' mostly – but the recipients of the £20 Gilbert Cowper left in his will as the century closed were specifically described as:

fortie poore maydens of the Towne and parishe … Tenn shillings a peece
to be paide by myne Executors on their mariage day, the sayde maydes
beinge of honest name and fame.

Finding forty poor maidens wouldn't have been difficult. Finding enough without
a stain on their character may well have been a challenging task. Another testator
who gave her executors a headache by leaving money to the poor was Ellen
Bell in 1581. She intended to raise the twelve shillings she gave them by getting
one of her sons to buy her 'kobarde'. Evidently it occurred to her that her sons
might not agree with this arrangement, so she added 'yf none of them wyll bye
it, then I wyll ye kobard to be sould to the vayller of it & so given to ye pore'.
The somewhat eccentric spelling of Widow Bell's will must have given her son
Richard a momentary start when he learned she had given him 'a bollok'. Ever
generous, she also left him a half-share in a 'table that is broken'.

One answer the better-off villagers came up with to help the village poor
was to provide an almshouse. It existed in 1544, when the rector left two
mattresses and a pair sheets for the use of the inmates. It was still there
sixteen years later when William Harmer left eightpence to repair it. In the
decade following it must have fallen into disuse, because John Hobbs in
1569 bequeathed twenty shillings 'if the said almysse house be set up'. We
must assume it was, because two years later his widow gave 6s 8d towards
its upkeep. Then Richard Jacob in 1577 muddied the waters by leaving 40s
'towardes the buildinge or reparacons of the Almes howse'. Confusion still
reigned in 1593 when John Massye made his will.

I bequeathe twentie nobles to be bestowed to the best and most profitable
use of the power people of Gamlingay, either by buildinge of one Almes
howse or otherwise as shall seme good …

And so it went on until 1665 when a permanent solution was finally reached
and the present almshouses were built.

The village school was a similarly ethereal institution. Virtually all the
larger Cambridgeshire villages possessed a school of some sort where children
could be taught the basics of reading and writing along with a little grammar.
Teachers were often young clergymen waiting for an appointment to a living
(in the early years of the seventeenth century the vicar, John Jackson, gave the
Gamlingay children their lessons). The village school did not cater for learning
much beyond the age of eleven or twelve, when most village children were
expected to be at work. Education beyond that, probably outside the village,
was available to the children of parents who could afford to pay.

The Harmer family were keen on the benefits of education. John Harmer
lived in what would later become Cockayne Hatley and had considerable
property in Gamlingay. He shared it among his two eldest sons in his will of

1544, but decreed that his youngest boy was to be sent to school for two years before taking up an apprenticeship. John Harmer junior, now a Gamlingay resident, only enjoyed his legacy for two years before the time came for him to make his own will. Following his father's example he instructed his wife to send their son 'to Skole at hur own proper costs & charges' until he came of age. In 1560, his brother William likewise wanted his son to be kept at school for a year to 'larne to wryght and Rede'. Another villager well aware of the advantages that an education could bring a boy was John Condall, who willed in 1563 that 'my 2 sones to be kept at skoole untill the age of 18, and that they shall lack nether meat nor drink nor anything'. Note that it's usually boys who are being educated. Parents did sometimes send their girls to school, but anything beyond the basics would have been considered a waste of money.

Gawen Robynson was another of those people who were concerned to ensure their son received a proper education. A less attractive side of his character is shown in his attitude towards his godchildren and his servant James. He left 20d to each of his godchildren, but only 'if they come for it', while James was given

> my worst lyvereye Coote and an acre of barlie to be delyvered the next harvest after my decese if he do my wife service, and if he goo awaye he to have the cote and lett hym go.

John Hedding couldn't afford to educate any of his own children, but when he died he gave a shilling 'to be distributed emong schollers of Gamlyngaye'. He was not poor compared to others, yet if you tot up what he actually left it amounted to no more than the lease on his house, five shillings in cash, a few old clothes, some tools, three or four sheep and two tiny plots of land. It was all carefully distributed among his friends and family, a penny here, an old shirt there. I reckon John Hedding was one of those rare people who always consider others to be less fortunate than themselves.

Most executors seem to have tried their best to do what they had been asked, and two men noted specifically that they were literally doing the will of others. John Hitt gave his two sons nine quarters of barley between them and 20s each left to them by their uncle. Thirty years after being made supervisor of Richard Berry's will in 1526, Thomas Basse instructed in his own will that an obit be kept yearly for Berry 'as the wyll of Beriy do speake'. Basse was not to know that the revival of Catholicism under Mary would end two years later with her death.

The contemporary attitude of men towards women was neatly summed up by Helen, the wife of a later Thomas Basse, in 1573. She disarmingly admitted that her last will and testament was made 'with the licence and consent of my husbande Thomas Baysse, which hath sett his hand unto the same ...' She doesn't seem to have been particularly upset by having to ask permission to write her own will (it was in fact a legal requirement). Perhaps her husband

was more understanding than most. Just as revealing of the attitude of men is this from Robert Clark in 1600. Directing his wife, he says:

> shee shall at the tyme of her death geve all her goods to her frends and myne together at her discretion, equally to be devided emongst them.

Her discretion regarding her own possessions was limited to who should have what. A husband was of course still very much concerned with his wife's future. We've seen the harsh and exacting conditions William Whiting laid down if his wife remarried. The slowly changing attitudes are illustrated by the will of his son Thomas. He left his wife a decent annuity and her board with their son-in-law, as well as half his linen (their linen?) and a featherbed. If she didn't like living with her son-in-law, he was to pay her £6 13s 4d a year, and she was to have 'the Chamber over the buttrie in my nowe dwellinge howse' for life, along with a couple of acres of land and pasture for a cow. Not only that: if she wanted to remarry then all the arrangements were void (except for the bed and the linen), and she was to have instead the enormous sum of £40 as a gift. Perhaps it was a case of the sins of the father not going unnoticed.

Thomas Whiting's will brings us to another major social upheaval that was going on in southern and eastern England at the time. Whiting gave his nephew a strip of land on which the executors were to build him a house, specifying it should be of two rooms with a chimney, the standard layout for a new house at the time. This was in 1596, right in the middle of the period known to historians as the Great Rebuilding. In virtually any other village the story of that rebuilding would be relatively straightforward to tell, but one significant event in Gamlingay's history prevents it being quite so simple. What it was will have to wait until a later chapter, but it does mean that the rebuilding of Gamlingay happened in two stages.

The Great Rebuilding was a direct consequence of the steady rise in living standards enjoyed by a large proportion of the population from about 1540. In the countryside the main beneficiaries were yeoman farmers, but enough money trickled down the social scale to make many people feel they were more comfortably off. There were several reasons for this general improvement. Stable government and relative peace helped, but probably the biggest single factor was a slow change in the basic economic facts of life. At the root of it was the modern bugbear, inflation. The yeomen of England were in the envious position of receiving continually rising prices for their produce, while at the same time enjoying security of tenure and low rents, many of which had been fixed way back in the middle ages.

Even the most incompetent yeoman could make money. He then spent it of course, because that's what money is for. Cautiously at first, buying up a few pieces of land here and there, adding a sheep or two to the flock and so on, then as his confidence grew, by lavishing money on a more luxurious lifestyle. From around

1570 until about 1640, the prosperous south-east was transformed. Houses that were perfectly adequate only a generation earlier now seemed hopelessly out of date. People wanted more comfortable homes to live in, and thousands of houses were altered or knocked down and better ones built in their place. In some ways history has just repeated itself. Our recent obsession with improving our homes may well be seen by future historians as another Great Rebuilding, happening four centuries after the first. The motives behind both were the same.

For a Tudor villager the usual way of modernising an old medieval open-hall house was to put a ceiling over the hall and insert a chimney, thus virtually doubling the available living area. In Gamlingay this was done, for example, in the two houses built by Thomas Bird a hundred years earlier. Both the rectory and Merton Manor Farm have inserted ceilings, but they also gained extra space by having a new wing built on, transforming them from L-shaped plans into H-shaped ones.

Fifteenth-century manorial records frequently complained that buildings were falling down. By the sixteenth century they were in such a tumbledown state that knocking them down and starting again was often the only option. Many medieval houses were at the end of their useful lives anyway, like Whitehall, the Burleys' Falcon. It was in such disrepair in 1585 that Merton College leased it without demanding the usual entry-fine on condition that the new tenant rebuilt it.

Even such ordinary items as pots and pans reflect the new prosperity. Pewter came into widespread use. William Roger (1554) would have earned his long swig from his 'pewter pinte pott' after a day spent hammering and sweating in his blacksmith's shop. With pewter now commonplace, men like William Welles (1555) could emphasise their superiority by owning utensils made of brass ('brasse panne with brode brynks'), or better still, silver, like Abraham Jacob, who received 'twoo Saultes and a standinge Cupp of silver and guilte' from his father.

Chests and coffers of all kinds were still in widespread use, and there are many references like 'my little Cofer with all the Lynnen therein' and 'one hutche under the wyndowe'. A hutch was a grain bin or dough bin. One of Alice Mason's coffers was described as 'wyned', which means it was fixed to the floor. Gilbert Cowper was probably not a budding Shakespeare when he referred to 'my Coffer and all in it unbequeathed, my wrightings onlie excepted' in 1599. He left those papers to his executors, which means they were almost certainly dull deeds or other legal documents.

Despite the new craze for home improvement, sleeping arrangements had not changed very much. These Tudors may have prided themselves on having their blankets, bolsters, pillows, coverlets, mattresses and occasional fine silk, but most of them still slept downstairs as their fathers and grandfathers had done before them. It took some time before the new chambers upstairs were used for anything other than storage. Creating these upstairs rooms caused another problem still very evident in many old houses – where to put the stairs? Some people didn't bother with them, preferring a ladder instead. If they did put

in a staircase it was often steep and narrow, frequently positioned next to the chimney to avoid too many alterations to the existing structure of the house.

Children or servants often slept in the same room as the master of the house, on a small bed on wheels that could be rolled under the main bed when not in use. Gilbert Cowper described the one he owned as a 'trusle bedd', but they were more commonly known as truckle, or trundle, beds. The 'furniture' belonging to the beds is still lovingly listed by many testators. The difference now is that because people have more money, there's more of it to describe. Much more, believe me, but I'm under no obligation to quote any of it. However, Nicholas Ratford is worth quoting because he helpfully tells us what his six pairs of sheets were made of: 'twoo of them flaxen, two taw hempen and twoo harden'. The picture they conjure of Nicholas Ratford comfortably tucked up between them becomes less rosy when you know just how coarse those materials actually were.

Thomas Basse the elder was an exception to the general rule about sleeping downstairs. Although in his mid-seventies when he made his will in 1556, he was nonetheless abreast of the times because he left his wife 'all the hangyings of the over chamber with bedsted'. He also owned 'a chayer in the chamber in betwyne the dores'. Robert Gyllson in 1557 has left us with the only other reference to a commode in all the Tudor wills from Gamlingay, when he passed on his 'chayer of eysment' to Steven Russell.

Even relatively humble countrymen could now afford to be clothes-conscious. There are dozens of references to them in the men's wills from this period. Nearly everyone owned a gown or a cloak, but only one man mentions his hat. Changes in fashion gradually filtered through to the village. Until the 1570s virtually all men wore a doublet and hose over a shirt or a petticoat, or else wore a coat, but after that date neither doublets nor coats are mentioned. Jackets and jerkins are preferred instead.

All the testators tenderly described the clothes they owned. Often this was in terms of their colour or the material they were made of, but sometimes they were described simply as old or worst or best. The materials varied: doublets were made of leather, buckskin, or fustian – a coarse cloth made from cotton and flax. Jackets and jerkins were made of chamlet, leather, worsted (wool) or frieze, a rough woollen cloth. Pairs of hose were simply hose or hosen, although one man called his loose-fitting pair *gallygaskins*. Shirts are only mentioned twice, once as 'flexen', which must have been particularly uncomfortable to wear. Some of the cloth was made in the village in the middle of the century by Robert Alryche, who left his 'loums wythe all that belongethe ther unto'.

Oddly enough, footwear is noted only once, by Ralph Goode in 1563, who left 'a payer of hye shoues'. While many of the clothes were merely workaday items, many folk had a suit of clothes they kept for best, and no doubt enjoyed showing them off before their neighbours at church on Sundays.

By and large women's wills seldom mention clothes, but occasionally a woman will describe some of her attire for us. This is Alice Mason in 1584:

unto Elizabeth my mayde … one neckerchiff with one Apron.

unto Johane Carrington my olde frocke, and an other which I weare I gyve unto Johane Malyn.

unto Alyce Marham one kerchiff with one neckerchiff.

I give to goodwyef Waters my best hatt.

And my hatt which I weare I give to goodwyef Burdall.

I geve to goodwyef Burley a kerchiff and a neckerchiff, and to everie one of her daughters a neckerchiff.

Many testators now tack a list of debts they were owed, or which they themselves owed, on to the end of their will. It was not unusual for a debtor to be 'forgiven' the money as an act of kindness or friendship, or because the testator felt it was unlikely the money would ever be recovered. Conversely, lots of people bequeathed goods to their creditors in payment for money they owed. Rafe Sherwood (1589) left his son two jackets and a jerkin on condition that he paid William Stonnes of St Neots the money Sherwood senior owed him, 'the which is aboute 30s, or betwene thyrtie shillings and fowre nobles'. This may well have left the son out of pocket, so to speak. Rafe Sherwood was in fact rather mean. He asked Thomas Hedding to be the supervisor of his will and gave him 'twoo shillings, the which Gilbert Coper oweth me', leaving Hedding the delicate task of recovering the money. This isn't the only unusual payment given to an overseer or supervisor: William Huckle's overseer received 'for his paynes, a swarme of bees'.

Many of the wills from this period were witnessed (and probably written) by the vicar, Thomas Huckle. He it was who was implicated in the excommunications for wife-selling, but who was dead by the time the participants were brought before the authorities. Like many villagers through the centuries, he couldn't resist the temptation to add his name to the countless others who have scratched theirs into the soft sandstone of the church. Huckle was succeeded eventually by Henry Baldwyne, who held the post until his death in 1590. Baldewyne's will shows he too thought he might be in posthumous trouble with the Church authorities.

And yf that after my departure, there happen any troble or sute concerning delapidacions of my parsonage howse, my will is that Mr Philipp Stringer be called upon to discharg me for the dovehowse which he caused in his ty[me] to be pulled downe: thys he hath faithfully promised, & I make no doubt of his willing & ready performannce therof.

With hindsight Baldewyne need not have concerned himself because before long the parsonage, like the dovecot, was no longer there.

ON THE MAP

I'm sorry about to-ing and fro-ing like this, but we need to return briefly to 1501. If you can remember back that far, Merton College owned Merton manor, Thomas St George owned Avenel's manor, Woodbury belonged to Audrey Delves and the Cistercians of Sawtry Abbey still had their hands on the Shackledon estate.

The monks' grip was rudely shaken off Shackledon by the Dissolution of the Monasteries in the 1530s and the estate quickly sold, the buyer being Richard Williams, alias Cromwell (yes, *that* family). He in turn sold it for a quick profit in 1538 to John Burgoyne and his son Thomas. The Burgoyne family still owned it at the end of the sixteenth century, which is all any of us need to know for now.

Woodbury passed from Audrey Delves to her daughter Ellen. She was married to a colourful if ultimately unlucky knight called Sir Robert Sheffield. He had fought with Henry VII against Lambert Simnel, the pretender to the throne, and was knighted as a reward. He became an MP and eventually Speaker of the House of Commons in 1512. His downfall came three years later. During what came to be called the Richard Hunne affair (a minor scandal of the time), Sheffield persuaded the young Henry VIII that his royal prerogative was threatened by the clergy. Henry followed Sheffield's advice and won a small victory at the clergy's expense. Sheffield became a marked man in the eyes of the Church, and Cardinal Wolsey soon found a way of having him clapped in the Tower of London on a trumped-up charge. Henry could quite easily have had him released but chose not to, and Sheffield died still locked up.

Not that many Gamlingay folk could care less what happened to him. Sheffield was not a popular man. He had been in charge of Woodbury for a long time in fact, if not in title, and was responsible for its enclosure in 1492/93, when he callously threw out a dozen families and laid the arable down to grass. By 1510 he had defiantly enclosed some of the village's common land

too, and loud complaints were heard in Merton's court. Sheffield's reasoning was simple: grazing a flock of sheep brought in more cash than arable farming. After his death the estate passed through several generations of Sirs and then Lords Sheffield until it was sold to John Manchell of Hackney in 1591.

We left Avenel's at the turn of the sixteenth century with Thomas St George, so conveniently 'acraysed of a Surfett' on the day of Edward Slade's arrest in 1532. The surfeit did him no lasting harm because he soldiered on until 1540, when he died at the advanced age of sixty-eight. Avenel's was sold to Henry Brograve, who sold it to John Gill. The manor had become a run-down, dilapidated farm by then and it was no doubt with some relief that Gill sold it to Merton College in 1599, who paid £1,830 to obtain about another third of the parish. This gave the College a large proportion of village land and all of Gamlingay Wood. Avenel's manorial buildings were virtually derelict but the College could administer both estates jointly. Inadvertently, their purchase of Avenel's may well have sparked the biggest catastrophe in Gamlingay since the Black Death.

On the morning of Sunday 25 May 1600, Queen Elizabeth's Privy Council met at the court in Greenwich. This inner circle of advisers handled most of the day-to-day affairs of state. Among the men attending the meeting were the Chancellor of the Exchequer, the Lord Chief Justice, and Robert Cecil, the Secretary of State and in effect the Queen's Prime Minister.

One of the items of business the Council dispatched at this sitting was to direct a letter be sent to Sir Thomas Egerton, Lord Keeper of the Great Seal of England. It said the Council had been informed by the Cambridgeshire Justices of the Peace of a 'lamentable accydent' in Gamlingay which had occurred on 21 April 'by casualltie of fire', during which 'the moste parte of the said towne to the number of 76 houses with divers barnes and stackes of corne were suddainlie consumed'.

> By which meanes the poore inhabitantes there are brought to great extremytie, and are unable of themselves to re-edyfie those howses that were thus consumed, or to releeve themselves, theire wyves and children. And therefore they have made humble suite unto her Majestie that some charitable course might be taken for a contribucion to be made in the counties adjoynynge, towardes the buildinge up of those howses that were so consumed by the violence of the fire, and for theire releefe in their lamentable dystresse.

In all probability the Privy Council didn't believe that figure of seventy-six houses destroyed. I don't believe it either. There were barely more houses 300 years later when the population had greatly increased. Perhaps the total included those 'divers barnes' as well. Some understandable hyperbole was used to sway the Privy Council into giving the village some practical help in its hour of need.

The Council granted the request for a contribution from neighbouring counties, but the only record of any money actually being collected comes from the parish register of Knebworth in Hertfordshire under the year 1600:

Item, to a collection for the burning of the town of Gamlingo in the Countye of Cambridge – 2s.

And that is just about all the direct written evidence there is of what was a major disaster for the village and its inhabitants. Gamlingay was not unusual in being burned to the ground. Most, if not all, towns and villages have suffered at least one major fire in their past. Wooden buildings topped with thatch meant the fear of fire was ever-present, and if one broke out and the flames got hold there was little anyone could do to stop them.

By great good fortune we can turn for help to a series of maps made in 1602 for Merton College. The fire had nothing to do with the College commissioning them, and everything to do with their purchase of all those acres belonging to Avenel's. They knew what they had bought, but needed to know exactly where it all was. The maps show the village as it was almost two years to the day after the fire.

Surprisingly, there are no gaps between the houses, no great swathes of unoccupied land to help us piece together the course of the blaze as it swept through the village. Just about everywhere there ought to be houses, houses there are. There are one or two crofts which should contain buildings and do not, and one unoccupied house in Church Street labelled 'a cotage decayed'. But there are two important buildings missing. One is the vicarage, or parsonage. There's no doubt it was destroyed in the fire because in 1601 the Archdeacon's visitation book noted that 'the vicaredge is burnt downe', and you can't say it more clearly than that. The churchwardens were ordered to spend a percentage of the profits from the vicarage each year upon 'repaireinge the howse to the Queenes Instructions, until it be fully repaired'.

The other building, or rather buildings, which are missing are those on Avenel's manor. The site of the manor is marked correctly as Bury Close, and you would expect to see the manor house and the outbuildings shown in it, but the close is empty (every succeeding map of the village shows it to be empty too). They weren't there in 1604 either, when Merton had an inventory made of the goods and chattels on Avenel's manor. It records only cattle, horses, carts and ploughs, with a few agricultural implements thrown in – no mention of household furniture, dairy equipment or brewing vessels and no manor house.

Bury Close is a ploughed field today, but within living memory it was a meadow, with the sites of the buildings preserved as mounds beneath the grass. When the field was levelled sometime around 1960, it was rumoured that as the mounds were ploughed out many pieces of charred timber were found, but contrary to what the Church courts may have thought, rumour

is not evidence. My own fieldwalking expeditions twenty years later turned up shattered medieval peg-tiles, a few animal bones, some sherds of medieval pottery and dozens of oyster-shells, but of the burnt wood there was no sign.

What about the clues provided by surviving buildings? The whole village was surveyed house by house in the 1960s by the Royal Commission on Historical Monuments, and using their findings and some guesswork of my own, I reckon that six secular buildings and the church survived both the fire and the centuries that followed. They are Merton Manor Farm, the Rectory, The Cock, Whitehall, and two others in Church Street near the crossroads. This list doesn't take into account the fact that other houses may have survived the fire and subsequently been demolished because there's no way of knowing if any did fall into this category.

If you will allow me to make one important assumption, my best guess is that the fire began on Avenel's manor. The manor house and the outbuildings clustered around it may have been occupied by a farmer in 1600, but again there's no evidence to go on, although you would expect Merton to have noted a sitting tenant when they bought it. It's more likely that the tumbledown buildings were being used by squatters – there were plenty of poor people in the parish at the time, some of whom would have been glad of a roof over their heads.

Alternatively, the occupants could have been one of the many homeless families, vagabonds or even disbanded soldiers who were constantly pushed around from one parish to another. It isn't difficult to visualise them building a fire to keep warm and accidentally setting one of the barns alight.

What was needed to spread the fire from Bury Close into the village itself was a strong wind. April in this corner of Cambridgeshire often brings icy winds blowing across the North Sea from the continent, and if they are caused by a high pressure system over the North Sea, those bitter easterlies can sometimes last a week or more. Assuming that the wind was blowing from the east allows the other pieces of the jigsaw to fall into place. Sparks could fly across to the thatched roofs of the nearest dwellings in the village, and once alight the wind would set off a chain reaction as the conflagration spread from one home to another. There are no surviving pre-1600 houses between Bury Close and the church except the Rectory nestling beside it, so it's reasonable to assume that the whole range of tightly-packed buildings on both sides of the road leading to the church went up in smoke.

The road bends slightly northwards by the church (being built of stone, the church itself was virtually fire-proof), which may account for the Rectory avoiding the fire. The flames next set light to the buildings in Church Street. Stray sparks accounted for the vicarage, which was tucked away behind the properties on the south side of Church Street. Chance, and the passage of time since the blaze began, allowed the other surviving buildings, which are all nearer the crossroads at the furthest end of Church Street, to escape. In all probability the fire caught some of the buildings on Mill Street near the

crossroads, but beyond them there were only closes and gardens. The blaze would have died out before it could reach the cottages in Green End.

A crucial factor to bear in mind is the time it took for the fire to eat its way from one end of the village to the other. It gave the people who lived near the crossroads a vital hour or two to prepare for its arrival. At the very least, it gave them time to gather some of their belongings and get them safely out of the way, but it also enabled them do what they could to stop their homes catching fire – drawing water from the well in readiness, and grabbing whatever was to hand to pull burning thatch off the roof.

Four of the six surviving buildings are close to the crossroads. Whitehall was actually on the crossroads, The Cock and the other two a little further down Church Street. The Rectory escaped because it's set back from that fortuitous bend in the road. Merton Manor was safely out of the path of the fire in any case, although had the wind been a north-easterly instead, there's every chance it would have been burned to the ground and the rest of the village spared.

So far as it's possible to tell, nobody died in the fire. The large number of now-homeless villagers would have been able to find lodgings with friends or relatives luckier than they were, or taken refuge in barns or sheltered in the church. Sooner or later, though, they were faced with having to rebuild their homes and their lives. Some of the houses reported as being destroyed were probably capable of being repaired: it's noticeable that the structure of a timber-framed building often survives when the thatch catches fire. Perhaps some homes were patched-up fairly quickly.

There are a couple of hints of the ravages of the fire in the early seventeenth-century wills. In 1602, Francis Burley left his wife a plot of land 'in lenght from the streat so far as the new orchard to sett her a Cottage thereuppon', which could mean that fresh trees were planted to replace old ones destroyed in the fire. Possibly the new cottage was a replacement too. Twenty years after the fire, Stephen Apthorpe casually mentions a meadow in his will 'which did some tymes belong to the Bell which was latelie brent in Gamlingaye'.

As we've seen, the villagers were used to co-operating with each other, particularly in the fields and especially at harvest-time. And now, in their distress, the villagers must have worked together to repair and rebuild their homes. They did rebuild, and they did it astonishingly quickly. The evidence for this huge communal effort is on Merton's maps, which bear eloquent witness to the speed with which the village recovered in the two years after the disaster.

The resilience shown by the villagers is remarkably similar to that following the Black Death 250 years before. In both cases what's impressive is not the devastation suffered, but the way the people regained their equilibrium so quickly afterwards. In reality, as with the Black Death, they didn't have much choice. What was done could not be undone. The land was still there, the crops still growing. What was the alternative to rebuilding, and quickly, with or without charitable contributions? The better-off villagers took the opportunity to build in

a more fashionable, up-to-date way. The fire interrupted the great rebuilding of the village, but also cleared away most of the rickety outdated buildings, allowing better ones to take their place. The reason that Avenel's manor house and outbuildings were not rebuilt is simply that they were surplus to requirements.

Forgive me one small digression, but there's one further aspect of the fire which needs to be cleared up. Many of the history books and guidebooks about Cambridgeshire that mention Gamlingay refer to it losing its 'important' market to neighbouring Potton because of this fire, implying it was hugely detrimental to the village. This is nonsense. The market was never of much economic importance to the village, except perhaps for a year or two back in the thirteenth century when it first started. By 1600 it was ripe for extinction: it had been moribund for most of the previous century. Potton market was a different matter. Ancient and well-established, it didn't need Gamlingay's business. Having a successful rival a couple of miles away was one reason Gamlingay market never amounted to much.

The man who surveyed and mapped the new, post-fire Gamlingay at the end of 1601 and into the early spring of 1602 was Thomas Langdon, one of the leading exponents of this relatively recent art. The fifteen priceless and in their own way rather beautiful documents he produced are preserved in the Bodleian Library in Oxford.

Someone once said that maps are a window on the world, and by his labours with quill pen, paintbrush and dividers, Thomas Langdon opened a window on late Elizabethan Gamlingay. Merton College paid him £12 to gain accurate up-to-date information about their newly-enlarged landholdings in the village, and rarely can £12 have been better spent. The highly detailed and accurate maps Langdon created are drawn in colour, and cover the entire parish except Woodbury (there was no College land there, of course). As the College's holdings were scattered far and wide, his main task was to plot the whereabouts of every single strip of land. To place each map in context, Langdon drew a small-scale general view of the parish. He followed this with a series of larger-scale plans of the village itself, and the individual fields and closes.

On the plans of the village, houses are shown in their accompanying plot of land or close. Each house is illustrated by a tiny sketch of a Tudor building, complete with doors, windows, roof and often a chimney, and each is labelled with the owner's name and the acreage of the ground it stood on. Virtually every close is enclosed by a hedge with trees growing in it, as in reality they would have been, but the drawings of the trees and bushes are too evenly spaced for them to be taken literally. They are cartographer's shorthand, as are most of the drawings of houses.

Even so, this is the kind of detail that immediately brings the village to life. Christopher Mead, for instance, whose own life is well-documented in the village records, springs into sharper focus by the knowledge that he lived on the south side of Church Street, with Stephen Hill and Roger Mayes as his

neighbours, but if he wanted a drink in Henry Greene's alehouse he would have to walk down the street and past the church to find it. Greene's alehouse abutted on to Bury Close and may well have been the first casualty of the fire. If it was the first to burn, then the second was Greene's next-door neighbour John Chesham, and the third, on the other side of a narrow lane, was Thomas Russell's homestead. If Mead fancied asking Isabell Bowers about the incident of twenty years earlier when she was sold by her husband and excommunicated by the Church, he could find her at her cottage standing in a tiny triangle of land at the junction of Stocks Lane and Mill Street. What Langdon's maps can't show is the reply he would have received had he done so.

Langdon solved a mystery that had bothered me for years. Exactly where was the Avenel's market place? I'd been studying the maps for years, but had never been able to find a likely spot for holding a market. Naturally, I'd noticed the roughly square area of land attached to the north-east side of the crossroads (I'm not a complete fool), but I'd grown up knowing it as the small car park in front of the Hardwicke Arms pub, so that's how I mentally labelled it. Then one day the penny dropped. When the maps were made, there was no Hardwicke Arms pub and no cars to be parked in front it of either. What else could it be but the marketplace? Of course it would be at the crossroads – where else would you put it? And how stupid of me not to realise it before. That's when Brown's Fourth Law of Research came into being: study a document for long enough and you'll eventually see what was obvious from the beginning.

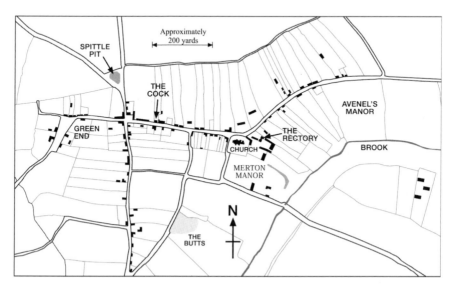

Sketch map of Gamlingay at the end of the Tudor period. It is based on Thomas Langdon's maps of 1602 and includes all the buildings shown by him in the main village. There were outlying homes at The Cinques to the north west, and one house by Mill Bridge along with a windmill to the south. Although it is only two years after the fire most of the village has been rebuilt. Note the lack of farm buildings on Avenel's manor.

Langton's field maps are just as informative. The furlongs and the maze of tracks and baulks which both divided them and allowed access to them are shown and named. The dozens of curving strips that made up each furlong are all marked with the owner's name and the size of the strip, written on in a miniscule script. As a source of field-names alone, the maps provide hours of pleasure. Some names are clear enough in their meaning, such as the Sands, Stocking ('field of tree stumps'), Shortmead, Coney Close, Foxen Furlong and Twelve-acre Piece. Others are named after their medieval owners – Welleses, Cloptons and Maggot's Holme. Some indicate their use: Walnut Close, Bean Lands, Peasland, Rush Furlong, Willowbed Furlong, Wool Lands and so forth. A few, more ominously, speak volumes about the problems medieval and later villagers faced in taming the soil: Thistle Lands, Water Lands Furlong, Puddle Furlong, Stonehill and Clay Croft.

Beside the entrance to Merton Manor is a sketch of a stone bridge with two central piers spanning the village brook. Next to it is Merton Barre furlong, which got its name from the gate or bar that closed off the road every evening in earlier times, mainly to prevent livestock straying, but perhaps also to give what was at best an illusory sense of security to the villagers. On modern Ordnance Survey maps the present bridge over the brook at this spot is called Martin Barrow Bridge. Having spent many years trying in vain to discover who Mr Barrow was, it was Langdon's maps that solved the mystery. Martin Barrow didn't exist. The name is simply a corruption of the medieval Merton Barre.

The field-names include several which point out prominent village features. 'Monk's Burge' is the name given to the point where a road was crossed by a small stream issuing from what was once the Abbot of Sawtry's Shackledon estate. Spittle Pitte was a large pond between the angle of two roads which was only filled in and grassed over at the end of the 1950s.

All the major roads are marked as 'ways', usually preceded by the name of the town or village to which they led (villagers still travel from Gamlingay to Cambridge via Cambridgeway Hill), but the minor lanes and tracks which meandered hither and thither between the fields and furlongs show greater originality. There's a poetic quality to names like Dewberry Heading, Still Deane and Pincott Balke, Snake Hill, and Crabtree Haden, and a darker one to 'Pore mannes Lotte'.

Langdon took pride in his evident skill, using cartouches and heavily ornate scales to embellish the plates, but like all maps his were out of date the moment they were finished. Yet in freezing the village exactly as it was in 1602, Langdon was also unwittingly looking back across the centuries to the medieval village and beyond. Names and features occurring in thirteenth-century records can be sited with great accuracy and traced on the ground today. Even where field boundaries have changed, aerial photographs often let you plot their original position. Invariably they are exactly where Thomas Langdon said they were.

PARISH MATTERS

For most of the sixteenth century and on through much of the seventeenth century there are no surviving Merton court rolls, save for two strays from 1611 and 1612. At first glance they aren't much different from their predecessors, and you could be forgiven for thinking we're back in the medieval village. The roll for 1611 even continues the long-established tradition of restating the by-laws, though in English for the first time.

> noe man shall digg noe turfes but bee turfes, that is turfes for the coveringe of their bee hyves for his owne use, uppon payne of every default 10s.
> noe man shall digg noe Claye, nor sand, to make bricke nor tills [tiles] uppon our comon uppon payne of £5 for every default.

There are many more like that, echoes of similar orders from centuries before, the only difference being larger fines. This, though, is new:

> if the lord and his tennants [farmers of the manor] using the manor or Lordshipp shall keepe them, then wee will keepe all theise orders sett downe; otherwyse wee be att liberty.

I wonder what the steward thought of the villagers telling him that what's sauce for the goose is sauce for the gander? They wouldn't have dared speak like that to the lord of the manor even a hundred years earlier. Some of the by-laws reflect a relatively recent development. The introduction of the Poor Laws during Elizabeth's reign made the villagers wary of any newcomers who might become an extra burden on the Poor Rate. The following is an attitude we shall meet again and again in the coming centuries:

Item. hee that hath taken in any Inmate or shall erect any Cottadge shall avoyde them away betwixt this and midsomer next uppon payne of fyve pounds.
Item. there is noe man shall take in any stranger but by the consent of the lord and twoe Justices of peece and the sixe men, uppon payne of £5.

Those six men were a sort of reeve committee, supposed to oversee the management of the village land. One man chose to ignore the injunction against introducing strangers into the village and paid dearly for it.

Item. wee fynd that John Bretherton hath receyved one William Ierland, beinge a stranger, into this Towne, without consent of the sixe men … and hath forfyted to the lord £5 for the same.

By the time the court next met in 1612 these by-laws had been put into effect, and the court roll contains a long list of offenders presented for breaking them.

Widdowe Warrine for keepinge of Catell upon the commone contrarye to the ordares.
Thomas Wattares for cuting of Turfes contrarye to the ordere.
John Hodsonne for takinge In a undersettare in to the towen contrarye to the ordare.
Thomas Wattares for diging of claye to macke breckes & tilles upon the commones.
John Dent for Diging up the kynges hie waye.

On the face of it, this seems like a genuine attempt by the manor court to come down hard on villagers who put their own interests before the rest of the community; in reality nothing could be further from the truth. Apart from stating the offence, no further action was taken – no fines, no threats, nothing – because most of the offenders were the jurymen themselves.

This waning of manorial prestige was a slow process that had been going on for at least 150 years, but as the Tudors gave way to the Stuarts there was a gradual rise in the power of the parish and its officers to balance it out. Control of affairs passed from external manorial officials to the villagers themselves. If you think this sounds like the beginnings of a local democracy, I'm afraid you're going to be disappointed. Authority was transferred to a village oligarchy, drawn from the wealthier families in the village who contributed most to the parish rates. Many of them were the type of people still found in villages today, who voluntarily take on responsibility and enjoy sitting on committees. Few of them were from the lower reaches of village society, and none came from the ranks of the poor. While these men had the

advantage of local knowledge, in the long run their vested interests prevented change happening when it was sorely needed.

The growing importance of these various officers resulted in another tide of documentation. For the first half of the seventeenth century, the churchwardens' accounts plus their offertory accounts (which show how they spent the gifts of cash placed in the church poor box) are the most revealing. The accounts take the form of an annual statement of income and expenditure, made up and audited each year during Easter week or at Whitsun, when fresh churchwardens were elected, and they run with a few gaps from 1608 until 1745.

The office of churchwarden is of great antiquity. It was a temporal office, and although the new churchwardens rode off to Cambridge each year to be sworn in by the Archdeacon, he had no power to disallow the appointments. There were normally two churchwardens and their accounts, although shorter and more straightforward than the earlier bailiffs' accounts, contain a fantastic amount of detail.

They were usually written in a flimsy paper booklet, or on a single sheet of paper. One of the attractions of parish records lies in the fact that they were written by the villagers themselves, rather than by clerks hired for the purpose. Because some of the words are obviously written phonetically you can almost hear these long-dead villagers speak. When the churchwardens write about *gooing* to Cambridge to swear their oaths or buying some *glew*, or a date is written as the '*fust* day of may', I'm listening to the lazy drawl I grew up hearing every day.

Even when you've unscrambled the inky scrawl and unravelled the words written phonetically you are still left with some very idiosyncratic spelling. Ben Jonson's dictum that only a dullard would spell a word the same way twice was taken at face value by these worthy men. It took me a long time to realise that *baggars, bagers, baggets, bagards, bajers, bajuers* and *bajeers* were not very successful attempts by the churchwardens to spell 'badgers'. But what, you may reasonably ask, have badgers to do with churchwardens? The answer is that an Act of Parliament made the churchwardens responsible for controlling 'Noyfull Fowles and Vermyn'. The documents have hundreds of entries like these:

> paid for a heg hog, 4*d*.
> for wone [one] powle Catt head, 4*d*.
> to Oliver Bollnest for a foxe head & 3 young Baggars heads, 4*s*.
> laid out for Caching of sparrowes to Kinge, 2*s* 6*d*.
> my selfe kild a foxe in grat heath, 6*d*.
> payed to Frances Horsley for killen of 34 moldes, 3*s* 10*d*.

To claim the reward you had to present the churchwardens with the head of the creature you'd killed. I've no idea what they did with them, but I wouldn't be surprised if the skins of decapitated moles ended up as trousers and waistcoats.

Parish pest-control officer was just one of the many duties the churchwardens undertook which appear to have been almost entirely secular. During the first forty or fifty years of the seventeenth century, they were to all intents and purposes overseers of the poor. A series of Elizabethan Poor Law Acts had laid the foundation of a system of poor relief that lasted for 200 years and more. The law said that rogues, vagabonds and 'sturdy beggars' were to be beaten out of the parish, strangers settling there could only stay if they could prove the parish wouldn't have to pay for them if they became unemployed, and the indigenous parish poor were to be maintained and set to work by the overseers. If it sounds like a rather brutal and insensitive way to treat poor people, that's because it was a rather brutal and insensitive way to treat poor people.

Until the middle of the seventeenth century the overseers usually consisted of the churchwardens, along with one or two substantial householders, who raised the money to relieve the poor by levying a rate. There will be more to say about the poor when we come to look at the separate overseers' records later on, but in the meantime the offertory accounts and the early churchwardens' accounts give an idea of the problems involved in looking after the poor and the sick.

> Offertory accounts, 1595 to 1627:
> To Widowe Sanforde beinge sick 3*d.*
> Geven to goodwife Peter for keeping a childe 4*d.*
> Geven to Widowe Marham toward hir losse when her house was broken & goodes stolen 2*s.*
> Geven to Tomson beinge longe sick & lame 8*d.*
> To Widowe Foreman for tendinge Widowe Heminge 11*d.*
> A sheete for Widowe Heminge, drinke & houserome 18*d.*
> Laid out for her buryall 12*d.*
> To the soldyer that was prest out of this towne to ward his charges homeward 4*s.*
> Given to an Irishe woman & her company 12*d.*

> Churchwardens' accounts 1610/11:
> layed forth to the Criple, 6*d*, layed out to the pore man licensed, 2*d.*
> layed forth twoo pore men burnt with fier and had a passe, 4*d.*
> layed forth unto one pore woman that had a passe, 2*d.*
> To one man licensed burnt with fier, 4*d.*

These people armed with passes, or 'passengers' as they were often known, had been licensed to beg on their way to their home parish where they could expect relief – of a sort. The number of licensed beggars markedly increased during and after the Civil War, becoming rather of a drain on parish resources,

as these extracts from the accounts of 1645/46 at the height of the conflict show:

> Given to a minister being plundered & in wante, 1s.
> Given to a woman that hade loste hure meanes, 8d.
> Given to anould man by consent of sume of the parish, 2s.
> Given to two that had lost thar Estates in Irland, 1s.
> Given to a man & wife having many children, being undon by plundering & burning, 2s.
> Given to two women that had thare husbandes slayen and having many children, 2s.

There are dozens of similar entries from this period. In normal times the people who dished out money to the poor and needy were not renowned for being open-handed, but being faced with the graphic evidence of the poverty, homelessness and sheer misery that the Civil War often brought upon the ordinary men and women of England must have softened even the hardest heart. That payment to an old man 'by consent of sume of the parish' is a hint of the tensions that must have existed in Gamlingay, as in the rest of the country, at the time. There was nothing very romantic about fighting your fellow-countrymen. If its romance you want, there's a hint of it in these payments:

> 1624/25
> Allso to a man which suffered shipwracke under the Turke, 12d.

> 1647/48
> Paid to 2 men that had bin imprisoned by the Turkes, 6d.

> 1662/63
> Laid out to Robart Morten that wase sold in to Turkey, 1s.

The Muslim pirates from North Africa who infested the Mediterranean during the seventeenth century were often known simply as Turks. Their presence made any sea journey, even in English waters, a risky affair, and anyone they captured stood a fair chance of being either ransomed or sold into slavery. However he managed it, Robert Morten was a lucky man to escape from his captors.

Much of the churchwardens' work in relieving poverty was far more prosaic. To be fair, dealing with the poor was no easy task at the best of times. Many were old and sick, some were young and sick, and quite a few were widows. The cash payments they received were unlikely to keep them alive for very long without some form of material help. The accounts are full of items like

the 'come of Cooles' (a sack of coal) bought in 1639 for John Paine, or Kate Whalesbie's shoes which cost the churchwardens 2s in 1623, or the money 'Leayed out for cloth & making of twoo smockes for widow Hemming' in 1610. These payments were often made during times of sickness or desperate need, but usually only for a short time. The sick either recovered or died, and the needy found work or presumably relieved their own distress in some way.

There were a few people permanently supported by the parish, such as Edward Foreman, who was paid amounts varying between threepence and a shilling a week during 1610/11, or the 'six pence a weke for 48 wekes' that Widow Catlyn somehow survived on in 1645/46. Their numbers were to grow steadily throughout the century. The stark choice facing the churchwardens was between paying up as little as they could square with their consciences, or watching their neighbours starve to death. As we've seen, most of the villagers who left wills bequeathed money directly or indirectly to the poor, but on one occasion (in 1621) the churchwardens were forced to spend sixpence out of the poor box on 'making a search for Mr Catleines will for the legacy for the poore'. I hope they were more successful in tracking it down than I have been.

Unfortunately for the churchwardens and those who had to meet the rate, the expense didn't stop at simple maintenance. Not only was money doled out to keep the sick and needy alive, but there was always the possibility that they would require some sort of medical attention. Most villages had their healers, people able to cure many of the ills which beset their patients – or at least who thought they could, which doesn't necessarily amount to the same thing. Goody (short for 'Goodwife') Titmus was one such, as this next entry shows:

1631/32
to Goodye Tichmues for healinge of belles leage, 3s 4d.

We aren't told what Bell had done to his leg, but judging from that terse entry it seems her treatment worked. Inevitably there were times when more than the potions and simple bone-setting skills of village healers were needed, and a more expert hand was called in. That same year, the churchwardens paid 7s 6d on behalf of two patients for 'leten blude & Giveine them visecke'. Blood-letting was for centuries the panacea for nearly all ailments. In this instance the procedure was undertaken by Francis Jessop, Gamlingay's own licensed surgeon, who left at his death in 1647 'my Instruments for Chirurgerie and all my bookes for Phisick and Chirurgerie'.

Eventually the job of relieving the poor became too big for the churchwardens to handle, and the overseers became a separate entity towards the middle of the seventeenth century. The poor who died – killed by the cure, perhaps – were occasionally buried at parish expense, but again we can look at that in more detail when we come to the overseers' accounts.

When the poor died, there were often orphans to consider. The standard practice was to apprentice them to a local man who would teach them a trade. When the apprentice had served his time, the taxpayers' fervent hope was that he would be able to make his way in the world without becoming a charge on the parish. Usually the orphan was fitted out with a set of new clothes at the start of his apprenticeship as a gesture of goodwill. With luck it would be the last payment he would receive.

Many of the indentures made between a master and the parish have survived. They set out the terms under which apprentice and master were bound. In 1645 John Lunn, an orphan aged about eleven, was put out to Stephen Apthorpe, yeoman, until he reached the age of twenty-four. Lunn's part of the bargain was to do as he was told and behave himself towards his master and his family. In return, Apthorpe agreed to teach him the skills he 'useth in husbandrye' as well as to house the boy and provide him with food, drink and clothes, all according to the 'Custome of the Countie of Cambridge'. What kind of life the boy led thereafter mostly depended on the master. If he was kindly and humane, the orphan could emerge from his long and happy apprenticeship as a skilled craftsman or husbandman well able to take care of himself. But if the master was harsh and tyrannical, he could look forward to a miserable and lonely existence.

Another responsibility was the town house, where the village herdsman lived. In 1701, the Cambridge Quarter Sessions were told that it was falling down, and that the churchwardens and overseers had always been responsible for its upkeep. The court ordered them to fix it. Several substantial landholders appealed against this decision and won a ruling that only those people who exercised their common rights should pay for the upkeep of the town house. This was the prevalent attitude among the village rulers. It was bad enough having to cough up for the rates, but why should their money go towards the town house when they didn't use the services of the herdsman who lived in it?

The primary function of the churchwardens was, of course, to ensure the smooth running of church affairs. It was their job to keep the church itself clean and in good repair, see that the fixtures and fittings were properly maintained and look after the churchyard. The Church authorities were always poking their noses in to check up on the churchwardens, and woe betide them if they were found wanting. The Archdeacon descended on the church in 1685, and sniffily described it as slovenly. The font had 'noe plugg, they use a Bason', the chancel needed paving and painting, while the vicarage was 'most wretched' and the parsonage 'much Dilapidated'. It's not surprising, then, that the churchwardens' accounts contain countless items concerning this aspect of their duties. One regular task was providing bread and wine for the Holy Communion:

Layed out at Whitsontide for bred and wine, 2s 1d.
Layed out for the feching of it, 2d.

In 1610/11, when those payments were made, they also bought the bread and wine used at Michaelmas, Christmas, Easter, Maundy Thursday, and what the writer of the accounts called Plam Sunday and Low Sundunday. I think we can guess who finished off the leftover wine.

When discussing the medieval church, I mentioned there were no pews and that the church was strewn with straw or rushes for the congregation to sit on. Now there were pews, but the practice of strewing rushes continued, although it seems to have been more ceremonial than practical.

> for karreing of a lode of Rushes to the Church, 8s.
> paid to John Basse for feching Rushes for the Church, 1s.

For centuries the interior walls of the church had been covered with pictures illustrating biblical scenes, but these were now considered 'Popish' and a coat of whitewash was applied every few years to keep them hidden them from sensitive Puritan eyes. The churchwardens paid £10 in 1632/33 for 'whitin the Church & mendin the aylles & mendin the flore in the stepel'. What sort of brushes were used to apply the whitewash? Answer: 'a Brush Besume when thay whited the church, 2d'. And how did 'thay' reach the far cobwebby corners? By paying John Overall 'for his lader for whiting the Church'.

There had been a clock on the church since the middle of the sixteenth century – Robert Gyllson left 3s 4d to repair it in 1557 – and villagers no longer needed to consult the crude sundial hacked into the wall on the south side of the chancel. For those who could tell the time, the new clock on the church tower could do the job more accurately and in all weathers. The sundial remained in use, for the churchwardens paid out for 'figgering the sun Diall and a Noman', the gnomon being the piece of metal that throws a shadow on the sundial.

The clock was a bothersome piece of engineering and required constant maintenance. Virtually every set of accounts shows money spent on it in one way or another.

> for mendinge the clocke hannd, 4d.
> paid to the smyth for worke about the clocke and bells, 12d.
> I laid out for wyere for the Clocke, 2s 2d.
> paide to Mr Barnes for toe pintes & halfe of oyle, 2s 1d.

Sometimes the men who compiled the accounts were plainly unable to understand new-fangled mechanical devices, an affliction I share with them. This next quotation, taken from the accounts of 1640/41, is a particular favourite of mine:

> Item. paid to James Robardes for mending sumthing for the Clock, 2s 2d.

The clock, patched up and repaired, gave its last tick in 1673, when a new one was bought for £20, along with a watch. The new clock proved almost as troublesome as the old one, and by 1678 the churchwardens were paying out half a crown to the 'Clock maker for his Judgement'. The parson, meanwhile, could time his sermon by using a much simpler and older timekeeping device, what the churchwardens described as 'a nouerglas for the Chorch', the last time they bought one. Sermons were delivered from the pulpit, of course. In 1616, the churchwardens paid a 'joyner for makenge the pulpitt cover & the staires & settinge the pulpitt higher', which reflects the growing importance attached to sermonising. No doubt the congregation kept a close eye on the hourglass as the parson preached to them.

Keeping the bells in good repair was another regular expense. They presumably took their cue from the clock and were rung every day. John Larkins was paid ten shillings a quarter in 1674 'for ringen the 8 of Cloke bell', which was probably the evening curfew bell, when fires were supposed to be extinguished. How much notice was taken of it is debateable.

> for mendeinge the greate bell clapper, 5s 6d.
> To John English for the bell Clapers and for the belfre dore locke, 14s 2d.
> To widow Brown for 2 bellropes waying 15 pownd, 7s 6d.

The bells were rung enthusiastically on every possible occasion, and fittingly the bellringers were paid not in cash, but in beer. Guy Fawkes unwittingly provided an excuse every 5 November for the ringers to show off their skills in commemoration of what one churchwarden called 'Gunpoudertrasn', but they were also rung on royal occasions such as the 'Crownation' of Queen Anne in 1702, a victory at sea in 1704 and the King's birthday in 1734. They also rang out 'when the Bishipe war heare' in 1688.

The fabric of the church had money spent on it every year. This brief sample is just some of what Thomas Warner and Francis Ratford forked out during 1613/14:

> for woode for the Plummer in June 1613, 6d.
> for a bushell of malt for Morter, 3s.
> to the mason for carryeinge in the lyme and helpeing to choose the brick, 6d.
> for diggeinge and carryeinge two lodes of Sande, 8d.
> for five hundred of Bricke, 7s 2d.
> for the churchyard gate, 4s.
> for three fete of glasse, 18d.

It was endless. If it wasn't the pulpit door that needed 'one Joyngt' making for it, then they had to pay for 'making a end of the church wall'. Money had to be spent on 'mending of seates', for 'glasin and latisin the vestri windows' or on 'a foot and halfe of Oack for the Church stile' and 'Spredin a lode of gravill at the Chorch geat'. A number of village craftsmen and jacks-of-all-trades were kept busy by the churchwardens in their efforts to preserve the church. The battle still goes on today.

The churchwardens were responsible for paying the stipends of the sexton and the parish clerk. They regularly bought paper and parchment for the clerk to use, and, rather more ominously, the spades and shovels used by the sexton. They also had to provide refreshment when the parishioners paused for a rest on their yearly perambulation of the village bounds.

> 1683
> For the prosessional [at] hatly hedges for beare, tobacko and pipes, 6s 7d.
> The same day at millbridge for beare tobacko and pipes, 3s 5d.

> 1687
> paide to Christopher Parson for bred & Chese & beare & tobacko & pipes the sum of 10s.

Another duty was to provide and maintain the various items used in the church's services. In 1614 they levied a rate on the parish towards 'the buyeinge of a greate Bible, The Apologie of the church and other necessarie charges'. Churchwardens were obliged by law to obtain Bishop Jewel's *Apologies* (a popular defence of the Church of England, and a gripping read, I'm sure) and the then-new Authorised Version of King James. Also on a royal note, in 1608/09 the churchwardens paid for making 'the kynges armes & tenne commanddementes', which had to be displayed in the church. The arms of King James in bright colours with the Ten Commandments written below were probably painted on a wooden panel and hung on the chancel arch, and must have gone some way to brightening up the otherwise plain, whitewashed church.

The popular Catholic ceremony of churching had been allowed to continue after the Reformation. It usually occurred a few weeks after giving birth, when most women went to church to celebrate surviving the traumas and dangers of childbirth and to mark their return to everyday life. Normally this had nothing to do with the churchwardens, but they provide the only record I've found of churching. Alice Paine was a young mother-to-be when her husband was buried at parish expense in September 1639, and after the birth of her son Christopher she and the child were 'on the parish'. It therefore fell upon the churchwardens to pay the 8d due to 'Mr Worledge for Churching of goody

Paine'. She and her child didn't burden the ratepayers for long as the young widow married Nathaniel Lunn, a widower, in 1641, and the couple produced a family of their own. They were married for thirty-six years before Nathaniel died and 'Widdo Lun' had again to be maintained by the parish.

The accounts, as most of the parish records do, contain their fair share of conundrums. I have no idea what 'the ordear about ye horned Cattle' was that the churchwardens paid a shilling for in 1745, nor why they paid the large sum of fifteen shillings to 'Ginger ye Saylers man' in 1623. It would be reasonable to assume the 'towne hookes' bought in 1640 were for pulling the thatch off houses in case of fire – after all, the devastating blaze of 1600 would have been a strong memory in the minds of older villagers. The candles they bought in late 1688 'when the Skare was', and the very next entry, 'Goen after the Sogers to Grandson', may be connected to what is sometimes called The Glorious Revolution, when James II fled and left the country in turmoil. His successor William III was duly proclaimed by the Gamlingay bellringers when he was 'Cround'.

The churchwardens' accounts abound in fascinating details like this but my space and, I suspect, your patience are limited. As, indeed, was the churchwardens' income. It consisted of interest ('use' money) on cash lent out, occasional gifts from wealthy men, rent from the church meadow and town house, and what was raised by rate. Frequently this was inadequate to meet all the expenses and the churchwardens must often have dipped into their own pockets when there was a shortfall. And with this welter of business to attend to, all of it unpaid and part-time remember, they could be forgiven for heaving a sigh of relief when their year of office came to an end. They must have received some satisfaction from doing a demanding job, but I doubt if they got more than grudging thanks from the rest of the village for doing it.

CHAPTER 11

AND OTHER LUMBER

What happened when someone was lying on their death-bed and had, through carelessness, undue optimism, accident or sheer indecisiveness, neglected to make a will in good time? The law provided a simple solution to this difficulty: the people present could later make a statement on oath recording the deceased's final wishes, and this was regarded as a legally acceptable will.

The resulting documents are as near as makes no difference verbatim reports of the dying person's last words. These nuncupative or spoken wills can take you straight into the homes of village people, often conjuring up a vivid picture of what was happening at a particular moment in time. For instance, on 23 April 1613 Henry Harper, though 'sicke in bodie', was sitting by the fire in his brother William's house in Gamlingay, trying to keep warm. Everyone could see he was extremely ill. His mother, Agnes Steward, was there, but not it seems to comfort him in his time of distress, for with singularly little concern for his health but a great deal of concern for his money, she asked her son Henry 'what he would give her', to which he replied 'she shoulde have five poundes'. Whatever Henry's illness was it grew rapidly worse.

> the next daie followinge, as he lay in his Bedd in the said house ... Henry Harper asked if Agnes Wheelewright [his niece] were come home from schoole, and his said Mother sayinge unto him, here she is now, what will thou give her? he said she should have three poundes; and his said Mother demanndinge of him who should have his paire of flaxen sheets and his Coverlett, he said ... Agnes Wheelewright should have them.

Now I don't want to damn Agnes Steward out of hand (after all, it may just be unfortunate phrasing), but it does sound as if the old lady was more concerned about where her son's effects were going to end up than by the fact that he was dying before her very eyes – perhaps between those same flaxen sheets and beneath the same coverlet she was pestering him about. This impression

is strengthened by the rather cold and calculating way she reminded him that he had given her five pounds, 'and asked him where she should have it. And he said it was in Squires hande'. A gratifying answer, but it would be the last time Henry Harper would please his mother: he was buried the next day.

When the widow Maud Greene was asked in 1607, about a week before she died, who should have her property, you can almost feel her affront at being asked what she obviously thought was a silly question. She replied, 'Who should have yt but Henry Greene, my sone, he shall have yt,' and doubtless raised her eyes to the ceiling as she said it. On the other hand, whatever was wrong with widow Joan Huckle in 1627 didn't prevent her from rattling off a long list of her clothing to be given to friends and relations, ending up with 'the hat which was hir husbands'.

Henry Franklin was another of those men who breathed their last knowing their children would be orphaned. Franklin's wife had died in January 1618, and one of his sons in July. He remarried in the October but his second wife was dead just two months later. Having buried two wives and a son in the space of a year, the following April he too was on his deathbed. He hoped he was providing adequately for his children when he declared Alice Empson (his first wife's sister) should have his goods and chattels so that 'herewith she shold have a care to bring them up and provide for his children, Elizabeth Franklin, Joan Franklin and William Franklin'. The children were nine, two and six years old respectively. I'm pleased to tell you they were still alive six years later when their aunt made her own will, because she left little Joan her best green apron, a bed, heaps of bedding, a salt cellar and £6 in money. She gave £5 each to William and Elizabeth, who also received 'my best petticote, wastcote and ruffe'. The parish register reveals that Elizabeth at least made it into adulthood, marrying in 1632.

In 1622 the village blacksmith, Zachariah Gray, was equally worried about the fate awaiting his wife and children. Almost four hundred years after he uttered them, the heart-rending words he used as he lay on the verge of death still speak of his distress. He said 'by word of mouth unto his wife Dorothy Gray' that she should have his few belongings, 'because his children were all yong, and that she shold have need of it to bring them up, repeating it oftentimes, that all that he had wold not bring his children up'.

In contrast, John Martin's nuncupative will made in 1626 contains no such sentiments. He was a labourer and a bachelor, and what little he had was mostly left to his kindred, except for a little cash 'to make a good drinking for such as shold attend him to his buriall'. The same year another labourer, Henry Conquest, could only afford to give 'twelve pence apiece to every one of his five children'. In 1627 George Hayward, grocer, showed touching fidelity by saying, 'I do give my wife Fortune all that I have, I will give nothing from her.'

The everyday wills of this period also have their moments. Thomas Bowers began his cheerfully enough with the words 'To all Christian people to whom

this present writing shall come, Thomas Bowers sendeth greeting'. Sadly, the rest of his will follows the general trend of seventeenth-century wills: as the century wears on people have more cash to leave, financial matters dominate and the wills become less revealing.

This isn't to say that these later documents are devoid of interest. Even the dullest of them may contain a juicy tit-bit, like Elizabeth Johnson's of 1645. She knew the time-honoured way to show utter contempt for a relative was to leave them only a shilling. The only drawback was that it left future generations wondering what the recipient had done to deserve it. Widow Johnson was determined that nobody should be in any doubt about why she treated her son-in-law in the traditional manner, and she condemned him in no uncertain terms:

> I give and bequeath unto Thomas Warner, the husband of my daughter Elizabeth, deceased, the some of twelve pence to be paid him upon demand after my decease; and the reason why I give him noe more is because he hath consumed and spent his owne estate, and my daughters portion, and now lives in an idle and debayst course of life.

There are the usual crop of revealing preambles. Stephen Apthorpe in 1616 was 'mynded to set a quyet Course betwene my sonnes after my decease', and he was probably correct in anticipating family friction after his death. Since he owned The Cock and much more besides, there was a lot at stake. Christopher Mead's will hammers home the point that infant mortality was frighteningly high when he requested burial 'neare to my fathers grave, above all my children that are already buried'.

A few men were still trying to exercise posthumous control over their wives, but most took a more enlightened attitude. John Jackson, the vicar, left five shillings in 1629 to 'the poorest sorte of people of the parish' and gave everything else to his wife, adding that he didn't doubt 'but she will give unto my Children what it shall please god to enable her'. His state of health is given away by his shaky signature on the will, which was in fact proved a week later.

Henry Greene was typical of this change in attitude by giving Mrs Greene his house, her choice of some of his best sheep and pigs and 'all my Bees exceptinge two swarmes of the best'. Robert Bestowe (1617) gave his wife 'the little howse which stands in the yarde', telling his daughter and son-in-law to 'sett up a chimney therein'. She was also to have a garden and the use of the well, the daughter sharing the cost of 'buckett and rope'.

Beds are still the most important items of furniture and are sometimes said to be 'wherein I lye', although Robert Bestowe's wife Elizabeth bequeathed the 'matteris which bee upon mee'. Presumably her bed was by now in that little house her husband had arranged for her to live in. Margery Parsons left her

grandson 'the standing bedstead, it stands up in the loft'; like many people, she now slept upstairs.

New houses were built after the fire, and those untouched by the blaze were improved. The village still possesses many fine examples of seventeenth-century houses, and the wills record some of the improvements in the standard of living. Urias King's of 1609 mentions 'all the pothangers and yron work in the Chymney'. Some of his food was doubtless cooked in 'the Brasse pott which we use Daiely' and served on 'the best platter'. Chairs and tables are normally 'joined', but occasionally trestle tables, survivors from an earlier age, are noted. Richard Bestowe's 'presse cubbard standing within the parlour' (1640) is a reference to the type of furniture that was slowly replacing chests and coffers: it was an early form of wardrobe.

By 1639, Dorothy Mause would have seemed an old-fashioned lady to the younger village women, clinging to traditional forms of decoration – 'the painted cloth against the wall' and 'the painted dish and the painted cloth that hangeth over the table' – which were medieval in origin, and the gowns, smocks and 'my best ruffe' that she had worn in the days of her youth. The ruffs so familiar from Tudor and Stuart portraiture hardly get a mention. By the time they had descended far enough down the social scale to merit distribution in a village will they had all but gone out of fashion. As the seventeenth century progressed, other clothing rarely receives more than a passing note, although it's clear that the gorgeous colours and rich materials have gone, replaced by more humble, homespun, sober and altogether more appropriately Puritan clothing. One intriguing reference comes from Thomas Cook in 1609, when he left 'one Cipresse which is upon my worst hatt'. Cypresse was the name given to fabrics originally imported from Cyprus and often used as a sign of mourning, although as he wore it on an old hat perhaps his grief was more apparent than real.

As time goes on the wills become more and more verbose and less and less informative. As luck would have it, another kind of document now often accompanies a will, one that's more revealing about testators' houses but less so about their individual characters. Agnes Steward, the grasping mother of the unfortunate Henry Harper, tells us what it was in her will made in 1618. She left some of her clothes to her sister (meanly adding 'which she hath already'), but the clothes, linen and 'household stuffe' she left to her granddaughter Agnes Wheelewright was to be found 'valued and praised in the Inventory of my goodes, debtes, rights and Chattles'.

Agnes Steward's inventory has disappeared during the intervening centuries, but in theory probate could only be granted on a will if it was accompanied by a list and valuation of the deceased's goods and chattels. The inventory was supposed to be drawn up by two honest, literate men of the village, but this was often easier said than done: literate men were not necessarily honest, and not every honest man was able to read and write. In fact, few inventories date

from before the mid-seventeenth century, at least in the countryside, and after 1782 having one made was no longer an automatic requirement. The first surviving personal inventory from Gamlingay is dated 1666. During the next century or so, seventy-one villagers' wills have an accompanying inventory.

Fashions changed during that time, of course, and generally speaking the will-making class lived more comfortably and had more possessions by the end of the period than at the beginning. But the village was still an open-field community in 1666 and remained so in the 1780s; the land was still farmed the same way it always had been, a plough was still a plough, poultry was still poultry, and just as difficult to count as it was in the middle ages. The contents of a house and outbuildings are much the same in the first inventory as in the last. Nor had attitudes changed much since the middle ages. For example, William Jeakins had 'in the Streett, 6 timber sticks' in 1730. These 'sticks' were probably large beams, and there is really no difference between Jeakins' contempt for the village roads and that of his medieval forebears.

In one sense inventories are unreliable documents, because the valuations given by the two appraisers usually bear little resemblance to reality, frequently being far too low. No doubt factors of class and personal taste came into the reckoning, but so did the possibility that when an appraiser came to put a value on a cart or a chair, he had at the back of his mind the thought 'am I likely to be buying it in the near future?'

An inventory normally begins with a brief statement, more or less like this one.

A true And parfet Invinetare of the Good And Chatells of Edward Bass of Gamlingay in the Countey of Cambridg, bacholder, Decesed, Aprased And vallud as foleth by us, howe names is under Riten, this fust day of may 1690.

The word 'inventory' caused the appraisers endless trouble. One said he was writing an 'Imnaritary', another claimed the document was an 'Imnetarey' and yet another called it an 'Inmetarie'. If that was how they spelled it, how did they pronounce it? Nicholas Paine, who really ought to have known better, and Joseph Wilson, who probably did, deserve some sort of posthumous recognition for rendering 'kitchen' as 'Chiching', although even they were trumped by the appraisers who examined James Wells's house in 1734 and came up with 'Chicking'.

One feature common to most of the inventories is the appraisers' tendency to lump together all the smaller items in a room under the all-purpose heading 'other lumber'. On one occasion, the appraisers even went so far as to add ten shillings to an inventory for 'Lumber and things forgot & not seen'. I'd love to know how you value something you haven't seen. It's a good illustration of the point about taking the prices given in the inventories with a pinch of

salt. And what's actually listed by the appraisers sometimes tells you more about the appraisers themselves than they may have intended. Some simply dismiss the household items in a few lines, yet list the contents of the yard and barns in great detail, no doubt reflecting their own background as farmers or yeomen. Others seem to take huge delight in noting everything in each room in the house, enjoying the chance to do some legitimate snooping in their late neighbour's cupboards and drawers.

The deceased's clothing is normally listed first (but never described), together with any cash the appraisers found when sifting through it – hence the need for honesty as well as literacy – under the heading 'wearing apparel and money in his/her purse', the combined valuation ranging from a few pounds to a few shillings. It was a fictitious sum in any case, a round-figure approximation not meant to be taken too seriously. This doesn't mean the appraisers were unable to produce a fairly detailed inventory, one that could be relied upon to be accurate as far as it went. When we're told that Lewis Careless's parlour contained a bed with its bedding, a wicker chair, two chests and a couple of coffers you can be sure that's exactly what was in it, but we can safely doubt the £5 valuation his appraisers put on them.

Coffers (which sat on the floor) and chests (which had legs) appear in virtually every inventory. The first to survive lists no less than six coffers while the last mentions two, reflecting the gradual introduction of more user-friendly ways of storing clothes and household linen. For centuries housewives had to remove most of the contents to get at the items buried deep in a chest, but now chests began to appear with a drawer fitted at the base, then with two, until the logical extension of the idea led to what was literally a 'chest of drawers', the first example in Gamlingay noted in Nicholas Brotherton's 1690 inventory.

Most inventories start with the downstairs rooms. The hall is mentioned in about a third of the inventories, but it's clearly now just an anachronistic name for an ordinary downstairs room. Nevertheless, there was still a certain residual prestige attached to it. In 1672, Christopher Charnocke's hall was stuffed with a couple of tables, seven chairs and shelves full of enough pewter dishes and drinking vessels to entertain a small army. After a night's eating and drinking, his guests could relieve themselves in the pair of chamberpots he kept handily placed in the hall. He had another eleven leather chairs parked around the house, but there was no room for his two other tables which had to be kept at The Rose and Crown public house.

After the invention of the pendulum, long-case clocks began to appear in early eighteenth-century village homes. The earliest mention of a domestic clock comes in 1708 from Thomas Paine, who kept his in the parlour, the next three years later in Nicholas Apthorpe's inventory when his clock stood by the staircase of his house in Brook End, but gradually the fashion spread among lesser mortals and after 1730 they became commonplace. Nicholas Fickis had a clock in his hall in 1733, but the picture of genteel cultivation it evokes is

spoiled by the fact that he found it necessary to keep his bacon-rack in the same room.

Thomas Paine had a 'Pickture' hanging near his clock, but so far as I can tell from the inventories art and literature did not play much of a part in villagers' lives. Thomas Cawthorne's inventory of 1731 lists 'Six Picktures and Seven Chairs', but Paine's picture wasn't valued separately, and Cawthorne's pictures and chairs together were only valued at six shillings. These pictures were not exquisite eighteenth-century oil paintings but cheap prints, similar to the seven recorded in Lawrence Mead's parlour. Yet how could semi-literate villagers put a value on pictures, whether paintings or prints? Thomas Cawthorne may have had half a dozen genuine Rembrandts hanging on his wall for all the appraisers knew.

Literature fares equally badly. The first inventory to mention books is that of the rector Edward Sclater in 1710, who had 'a parcell of Books' worth five pounds in his study. Otherwise there's no evidence that anyone ever looked at or read anything more stimulating than an account book. After 1710 the inventories do show that a handful of villagers took an interest in the written word. Mary Stokes (1714) kept her small library in the chamber over the kitchen. Two village yeomen were also readers: John Overall in 1725 and John Custerton in 1736 possessed a few books, as did Simon Page, a cordwainer.

Returning to the house itself, it's clear that the parlour was the second-best room in those houses that had halls, and the best in those that did not. As well as containing his clock and picture, Thomas Paine's parlour was home to 'two pares of Window Curtains with Iron Rods' and a 'Parsell of hops'. Francis Bacon, a blacksmith who died in 1700, kept a livery cupboard, used for storing food rather than clothes, in his parlour. Stephen Apthorpe had 'in the parllor, two tabells, A Clock, Eight Kaine Chaiers, two plaine Chaiers, bellowes, Gratt and other fier Iorns, Candelstick and warming pan' in 1720, which is what you would expect a retired well-to-do gentleman to have in his parlour. What you would not expect – or at least, what I didn't expect – was that parlours would continue to be used for their old-fashioned purpose as downstairs bedrooms, but the inventories provide ample evidence that they were. Richard Collins had for instance:

> in the parlor 2 Bedsteads, 2 featherbeads, 2 feather bolsters With Curtaines and vallants and Ruggs and other things there unto belonging; and 2 tables and 3 Turky Worke Cheares With other things.

Turkey Work was a kind of woollen upholstery made on a loom in imitation of a Turkish carpet, while rugs were usually kept on the bed for additional warmth. The same inventory tells us that Collins' cellar contained '4 hogsheads emty and on full on'. Since a hogshead was a barrel holding six gallons of beer, it's not difficult to guess that Richard Collins was an innkeeper. He owned

The Rose and Crown in Dutter End, and the building is still there, much altered, today. The brew-house, which in 1692 contained 'a Brass Copper and a Mashinge fatt and all other Brueing vessels', is now a garage. The gatehouse with its 'little Lodging Roome' nearby has long since vanished. The practice of keeping beds in the parlour continued well into the eighteenth century. The very last inventory, from 1781, has 'in the parler 1 Bed, Six Cheares', indicating how conservative even a man like Thomas Main, worth almost £350, could be.

Some of the larger homes also had cellars, all used for storage. The mason John Dale kept 'Two Kilderkins of Ale, 1 Kilderkin Empty & 2 Tubbs' in his in 1701, but this was nothing compared to Thomas Paine in 1708, whose cellar contained among other items:

Two hogsheads 1 Full of Beer
Six hogsheads & Eight halfe hogsheads
One halfe hogshead with sum beer in itt
Three Barrels
One Wooden funnel, one tinn funell
Twelve Dozen of glass Bottels
One Quart pott and three Mugs

There was a good reason for all this: Paine was a victualler. He had a 'Bottelhouse' in his yard, presumably some kind of building where bottles were stored.

One other downstairs room deserves mention: the kitchen. The rickety lean-to of earlier times had developed into the more familiar farmhouse kitchen, an integral part of the structure of a house. Perhaps you ought not to know that Clement Sell kept his pewter chamberpot in his kitchen, but the two flitches of bacon hanging in Robert Adams's kitchen was a sight that would have greeted a visitor in most country kitchens until fairly recently. I was tickled but not surprised to learn that Francis Bacon indeed had a flitch of bacon in his. John Webb (yeoman) kept his clock among the fire-irons, pewter dishes, bellows and the obligatory other lumber of his kitchen in 1712. There was no space for a clock in Nicholas Brotherton's since it was already overflowing with

One Jack and three Spitts, two Dripin pans
Hand-irons and fire Shovll and tongs, and the back-iron; and pott hoockes, six Peuter Dishes and one flagon and other small peuter
two boylers, four kettles and two skilets; one table and form, six Chairs and other small things

To a Stuart or a Georgian housewife this equipment meant work, and hard drudgery at that. Preparing food involved huge effort, much of it about the

fireplace. Most houses had a large cooking pot hung over the fire by a hook and chain known as a pot-hook, or from a pothanger suspended from an iron bar fixed in the chimney. Long-handled skillets or posnets (early saucepans) had short legs to enable them to stand in the embers. Kettles were smaller pots that could hang on a pot-hook above the heat of the fire.

Meat was roasted on a spit supported by andirons or cobirons. The spit was turned by hand or by a mechanical device called a jack, which used a system of weights and gears to turn it automatically, an invention Mrs Brotherton and many other women must have welcomed. A dripping pan was placed beneath the spit to catch the juices falling from the meat as it cooked. It was as unthinkable then to throw away dripping as it is nowadays to consume it.

Nearly every inventory lists some or all of the other essential equipment associated with the hearth: bellows, fire shovels, tongs, gridirons, frying pans, pokers and the iron fire-back (Brotherton's 'back-iron') which stood behind the fire to prevent the back of the fireplace getting too hot, and which was sometimes embellished with the royal coat of arms. The food so laboriously prepared was served on the ubiquitous pewter plates and dishes and usually eaten in the kitchen, since most of them contained a table and chairs for the purpose.

Most of the larger houses brewed their own ale or beer, and this too was often the housewife's responsibility. The place where the brewing was done was confusingly called the buttery. The blacksmith Francis Bacon had 'three Barrills, two drink stalls' in his, so while he was working up a thirst at his forge his wife was engaged in providing him with the means to quench it.

The dairy features even more often than the buttery. Nicholas Brotherton's wife must frequently have busied herself with her 'Cheespress and cheese Tube and one churm and other milk vesells', producing cheese and butter for household use as women like her had done in the village for hundreds of years. Lawrence Mead's yard contained an outbuilding described as a 'Slap house'. There's no recorded use of slap-house so far as I can discover, but slip was curdled milk, so perhaps Mead's slap-house was a slip-house and used for the preparation of dairy products.

Although most of the agriculture in the village was arable, nearly everyone kept at least a cow or two for milking. One exception was the widow Ann Squire, who died in 1714 at Woodbury where the lush green meadows were ideally suited to dairy farming. She maintained a large herd of cows and the milk they supplied appears in the form of cheeses stacked on the shelves in her two cheese chambers. The appraisers noted thirty old cheeses stored alongside no less than 340 new cheeses ripening on the shelves, most of which would have ended up at local markets or fairs. Her total worth was reckoned at £437, making Widow Squire by far the richest village woman to leave an inventory.

Most housewives would have baked, although the bakehouse as a separate room does not appear very often. When it does it typically contains the 'one

Copper, one frying Pan, one dough stand, 5 Tubs, 5 Brass kettles, one Boyler' noted in John Basse's inventory.

After listing the items of interest to be seen downstairs, the appraisers usually take you upstairs and into the bedrooms. Most of them were bedrooms, too, despite being called anything but – 'chamber over the hall', or 'parlour chamber' or 'chamber over the kitchen', never just a straightforward 'bedroom', a word that in its modern meaning is first recorded in 1616 and did not come into widespread use for another century or more. Even if they didn't think of them as bedrooms, the majority of folk now had beds upstairs. This is what was in Lawrence Mead's hall chamber:

> Bedstead, feather bed, Curtains and other appurtenances.
> Chest of drawers, looking glass, a Great chest, hutch, hanging press, nest of drawers, close stool, five chairs, Truckle bed, flock and other appurtenances
> Twenty pair of sheets, five large table cloths, a dozen of napkins, ten pair of pillowbers and five Towells,

The curtains are of the type drawn around four-poster beds and not window curtains, which are specifically singled out in only three inventories. The close-stool was a descendant of the Tudor 'chair of easement' – a commode. Most villagers still used chamberpots, but the '6 Chamber Potts, Earthen' in John Dale's bedroom seem a trifle excessive. He also had a 'Looking glass, small', which were becoming fashionable items of furniture. Henry Sell kept his gun alongside his bed in 1666. Many villagers must have owned a firearm, particularly farmers like Henry Sell, if only for taking potshots at rabbits and birds, but this is the sole reference to one in all the Gamlingay inventories.

Where servants had their own bedroom, it normally had little in it beyond the 'One old Servants Bed' of John Careless in 1743 (was it the servant or the bed that was old?), or the feather bed and two coffers that John Basse allowed in his servant's room. Servants were there to work, not to laze around in comfortable beds. Mind you, Basse could well afford a 'Maid's Chamber' and the maid who slept in it. His is the only inventory to mention jewellery – three gold rings kept in a 'Chester drawers' along with three silver spoons. Only two other people had any silver: William Jeakins had a silver can and John Overall four silver spoons.

Beds are not usually described in any great detail, and other bed furniture is dealt with equally tersely, like Henry Sell's 'one boured bed and an old Joyne bed'. Samuel Lewis was sleeping on 'one straw bedd' in 1726. Compared to him, Thomas Cawthorne lay in the very lap of luxury on a bed with a 'Top peice & head Peice & Coard & Curttin Rods' worth seven shillings in the opinion of his appraisers. One desirable piece of equipment in the days before hot-water bottles and electric blankets was a warming-pan, and they find

their way into the inventories as often as they must have been inserted in their owners' beds on cold evenings.

Clothes, along with the household linen, were usually kept upstairs. John Basse had no less than forty pairs of sheets, forty-eight napkins, four table-cloths and twelve pillow-cases, quantities which reflect his wealth and status. Most of this linen was woven by the village weavers from yarn, which in turn was spun from the flax grown in the village. There is mention of a field called Flexforlong in a thirteenth century charter, so they were following a long tradition. The many sheep in the parish provided wool, which again had to be spun before it could be woven and several inventories do in fact mention spinning wheels.

Upstairs rooms had other uses. Most of the larger farmhouses had a cheese chamber, containing, like John Webb's in 1712, 'some Shelves and about seventy Cheeses'. Nicholas Apthorpe stored his apples and cheese in the same room. The smell wafting through the house must have been mouthwatering, in contrast to the more eye-watering aromas of most village homes. One of William Jeakins's upstairs rooms was home to '11 quarters Malt & skreen, 1 bushel & 3 shovills'. He was a maltster, and the screen and shovels were part of his equipment for making malt from barley. The strain on the floorboards from all that malt was immense. A quarter of malt weighed 336 pounds, so Jeakins had nearly one and three quarter tons of the stuff in his malt chamber. The bedroom floorboards of old houses sometimes contain their own evidence of their earlier use, if you care to look: there's often chaff, apple pips and so forth lying between and beneath the boards.

After finishing in the house, the appraisers took their pens, ink and paper into the yard and outbuildings. Tools, implements and stock of various trades often appear in the inventories at this point. The appraisers could hardly have avoided the 'Ten thousand of bricks' or the mound of 'Brick earth dugg' they found in the yard of Nicholas Fickis, described as a bricklayer but who must have made his own bricks too. Robert Wallis had made his living as a cutler, and his stock was listed in 1685:

In the shopp:
5 dozen of sissers & 6 Rasors
one dozen of Spurrs & 10 Sythes
about 30 dozen of knives
with other small ware belonging to his Trade
£10 10s 0d

Thomas Cawthorne, whose inventory has already been widely quoted in this chapter, obviously used his 'Pare of Stillyards' and his 'Pare of Scales & Leaden waits' in his stated trade of hempdresser. Three men earned their living as shoemakers. This is the working stock of one of them – James Meeks, in 1752:

Upstairs.
Twelve small Calf skinns, Two and Twenty Larger Calf Skinns, five
Hydes, six Brooken Hydes and Old Pieces, £16 5s 0d

in the Shop.
A parcel of Nails, 7s 6d
Three Sides of Back Leather, £2 10s 0d
A Pair of Boot trees, Three seats, A dozen of Lasts and other Lumber,
15s
Book debts, £3 10s 0d

Book debts and other debts often account for a hefty slice of a man's total
wealth, especially a tradesman. Thomas Clarke, a tailor, was owed £25 at
his death in 1691, which was almost exactly half his total worth. The baker
John Parsons was due £60 out of just over £73 his appraisers thought he was
worth. Thomas Handley, a carpenter, was owed the astonishing sum of £150
out of a grand total of £168 11s 6d. These large debts are almost certainly due
to the common practice among tradesmen of only sending in their accounts
once a year.

Sometimes, when a man had retired from his working life, he lent out his
capital and lived on the interest – the very definition of a gentleman. Stephen
Apthorpe 'Gentt' had £440 out on loan. Private lending was just about the
only way anyone could borrow money before the rise of the country banks.
Even Clement Sell, 'singleman', whose belongings were worth a mere £6 or
so, had £65 'out upon bond'. Lending money and living on all or part of the
interest was not confined to men. The widow Ann Charnock was worth almost
£74, but of this £50 was 'In Bills and Bonds And Debts Good and badd'.

The equipment and implements listed in the barns reveals little that is new.
Although in general agriculture was much the same as it had been in the middle
ages, with basically the same crops being grown and the same livestock kept,
new ideas and improvements were gradually filtering through to ordinary
villagers. Oxen had disappeared from farms and horses were used instead to
pull the lighter ploughs now in use. Existing breeds of cattle and sheep were
improved, and new ones imported from abroad.

Evidence is hard to find because most livestock is simply described
generically, but John Knight, a thatcher who died in 1748, had in his yard 'a
Cow & Calf, a Guesi Cow, a Pigg'. Prized for their rich and creamy milk, Jersey
cows (sometimes confusingly called Alderneys) were beginning to be imported
into mainland Britain from the early eighteenth century, and the sight of one
in Gamlingay was sufficiently unusual for Knight's appraisers to single it out
for special mention, even if spelling it correctly was beyond them. Curiously,
only two inventories list what must have been a common item in most village
homes, particularly those with livestock out in the yard – a lantern.

All but four of the inventories have legible totals. The richest man in the village by far was Nicholas Apthorpe, whose goods and chattels were valued at a few shillings under £814 in 1711. He was worth a hundred times more than the poorest man to leave an inventory, a labourer called Henry Barnes, worth just £8 6s 0d when he died in 1722. The next wealthiest man was John Basse, valued at £512. The average value of the seventy-one inventories is £131. Samuel Lewis, living in a one-up, one-down cottage and sleeping on a straw bed, had worldly goods valued at just £3 16s 0d, discounting the debts of £35 owing to him, but even he was not poor. The real poor did not make wills or have inventories made.

Nicholas Apthorpe may have been the wealthiest villager of his era, but there were many other Apthorpes in the village before and after him. They represent an example of a common feature of village history, that of one family dominating affairs for a century or two before dying out or moving away.

The Apthorpes may be descended from the Aythorpes who were regularly brought before the manor court in the late fifteenth century. One of them, William, was fined for brawling shortly before being elected constable, which may make him the first in the long line of Apthorpe officials. Alternatively the line may come from John Apthorpe of Waresley, who died in 1556 leaving a large family of young children. They may all have been related – it's impossible to tell. I know, because I've tried.

Apthorpes were active in Gamlingay for about 300 years, but for most of the sixteenth century they had to be content to play second fiddle to the Russells, Ratfords, Webbs, Bestowes and Basses who between them made up the village elite. Then, around the turn of the century, the Apthorpes emerge as the leading village family, with a finger in just about every important village pie. They were also the largest, related by blood or marriage to virtually every other family in the village.

The seventeenth century saw the Apthorpes reach the zenith of their power and influence. Before their decline and eventual disappearance in the eighteenth century there were few (if any) village assets which did not pass through their hands: land, shops, inns, mills, malthouses, the larger houses and so on all became a part of the Apthorpe empire. The family were also inveterate office-holders. It was a rare year when there were no Apthorpe churchwardens, Apthorpe constables or Apthorpe overseers busying themselves with parish affairs.

Their influence spread far and wide. There were simply so many of them. Between 1606 and 1749, there were at least seventy-eight Apthorpes born in Gamlingay – probably many more, but the records are incomplete. On one happy occasion an Apthorpe married another Apthorpe. Many of the male Apthorpes were given the same Christian name – Stephen – which is fair enough. Lots of Basses were named John, and there were several Thomas Ratfords. But there were at least a dozen Stephen Apthorpes active in

seventeenth-century Gamlingay, which causes a certain amount of confusion, especially for anyone trying to sort out their family tree.

Heaven knows what confusion it caused at the time. There was only one East Apthorpe, though, an instance of the common practice of using a mother's maiden surname as a Christian name. With so many Stephen Apthorpes around, most of them needed epithets to sort out one from another. There was a Stephen Senior and a Stephen Junior, Stephen the Elder and Stephen the Younger. There were Innkeeper and Shopkeeper Stephens, Farmer, Yeoman and Dissenter Stephens, a Stephen gent and a Stephen 'of Brook End', although how you knew when a Junior became a Senior, a Younger an Elder or a Yeoman a Gentleman is beyond me.

There was even a Grocer Stephen, who was one of only two people in the village ever to have their own coins made. To be accurate they were trade tokens, used during periods when small change was in short supply and exchangeable only in Grocer Stephen's shop. He had three issues minted, in 1657, 1659 and 1666, all worth a farthing and all bearing the legend Stephen Apthorpe of Gamlingay (or Gamlingham, or Gamlingam). The only other person to have tokens made was Joseph Harvey, also a grocer, whose own tokens appeared in 1667. Occasional examples of these tokens still turn up today in village gardens or in coin-dealers' catalogues.

Eventually, the Apthorpes' power waned. One branch of the family sprang up in Potton. Another migrated to Cambridge. Other branches withered and died or else moved farther afield. In 1699, Merton manor court could still muster three Stephen Apthorpes but one was 'of Gransden', a sign of things to come. The last Apthorpe to be buried in the village was Mrs Katherine Apthorpe in 1783, after a long and fruitful life during which she gave birth to twelve children.

When the Reverend William Cole, who was related to the family, visited the church in the mid-eighteenth century he found several inscriptions to departed Apthorpes which reveal a darker side to at least some of the family. Cole said he could 'make neither Head nor Tail' of one erected by Eleanor Apthorpe to her son Nicholas, who died in Bethlehem Hospital, popularly known as Bedlam, in London in 1730. The inscription is difficult to comprehend, not helped by the use of words like 'Propagandifidy', whatever that means, but 'lost his Wits' is plain enough. Cole also quotes this inscription, on her daughter's gravestone:

Here lyeth Rebecca Apthorp, Daughter of Nicholas Apthorp, died Octob:
22 1741, aged 27 yrs.
Here lies the virtuous pious Maid,
Who thought herself in Love betray'd;
Her carnal Mind was first so odd,
She fear'd thereby displeased God;

Submitted under Pennance Rod,
Beyond its Rules for want of Sence,
Abstained, starv'd herself, from hence.
A Church of England Member died,
On Christ her Saviour she relied.
Her Soul does now with Angels fix,
With interferring Kisses mix,
In greater Pomp than Coach and Six.
No room for Mother's Tears below,
Who's sure to meet when Trump does blow.

Eleanor Apthorpe was described by Cole as 'a Roman Catholic and a little out of the way', yet she said her daughter died a member of the Church of England. Was there some argument over religion between mother and daughter? Or did poor Rebecca, starving herself to death, suffer from *anorexia nervosa* as a result of an unhappy love affair? Was she, like her brother, a victim of this branch of the family's mental instability? Rebecca's will, short though it is, hints at a falling-out with her siblings, because she leaves them just a shilling each. As we have seen, this was the traditional way to express disapproval – the testamentary equivalent of putting up two fingers.

By chance, a letter survives from Eleanor Apthorpe, written in September 1745 from Gamlingay to her friend Mary Edwards, residing at Bow Church Yard in London, which does lend some credence to William Cole's notion that she was, perhaps, a penny short of a shilling. The letter is rather muddled, as if her thoughts were galloping ahead of her pen, and it is difficult to make sense of it, except when she writes in her bold, rather childish hand of her concern about the threat of a French attack on London in support of Bonny Prince Charlie's rebellion in Scotland.

many a tru word spoke in a jest. I little thought of ye french coming when I joakt with cosin great nose. I am so sencible of the tim[e]s coming of Blocking up and fierying and that the Blud of the Ritious being spilt in that great town; blud is Requerd ... thay that think London safest I dowbght will find them selves mistaken when to late; there it will End and you will be safe.

She adds a postscript saying that 'pegy [her daughter Margaret] sends her duty to you; my servis to mrs pain; I drink both your hea[l]ths in her pott'. Presumably Mrs Paine had given her a teapot, because she adds plaintively 'my tea shuge [sugar] is don'. Characteristically, she advises her to 'furnish your closit with lanscuwers gifts'. She may have written 'lanscurvers', but neither version makes any sense, so perhaps it's another invented word like her 'Propagandifidy'.

I have been unable to discover whether Edward Apthorpe was one of Eleanor's children, but he was another of the Apthorpes to suffer from mental illness, as illustrated by these references from the overseers' accounts.

1729
Spent when I mett about Ed. Apthorp, 3s 6d.

1730
to John Parson for Ed. Apthorpe, 14s 6d.
to Richard Richardson for Looking after Ned Apthorp, 9s.
to Rich. Richardson on Edward Apthorp account £1 17s 2d.
Spent when we mett about Edward Apthorp to gett him a way, 2s.

1731
paid at Jarg [George] Parson for Bear when the sertifecate was Handed and for Returning Letter on Ed Apthorp Account, 5s.
to Richard Richardson for Edward Apthorp Chargis att London, £2 2s 0d.
to John Parson 143 Loafes Ned Apthorp, 3s 6d.
& 28 qts [quarts] of Bear, 1s 2d.

1732
Sent to London for the use of Ed Apthorp In Cash, £3 0s 0d.

Richard Richardson was innkeeper at The Castle, and Edward Apthorpe obviously lodged with him at least some of the time. The overseers occasionally gave Edward Apthorpe small amounts of cash, bought him shoes, stockings and shirts, and twice purchased half a pound of nails for him, even, on nine separate occasions in September 1730, buying him a large round cheese to eat. There can be little doubt that when he was sent to London, it was to be taken to Bedlam. The last entries concerning this tortured man come from the parish register, which duly records that on 12 January 1734 they laid to rest Edward Apthorpe, 'lunatick', and from the overseers, who paid out two shillings at his burial for the mourner's refreshments.

But the Apthorpes deserve to be remembered for more than the madness which afflicted a few of them. To redress the balance, the Reverend Cole also noted this inscription to Thomas Apthorpe, a London glass-seller who lived to the age of 68 and was buried in Gamlingay. He, it said, 'lived beloved & died lamented', and that's as fine an epitaph as anyone could wish for. The Apthorpes were a vigorous family who in one way or another contributed enormously to the village. I'm glad to say they are still going strong today, with their own Apthorp(e) Society to record the family's history. Their ancestors will make many more appearances in this book before they eventually fade out of sight.

SIR GEORGE AND THE DRAGON

Merton's role as lord of the manor was effectively over by the end of the seventeenth century. The College still tried to behave as though nothing had changed, but its inconsequential efforts at trying to influence village affairs through the manor courts proved the opposite was true.

The court records begin again in 1675, but they are very different from the earlier ones. I recommend them if you fancy some exceptionally dull reading. That of 1675 is a case in point, repeating the lengthy village by-laws as if the court could bore the villagers into obeying them. Usually the rolls confined themselves to lists of land and house transfers, information I need to know, but fortunately you do not. Occasionally the court shook itself like an old dog and barked.

> wee present Thomas Tomlin for breaking open the pound & takeing out 2 horses, & amerce him 3s 4d.
> wee present Francis Bacon, Thomas Heywood, John Basse, William Lune & Robert Webb for not scouring the ditch at the end of each of their closes next great heath; & wee give them time to scoure it till the 28th of November next upon paine of 3s 4d.
> wee present Thomas Witt for digging & carryeing sande from little Heath, & allso wee present him for carryeinge turves from Great Heath, & amerce him 6s 8d.

The court's bark was worse than its bite, but nobody could say that it didn't try to maintain manorial discipline. On the other hand, nobody could say it succeeded.

The College had long exercised its own ancient and well-defined right to levy a toll when droves of cattle on their way to market passed through the village.

we present that May the wife of George Fisher hath severall times since the last Court stood in the felds & in other places in the comon feilds within this Mannor & hath received toll for severall droves of catle which have passed through the comon, which is an incroachment upon the Lord of this Mannor, & therefore she is amerced 3s 4d.

So much for manorial authority. May Fisher must have been a formidable lady to force the tough old drovers to pay up. You may be sure she did not hand over the fine: people with that sort of cheek were not going to be intimidated by any punishment dished out by a manor court. And although I can't prove any link between her and those fifteenth-century Fishers, it's odd how anyone called Fisher usually meant trouble for the court.

These threats and fines were not quite the last kick of a dying institution. At the turn of the eighteenth century the court baron of Merton fined a grand total of eighteen people for various offences, but the three-and-fourpences remained unpaid and the College seems finally to have accepted its impotence. The courts became purely administrative, collecting rents and admission fines while leaving control of village affairs to others. The courts continued to sit, however. It was well into the twentieth century before Parliament finally got around to bringing a formal end to manor courts, lords of the manor and nearly 1,000 years of history. And with the College's realisation that economic and social changes have sidelined their authority, our interest in their business comes to an end.

Now let's leapfrog back to 1600, and Woodbury manor. We left it in the hands of John Manchell of Hackney, and he left it – heavily mortgaged – to his grandson John. Sometime before 1640 Sir John Jacob bought it. Although based in London, the Jacob family had had connections with Gamlingay for many years and Sir John himself had been baptised in the village in 1597. The family wealth came not from farming the green pastures of Woodbury but from farming the nation's customs. Soon after purchasing Woodbury, Sir John was obliged to mortgage the estate to his brother Robert to raise money for Charles I to fight the Civil War. Judging by his rather glum-looking portrait he was not best pleased by this turn of events, his saggy face bearing an uncanny resemblance to a eunuch's scrotum.

Sir John's finances improved a little after the Restoration, and in 1665 he finally put an end to all the wrangling and jerry-building that had bedevilled earlier attempts to build an almshouse by paying for a fine terrace of ten tenements on a site in Church Street given by his father Abraham Jacob in 1628. A tablet was placed in the centre of the row commemorating Sir John's generosity. The Reverend William Cole, who visited the parish a hundred years after they were built, said 'about a Furlong from the Church stands a very handsome Range of Alms Houses of brick, very regular & of two Stories, with an high Wall before them', a description that, like the almshouses, still stands today.

By the time the almshouses had welcomed their first occupants Sir John was nearing his end. He died in 1666 and was succeeded by his son, another Sir John. A rental, one of the few documents from Woodbury to survive, gives us a rare glimpse of the estate in 1672. The house, farms and land were all leased for around £500 a year, with a further £124 coming from several houses and land in Gamlingay 'lett to severall townes men, I thinke', as the anonymous writer puts it, his hesitation being an allusion to the financial mess left by previous owners. He went on:

> There is a parke, well stored with deare, wherof the land & timber is worth about £3,300, but is seazed uppon by one Hancock, a Creditor of Sir John Jacobs, & I know not who hath power to sell it, but it lyes within two or three fliteshots of the mantion house ...

The manor could be let for £600 a year, said the writer, 'if troubles were not uppon the land', and added that 'a little before Christmas last Sir John Jacob was offered for it £10,000 ... but the stoppage in the Exchequer hindred the purchasers proceedings'. The phrase 'stoppage in the Exchequer' is a polite reference to the bankruptcy of the state itself. The Jacobs' finances were not the only ones in a mess.

Shortly after this rental was made, the estate was finally sold. The purchaser was William Mainstone, an East India merchant, from whom it passed to his nephew, who sold it to Ralph Lane in 1696. The estate was groaning under the weight of heavy debts. Lane was a merchant who traded with Turkey, but he didn't buy the whole estate. The northern section was sold off separately, causing the isolation of the original manor house. When Lane died, the failure of male heirs meant that the estate followed his eldest daughter into the welcoming arms of George, Earl of Macclesfield, and his family. And that's where we'll leave them both for the time being.

With nothing to say for itself for hundreds of years, the Shackledon estate now steps forward to take centre stage. The Burgoynes who had it in 1600 eventually sold it to Sir George Downing. Born in Ireland and raised in Massachusetts, Downing was one of the most influential men in mid-seventeenth-century England, reputedly the richest and also the meanest man in the country. He managed the difficult feat of serving both Cromwell and Charles II, successfully enriching himself at their expense with a laudable lack of bias. Downing Street in London takes its name from his property there, but his country seat was at East Hatley, adjoining Hatley St George.

Perhaps his greatest service to posterity was to employ Samuel Pepys at the beginning of his career. The great diarist found Downing a 'niggardly fellow' and a 'mighty talker', and tells several amusing stories at Downing's expense. Although he respected Downing's capacity for business, Pepys never liked him. To be absolutely fair to both Pepys and Downing, neither did anyone

else. Downing, who was when all is said and done a nasty piece of work, couldn't have cared less. He invested some of his vast wealth by purchasing large swathes of land in west Cambridgeshire, including the Shackledon estate in Gamlingay. When he died his immense fortune was inherited by his son, also named George, who chose to spend most of his time at East Hatley with his wife, Lady Katherine.

How can I describe the second Sir George? Energetic, humane and charming – these are just three of the words I wouldn't use to describe him. One historian dismissed Sir George as being 'of no note', and that was being kind. Someone else said more accurately he was 'of unsound mind'. His only contribution to this story is recorded in the parish registers:

Christenings:
October 24th 1685: George, son of Sir George & Lady Katherine, born October 22nd.

This infant, the third George Downing, was destined to grow up with few if any memories of his mother, since she died when he was but three years old. Rumour had it that her husband's ill-treatment killed her.

His rich but idle nonentity of a father lived on in the house at East Hatley with a woman named Priscilla Payne, by whom he had a son. It was thought prudent to remove young George, the legitimate heir to the Downing fortune, from the vicinity of his unstable parent and he was sent to live with his maternal aunt at Dothill Park in Shropshire. This turned out to be not such a great idea after all. His aunt and uncle, Lady Forester and Sir William Forester, saw him not so much as a boy who needed some normality in his life, more as a golden opportunity to enrich their family fortunes.

In 1700, when George was fifteen, they had him secretly married to their thirteen-year-old daughter Mary and effectively ruined both their young lives. Although each was over the age of consent (at that time fourteen for a boy and twelve for a girl), it was such an outrageous example of fortune-hunting that the match had to be kept secret or it might have been annulled on the grounds that the couple were victims of a conspiracy. The marriage was not consummated, although the youngsters were made to lie together in bed in public for an hour after the wedding as a token of consummation. Almost immediately George was sent away, probably to school, and then on a Grand Tour of the continent.

He remained abroad for three years. His wife Mary, meanwhile, grew into a beautiful and vivacious young woman. Her husband became aware that she might be summoned to the Court of Queen Anne as a Maid of Honour, and made it clear he didn't want her to accept the invitation. When he learned that she had indeed gone to the Court, he wrote to her. He said he'd imagined her still at home in Shropshire while he travelled round Europe; instead, he

discovered she was now 'blazing as a star of the first rank in the fashionable splendour of Court'. There is an apocryphal story that on his return to England George Downing saw Mary Forester waiting on the Queen, but didn't recognise her. Taken by her beauty he asked who she was, to be told to his surprise that she was his wife.

Downing went off on his travels again, not returning for good until 1709. He refused to live with or even acknowledge the wife arranged for him by his greedy aunt and uncle. Mary considered herself to be a single woman. The writer Jonathan Swift met her in the summer of 1711 during a visit to Windsor, and he too was confused about her marital status, referring to her as Miss Forester on one occasion and Mrs Forester on another, although he had no doubts about his own feelings towards her: 'she is', he wrote, 'a silly true maid of honour, and I did not like her, although she be a toast, and was dressed like a man.' I hasten to add this was the fashion at the time.

Nevertheless, she had many admirers at Court and would undoubtedly have married but for the inconvenient fact that she already had a husband. Eventually, in 1715, she petitioned the House of Lords for a divorce (which required an Act of Parliament) on the grounds of the respective age of the partners at marriage. She had never, she said, taken the name Downing, and because such 'Disgusts and Aversions' had arisen between them there was no possibility they would, as it was delicately phrased, 'perfect the said Marriage Contract'. Downing supported the petition, saying he'd never acknowledged her as his wife, but despite his support the attempt failed by forty-nine votes to forty-seven. From then on, the pair lived separate lives.

Mary was doomed to maidenhood after the failure of the divorce and spent most of her time at Court, until at the age of forty she was pensioned off and given a house at Hampton Court. A later portrait of her shows her still to be a beautiful woman, smooth-skinned with dark, sad eyes, rosebud lips and a slightly bulbous nose. She lived as a maiden aunt, and although it's said Sir George was a frequent visitor during her retirement she had no wish to see him, and endured his unwanted visits until her death in 1734 relieved her of the necessity.

On his return from his travels, Downing had become the MP for Dunwich in Suffolk. A year later, in 1711, his father died and he inherited both the title and the estates, amounting to almost 7,000 acres. Rich enough to indulge his every fancy, what the third Sir George Downing fancied was to have the old ramshackle family mansion in East Hatley flattened and a larger, modern one built on the Shackledon estate in Gamlingay. For all their wealth, the Downings were always a penny-pinching lot, and the grandly-titled Gamlingay Park was built in part with material carted over from the demolished house in East Hatley. Even so, Gamlingay Park cost Downing the small matter of £9,000. To put that sum into perspective, at the same time as the army of craftsmen were building his dream home, dozens of his new neighbours were existing on two shillings a week handed out to them by the overseers of the poor.

What Downing got for his money was the most imposing building the village had ever seen. Built in the rather plain but nonetheless elegant Queen Anne style, the plan of the house was in the shape of an 'E' without the centre bar. The three-storeyed main block faced south towards the Everton Road. The two end wings were of single storeys. In front of the house, between the wings, was a gravelled courtyard with a circular lawn in the middle.

A small vignette preserved in Downing College gives the impression that the house consisted mainly of windows – twenty-seven on the frontage of the main building alone, and sixty-eight in all. The rooms facing south would have been flooded with light. In summer it must have been like living in a greenhouse, and in winter impossible to keep warm, which explains the twelve fireplaces in the main house, one of stone and the others of fine marble. When the sun shone, the glittering reflections from the multitude of windows would have dazzled anyone passing by.

I can't tell you how the house was furnished because no record exists, but there's plenty of information about the building itself. Visitors to Gamlingay Park stepped down from their coach and on to the gravel in front of the door. Once inside the house, they paused to admire the grand entrance hall. The floor was paved with stone decorated with black dots; around the hall were columns with carved capitals, and in front of them was a magnificent staircase with a handrail, carved banisters and brackets. Sir George's guests were shown into the drawing room where they could admire the wainscotting made of deal and Norway oak with elaborate cornices and mouldings, the marble chimneypiece and yet more columns and capitals. From there they were directed into the long gallery in the west wing, where they might use the privy if their journey had been a long one, and in winter warm themselves at any of the eight fireplaces the wing boasted.

The visitors' coach and horses would have been taken to the east wing, which housed stables and a coach house, plus a brewhouse and presumably the servants required to run such a large establishment. Tucked away out of sight, on the other side of the east wing, were the other estate buildings, a house for the gardener and what's described as a 'Cold Bath Building', although it's difficult to imagine a naked and rather plump Sir George ever taking a cold dip in it.

After admiring the house and Sir George's good taste (influenced, no doubt, by his travels around Europe), visitors would have been taken on a tour of the Park and gardens, which were laid out in equally magnificent style. Behind the house were a series of terraces which led down to a stream. Its water fed a large lake edged with apple trees, and the series of fishponds that so fascinated me when I was young. Much of the rest of the Park was wooded, dotted with small ponds and criss-crossed with straight paths. At the end of each path Sir George had placed an obelisk or a pyramid, or a piece of statuary in Classical style for his visitors to admire.

At the northernmost edge of the Park he had a 25-feet-high gate erected in red brick, known as the Full Moon Gate, and a smaller one nearby, known as the Half Moon Gate, for reasons known only to himself. What survives are a couple of piers on each side of the bottom half of what was once a large 'O' made of brick. I suppose every village child over the last two centuries has made a point of climbing the remains. Unusable as gates when they were built, they were probably Sir George's version of the English gentleman's folly. Neither did he neglect to build that other prerequisite of a country house garden – a maze. Downing's was actually rather a good one, enclosed in a 10-feet-high brick wall with the paths set between 10-feet-high hornbeam hedges.

The Park was described by Edmund Carter in his *History of Cambridgeshire*, published in 1753. Carter said it was 'the most agreeable and pleasant situation in all this country, having every beauty that nature can afford, nor hath art been wanting to complete it'. William Cole simply said that Downing had built 'a most elegant House'.

Despite living in splendour and comfort, I don't think the last Sir George was a happy man. It would have taken someone with a strong inner drive and an energetic nature to rise above the early loss of his mother, a disturbed father, a difficult childhood and a disastrous forced marriage. One look at his portrait miniature tells you Sir George was not that man. He stares out from it with large protuberant eyes under dark arched eyebrows. Beneath the fashionable shoulder-length wig his face is soft, his nose long and straight, his mouth small and rather feminine. He looks well-fed and slightly fleshy, with small rolls of fat beginning to appear beneath his chin. The stock around his neck and the striped coat he wears gives him a rather dandified appearance, but this is offset by the way his lips are pursed and the suspicious look he gives us. This is a rich man, a man used to deference, but also a weak and indolent one. He may have been wealthy beyond the dreams of most men of his time, but his portrait suggests he was essentially an unhappy man.

For the people of Gamlingay, this was the first time for centuries that someone of social standing and importance was living among them. One of them soon discovered the hard way just what that could mean. Shortly after Gamlingay Park was built, Edward Haylock was hauled before the Cambridge Quarter Sessions in January 1713

for speaking [and] reflecting unmannerly words of her Majesties justices of the peace for this County, and particularly of Sir George Downing, Baronet. And having upon his Appearance here this day in open Court submissively begged pardon upon his knees for his said offence, This Court doth therefore order that the said Edward Haylock be discharged.

Haylock's grovelling apology served notice that the rest of the village, free for so long from the presence of a resident squire, now had to swallow its pride and realise that a man like Downing demanded the respect and submission due his rank. It would be unfair to lay too much blame on Downing. He was only asking for the same deference that every other man of wealth and position expected as his right. 'God bless the squire and his relations, and keep us in our proper stations' was an attitude that most people, rich and poor, considered to be a fundamental fact of life.

Fortunately for any villagers who didn't subscribe to this view, Downing was away in London when Parliament was sitting and spent part of the summer months at his house in Dunwich. But beyond the obvious attractions of his house and Park in Gamlingay, there was another, less obvious attraction to draw him back there.

Mary Townsend began as a kitchen maid in the Downing home at East Hatley, but when the new house was built she moved there with her master. Mary was promoted to housekeeper and helped to run the estate, which may have been due to her administrative skills but probably had more to with the fact that around 1718 she became Downing's mistress. She was not the first servant to use her sexual charms for her own advantage, and Downing was not the first country gentleman to fall for them. Nor was he the first or last to father a bastard on a female employee. The birth of the couple's daughter Elizabeth in 1722 cemented the relationship. When Elizabeth was five or six years old Downing added a codicil to his will, giving her a £500 life annuity and one of £250 to her mother.

Mary Townsend lived on as housekeeper at Gamlingay Park, and presumably continued to share Sir George's bed. As time went on Sir George's character altered, and the traits inherited from his father and grandfather became more prominent. The miserly streak in particular came to the fore and Downing gradually lost all interest in maintaining his affairs. He spent nothing on the upkeep of the houses and farm buildings on his estates, and it was reported he was losing £1,500 a year in west Cambridgeshire because his tenancies were not filled. William Cole described him as leading 'a most miserable, covetous and sordid existence', but to his credit Sir George did not neglect to provide for his daughter, giving Mary Townsend sums of cash for Elizabeth's use, although how much of this was due to her mother's prompting is impossible to say.

Sir George stirred himself from his lassitude in 1744 to build another useless folly, this time a tower on his estate at Tadlow. One day, while watching it being built, someone attacked him, clouted him on the head with a hammer and took several potshots at him. When arrested, his assailant justified the attack by saying he didn't see anything wrong with killing someone 'who paid nobody and was so ill a landlord and paymaster with so great an estate'. The assault did Sir George no good. Already in poor health and suffering from the eighteenth-century gentleman's archetypal complaint of gout, he slowly declined.

Like all men of fortune, Sir George's first priority when he made his will was to perpetuate the family name. He could not leave his vast wealth to a legitimate heir. Instead, he left his estates and his title to his cousin Jacob Garrard Downing, along with the proviso that if Jacob died childless they would go to any one of three distant cousins. In the unlikely event that all four potential inheritors died without heirs, Sir George left instructions that his wealth was to be used to found a college in the Downing name in Cambridge. In doing so he had no thought that such a circumstance would ever come about; nor had he any discernible interest in education. The college was merely a convenient device to keep the Downing name alive.

Five years after the assault, Downing lay dying at Gamlingay Park. Mary Townsend sent a message to his heir in London, informing him of the state of Sir George's health. Jacob Downing did not immediately go to Gamlingay but sent his steward, Mr Wingfield, instead. Before Wingfield arrived, at ten o'clock in the evening of 9 June 1749, aged sixty-three, Sir George Downing breathed his last. There were only two people at his bedside – Mary Townsend and her daughter Elizabeth.

Mary Townsend had no time to lose. With Sir George now dead in his bed and Mr Wingfield on his way, she ransacked the house, trawling through drawers and turning out cupboards, searching for the cash she knew was hidden about the building. When she'd finished, Mary Townsend had unearthed £14,000 in cash and several thousand pounds in banknotes. Discussing with her daughter Elizabeth what to do with such a huge sum, she decided to say that £10,000 of it had been given to her by Sir George for the use of their daughter (as indeed it had), and pass the remaining £4,000 to her brother to bury in the garden.

When Wingfield arrived she duly admitted she had £10,000 in trust for her daughter, but kept quiet about the rest. Eventually, Sir Jacob (as he now was) turned up, but did not suspect Mary Townsend of any dishonesty. There were other things on his mind, including the burial of Sir George, which took place three weeks after his demise in the family vault in Croydon church.

Sir Jacob was now a considerable catch, and a year later he married. His bride was Margaret Price and the happy couple settled down to their new life at Gamlingay Park in the full expectation that she would provide him with an heir. Prior to Sir Jacob's wedding, Sir George's illegitimate daughter Elizabeth Townsend had married John Bagnall, and reputedly took her new husband to live at No. 10 Downing Street on the proceeds of the £500 annuity from her father, and the £10,000 her mother had from him on her behalf, which had been invested for her in the South Sea Company. If she did go to live at No. 10 Downing Street she was the first, and so far the last, Gamlingay-born resident to use that famous address on her notepaper. The story loses some of its gloss, however, because what is today No. 10 was actually No. 5 until the street was renumbered in 1779.

Her mother did not fare so well. Something or someone made Sir Jacob suspicious that Mary Townsend had not been telling the whole truth about the money she had found. The trusty Mr Wingfield made enquiries, and forced her to admit to the additional £4,000 that had been buried in the garden. By the time the matter reached the courts Mary herself was dead, and her heirs were ordered to give up the money.

Sir Jacob was a largely unremarkable man, but he did slowly put the estates back on their feet, presumably for the benefit of the children he assumed Lady Margaret would provide, and who would inherit them in due time. Sir Jacob was described in fulsome terms by Edmund Carter in his *History* as 'a gentleman devoted to make the neighbourhood happy, having a very generous soul, and an extensive fortune, and so many amiable qualities that few inherit; and who is now very busy in improving the house and park, and employing many of the poor, who before wanted work'. Either Sir Jacob was a paragon of virtue or Edmund Carter was flattering a potential purchaser of his book.

Sir Jacob made sure that nobody inherited his many amiable qualities by duly dying childless in 1763. A twist of fate had seen the other three possible inheritors of the title and the estates also contrive to die without heirs. What should have happened then was the founding of a college, but Sir Jacob, no doubt urged on by Lady Margaret and in brazen contravention of Sir George's will, had left everything he had to his widow.

Lady Downing was a formidable woman. One glance at *her* portrait tells you that in character she was everything Sir George never was. It shows her to be a plain, dark-haired, middle-aged woman, standing stiffly erect in an expensive dress and pearl choker, but it's the firm set of her mouth that is her dominant feature. She's a woman used to getting her own way. It's easy to imagine her sweeping grandly through the great house, with her long silk dress rustling behind her, running her fingers along the edges of the furniture before castigating the maids for their idleness.

When the University of Cambridge tried to take possession of the property left them by Sir George, she refused point-blank to give it up. Inevitably, her stubborn refusal led to litigation, and equally inevitably (possession being nine-tenths of the law) the case dragged on for year after dreary year. Lady Downing remarried in 1768, but clung on to her title as well as Gamlingay Park and the other Downing estates. With no children of her own, she made a will leaving everything to her favourite nephew, a Captain Whittington.

Thirteen years after Sir Jacob had died it was obvious that despite her best efforts the University would win its case. By now the Downing estates had been run down again because Lady Downing resented spending any money on their upkeep, but it can only have been pure spite that made her do what she did next. In a breathtaking act of vandalism, she set out to totally destroy Gamlingay Park.

In 1776 workmen moved in and completely demolished the great house, leaving not one brick standing upon another. Only the cellars were left

untouched. Everything that could be sold was organised into lots and put up for auction to the highest bidder. A leaflet was printed entitled 'A CATALOGUE OF THE SEVERAL MATERIALS OF GAMLINGAY, The MANSION and SEAT OF THE LATE Sir JACOB DOWNING, Bart', which listed the lots available.

The auction catalogue included a note saying there was reason to think that money and valuables had been hidden in the building, and that if any were found they were the property of Lady Downing, who would graciously give the finder a 10 per cent cut. It was almost certainly a waste of ink. Viewing of the lots was possible a week before the sale, and at noon on Monday 14 October 1776 a crowd of interested purchasers and onlookers gathered on the site for the auction, conducted by the famous auctioneer Mr James Christie.

Everything sold. The staircase from the entrance hall made fourteen guineas, the wainscotting just over £28. The sixty-eight windows from the main house went for seventeen guineas, the lead from the gutters, troughs and windows fetched the most money at over £87, while the stone steps and windowsills were knocked down for the bargain price of £2 17s 6d.

As the bricks and tiles, timber and stone, the fine marble fireplaces and the panes of glass were being loaded on to carts and carried away, did Lady Downing allow a faint smile to cross her lips? If she did, it must have been a fleeting one, because the auction netted her just under £800, less than a tenth of the cost of building the house sixty-odd years before. It was sheer wanton destruction, but Lady Downing did not live long to enjoy her triumph. She died two years later at her home in London of apoplexy. Even then it took until 1800 and more litigation before the University won its case, and until 1807 before the foundation stone of Downing College was eventually laid.

What's left of Gamlingay Park is best seen from the air on a summer's evening, where from a thousand feet up, the long shadows cast by the sinking sun clearly reveal the hollows, terraces, circular lawn and the plan of the house to any passing aviator. On the ground, it's still possible to look across the lake (drained in the nineteenth century but since refilled), gaze at the trees Downing planted, the fishponds he once tended and the crumbling remains of the folly, and ponder on the vagaries of avaricious men and women.

WOEFUL BAD

The Downings have taken us ahead of ourselves. We need to go back to the Civil War, where another important change in village life had its roots.

Exactly how the Civil War touched Gamlingay is impossible to say for certain. If you are so inclined, you can imagine the men agonising over their divided loyalties and arguing among themselves as they tilled the fields – should they support the King or Parliament? No doubt the course of the war was a hot topic among the villagers, but the question of whom to support was a foregone conclusion. They had no choice. The whole of eastern England supported Cromwell and his Roundheads. Gamlingay, like so many villages in the area, had ties with the Cromwell family, and backed the Parliamentarians.

There's no way of knowing how many village men were actively involved with Cromwell's Eastern Association but two brave souls, George Fisher and Francis Harvey, joined the cavaliers and were rewarded with a small pension at the Restoration. Sir John Jacob mortgaged Woodbury manor to raise money for Charles I. But as far as direct evidence from the village documents is concerned, the Civil War might never have happened.

The religious convulsions associated with the Civil War had an impact on the village clergy. A couple of the rectors in the 1630s achieved high ecclesiastical office in the Church of England, but lesser men like John Woolridge (or Worlich) were not so lucky. He became vicar in 1629, but fell foul of Puritan zeal, lost his job in 1645 and had to wait until 1662 to get it back. Charles Gibbs, rector from 1637 and a prominent preacher, was forced to give up his living in 1647 and leave the village.

A century after the Church of England had been established, the fresh disputes over religion caused more superficial physical damage to the church. In 1638 Matthew Wren, the Bishop of Ely, ordered the churchwardens to 'turne the ministers deske, the seates to be cutt lower'. Six years later William Dowsing, a Cromwellian commissioner from the opposite end of the

ecclesiastical spectrum, ordered 'Superstitious Pictures & crosse to be taken downe, which the churchwardens promised to doe'.

The religious upheavals came to an end with the return of Charles II in 1660. The Church of England was restored as the state religion and the bishops were back in favour when, in 1665, the churchwardens were told to restore the communion rails (then in the west end of the church) to their proper place. I suppose it all mattered at the time. Passions had run high on both sides, and a post-Restoration clerk of the parish couldn't resist making this deliciously sarcastic comment in the parish registers (not usually the place to look for sarcasm) on the abilities of his Commonwealth predecessors.

> Mr Hills was a woefull bad Register [i.e. Registrar], as he could scarcely spell or write, but he dying in 1655 was succeeded by John Toseland, *equally eminent*.

If you were not prepared to accept the state's way of worship you were labelled a Nonconformist, or a Dissenter. Those who would not conform turned away from the established Church, and began to worship in ways more amenable to themselves. So far as Gamlingay is concerned the most important among the many sects that grew out of this split with the Anglican Church were the Baptists.

The Caxton Baptist church made its first convert in the village in 1652, and from then on nonconformity was to be a feature of village life. Nonconformism tended to flourish among farmers and tradesmen, and Gamlingay had plenty of both. Without the controlling hand of a resident squire, dissent grew rapidly.

Just how rapidly is shown by the Episcopal Returns of 1669, which record about forty dissenters in the parish, described rather sourly as 'All (Except 5 or 6) of poore & very meane condition', who were receiving instruction in a weekly conventicle. Seven years later there were forty-four (plus one papist), and in 1682 twenty-four people were presented at the Archdeacon's visitation for failing to attend the parish church, but the ecclesiastical courts, like their manorial counterparts, had lost their power and nobody took them very seriously any longer.

In 1670 the congregation in Gamlingay applied to join the Bedford General Meeting, led by John Bunyan, author of *The Pilgrim's Progress* and the most celebrated of all seventeenth-century dissenters. Nine Gamlingay men were accepted, and for the next forty years the Gamlingay Open Baptists belonged to the Bedford church. Occasionally the church held its meetings at Luke Astwood's house in Gamlingay, which was properly licensed for the purpose by the Quarter Sessions in Cambridge.

Those members of the Anglican Church who remained loyal to the Church of England were sometimes not impressed with the quality of the clergy engaged in doctrinal battle with the nonconformists. Elie Barnes was presented in 1686 for quarrelling with, striking and doing violence to the curate, for breaking his

leg, 'and afterwards wishing it had been his neck'! That same year, 130 people were presented for not attending divine service. I don't suppose all of them were dissenters, but the figure shows the level of apathy generated among ordinary folk by the Church of England.

The authorities subjected dissenters to a lot of pressure. Despite this persecution (or perhaps because of it), the sects grew in numbers and strength. Many harmless dissenters suffered greatly. Bunyan himself was imprisoned from 1660 until 1672, albeit rather loosely at times, and none could really feel safe until the Toleration Act of 1689 put an end to persecution. Bunyan was often in Gamlingay. On one occasion, he reluctantly gave a young woman called Agnes Beaumont a lift on horseback from her home in Edworth to the meeting in Gamlingay and left himself open to some vicious sniping. She found herself in deeper trouble with her father when she got home.

The sect leaders expected the brethren to maintain high moral standards, for reasons of prudence as well as doctrine. They were frequently disappointed. The Bedford Church Minute Book gives an idea of the very strict standards of behaviour expected from Baptists, and records some of the Gamlingay brethren who failed to live up them. Brother Witt's wife was dismissed for 'railling and other wicked practises'. Sister Landey was cold-shouldered not only for failing to attend meetings, but also because she had taught her children to play cards. A complaint was made against William Robinson because he had decided to marry 'a carnall maid, and would not be perswaded to the contrary', and the church turned its back on William Gardiner 'for wicked light speches and carages towards a woman as liveth in Gamlingay'.

By 1710, the long tramp on foot or horseback to attend church meetings in Bedford was proving too much. The brethren in Gamlingay asked to be collectively released so they could build their own chapel in the village, parts of which still survive in the present Baptist chapel. Their first pastor was Richard Freeman. He had settled in Gamlingay as a Baptist preacher in 1699, and his house was 'lycenced for the Worshipp of God' by the Quarter Sessions. Freeman and the Baptists thrived, Freeman once preaching to an enormous congregation of 250 people.

Dissent was all the rage. The Anabaptists gained a footing, and Bartholomew Webb, a Quaker, had his house and his malthouse licensed as a meeting-place. I'd like to say the Church of England reacted positively to this competition, but the fact is that it did what it usually does at such times and tried to ignore what was happening in the world around it, while its clergy grew increasingly apart from its falling congregation.

Even so, the nonconformists could not relax their vigilance. Fortunately, the Gamlingay Baptist Church Minute book survives, covering the period from its foundation in 1710 as an independent meeting through to 1815, and it fully illustrates the difficulties the church faced, particularly in enforcing the strict discipline expected of its members.

The church drew its members from both Gamlingay and the surrounding towns and villages. Each applicant for membership was asked to relate their own religious experience before being formally welcomed into the church. Once accepted, the new brother or sister was expected to attend the services and conform to the beliefs, practices and rules of the church.

By and large, the majority managed to live their lives within this somewhat constricting framework. For example, Nicholas Paine, when he died in 1796 aged seventy-three, was given fulsome praise in the Minute Book for his devotion to the church. He was, said the writer, 'a wrestler at the throne of Grace', remarkable for 'lamenting before God his own sins, in particular those of the Church of God of the Neighbourhood, of the Nation, and of the World in general'. I think we've all known people like that.

Unsurprisingly, the church reflected the social, moral and business backgrounds of the independent Bible-reading farmers and tradesmen like Nicholas Paine who found a spiritual home within it. Vice was not tolerated, and those suspected of sinning were visited by 'messengers' from the church who came to discuss their sins. As with the earlier Bawdy Court, you can't escape the feeling that some church members rather enjoyed reporting offences to the church officials.

Offenders who were unwilling to admit their guilt and mend their ways were admonished, either in private or in public at a church meeting. Almost any innocent pleasure can be interpreted as a sin if you try hard enough, and the Baptists seem to have tried very hard indeed. Those who refused to accept they had done any wrong were excommunicated, or 'the church withdrew from them' as the Minute Book puts it. Those who repented were usually welcomed back with open arms.

Most offences concerned the usual failings of humanity such as excessive drinking or sexual promiscuity, or both. In January 1712 a church meeting found Sister Martin guilty of

> unlawful Love unto Thomas Meeks, and manifold instances of her allurements towards him; how she allured him with her kindness and by other unseemly gestures, the which was then proved upon her, and for the same she was Authoritively Admonished in the presence of the church.

In March the church sent three messengers to admonish her again. In April Sister Martin attended a church meeting, sorrowfully confessed and was restored to full communion. Thomas Meeks himself was in trouble a decade later, and the circumstances indicate Sister Martin and her allurements may not have been entirely to blame.

He confessed he was guilty of fornication, and after agreeing to marry 'the woman he had Commited that evil with', he then left both the church and the

woman, despite being admonished in private for having previously tempted 'some others unto the same sin of fornication'. At the next meeting, in October 1722, the church had seen no signs of repentance – indeed had seen no sign of Thomas Meeks at all, since he was still 'fled away and would not come to any of his Brethren when he came to Gamlingay'. When he did return to the village it was obvious what he came for, the Minute Book noting that he 'staied one night in the Town and went away privately the next morning'. Thus

> for his fornication and for his fleeing away from the Church and the woman he had commited fornication with after he had published his Contract for Marriage with her, he was excommunicated by the church in hope of his futer Recovery.

The punishment may have had some effect. Two months later, on New Year's Eve, Thomas Meeks, labourer, married Elizabeth Dean, widow.

Almost a century later, in 1810, when Mary Whales was charged with the sin of incontinence, the Minutes delicately explained that 'Circumstances being so plain rendered the appointment of messengers in the present instance unnecessary'. Just as plain was Mary's distress and open contrition at being pregnant and unmarried. Despite this, the church reluctantly felt it had to excommunicate her. At the next meeting it was reported 'there were circumstances of a peculiarly malignant nature in the case of our Sister Whale', namely that she had 'admitted of a course of medicine wholly improper to her circumstance'.

With stunning insensitivity, two of the *brethren* were asked to find out if it were true. Sanity prevailed and, 'for prudential reasons', two women were sent instead. They reported back that though the evidence didn't amount to proof of guilt, it nonetheless gave rise to 'painful suspicion that very improper practices had been adopted'. What really seems to have shocked the church was not that Mary Whales had conceived a child out of wedlock, or that in her desperation she had probably tried to abort the pregnancy with some kind of quack medicine, but that she had declined 'honorable marriage when it was in her power to have obtained it'. That was her real sin: she had refused the cloak of respectability that would have restored her position in society.

In 1721, it was a potentially unsuitable marriage that got the church elders hot under the collar. Sister Clayton was found guilty of keeping company with a common drunkard 'in an espousal way in order unto marriage'. The evil in the opinion of the church was that she had told some people she didn't intend to marry him, insisting she would not see him any more, 'yet went on in keeping of him Company privatly'. John Apthorpe's widow, Mary, offended by actually marrying 'a wild, carnal man, altogether ignorant of Jesus Christ' in 1719. She confessed that 'her heart deceived her', and that she now saw her evil in marrying him. This 'wild, carnal' man was John Kefford, a labourer

from Hatley St George, and we shall see what happened to him and his wife Mary in the next chapter.

Mary Garret's crime would have been obvious to any onlooker. There may well have been more than one looking on, for she was 'publickly caught in the act of fornication' in 1772 – and not with her husband either, if we're to believe Joseph Garret when he said he wasn't 'privy to his wife's conduct', although he did confess to being 'often overcomed with Liquor to excess'.

Garret may have been too drunk to notice his wife copulating, but he was far from the only one to seek solace in alcohol. Thomas Gipson was reproved for his drunken behaviour in 1799, but despite the efforts of the minister and others to convince him of his sin he would not admit it. Rather, he said he despised the church for bringing the charge, although he did concede 'he had drank nearly six pints of ale in less than six hours', which seemed proof enough to the church. Many young men today would probably not consider drinking six pints in six hours excessive either.

The problems associated with drink run like a thread through the Minute Book as they ran through society at the time. Jonathan Philip was accused of 'drunkness and excess of drinking and tippling at Ale-houses' in 1729. Thomas Careless was reproved in 1724, 1725, 1726 and 1728 for repeatedly being drunk – and he was a deacon of the church. On the second occasion in 1725 he was questioned about:

> Being at the Ale house the Satterday night Before the church meeting, with his wife, with some carnal men and staid all the night until the Lord day morning did appear … and that he and his wife did at the Ale house Revile one another.

Careless and his wife were both warned to avoid publicly 'Laying open each other's nakedness', presumably a figurative expression rather than one to be taken literally, although you never know.

Even spending the evening in a private house could still lead to conflict with the church, especially when the accused couldn't see what all the fuss was about. Rose Robinson, a widow, found herself admonished and suspended in 1721 for what she innocently considered 'so small a thing', but the church took a dim view of her actions, declaring them 'scandalous and treacherous'. She was alleged to have been

> disordered with drink at goodman Chesham's on the night on which the shoe-makers keep a feast, and there did very often urge and presse on other carnal people to sing vain heathenish Love Songs, and though none of them would comply with her to do so, yet she often stirred them up and pressed them with urgency thereunto.

Rose did allow she had 'drunk about a pint of Ale' before going to Thomas Chesham's party (he was a shoemaker) but wouldn't admit she was drunk, and it was two months before she confessed and was received again by the church. At least she didn't add to her sin like Thomas Damack in 1772, who combined drinking with dancing and then compounded the offence by doing it on the Sabbath.

Things reached their nadir in the late 1760s. This time it wasn't one of the flock who was scandalising the church by indulging in too much drink but the Pastor himself, Mr Joseph Billing. He had come to lead the Gamlingay Meeting in 1754, and at first things went tolerably well, but his liking for the bottle had led to 'a sad declension and falling away', so much so that by 1771 he'd been suspended for neglecting his duties to the church and his family, and the church was likened to a sheep in the wilderness without a shepherd. Billing had built a large and comfortable manse for himself and his family in 1761, a building which still graces Mill Street today, but when he was barred from the church the elders thought it prudent to repay the £28 5s that Billing was out of pocket over it, so 'that he might not Blame us and say he was he Loser By us when he was put out of office'. As the Minute Book commented sadly, 'What trying things there were.'

If I were to recount all the instances within the pages of the Minute Book of people accused of lying, slandering, backbiting, thieving, fighting and a host of other human frailties, I'd risk giving the false impression that the church was made up of nothing but bad apples, when in fact most of its members were decent men and women who did their best to live up to the high standards demanded of them. The church expected honesty and sobriety from its members in every aspect of their lives, including their business dealings. Getting yourself into debt was considered to be both scandalous and dishonourable to God. The most spectacular example occurred in 1772, when James Williamson was declared bankrupt, and

> ... Broke in Debt near £1200, and his flock were valurd by the commissioners of Bankruptcy about £250, and it was commonly reported of him being often perceived much in liquor and guilty of many presumptuous lies and defrauding persons of their money.

But whether alcohol was the cause or a consequence of his financial difficulties isn't clear.

Problems were not exclusively caused by adults. In 1722, the church discussed 'the disorders of the Children at the Lord's Table' and 'the people Bringing dogs with them unto the meeting'. They resolved that Brother Moss should be paid one shilling and sixpence a quarter to 'Look after the dogs and Beat them away, and not suffer them to come into the meeting place', as well as to 'Looke after the children that are Rude or play at the meeting or in the meeting-yard'.

The church often reacted to the stress of disciplining its members by appointing a day of fasting and solemn prayer. On one such occasion in 1743 they asked 'God for his Blessing to be poured Down upon his Church In pertickler and the Nation In Genaral', but other days of fasting and prayer were held in the hope that the combined efforts of the congregation would assist in overcoming actual or potential natural disasters such as disease, drought or unseasonable rains.

1717
Day of prayer 'to Humble our selves Before God, and to Intreat his favor and mercy unto us on Behalf of the prevailing distemper, the smal pox … and Remove it from the Town, and especially from his own people [i.e., Baptists]'.

1725
Day of prayer and fasting 'to Stop the Bottles of heaven, and Restraine the great Rains … that the hay Might be gathered in without further damage, and the grain harvist might be Ripened.'

1758
Agreed to set aside 'Monday morn from 5 to 8 o'Clock, to seek God's Blessing of Rain, it being greatly needed … It Pleased God to send Rain at the same time plenteously.'

This last example made such an impression that it was long remembered, and referred to in the Minute Book almost half a century later as a remarkable instance of divine presence, when God 'gave rain even as we left the place of worship, and even while one of our Brethren was asking for rain the blessing began to come down'. 'Even carnal people' the writer added, 'seemed surprised at it.'

ROGUES AND PAUPERS

There had been a constable in the village since at least the early fourteenth century, appointed by the villagers themselves through the manor court. As the medieval system of tithings fell into disuse the constable gradually took over the responsibilities of the chief tithingmen, but although he was still chosen by the villagers the constable had to be sworn in by the Justices of the Peace. From the sixteenth century onwards, government made extensive use of the Justices to enforce their policies on law and order at a local level, and the Justices in turn used the constables to do so within the parish.

The primary duty of a constable was to keep the peace. He was responsible for arresting law-breakers, keeping a village watch, collecting certain taxes, removing vagrants, whipping recalcitrant beggars, supervising the alehouses and furnishing men for the militia. Like his counterparts the overseers and the churchwardens, the constable had a difficult job to do, and like his brother officers he wasn't paid, although he could claim out-of-pocket expenses.

Occasionally there was a spice of danger to liven things up, as the Tudor constables William and John Burley had discovered. But as with the other parish officers, for no apparent reason little odds and ends became the constable's particular responsibility and their accounts contain a mixture of items that should in theory have been the lot of somebody else.

So far as Gamlingay is concerned there is only a scattering of constables' accounts from the period 1670 to 1735, along with one stray from c. 1629 and another from 1823, to show us what this important village officer got up to. The accounts were usually kept on folded sheets of paper and written by the constables themselves, which means they share the same eccentricities of spelling and almost indecipherable handwriting of the other village documents of the period.

Most of the constable's time was taken up in dealing with people who were passing through the village on their way back to their place of settlement to obtain parish relief. John Webb in 1671/72 had to deal with no less than ninety-nine people armed with passes during his year in office, some of whom

had to be lodged for the night at parish expense. Often they were sick or lame, and had to be carried by cart to the parish boundary, where they were dumped on the neighbouring constable, who in turn passed them on until eventually they reached their home parish. William Bestow's undated accounts of *c.* 1629 begin with the heading 'Criples' and continue with payments like 'given to pasengers that whent with pases', and 'for a Sick man that lay alnight'. Nearly a century later the constable was constantly being disturbed like this:

Paid to a dum Man att door, 2*d*
Paid to a man att my door, 1*d*
Paid to five saymen that came to my door, 1*s*
Paid to Great Belley Woman, 2*d*
Paid to Great Belled woman for to Gett hur out of the town, 2*s* 6*d*

Pregnant women were often graphically described as great-bellied or big-bellied. When these passengers had to be accommodated for the night it was sometimes at an inn, but no doubt they often slept in someone's barn or outhouse, although on one occasion the constable awarded himself fourpence for 'Lodging tow saillers at my hous'. Now and again the constable took pity on these wretched souls and forked out for some sustenance, such as the 'flaggon of Beere which some passingers had that Goodman Wallis carryed to Potton'. Christopher Fickis claimed expenses of ten shillings 'Concerning the pashengers which was Caried Back to Statfold' (Stotfold, Bedfordshire), but there must have been some dispute over this claim because a year later the Quarter Sessions ordered the payment of 16*s* 4*d* to Fickis for his 'Trouble and Expences in reconveying and maintaining four vagrants that were sent to him by an illegal pase and in the wrong Road'.

Bureaucratic muddles like that made the task of seeing passengers safely on their way more difficult than it already was, but when the poor man or woman was mentally disturbed it must have been doubly difficult.

1678/79
Layd out to too men for holding A Crased woman in A Cart, 2*s* & to her 4*d*
For A Scothman which was distracted that John Wallis brought, his father not being at home, 3*d*

At virtually any time in the seventeenth century there were always disbanded soldiers and sailors wandering around the countryside, though they seem mostly to have been armed with nothing more lethal than discharge papers and certificates.

Laid out to 2 disbanded souldiers that were disbanded at Diss in Norfolke, being Aged & Sick, 6*d*

Layd out to 2 disbanded souldiers that came out of Flander sick, which
had A Lawfull certificate signed by the next Justice A peace, *4d*
Laid out to 3 disbanded souldiers that were disbanded at whayght in
Suffolke, *6d*
For 3 shippwrackd seamen, *4d*

When the constable forked out a shilling in 1678/79 'to keep out the draggones',
it had nothing to do with fabled beasts or his fevered imagination. They were
of course dragoons, bribed with a shilling to keep clear of the village.

The constables' responsibilities often overlapped those of the overseers of
the poor. There must have been some kind of co-operation between them,
but the only hint of it comes from 1698/99 when the constable spent two
shillings 'at ye Rose with the ofeseers'. The Rose and Crown in Dutter End
was a favourite watering hole of parish officers during the final two decades
of the seventeenth century, and talk of how to deal with the increasing
numbers of the poor must have flowed as freely as the ale they drank at parish
expense.

Constables were used by the government as unpaid tax-collectors, riding
hither and thither delivering money to this or that authority. John Webb in
1671/72 made quarterly journeys to Cambridge 'about the thre month tax',
which was in fact the County rate. William Triploe paid a shilling 'for winder
tax Bill' in 1725/26, an amount that might leave you wondering why the
village possessed so little glass were it not for an entry in a later set of accounts
'for windes sesements'. The shilling was to cover the cost of assessment.

We came across the system of purveyance – buying goods for Royal use
at reduced prices – as far back as the fourteenth century, and the system was
still in operation three hundred years later. Many of us today complain about
being overtaxed, but how would we feel about being forced to contribute to a
rate made by the constables for 'the provisioninge of fattlinge & powltrie for
the Kinge Majesties howsold'? The taxpayers of Gamlingay had to do so in
1623, raising just over £4 towards feeding James I and his court favourites.

Another of those oddments of parochial responsibility which devolved on
the constables was that of keeping the village bridges in good repair. There are
many entries in the accounts such as 'paid to John Larkins for mend the Briges
and the Rayles att puddle pitt' and 'mending ye foote of ye bridge at broade
Layes'. As you might expect, the constables were also in charge of the village
stocks. Keeping them in good repair was another constant expense:

For Mending the stocks: 2 shillings the smith had, and 6 pence the
Carpenter had
Peaid to Georg Langley for menden the stokes, *4d*
For mending the Iron work in the Stocks, *8d*

The stocks were still in use from time to time, although this is the only instance recorded by the constables:

> 1723/24
> Paid for Bear 1 shilling, when Henry Hart sat in the stocks

Here's another example of the ambiguity of village documents: was the beer for the constable or for Henry Hart? And anyway, what had Henry Hart done to be locked up in the stocks at the age of fifty-three? He was probably too old for it to have been anything as demanding as 'the man that Rid away with John Smiths horse' whom the constable had to escort to Cambridge Castle that same year.

The accounts also contain their share of mysteries as well as ambiguities: why did the constable pay threepence 'for wacheng of wid Scot house' or buy the village herdsman his 'Hoorn'? Another enigmatic entry comes from 1688/89 when the constable paid a shilling for 'Expenses about Arthur Mallet, for A man to watch him all day till ye Justices came home'. The accounts for the next few years haven't survived, but the fact that the Quarter Sessions in 1692 awarded the parish £5 to cover the expenses 'touching the Cure of Arthur Mallett, a wounded person' goes at least some of the way to solving the enigma, but doesn't explain how Arthur Mallet got his wounds in the first place.

The constable was also in charge of the village watch. This consisted of one or two men armed with a lantern and a staff, who walked round the village during the night on the lookout for evil-doers and calling out the time. It was an efficient system if you wanted to know it was ten o'clock and all was well, and sometimes they were lucky enough to apprehend someone.

> Expences for Lodging A man taken up by the watch one night, 10*d*
> For seeing the wach over a man att John Lowings, 8*d*

At other times they dragged the constable out of his bed for no good reason. Christopher Fickis was woken from his slumbers to visit 'the wach that night when Christopher Parsons suspechet Rogs', and again when 'the wachmen as was when the[y] thought was some Loos fellows in the town'. Loose fellows or rogues, it was the constable's duty to check on it, and judging by the shilling or two spent on the watch each time it seems there was some sort of back-up system the constable could call on when necessary.

During daylight hours, catching a criminal was the responsibility of everyone in the parish. When a crime had been committed the victim was supposed to yell 'out! out! out!' at the top of his voice, warning the neighbours to arm themselves and join in the pursuit, sounding horns and shouting. The din and commotion was intended to alert the rest of the village.

It was a very old idea, perhaps in use as far back as the seventh century, and definitely still in use a thousand years later. If the criminal managed to cross

the parish boundary without being caught, the 'hue and cry' (as it was called) was passed on to the next village and so on across the countryside, following the villain wherever he went.

1670/71
For sendinge a Hew and cry to Everton, 4*d*
Gave to John Buntinge for Carryinge off A hewandcry to Gransden, 4*d*

1678/79
For Carrying a Hue & Cry to Potton, 2*d*

1725/26
For my Going a bout town with Hu in Cry, 1*s*

This method must have been fairly successful (or rather, nobody found a better one), but the records seldom tell much beyond the barest of bare facts. What, for instance, was this all about?

For Carrying the Robbery money to the High Constable, 1*s*

Another mystery in the same vein is why the constable paid 15*s* 2½*d* 'for the Robery money' in 1735/36. But other than the occasional arrest or serving a warrant, such moments of excitement were rare in the life of a humble village constable. A more mundane task was providing men and arms for the county militia. This example is from around 1629:

To the soldyers at Elsworth at the second trayneing their, 4*s*

Among the constables' accounts are several bills. One dated 1675 shows the parishes of Gamlingay and Croydon joining forces to equip a cavalryman of the Light Horse, including paying for a pair of pistols, plush-lined holsters with fringes, a breast-plate, and scouring his 'Blunderbus & the swoard' as well as kitting out his horse. The militia was never universally popular. In the middle of the eighteenth century, the Militia Act was passed to provide an army to repulse possible French invasion, and sparked off violent riots in Bedfordshire, particularly in the neighbourhood of Biggleswade. The fear was that some men might be forced to go overseas, and the primary concern of the rioters was to obtain and destroy the lists of men eligible for service being prepared by village constables up and down England. The Bedfordshire riots spilled over the county boundary into Gamlingay during the summer of 1757, when rioters took the lists by force from the constable, who said he was threatened by the men. It was dark and he couldn't see who they were. The government, however, soon saw the light; the rioters got their way and the idea was abandoned.

By now you will have realised what a vast number of documents relating to the village have survived, most of them by sheer chance. Without them I couldn't have written this book, but having so much information meant that one of the most difficult things about writing it was deciding what to leave out.

Nowhere is this better illustrated than in the accounts of the overseers of the poor, who by the middle of the seventeenth century had become an entirely separate set of parish officers. Their accounts run only for a relatively short period of time – 1680 until 1734, with a few more from the end of the eighteenth and early nineteenth centuries – and even then they are by no means complete. Yet the copies I have run to almost 700 separate sheets. I have no hesitation in saying that if there was an award for the worst handwriting and the most eccentric spelling of any documents, it would surely go to the worthy compilers of these accounts, who expended so much energy in a losing battle with the English language.

The first half of the seventeenth century had seen the intractable problem of the poor growing ever more involved and time-consuming. All the parish officials spent much of their time and money on it, before eventually two or more men found themselves working as unpaid overseers of the poor. They normally served for six months – quite long enough, they would have said – with monthly meetings known as 'town meetings' to discuss day-to-day business and any emergencies that the overseers felt unable to deal with on their own. Almost all the meetings of the parish officers were held in one or other of the village alehouses: the churchwardens often met in The Rose and Crown, but the overseers seem to have preferred the George or The Cock.

The money the overseers spent on relieving the poor was raised by rate. Sometimes they paid someone else to compile the rate for them, as in 1685 when Shopkeeper Stephen Apthorpe was remunerated by an overseer for 'Riten my Rat'. Their accounts show how they spent the money, with the regular weekly payments listed separately from the other expenses. Let's begin by comparing two sets of weekly payments, separated by a half a century.

The first is from April 1682. There are nineteen recipients listed, four of them young orphaned siblings who were each allowed two shillings a week for their upkeep. (They were each shortly to be apprenticed.) Twelve women are named, of which nine are described as widows, and they got between sixpence and two shillings a week to live on. One of the women, Widow Lunn, who was surviving on 8*d* a week, is the woman we met in the churchwardens' accounts when they paid for her to be churched in 1640. Her son Nathaniel was one of three men listed, and was presumably using some of his weekly two shillings to help support his mother.

Moving on to August 1733, there are now twenty-three people listed, five of them children, assuming 'John Meecks is deafghtor' refers to his daughter. Ten of the fifteen women named are widows, and three men are also receiving relief. As

it did fifty years earlier, the money doled out ranges between sixpence and two shillings a week, discounting the 3s 6d a week Humphrey Clare was getting.

There's little monetary difference between the two accounts, but just how did these men, widows and children survive on the pittance they were given? How did an old widow manage to live on a shilling a week? I simply don't know. They must surely have got some help from their friends and neighbours, otherwise they wouldn't have lived more than a fortnight.

By 1733 there were more people who had to be supported by the parish, and the numbers were to continue rising inexorably during the next century. The support, such as it was, was not always freely given: 'I'm not paying to keep those idle so-and-sos' was as common an attitude then as it is today. Nor was it always received with due gratitude, as in 1732 when one of the overseers gave a shilling to 'John Dall wen he comeplend' and bought him a shirt too.

The overseers were always anxious to prevent any extra weight falling on the shoulders of the ratepayers, understandably so, since the overseers themselves were often major contributors. In a rate made in 1629 John Webb was assessed at 4d a month on his own account, and an extra 8d a week for 'bringeing Robert Hallam, a poore man, into our parishe' without giving the required security. Webb went the Quarter Sessions in Cambridge and got an order for the repayment of 12s he had paid in rates for Hallam and an indemnity against future charges. The 1629 poor rate was in fact disallowed because of this order by John St George JP, who had himself been the subject of a warrant issued to Gamlingay's parish officers a year previously to distrain his goods and chattels because he had not paid rates on land he owned in Gamlingay.

The parish records contain many bonds made by employers and relatives of these 'foreigners', intended to prevent any drain on parish funds and avoid disputes. Gamlingay's poor rate was for the exclusive use of Gamlingay's poor. The other side of the coin was that if someone with a settlement in Gamlingay but living in another parish became chargeable to that parish, the overseers there quickly got an order removing them back to Gamlingay.

The result was that when a stranger tried to settle in the village or looked like lingering for a while he or she was quickly soon moved on, forcibly if necessary.

1714
to the travelling woman as had like to lain in heare, 2s

1721
gave a woeman with child 2s 2d, and to see hur out of ye town, 6d

1730
Spent when ye men was warnd out of ye towne or to bring shuetes [sureties], 2s

The great danger of allowing a pregnant women to remain was that she may have given birth in the village, and that would never do. Mother and bastard child might then have a claim on the parish, a situation to be avoided at all costs. If the woman had a legal settlement and was very close to actually giving birth it was imperative that the overseers acted swiftly to prevent her and her bastard becoming chargeable to the parish.

In October 1731 the overseers came up with a novel solution and you can almost see their collective smiles of satisfaction when they arrived at it, even if it did involve bribery.

the day before Poton fare when the[y] brote the big beleyd woman with an order from Amtil [Ampthill, Bedfordshire].

Spent that nite at a towne meten	3. 0.
the next day mor[n]ing	1. 2.
And agreed with the man to marey the woman	1. 11. 6.
And paid for a lisance	1. 05. 0.
And paid pa[r]son for maring them	10. 0.
And ped for the clark	2. 6.
And for my time	1. 6.

£3 14s 8d

No doubt they thought it was money well spent. The happy couple were John Underwood, labourer, and Judith Leonard, who celebrated their nuptials in Gamlingay church on 20 October 1731. Other than her marriage I know nothing more about Judith Leonard, but since she's described on her wedding day as 'of this parish', she had that all-important legal settlement.

Judith must quickly have regretted becoming Mrs John Underwood. He had been born in Gamlingay and was twenty-six when he married Anne Chapman in October 1729. She died nine months later, probably in childbirth, and the couple's son was buried three weeks after his mother went to her grave. A year later, her husband chose to take up the overseers' offer and make a fresh start with a new wife about to give birth. Underwood had joined the Baptists and the Church Minute Book reveals why he was so keen to take the cash. In 1732, after his second marriage, the church held a meeting at the early hour of six o'clock one Sunday morning and found him guilty of

stealing his Master's grain and deceiveing his wife in marriage about his debts, and also of presumptuous Lying against his own Knowledge to cover his sins …

He was admonished, then, at the next meeting, excommunicated for his 'abominable wickedness'.

When a woman gave birth to an illegitimate child, the parish officers strenuously pursued the reputed father for maintenance payments, and charges in the overseers' accounts like 'for implyon of Aturny' must refer to such pursuits. In 1727 the overseers had a bond drawn up with Thomas Tickner because the widow Ann Easey had 'about three yeare since bin delivered of a female Bastard Child' that was chargeable to the parish. Tickner confessed he was the father, but had absconded until finally a warrant was issued for his arrest. He was forced to hand over six guineas to the overseers and agree to pay a shilling a week in maintenance for the child.

The suspicion that the overseers, like the churchwardens, were sometimes gulled into parting with money seems to have occurred to this anonymous overseer in 1725.

to a man & woeman & child soposed to have ye small pox to go out of Town, 7s 6d

Supposed? It should have been obvious. As for the indigenous poor, sometimes only a nudge was needed to persuade them to seek their fortune elsewhere:

1720
gave John Street for to go Away, 5s

As well as forking out small amounts of cash each week to those villagers who relied on them for their upkeep, the overseers often gave a little extra help with necessities like clothing, food and fuel in times of dire need. These are two examples from hundreds in the accounts.

1718
boatt [bought] for Katt Dammak a pare of shues, 1s 6d
boatt for Katt Dammak a Goune; the Goune and making the Goune and threed Cost 7s 6d

That was in February. How had Kate Damack managed until then without a gown or a pair of shoes? Given poor clothing, a bad diet, lack of warmth and general neglect, people at the bottom of the heap were more likely to succumb to illness than the better-off villagers.

When they did, it was the overseers who had to care for them. Usually the assistance is casually dismissed in bald entries like the sixpence given to Widow Carter 'wen sick', or 'Wodins Wife for A man and a Woman to Look atter, and for Vittels and Drinke'. Whatever was wrong with Wooding's wife, she ended up in the stocks and the overseers had to fork out another shilling for someone to watch over her.

Occasionally the medicaments they bought are noted in the accounts – salves and oils, quicksilver and so on – although the brandy and sugar bought for Widow Cooper when she was sick probably did her more good than poisoning her with mercury. These entries though are simply puzzling:

1687
Paid Mr Halfhead of potton for a botell of water for Davis, 1s 6d

1720
Paid Mathew Stow for three bottells of watter for Henerey Tilley, 6s

1721
Paid Mathew Stow for two bottles of watter for Henerey Tylley, 4s

Since every house in the village had access to a well, and the link between contaminated water and disease wasn't established until more than a century later, why did the overseers spend so much money on bottles of water?

When there was a severe outbreak of smallpox in the village the overseers were often stretched to the limit in trying to provide doctors, nurses and medicinal comfort. During one such outbreak in 1731, they paid 'for milk as An Eseys nos [nurse] had when the gal had small pox' and supplied the household with cheese, pork, necks of veal, bread and flour among other foodstuffs.

The overseers were not so keen on actually visiting people with smallpox. During that same outbreak they paid 1s 11d to 'William Robeson for going to see the small pox hou the went on'. If he went to see how John Kefford went on he would have discovered he was desperately ill. Kefford was the 'wild carnal' man the widow Mary Apthorpe had married in 1719, much to the chagrin of the Baptists. Her heart had indeed deceived her, as he turned out to be not much of a catch. She went to live with her new husband in Hatley St George, but they were swiftly removed from there to Gamlingay, where they had a settlement.

They passed a dozen years in poverty, until John Kefford contracted smallpox just as his wife was about to give birth to their child. The overseers made a long list of everything they spent on them during the crisis. First, of course, there was the obligatory meeting in the pub to discuss the situation, then a couple of trips to Cambridge for unspecified reasons. Nurses had to be hired (three different ones, two of them men), straw obtained 'for the noses [nurses] to ley one', food purchased, mostly beef and suet and bread and butter, and copious amounts of beer. Kefford lingered for about three weeks before he died, when two shillings was spent on 'leing John Ceferd out'. Smallpox victims seem always to have been buried at night, and Kefford was no exception.

The last payments the overseers made on his behalf were for his coffin, and for wool and bran. The bran was used for packing his corpse in the coffin.

The wool refers to an Act of Parliament passed in an attempt to aid the ailing wool trade, which required every corpse to be buried in a woollen shroud and in a wool-lined coffin. Compliance was shown by production of an affidavit, and the buying of them (as well as the overseers' struggles to spell it) features regularly in the accounts.

As Kefford was dying, his wife was giving birth. The parish gave her five shillings while she was lying in, paid for a midwife to attend her and for 'Omferey Thoroygood for 2 nites sleeping in her house'. Somehow Mary Kefford survived the trauma and struggled on, burying her daughter Hannah in 1740, and existing on the shilling or so doled out by the overseers each week until she herself died in 1750.

You can only read so much of this kind of thing before you are forced to switch off your emotions. Lengthy lists of funeral expenses, money for laying out the dead, endless and overwhelming evidence that despite doing their best the overseers were at the whims of nature soon leaves you unmoved, forced to adopt the attitude that the overseers themselves must have acquired before they had been in the job many weeks – one which enabled a man to write dispassionately about a shilling spent 'for buring the dead man found in the field'. The overseers, like doctors, couldn't allow themselves to become emotionally involved with the people they were trying to help.

Cures continued to be performed by village healers armed with herbs, charms, closely-guarded remedies and a rudimentary knowledge of anatomy. Sometimes they worked.

> 1720
> Goodey Eatten for Curing Ladey Boner, and Curing Caulberd's Childs head and face, 3s 6d

> 1726
> Paid to Goody Eaton for the Cure of John Grays Legs, 7s

> 1730
> Paid to ye Bone setter for Cutty Page boy £2 12s 6d

In case you are wondering who Lady Boner was – so am I. There's no doubt she was one of the village poor, perhaps the Mary Bonner mentioned a few times in the lists of those getting relief. The only other reference to her is from 1722, when the overseers gave a shilling 'to My Ladey Boner towards a pare of shous'. She might have been a lady in distress, but that entry sounds like heavy-handed sarcasm to me. The writer took great pleasure in recording it, because it's written much bolder and larger than the rest. The charge of sarcasm must also apply to the 'Ladey Wisley' the townsmen met about in 1731.

Sometimes the accounts reveal the overseers' individual attitudes towards the poor, like those sarcastic comments above. You find that one overseer will describe a man simply by his surname, to another he'll be 'old so-and-so', and to someone else he'll be 'poor so-and-so'. But there was one woman none of the overseers thought it necessary to dignify with a name, which perhaps says more about their prejudices than they realised.

During 1714 and 1715 they paid sixpence a week 'for loging the black woman', and at the same time gave 'The Black Woman' one shilling and threepence a week to live on. To discover who she was we have to turn to the parish registers, which record the christening in 1711 of St John Dale, the son of St John Dale and his wife Margaret, described as 'a Negro Christian'. We do not have to look much further in the registers to discover why the payments to her ceased: in 1716 'Margaret Dale, wife of St John, carpenter, a Negro Christian' was buried. I don't know what happened to St John Dale senior but the six shillings paid to 'Mr Shepston for a pare of In Denters [indentures] for the blake boy' in 1718 must refer to St John junior, quickly apprenticed and safely off the overseers' hands at the age of seven or eight.

The way the poor were treated reflects the harsh and often brutal methods that Parliament adopted to deal with them. Nothing was designed to be more humiliating, or to put the poor more firmly in their place, than the Act passed at the end of the seventeenth century which forced each pauper, his wife and children to wear a badge on the right shoulder of their uppermost garment showing a large letter 'P' (for pauper) and the initial letter of their parish. Unless the poor of Gamlingay were thus willing to be branded with the letters 'PG' they were deemed to be not entitled to their benefit, or sent to the house of correction, whipped and put to hard labour for three weeks.

Not surprisingly, there's some evidence that overseers up and down the country were reluctant to enforce this appalling law. Over a period of forty years there are just ten entries in the Gamlingay accounts recording the purchase of badges. Forty were bought in 1730, but the very scarcity of these payments implies that either Gamlingay's overseers were slack in applying the law or so tightfisted that when a pauper died they reused them.

When a pauper died the overseers had a claim on his personal belongings. After all, the parish had been put to a great deal of expense one way or another. In Thomas Farington's case there was the cash he had been given when he was sick, the money paid for nursing him, his coffin, the hire of a cart to take his corpse to the church, sixpence for the men who bore his coffin, the cost of burying him and another sixpence for the 'Afidaviet'. Any money that could be raised from selling his belongings was considered a partial repayment. His meagre possessions – blanket, bed, table, chest, a few tools and his clothes – made just over £1 when they were sold in 1690. It makes you wonder whether for Thomas Farington and the others like him, death came as a relief.

Thankfully the overseers' accounts contain more than just death, disease, poverty and despair. As will all the parish accounts, some of the payments are simply ambiguous. Why did they give five shillings 'to A company of foot Souldiers on Candelmas fair day' in 1689, for instance? Possibly because the soldiers threatened them if they didn't pay up. The occasional payments to the 'Chindey man', who was the village chimney-sweep, are legitimate enough, as is the spinning wheel the overseers bought for Goody Rogers in 1703, which she was no doubt expected to use to supplement the money they gave her – perhaps the same one mended ten years later, when the overseers paid for repairs to the 'wheel & a reel broke by ye Mad woman'. But there's no ambiguity about 'digin a hol to emtey potes in'.

I think all the overseers must have cared about the plight of the poor or they wouldn't have taken the job in the first place. Some may have cared more about saving their own and the parish's money, but all in their turn tried to alleviate the worst effects of poverty. Thomas Bedford is the only overseer to give a bonus, when he paid 'to the poore at Crismas, *6s 6d*' which must have brought some small cheer to the festivities of 1689. Now and again you find evidence that they would dip into their own pockets when necessary. This is from 1721 when the overseer, one of the many Stephen Apthorpes, was repaid for expenses met from his own purse:

> Alowed to Stephen Apthorp for money Lost bye his Rat that he never could gett, *1s 6d*
> Alowed him for A queire of paper, *1s*
> Paid him for doctor Rolt, a bill for ye widow Wiges, *8s 6d*

And I can't tell you how pleased I am to say that the Apthorpe habit of naming their sons Stephen appears to have confused them as much as it confused everyone else. Written at the end of the 1685/86 accounts are the words, 'I am Stephen Apthorp.' Yes, but which one?

The overseers left themselves wide open to criticism when they paid out money to those whom the ratepayers felt did not need it:

> An upon the 17 of may i paid upon the town account on pound ten shillins and Eight pence to Wm Jeaps, *which was to the dis sattisfaction of some*, but to my disadvantage, and set it last in the Charges of may.

Whatever it was that upset the anonymous overseer, he was plainly still distressed by it when he finished the accounts because he scribbled on them these three appropriate quotations from the Bible.

> I said in my hast all men are lyers.
> I was naked and ye Clothed me not.
> The poor you have with you allwais.

A PLACE BEYOND THE SEAS

As the nineteenth century dawned it must have seemed the poor were indeed always with you, and always had been, much as the open fields and the church had always been there. Actually, the church nearly wasn't there at all. The Church of England was in decline in rural England, many of the clergy simply using the income they received from their livings to subsidise their often idle, gentrified lifestyles. With hindsight, the growth of nonconformity through the eighteenth century seems inevitable, but if the Anglican Church had made more of an effort to reclaim some of its lost congregation things might have been different. The vicar was frequently an absentee, usually employing a curate to hold services for the few who felt the need to attend. The rectorship had for a long time been a mere sinecure, the incumbents collecting their tithes but otherwise ignoring the parish. The dissenters were villagers themselves, which gave them a distinct advantage in the struggle between the two factions.

After the turn of the century, things did begin to change. In 1802, Robert Hepworth was ordained as vicar. At least he lived in the vicarage, and took his own services too, although he complained that most families in the parish were dissenters and that only twelve or thirteen people received the sacrament. The vicar who succeeded him, Mr J. B. James, actively took the fight to the nonconformists.

The battlefield was education, something the village had never been very enthusiastic about. True, there was a small school attached to the Baptist meeting-house, and there had been a succession of dame schools for those who could afford the fees. By the early nineteenth century, most other villages in the county were sending roughly one in eleven of their children to school. Gamlingay could only manage the abysmal ratio of one in 225. Dissenters and Anglicans both ran Sunday schools, but the crying need was obviously for some kind of day-school offering cheap education to the children of the village. What Gamlingay actually got shows the ridiculous lengths the opposing churches were prepared to go in order to outdo one another. They both built schools.

The snappily-titled National Society for the Education of the Poor in the Principles of the Established Church had been set up in 1811 to plant an Anglican school in every parish, the clue to what they were primarily intended to teach being in the name. In 1848 they got round to planting one in Gamlingay, next door to the church, consisting of a schoolroom for 160 pupils with a schoolhouse attached for the head teacher to live in. Having lived in it myself for a couple of years, I can testify to both the thinness of the walls and the unrivalled view over the headstones in the churchyard.

The *Cambridge Chronicle* reported that when the National School was opened the children were given a dinner (after a sermon) of roast beef and plum-pudding, which was probably the first time many of them had tasted such delights. They were then walked in procession round the village, and after more organised merrymaking were sent home with the words of the national anthem ringing in their ears.

Not to be outdone, that very same year the Baptists opened their own establishment beside their chapel under the auspices of the British and Foreign Society. The opening festivities might have matched those of the National School, but I can't report them because the *Chronicle* failed to send a correspondent along.

The sheer stupidity of building two schools soon became apparent. The one to suffer was the National School, as anyone could have foreseen. It could only muster about half the attendance of the Baptists' British school. In 1867 the Reverend James reported to a Parliamentary Commission that the National School had an average of seventy-nine pupils while the British School and the dame school together catered for 161 scholars between them.

Apart from building one school too many, the rivalry between the two factions expressed itself in a rash of other buildings designed to express the good taste and devotion of their respective members. The Baptists rebuilt the original meeting-house in 1840. The Church of England responded by building a new rectory at about the same time (the distinction between rector and vicar was abolished, and the two united in one rectorship in the middle of the nineteenth century). The Methodists built a chapel of their own when they arrived in 1833. The Primitive Methodists erected a chapel in Green End in 1855. The Particular Baptists had their own chapel from the early years of the century, but not wishing to be outdone by the other sects built the Zoar chapel in 1866 as their contribution to a village by now overflowing with four chapels, a church, two schools and an apparent excess of religious zeal.

The village was slowly changing in other ways too. Two of the most heavily used roads were turnpiked in an effort to improve them. The first was the north-south Waresley to Potton road, incorporated as part of the Bury and Stratton Turnpike in 1755, then in 1814 the road to St Neots became part of the St Neots and Potton Turnpike. Road-users had to pay a toll, the money being spent on repairs. The rest of the parish roads were still as awful as they had always been.

The village inns had all acquired names by the eighteenth century. It's difficult to say exactly how many inns there were as numbers fluctuated over the years, but the thirsty villagers sustained nine in 1735, and some ten or eleven occur regularly thereafter in the licensed victualler's registers. Other new buildings appeared, especially in Mill Street following another fire.

It happened in 1812, and this time there was a newspaper to report what happened. The fire began, the *Cambridge Chronicle* said, about ten o'clock in the morning in Thomas Wright's wheelwright's yard, the fire from the forge setting alight a thatched roof nearby. Mr Woodham's barns and outbuildings were destroyed, then the fire:

> continued its dreadful ravages along both sides of Mill-street, burning down 22 dwelling-houses, six barns, and a great many outbuildings, when the arrival of an engine from Potton prevented the further extension of the flames, but which continued burning furiously amidst the ruins till nine o'clock in the evening ... The calamity, however, falls heavy upon the occupiers of the houses destroyed, 18 of whom are deprived of their homes.

A fund was set up to help the unfortunate victims, but some unscrupulous people saw the tragedy as a chance to make money, and the *Chronicle* had to warn its readers against 'unauthorized persons who have been soliciting subscriptions'.

Apart from the arrival of the horse-drawn fire-engine rattling over from Potton, there's not much difference between this fire and the one reported to the Privy Council 200 years earlier. Even the appeal for funds is the same. How helpless the village still was in the face of natural disaster – and how often history repeats itself.

Agriculture was still carried on in the great open fields, although more and more people were becoming convinced that the land would have to be enclosed before any real progress could be achieved. In 1794, Vancouver's *General View of the Agriculture in the County of Cambridge* reckoned that without enclosure and proper drainage, 'no improvement can possibly be made in the stock and husbandry of this parish'. The stock included about 1,200 sheep, 340 of which 'perished in the course of last year, by the rot, and the mortality at this time still continues'. Gamlingay's farmers blamed the bad state of the drainage in the open fields. It was to be another fifty years before enclosure, which Vancouver clearly thought was vital to the village, was to come about.

The history of the nation between 1750 and 1850 is often seen as the century of the industrial revolution, the coming of the railways and the development of commerce – in a word, 'progress'. But there was precious little progress in Gamlingay, or in the rural villages of much of southern and eastern England. For them it was a period of stagnation, decline, repression and despair.

The relative gap between rich and poor had grown slowly wider since the middle ages. By the early nineteenth century, the pauper or labourer living in a tumbledown cottage with a few sticks of furniture to his name was worlds apart from the farmer in his large, comfortable farmhouse. The farmer had little in common with his men, and often looked on them as little better than beasts. The rift between the patriarchal, pipe-smoking, church-going farmer and the sullen, resentful, ill-educated, poorly-fed and poorly-clothed labourers led them to fear and despise each other.

If you think I'm exaggerating the differences between them, let's compare two Gamlingay men. The pauper Joseph Triplow died in 1804, and these were his worldly possessions as listed by the overseers when they seized them.

Deal Table
Dresser & shelves
5 Chairs
Grate
Pothooks, Tongs, etc.
Tureen
Cupboard
Brown Table
Tea Kettle
Milk Kettle
Warming Pan
Bed & one Blanket
Bedstead & Curtains
4 Chairs 2 Boxes
One Window Curtain

It doesn't take much imagination to realise that Joseph Triplow must have led a miserable existence. Think of him on a freezing January night sleeping beneath his solitary blanket, hungry and cold. I doubt if he'd ever tasted the roast beef of Olde England. He probably never tasted meat unless he managed to poach an occasional rabbit or hare. Instead, he existed on a diet of potatoes, bread and weak tea, perhaps (as many people did) resorting to soaking a piece of toast in hot water to give an impression of tea when times were really bad.

At the other extreme, William Careless farmed the Merton estate and lived in the large and comfortable manor farmhouse, waited on by servants and living off the profits from hundreds of acres of land tilled by a small army of labourers. You can bet he never went to bed hungry. The College surveyed the estate in the early nineteenth century and found everything in excellent repair, from the farmhouse itself to the boarded and thatched barns, and the granary to the pigsties. William Careless's horses were better housed (and better fed) than the likes of Joseph Triplow.

Power was concentrated in the hands of the landowners and farmers. Landowners controlled Parliament, which passed savage laws protecting property. Their tenants – substantial farmers like William Careless – controlled the labourers through their monopoly of employment, and it was generally the farmers, or people of their class and sympathy, who served as overseers.

The Elizabethan Poor Laws began as a reasonably workable solution to the problem of poor people unable to maintain themselves. By the 1790s they had become a prison for the rising numbers of labourers. The parish boundaries were their prison walls, within which they could at least claim some sort of relief, however pathetic and inadequate. Outside them they were barely-tolerated intruders.

Those who tried to escape by fleeing suffered severe punishment if they were caught. William Birx tried it, failed, and found himself standing before the Cambridge Quarter Sessions in 1791, 'for running away and leaving his Family chargeable to the Parish of Gamlingay'. He was found guilty, needless to say, and ordered to be

> publickly whipped to morrow at Cambridge, confined to hard Labour one Month in the House of Correction, then publickly whipped at Cambridge and discharged.

Presumably he and his flayed hide returned to Gamlingay and the family he had deserted. James Wash had run away four years earlier; he was never caught, despite the reward of one guinea advertised in the *Cambridge Chronicle* for information leading to his recapture, and the picturesque description of the twenty-six-year-old Wash as 'round shouldered and knap-knee'd'. What a short distance the poor men of England had travelled since the middle ages: from bondsmen to landless paupers.

The number of poor labourers was growing all the time as men who had managed to eke a living from a couple of acres of land gave up the unequal struggle and became full-time wage-earners. Their position worsened after the adoption in Gamlingay and much of the southern England in 1795 of the so-called Speenhamland System of relief.

This was, in effect, a scale by which a pauper and his family received a certain sum each week from the overseers (related to the cost of a loaf) in addition to the wages he earned. The bigger his family, the more money he received. The new system was actually intended to help the poor, but the road to Hell is paved with good intentions, and it didn't take the larger farmers very long to grasp the fact that they no longer had to pay a man a living wage. The difference would be made up out of the poor rates, and the smaller farmers and the village tradesmen also contributed to the poor rates. In effect, by paying a man less, those farmers with large workforces had their wage-bills subsidised by the rest of the parish.

Shortly after the system was introduced, eight of the largest farmers in Gamlingay, including William Careless, got together and agreed a very low maximum wage among themselves. Obviously it was no good one farmer paying more than another. How do I know this? Because they had the brass neck to make a note of their agreement in the pages of the overseers' accounts, and sign it.

We whos names are herinunder written have determined and agreed to give the Labour[er]s not exceeding seven shilling Per week.

Wm Woodham Joseph Ingle
James Paine Tho Trustram
John Edwards Wm Mead
John Francis Guy Wm Careless

Date Nov 6 1797

Almost overnight after the adoption of Speenhamland, a labourer, even one in full-time employment, became a pauper without rights. Many small farmers were forced off the land as the poor rates rose steadily. Contemporaries claimed that the result was to make the labourers lazy, since they were paid whether they worked or not, and that it encouraged them to have large families to claim more relief.

There may well be some truth in these assertions. It's impossible to say whether labourers did become more indolent after Speenhamland, but the system gave them no positive encouragement to work. There is, however, some evidence that families did get larger. In 1798, one of the churchwardens compiled a list of all the inhabitants in the village: after much labour and arithmetical struggle, he concluded that Gamlingay contained a total of 824 people. According to his figures, there were 427 men and women in the village, along with 322 children, the rest being servants and maids. Astonishingly, approximately one in five of the men and women are described as disabled, both a sobering thought and a reflection of medical ignorance throughout much of our history.

The 1821 Census counted 1,256 inhabitants, an increase in population of roughly 50 per cent in just twenty-three years. There's some evidence from later on that during this period poor families were attracted to the village by easy settlement on the Heath – around thirty, it was claimed – which may have boosted the population by roughly 150 or so. The rest of the rise may well have been due to the new system actively encouraging larger families.

Farmers waxed fat as prices rose during the early years of the new century when Britain was at war with France. Despite the wartime boom, the labourers' position remained insecure and miserable until the end of the Napoleonic

Wars in 1815 brought an abrupt halt to the good times for farmers. The ever-rising poor rates were by now a hefty burden on the parish, and even the larger farmers began to feel the pinch.

The labourers were harder pressed than ever, and discontent rumbled dangerously throughout the country, flaring up during the next fifteen years in such sporadic and uncoordinated disturbances as the Littleport Riots, rick-burning and machine-breaking. It came to a head in 1830, in the last great rural revolt in this country, a disorganised, emotive expression of despair known as the 'Swing' riots. They got their name from the anonymous letters that were sent to particularly hated farmers and clergymen threatening them with arson – and worse – if they refused to meet the labourers' demands. The letters were signed by the mythical 'Captain Swing'.

There were outbreaks of machine-breaking in many of Gamlingay's neighbouring villages towards the end of 1830, especially in Huntingdonshire. Often the target was the new threshing machines introduced on farms as a labour-saving device, which deprived many men of their traditional winter occupation of threshing the corn by hand. Oddly enough, although Gamlingay was one of the worst unemployment blackspots in Cambridgeshire, there's no evidence of any demonstrations against the farmers in the village.

The atmosphere was highly charged nonetheless, and the authorities were ready to crack down on anyone they suspected, however remotely, of involvement in the disturbances. And so it was that one respectable and well-to-do nonconformist from Gamlingay unwillingly and unwittingly stepped into the national spotlight.

Joseph Saville was just nineteen when he married Mary Trustram in 1797. Her father was Thomas Trustram, who a month after his daughter's wedding put his signature to the maximum wage agreement quoted above. Saville was described as a tranter (someone who does jobs with a horse and cart) and later on as a farmer, but he seems to have been something of an entrepreneur as well. In 1812, he ran an advertisement in the *Cambridge Chronicle* announcing to millers the availability in Gamlingay of a 'newly-erected smock mill with Fan-tail; capable of grinding 150 loads per week ... well placed for bag-work or the London trade'. This smock mill on Mill Hill, built no doubt to take advantage of the boom in agriculture during the Napoleonic wars, proved to be a sound investment, for it passed to his son-in-law and continued working until as late as the 1930s; in a derelict and forlorn state forty years later, it provided a suitably melancholic subject for my camera.

By 1830, now in his early fifties, Saville had become a successful dealer in straw-plait, travelling constantly, ranging far and wide in his smart green gig to make his purchases. Straw-plaiting was a true cottage industry, especially in Bedfordshire, where Luton was the centre of the straw-hat trade, but such was the demand that in many neighboroughing counties thousands of women and children were employed at home, plaiting straw. The plaits, in many different

patterns, were bought by middle-men like Joseph Saville, who sold them on to be made into bags, bonnets, hats and baskets. Saville and his son (also Joseph) had a business in Luton, where Joseph junior undertook the selling-on.

On his travels Joseph Saville senior would have been well aware of the despair of the rural labourers. Perhaps it was being brought face to face with such poverty and wretchedness that converted him to the ideas of men like William Cobbett and Henry 'Orator' Hunt. These men were champions of the working classes, and supported such outrageous proposals as universal suffrage, an end to child labour, a ten hour day for workers and annual Parliaments.

Naturally, those in authority considered them and their followers dangerous radicals, and their ideas would not have found support in the dining rooms of the local gentry or with the farmers in Gamlingay. Saville was also a nonconformist which gave him, if nothing else, a deep resentment towards those he considered the fat cats of the Anglican clergy.

But it was neither his business acumen nor his radical leanings that brought him to the attention of the public at large. It came through the pages of *The Times*, the newspaper of the ruling classes. In its issue of 23 December 1830, the paper carried a story first published a day or two earlier in the *Suffolk Herald*. Under the heading 'STATE OF THE COUNTRY', after reporting the daily imprisonment of rioters and machine-breakers in Bury St Edmunds and that a crowd of labourers armed with scythes and flails had threatened farmers in Haverhill, the paper continued with the thrilling news that the mastermind behind the unrest across the south and east of the country may have been apprehended.

> A more than ordinary sensation was, however, excited here [i.e., Bury St Edmunds] on Friday evening, by the committal of a man said to be the actual and original "Swing". On Thursday morning, this person was observed to drop, from a green gig in which he rode, some papers in passing through the parish of Stradishall, about ten miles from this town; which papers proved, on inspection, to be threatening notices, signed "Swing".

After being allowed to deposit £580 in guineas and banknotes in the bank, Joseph Saville was arrested and carted off to Bury jail. He had on him a parcel of papers, 'some of which he tried to secrete in his topped boots. They appeared to be generally meant for the parsons and farmers, for the former of whom, Mr Joseph Saville, for that is his name, seems to have no especial affection'.

He admitted dropping letters, some of which, as the writer put it, were 'garnished with the texts from Holy Writ', but claimed he acted from the best of intentions and his religion. For the uninitiated, the paper explained that Saville was 'a Methodist, or more properly, perhaps, what is called a "ranter"'.

He says that he has travelled upwards of 1,200 miles in the last six weeks, so that his inflammatory circulation has no doubt been pretty extensive. It will be recollected that there was a person, who fled in a green gig, detected in the act of setting fire to some stacks near Cambridge. Saville denies that he was at Cambridge within the last three weeks. He was in this town the day before his apprehension, and had dropped a notice at Barton, for the clergyman of that parish. He denies having been engaged in any incendiary act.

With reporting like that, what chance did Saville have of a fair trial in the explosive atmosphere at the time?

Before he could be brought to trial, however, the local papers were busy reporting on further developments in the capture of 'Captain Swing' and adding juicy titbits for their readers. The *Bury and Norwich Post* inflated the money he had on him at his arrest to £700, described Saville as 'a person of rather gentlemanly appearance' and said he was well known in Bury St Edmunds as a traveller in business. The reporter was sceptical about identifying Saville as Swing, and speculated that 'from all we can learn we are inclined to believe that his intellects are disordered, and that he is in no way connected with any organized plan of alarming the country, which some have been very ready to imagine'. The press freely published examples of the threatening letters Saville was alleged to have dropped:

England! Beware that you do not bring Vengeance down upon your Heads by Robbing the Poor. – Swing.

If you dont behave better and give the Poor Man his due I will visit you or my name is not – Swing.

You Clergy, ye Vipers, you love Tithes, Cummin and Mint; ye are Men-eaters and not Soul-savers, Blind leaders of the Blind, twice dead, plucked up by the Roots.

Will you Farmers and Parsons pay us better for our labour, if you wont we will put you in bodily fear. – Swing.

O ye Church of England Parsins, who strain at a knat and swallow a cammell, woe woe woe be unto you, ye shall one day have your reward.

The *Cambridge Chronicle* report on the Saville story included the observation that 'In politics as well as plait, he appears to be a true and worthy disciple of Cobbett' and that he'd expressed great satisfaction at the election of the radical Henry Hunt to Parliament. Meanwhile, the papers found on him had

been sent to the Home Secretary, who ordered a search of Saville's house in Gamlingay. It took place on Christmas Day, a nice present for his wife and children. But although

> a letter has been found, which alludes in a mysterious manner to one of the fires in Huntingdonshire (where he was at the time when it occurred) the expectation of bringing home to him any charge of participation in these acts has not been realized.

A week later, four parish officers from Gamlingay wrote to the *Chronicle* in an attempt to present another side of Saville's character to its readers, one at variance to the dangerous and subversive 'Captain Swing' they had been reading about. Although regretting his folly, the writers were keen to emphasise Saville's charitable acts on behalf of the poor. He had set up a mutual society to help in times of sickness, and gave a good dinner for poor widows every Christmas. He distributed coal in winter, had lowered his tenants' rents, set up a Sunday School and supported Bible and Missionary Societies. They concluded by saying that Saville had 'resided here 30 years, and has always been much respected'. It did no good.

Saville's trial took place at the Suffolk Quarter Sessions held in Bury St Edmunds on Monday 10 January 1831, before a packed and excited court. The *Bury and Norwich Post* carried a full report of proceedings in the following week's edition. After being indicted as a wicked, malicious and seditious person for distributing threatening and inflammatory letters signed 'Swing', Saville was asked how he pleaded, and answered in a firm voice 'Not guilty'. One glance at the magistrates and their Chairman, the Reverend Dr Colvile, and the jury composed of men who had most to fear from a rural revolt, and he must have known he was wasting his breath.

Mr Eagle, the aptly-named prosecutor, addressed the jury, and frankly admitted that the case had excited considerable interest partly because of the 'situation in life' of the defendant. What he meant was that Saville was not the kind of man respectable society would have imagined to be on the side of the labourers: in other words, he was one of us.

When the letters themselves were produced in court, Saville's fate was sealed. There was little left for the defence to do but to produce character witnesses in mitigation. There were ten in all, one of them, perhaps surprisingly given Saville's views on the clergy, being the vicar of Potton. They all said much the same thing, emphasising Saville's respectability and religious frame of mind, admitting 'they were never so much astonished as when they heard of his apprehension upon this charge'.

The press had already found Saville guilty and the jury quickly followed, but recommended mercy to the prisoner because of his previous good character. The Reverend Chairman of the magistrates then addressed Joseph Saville:

> The sentence of the Court is, that you Joseph Saville be imprisoned for the term of one year, and pay a fine of fifty pounds, and be further imprisoned till that fine be paid.

Saville was taken away to begin his sentence, the court moved on to the next case, and the witnesses who had travelled to speak on his behalf began their weary journey home.

In fact, Saville had got off rather lightly. At the same court those same magistrates had sentenced seven labourers to transportation for their involvement in the machine-breaking and rioting. He wasn't given hard labour, and wouldn't have to pound away at the treadmill in the Bury jail as so many others were forced to do. During his incarceration, in the October of 1831, Saville petitioned the court to ask for remission of his fine, a request which the visiting justices passed on to the Lords of the Treasury with the recommendation that it be granted.

Joseph Saville returned to Gamlingay at the end of his sentence to be greeted by his wife and their three daughters still living at home. If the fire of radicalism still burned in him after his experiences at the hands of authority, there's no record of it. He died aged fifty-seven in 1835. Reading his will, you would never know he'd led anything other than a blameless life. He calculated he was worth at least £2,000 and provided for his family in generous fashion.

They obviously thought none the worse of him for his somewhat clumsy and muddle-headed attempts to help the poor in their struggles. His daughter Ann and son-in-law Jabez Dew, who inherited the mill, named their first-born Joseph Saville Dew in his memory. (Forty years later, in a curious echo of the past, that same Joseph Saville Dew appeared at the Old Bailey as a witness for the prosecution in a fraud case, after being swindled while trying to raise a loan of £150.) But by the time his grandson was christened, Joseph Saville was dead and the world had changed forever. The cause he had suffered imprisonment for had been defeated. The revolt of 1830 failed, and the labourers' defeat provoked an almost unbelievably vicious backlash from the landed classes who (quite rightly) saw themselves threatened by the rebellious lower orders: 19 men were hanged, 481 transported, and 644 imprisoned.

Equally harsh were the punishments meted out to those who dared to infringe the property rights of the landed gentry. Those who committed even petty offences knew they could expect no mercy from the Quarter Sessions. The fact that a prisoner, usually a labourer, could be convicted on little more than the word of a gentleman who believed him to be guilty meant that he had only a slim chance of being acquitted. The accused was in any case likely to be illiterate, without the means to hire someone to defend him, and probably terrified by having to appear in a court before his betters.

In many ways the Quarter Sessions in Cambridge had taken over the role of the manor court, and the cases it heard are similar to those recorded on the

manor rolls from previous centuries. These are a few of the cases concerning Gamlingay men and women heard by the court.

1822
William Ibbett, labourer, fined £10 with costs for cutting some branches off a walnut tree.

1829
George Payne, fined £5 for unlawful use of snare.

1830
John Boon fined £1 and 2s damages and 3s costs for stealing two hurdles.

1834
Sarah Cole, spinster, six weeks with hard labour for felony.

1834
John Paine fined £5 with £1 16s 7d costs for unlawful use of dog and gun to kill game.

1840
Fanny Kefford, spinster, imprisoned for one month for vagabondage and leaving bastard child chargeable to parish.

1852
Henry Cadge fined 6d with 14s 6d costs for driving a wagon without reins.

In very few of these cases does the punishment meted out seem to fit the crime. William Ibbett, for instance, was a twenty-seven-year-old unmarried labourer. It's fair to assume the branches he lopped off that walnut tree were used to provide fuel for the fire. His earnings would have been eight or nine shillings a week at the time. How was he expected to pay his fine? Ten pounds represented almost half a year's income.

The triviality of many of the cases brought before the court is often obscured by the legalistic phrases used to describe them: grand larceny was the theft of property worth more than a shilling, petty larceny described thefts of less than a shilling, while a felony was a crime worse than a misdemeanour.

Since crime recognises no boundaries, many Gamlingay men and women appeared before the Quarter Sessions of neighbouring Bedfordshire and Huntingdonshire too. Only one case differs from the norm: in 1853, nineteen-year-old Mary Ann Shepherd was found guilty in Bedford of trying to pass a

counterfeit shilling and having a mould 'for the purpose of making counterfeit coins'.

But the Quarter Sessions had another form of punishment at their disposal far worse than imprisonment, hefty fines, hard labour or a whipping: transportation.

At Woodbury Hall on Friday 2 October 1835, at about half past six in the evening, fifteen-year-old Miss Emily Shore and her younger brother Richard were in the library with their father, when they were interrupted by the footman, who announced that Mr Clutterbuck, their neighbour at Tetworth Hall, just over the border in Huntingdonshire, wished to speak to Mr Shore. Emily relates in her diary that Clutterbuck was brought into the library and told her father of

> a notorious poacher about here, named Page, for whose arrest a reward of twenty pounds has been offered. The clerk of Everton was knocked down and injured the other day in the attempt. Mr Clutterbuck and Mr T. St Quintin (the magistrate) sent for two Bow Street officers to take him up. He eluded them ...

This was not the reason for the visit, however, because in the meantime two men had 'committed a daring and impudent theft of two ducks at a farm close to our house, about two days ago'. They had just been arrested and handcuffed by the Bow Street officers in Gamlingay. Clutterbuck asked if the prisoners could be examined in the house, as it lay in Cambridgeshire. Shore agreed, and at that moment Mr St Quentin and another gentleman called Foley arrived.

They all adjourned to the servants' hall, along with five of Shore's pupils who came along to see the fun. Candles were lit, pen, ink and paper provided, and the prisoners, policemen and witnesses brought in. The prisoners were Samuel Gilbert and John Baines, two young men from the village. The witnesses against them were the Shore's footman; Green, the owner of the ducks; and Larkins, who saw the theft.

> One of the prisoners being asked if he had any questions to put, merely inquired of Larkins, in a drawling lingo, "Where did you ever see me catch a duck?"
> Larkins (in a similar tone). "At the ould pond."
> Gilbert. "Oh, did you?"

The pair were quickly committed for trial at the next Quarter Sessions in Cambridge and taken to Cambridge jail. The next day, Emily's diary records another meeting with the Bow Street men:

> The Bow Street officers are still hovering about the county in disguise, in hopes of arresting Page himself. Papa met them today while riding; one

was dressed like a gamekeeper, the other like a tinker. Papa knew them at
once, and spoke, not knowing that they wished to be concealed.

Papa. "Well, what sort of success have you had?"

Officer (in a low voice). "None yet. We are going about in this disguise
that it may not be known we are here." (Aloud, as papa was going on)
"We'll take the letter for you, sir."

Papa. "Oh, thank you."

This was to blind a carter who was a little behind them, and might find
them out.

The pantomime pair of Bow Street officers were unsuccessful in their attempts
to arrest the notorious John Page. Having been sentenced to two months with
hard labour in 1831 for poaching and fined £5 on two further occasions, with
a price on his head and the law in hot pursuit, he'd slipped away while he
could.

Gilbert and Baines could consider themselves unlucky that two Bow
Street officers were in the neighbourhood at the time of the incident, for in
all probability they would have got away with it had things been left to the
village constable. Perhaps the officers were relieved to have made an arrest
after their failure to catch the poacher they were after. The breathless way
Emily Shore records the excitement of the arrest and committal of the pair,
combined with the elements of comedy and high farce in the story, indicates
that she found the whole episode vastly entertaining. I doubt if Samuel Gilbert
and John Baines found it quite so funny.

The King *v.* Gilbert and Baines was heard at the next Quarter Sessions in
Cambridge. Samuel Gilbert was twenty-one and John Baines twenty-three
years old, and both were described as labourers. They were indicted on the
oath of John Green of Tetworth with stealing 'one live tame duck worth one
shilling' (not the two ducks of the diary). Forgive my incredulity, but only
when I held the original piece of paper with the indictment written on it could
I believe such a pettyfogging offence as pinching a duck – a *duck*, mark you
– could lead to a trial, and only when I read the court order book did I believe
the sentence they received for this daring and impudent crime.

They pleaded not guilty to the charge of felony and larceny, were swiftly
found guilty by the Grand Jury, and then the court delivered its sentence. They
were to be 'transported for the term of 7 years to such place beyond the Seas
as His Majesty with the advice of His Most Honorable Privy Council shall be
pleased to direct'.

They must have known that His Majesty with the advice of His Most
Honorable Privy Council would be pleased to direct them to be sent to
Australia. Transporting convicts to penal settlements had been practised since
the seventeenth century. From the government's point of view it was the ideal
solution: there were no proper prisons to house them here and the colonies

needed their labour. At first, most were sent to North America, but after the colonies there gained their independence the newly-discovered continent of Australia took its place. The first convicts sent there went to New South Wales ('Botany Bay'), but from the 1820s also to Van Dieman's Land (Tasmania) and later to Western Australia. As a method of dealing with criminals transportation left a lot to be desired, and between 1853 and 1864 it was gradually phased out.

Baines and Gilbert were first sent to one of the terrible 'hulks' – old rotting ships stripped of their masts, converted to floating jails and moored in the Thames or located along the Channel coast. There they remained, chained and ill-fed until the following April, when they were taken on board the convict ship *Moffat*, an old ship but 'strong and sound' according to the ship's surgeon's report compiled at the end of the voyage. He noted laconically in his medical journal that 'Previous to the prisoners leaving the Hulks they are all thoroughly washed and their flannel shirts & belts taken away'.

They were accompanied on their voyage by 397 other prisoners, with thirty soldiers to guard them. Once safely out to sea, the prisoners were released from their shackles. The voyage to New South Wales took almost five months of what must have been sheer boredom most of the time, coupled with moments of fear as gales lashed the *Moffat* and the sea washed in on the convicts through the leaky ports, when 'the prisoners' bedding was often wetted, and catarrhal, rheumatic and bowel complaints generally followed', as the surgeon observed. Well, what did he expect? When the weather was fine they would spend most of the day on deck, but when it was bad they were of necessity confined to the crowded prison deck and their hammocks.

As the end of their voyage approached some 160 convicts had been treated for various illnesses and ailments by the surgeon, but only three had succumbed and had the burial service read over them as they were consigned to the deep. On 30 August, as the ship neared its destination, Samuel Gilbert was put on the sick list suffering from diarrhoea. In his remarks the surgeon noted his 'Upper extremities moist, taking Calomel & aperient' (a laxative).

On 2 September 1836 he was taken from the *Moffat*, then at anchor off Sydney still with the convicts on board, to the General Hospital in Sydney. He was joined soon after by his friend John Baines, whose illness is not specified in the records but may have been the same as Gilbert's. Neither man was to trouble the hospital staff for long. On 14 September John Baines died, followed the next day by Samuel Gilbert. Almost a year to the day after they had been arrested, after six months in shackles in the hulks and an arduous sea journey half way round the world, these two young Gamlingay men were laid to rest in Australian soil. It was a high price to pay for stealing 'one live tame duck worth one shilling'.

If Baines and Gilbert were treated severely and suffered the ultimate penalty for their petty theft, there is little doubt that the first Gamlingay man to be

transported was a bad lot. His name was Hall Parcel (or 'Passell'), and he appeared before the Cambridge Quarter Sessions in 1821. In his late twenties, married with two young children, he was another who bore his mother's maiden surname as his christian name. He was indicted by Daniel Cartwright of Gamlingay for having obtained thirty bushels of potatoes, two bags and two shillings from him by pretending to be the son of Robert Taylor of Orwell who, Parcel told Cartwright, wanted to buy the potatoes. There was also another indictment by a farmer from Grantchester, who swore that Parcel had stolen five sheepskins from his shed. The verdict was guilty, the sentence seven years' transportation.

After spending several months in the hulks, he and 183 other convicts embarked on the *Phoenix* at Portsmouth on 10 November 1821. The Surgeon Superintendent for the voyage, Mr Evan Evans, maintained a meticulous log of the voyage, noting the latitude and longitude, the temperature and weather conditions each day they were at sea, as well as describing the daily routine of life on board. Reading Evans' strictly factual account written in his spidery hand, it's possible to reconstruct the entire journey, even at times to catch the creaking of the ship and the snapping of the sails in the wind.

The *Phoenix* had to remain in the Channel for two months as unfavourable winds and violent storms kept her penned in. The ship took what had by now become the standard route for convict ships, sailing steadily south until off the western coast of Africa, just north of the equator, where they entered the region known as the doldrums. The wind dropped and the temperature rose. Day after day the *Phoenix* drifted in the oppressive heat. The stocks of water and food were running low before the ship finally picked up the south-easterly trade winds and her captain could make for Rio de Janeiro on the other side of the Atlantic.

After a few days in Rio, the *Phoenix* set off again. This time the weather was in her favour and she made good speed across the South Atlantic, rounded the Cape of Good Hope and ran on relentlessly through rain and storm due east across the southern ocean until she finally reached Hobart in Tasmania on 20 May 1822. After zig-zagging halfway across the world, Evans concluded the convicts were now in excellent health from their time at sea and would be 'a great acquisition to that fine colony'. He qualified this upbeat assessment by saying there were some 'very bad characters amongst them'. Hall Parcel was one of them.

It should all have been relatively straightforward. Unless you were given a pardon, the sensible thing to do was to earn a ticket-of-leave. To get one involved keeping out of trouble for four years while working for the government, or as an assigned man to a master. A ticket-of-leave was conditional on good behaviour, so it paid to put up with bullying masters and overseers, the forced labour and the strict discipline, because although it had to be renewed each year, a ticket-of-leave meant the convict could spend the

rest of his sentence working for himself (or someone else), although he could not leave the colony. It was the chance to make good in a new country, with the opportunity to become a substantial farmer or a successful businessman beckoning those with the sense to see it.

Hall Parcel didn't have the sense to see it. In one way he was unlucky in that Tasmania was a new colony, not so much Surgeon Evans's optimistic 'fine colony' as a rough, tough island in the early stages of settlement, barely under control and with a fearsome reputation. Had he been sent to the mainland, he might have fared better. As it was, he reverted to type. Eighteen months after his arrival he absconded from the Prisoners' Barracks and headed for the Coal River. After a few days at large he was caught and received fifty lashes as punishment. Early in 1825 he appeared in court for stealing a pin, then he seems to have mended his ways and was granted a Certificate of Freedom in 1828.

It didn't last. In November 1833 he was back in court for stealing two colts, a mare and a foal, resulting in a prison sentence. After another escape and recapture, he was sent to Port Arthur, a truly dreadful place famed for its cruelty and aptly described as 'hell on earth', where prisoners were treated worse than animals. Caught 'trafficking' in the Prisoners' Barracks, Parcel spent a month on a chain gang. In January 1836 he was accused of allowing one of his men to dig kangaroo pits, presumably to trap them. The case was dismissed, but the sorry story continues. He fell asleep at his post; he absconded; he had a 'portion of a shirt in his possession for which he cannot satisfactorily account'; he wilfully allowed two boys to escape from his gang; he used 'a most blasphemous expression' – and so on and on. Punishments varied from solitary confinement on bread and water to whippings. Common sense finally prevailed, and he managed to stay out of trouble long enough to be granted a ticket-of-leave in 1843.

Twenty-one years after arriving in Tasmania, Hall Parcel was finally a free man, but the scars of at least 200 lashes on his back would mark him as a convict for the rest of his days.

Lewis Flint was transported for ten years in 1844 rather than the usual seven. It was the longest sentence handed out to any villager, presumably because his offence was described as highway robbery. He was no romantic stand-and-deliver Dick Turpin, more an incompetent mugger, guilty of stealing '1s 11d in copper money' and a knife worth a shilling from the pockets of the town-crier of Potton. Flint was a labourer, although unlike many of his class he was able to read a little.

He sailed on the *William Jardine* and arrived in Tasmania in November 1844. Despite occasional lapses – stealing a cross-cut saw, concealing an axe (an offence which brought him six months' hard labour in chains), several drunken episodes resulting in imprisonment and so forth – Flint was granted a ticket-of-leave after five years, which was revoked in 1853 when he didn't turn up to renew it.

Of the other villagers transported in the early nineteenth century, there is little to tell beyond the bald facts. In 1826 another young labourer from Gamlingay, Stock Criswell (alias Harris), received seven years for stealing some household items, stockings and 'about half a pound of cheese'. The only woman sent to Australia was nineteen-year-old Elizabeth Bartle, a housemaid who yielded to temptation and stole a sovereign and a five-shilling brooch from her employer. She was transported in 1847, served her sentence and almost immediately got married.

Edmund Yourby was transported in 1851 for the theft of £1 17s 6d. The same year, John Gilbert, standing just under five feet eight inches tall, stout, with grey eyes and a fresh complexion, faced the Cambridge Quarter Sessions charged with stealing 20 stone of flour from Jabez Dew (the miller, and Joseph Saville's son-in-law). Constantly in trouble with the law since he was sixteen, and with a character described as 'Bad', he knew where he was going. His younger brother James soon followed him to Australia. James shared his elder sibling's grey eyes, as well as his penchant for breaking the law. In 1852 he assaulted one Robert Beard Mallows, leaving him 'in bodily fear and danger of his life' before relieving him of a shilling, the offence for which he was transported.

All nine of the Gamlingay convicts were from what contemporaries called the lower orders – at least six were labourers – and none of them were saints. They had all committed offences of one kind or another, but while the Gilbert brothers, Flint and Parcel had previous convictions, the others were young, poor and gave in to temptation. With the best will in the world it's hard to see how they deserved the punishment they received, because transportation meant more than simply being sent away to the other side of the world for seven or ten years.

With one exception they were severed from their homes and families forever. That exception was Edmund Yourby, who had returned by 1871. Ten years later he was living with his wife and daughter in Cambridge, earning a living as a hawker, and died there in 1901, half a century after he was transported. One reason the rest of them remained in Australia was undoubtedly that having served their sentences they didn't have the means to pay for a return passage, but what incentive was there to do so anyway? In Australia they had a chance to carve out a new life in a new land free from the rigid system that held them in their place in the home country. In rural England, between the years 1820 and 1850, the best that most of the lower orders could expect was a lifelong struggle to avoid pauperism and the workhouse. It's no surprise that those who survived decided to stay where they were, or that the labourers back in England were so bitter.

THE FINAL ACT

On Christmas Eve 1832, a remarkable and precocious young girl took up residence with her family at Woodbury Hall. Her name was Emily Shore, and she was the eldest of the five children of the Reverend Thomas Shore, of Brook House in Potton, who acted as curate for the rector of Cockayne Hatley but whose main income came from taking in the sons of the gentry and the aristocracy, educating them and preparing them for entry into university.

Emily was excited by the prospect of moving to Woodbury. Her diary of 8 November 1832 records:

It was now settled that we are to do what we have long had in contemplation, viz. to remove to Woodbury, a good house near Everton. The reason is that we find Potton agrees very ill with our health, while Woodbury is remarkably healthy, and is situated on the celebrated Gamlingay heath.

In an earlier entry, she had noted 'Gamlingay heath is famous throughout England for the rare flowers to be found there; I wish we lived nearer to it'. The day after the move – Christmas Day – was Emily's birthday. She was just thirteen years old.

We've already seen from her account of the arrest of Samuel Gilbert and John Baines and the farcical attempts to catch a poacher that Emily Shore was a girl of sparkling intelligence allied to a keen sense of observation. She studied everything she could, from economics to languages, but she was especially passionate about natural history. She translated Greek and Latin, composed poetry, wrote histories and romantic novels and had a gift for drawing. Not only was she clever, she was also a born writer.

Her diary, edited by her sisters, was published as the *Journal of Emily Shore* in 1891. It is a fine literary achievement, and reading her vivacious account of life at Woodbury it's frequently necessary to remind yourself how young she

was when she wrote it. There's more than a hint of Jane Austen about Emily, paralleled both in her life and in the attitudes of the gentry classes reflected in her work. An ever-darkening cloud hangs over her journal, however: the onset and progress of the consumption that killed her when she was just nineteen. But it's the four short years she spent at Woodbury that are relevant here, before increasing ill-health led her eventually to Madeira in a last, desperate effort to find a cure for her tuberculosis.

Her father had taken a five year lease on Old Woodbury from the owner, the Reverend William Wilkieson, who had bought it in 1803. Wilkieson built a new Woodbury Hall in the park, half a mile from the original house, which then became known as Old Woodbury. He doesn't seem to have spent much time in his new abode, preferring instead – like many clergymen of the period – to pass it gossiping in fashionable Bath or Tunbridge Wells.

Old Woodbury lies to the north-west of Gamlingay, perched on the edge of a steep escarpment with extensive views across the flat farmlands of the Great Ouse valley into Bedfordshire and Huntingdonshire. Emily immediately fell in love with her new surroundings, writing in 1835, 'I believe that if I were chained for life to Woodbury, and never allowed to ramble from it more than three or four miles (the utmost limit of my walks) … I believe that even in this situation I should for ever be discovering something new.'

To young Emily, it must have seemed idyllic. The house was surrounded by gardens, overlooking luxuriant, boggy pastures. White Wood was close by, with its nightingales, lilies of the valley and carpet of bluebells. The wilds of Gamlingay Heath were just beyond, waiting to be explored. She wandered at dawn in the green woods and on the Heath, and sat late at night by her open window, studying the moon and the stars through her telescope. She collected plants for her garden, observed insects and spent countless hours birdwatching, noting everything she saw with scientific precision in her diary.

Emily was interested in knowledge for its own sake, rather than for any definite end. Girls of her background were expected to be able to sew, dance, play music, converse, marry well and produce children. Anything else – intelligence, wit, livelieness – was a bonus. Essentially, hers was a life of leisure lived within the bounds of the Shores' social equals, with only occasional trips to Cambridge or London to break the monotony.

May 16th 1833
I went a good way across the heath, with a trowel, to the bogs to get flowers. What grows here chiefly is a cotton grass, which has a stalk about four inches high, tipped with a waving substance which envelops the seeds. It looks just like the cotton which is put into ink-glasses; when it is in great abundance, the place seems to be covered with snow …

Mama takes a walk in the wood every morning, to hear the nightingales and gather lilies of the valley, which are now extremely abundant, and

when gathered scent almost half the house; besides which, they are very beautiful. I particularly admire the curl outwards of the blossom.

June 23rd 1834

There was a tea-party at the Astells' [in Everton]. Mamma, the gentlemen, and all of us went, so that, with the Clutterbucks, Paroissens, and some others, we were twenty-five in number. We drank tea out of doors, while the gentlemen of the party were engaged at cricket; then followed archery and Les Graces, during which I contrived to keep close to Miss Caroline, and had a great deal of merry conversation with her ...

September 26th 1834

Amongst the plants which I brought from the bogs on Tuesday was one which had an upright, leafless, undivided stalk, with a pinky bunch of buds at the top. I could find no other specimen, and, as it was only in bud, I could not tell what it was. I gathered it, and this morning one of the buds expanded, and I was able to examine it, and found to my great joy that it was the *Menyanthus trifoliate*, or marsh buckbean, an uncommon plant, and one of the most beautiful of all English flowers.

Surrounded by her siblings, watched over by her doting parents, with her needs catered for by a company of servants, Emily was very happy at Woodbury. But it didn't last. She was already suffering from the symptoms of tuberculosis, and increasingly confined to her bed. Her worried parents decided she should spend the winter in Devon with her mother, hoping the milder climate would aid her recovery, and on Monday 3 October 1836 she left Woodbury. She had an inkling she would never to see it again.

This is my last day at Woodbury – my last morning, I should say; for we set off at eleven o'clock. I took a long farewell of house, garden, wood, heath, and every other object with which I am familiar. It was a direful morning; every object was obscured by rain, and all the country appeared to the least possible advantage, yet still I looked on it with great regret. But it was far more painful to part with papa and my brothers and sisters.

Emily never returned, dying in her Madeiran exile at the age of nineteen. She was right to describe Gamlingay Heath as 'celebrated' – it was renowned for its flora and fauna among the scientific community. (The earliest mention I have found of a plant-hunting expedition to Gamlingay comes from 1662.) The first example ever recorded of the Queen of Spain Fritillery butterfly, an extremely rare visitor to these shores, was noted in Gamlingay in 1710. A century later, Professor Henslow of Cambridge University regularly took his

students on field trips to Gamlingay Heath. The Reverend Leonard Jenyns accompanied Henslow on his first visit in 1824 when they discovered the rare natter-jack toad in the bogs on Gamlingay Heath, and later recalled that the visits were very popular with the students.

The party usually hired a stage-coach with four horses to get them to Gamlingay, and according to Jenyns, its appearance

> … with the influx of so many strangers, in an obscure village, naturally excited at first some astonishment among the natives, and puzzled them much as to the object of their coming. Nor did the sight of the nets and boxes serve to enlighten them, till they had become familiarized with the uses to which these implements were put. They then learned to take part themselves in the fun of the day as they esteemed it; and, after a time, made a sort of holiday of it, being always ready to greet the arrival of the wise men as soon as they had notice of the intended visit, and in hopes of making a little money by the sale of any rare specimens they had been fortunate enough to pick up.

If ever a paragraph could sum up the huge gap that had opened up between the common man and his betters, this one would be difficult to beat. Jenyns might have been writing about a foreign country – and in many ways he was. This piece of fatuous, pompous, patronising prose would be insulting enough if it reported some nineteenth-century expedition to darkest Africa, but the simple natives he mocks were his fellow Englishmen. I wonder what the villagers really thought when a coach-load of well-to-do young men from Cambridge decamped on the Heath and tossed them a few coins in return for specimens of the plants, insects and amphibians familiar to them since childhood? No doubt any money they received was welcome, but it would not have escaped the natives that it was their labour that produced the tithes and rents which allowed clergymen like Jenyns and Henslow the luxury of ample leisure in which to pursue their botanical interests.

Both men are recognised today for the part they played in the advancement of science, but it was another of Henslow's students, also originally destined for the Church, who would later rock the foundations of society with his revolutionary theories and achieve worldwide fame. Charles Darwin was studying at Cambridge from 1827 until 1831 under Henslow, and took part in these expeditions, as he later remembered:

> Two or three times each session he took excursions with his botanical class; either a long walk to the habitat of some rare plant, or in a barge down the river to the fens, or in coaches to some more distant place, as to Gamlingay, to see the wild lily of the valley, and to catch on the heath the rare natter-jack. These excursions have left a delightful impression

on my mind ... After our day's work we used to dine at some inn or house, and most jovial we then were.

As well as the rare flora and fauna that thrived in and around the acidic bogs on the Heath, there was another botanical curiosity in the parish which drew visitors to the village to see it. One who described it in detail was Mrs Anne Plumptre, a writer and translator of considerable gifts. In a book published in 1817 on her travels in Ireland, she relates an anecdote about Gamlingay's famous weeping ash tree.

It had been recognised as far back as the middle of the eighteenth century as a great curiosity, but it was purely by chance that Mrs Plumptre made her acquaintance with it. Her father had the living at Wimpole, and one of his servants had married and gone to live with her husband in Gamlingay. The servant kept in touch with her ex-employer, and eventually persuaded him and his family to go and see the tree. It was, said Mrs Plumptre, 'a large forest-tree, the trunk growing to a great height quite straight, without a shoot, and from the head the long branches hung sweeping to the ground, forming a perfect arbour within; it did indeed appear to us a great curiosity'. The nameless servant's husband had taken some grafts and grafted them on to common ash stocks, and eventually presented one to Mrs Plumptre's father, along with another to Lord Hardwicke at Wimpole Hall, where it was planted in the grounds.

'These were the first two known out of Gamlingay,' Mrs Plumptre asserted, going on to report that since then 'the breed has spread very much; but I believe it may with truth be affirmed, that all are descendants in a direct or remote line from the same parent'. The last time she saw the parent tree, in 1813 or thereabouts, the venerable weeping-ash had been enclosed within the vicarage gardens to save it from being chopped down.

By then it was very old. Various people had tried to work out exactly how old it really was, but one of the oldest villagers, then aged eighty-eight, could only say he remembered it as a fully-grown tree when he was a boy. 'A remarkable thing is,' exclaimed Mrs Plumptre, 'that if the seeds of this tree are sown they come up as common ash trees, the only way of propagating the species is by grafts.' By 1851 another writer recorded that 'the noted parent weeping ash, famed for its age and extent of foliage' was beginning show the effects of its longevity.

The tree lives on today through its descendants, spread far and wide by enthusiastic Victorians who thought no churchyard, public park or cemetery was complete without at least one weeping ash tree. Although not as popular today as it once was, botanical reference books still trace the variety back to its origins in an obscure Cambridgeshire village.

Emily Shore's diary starts after the end of the 'Swing' riots, but the ruling classes had been shaken by the rural revolt, and reform of the Poor Law was now on the political agenda. On Sunday 30 December 1832, shortly after

moving into the comfortable surroundings of Woodbury, Emily Shore's father was discussing the subject.

Papa said also that during the war [against Napoleon], when the farmers were rich and flourishing, and were amassing thousands upon thousands, they showed the most brutal indifference to the poor who were perishing around them; but that now their turn came, they were getting poorer and poorer, their rents were not paid, and they were eaten up with the poor rates.

Something had to be done. The government dispatched commissioners all over the country with instructions to report on the operation of the Poor Law, which was to be drastically overhauled for the first time in 200 years.

Alfred Power, esquire, was given the task of looking at the way the Poor Law functioned in Cambridgeshire. His report was published in 1833 in a volume called *Extracts from the Information Received by His Majesty's Commissioners as to the Administration and Operation of the Poor Laws.*

Power said the poor rates in Cambridgeshire were used in three main ways. First of all, there were the weekly payments given to the old, the impotent poor and to widows. Then there were the wages paid to paupers working for the parish. Finally there was the money paid to the 'occasional and casual' poor – those suffering 'real or pretended' sickness, and the men whose earnings were made up to a subsistence level by the overseers.

When he wanted an example of the appalling mess a parish could get into when grappling with the problems caused by large numbers of paupers, Alfred Power turned his attention to Gamlingay. There were, he said, 'few worse examples of oppressive rates, aggravated by extreme mismanagement, than the parish of Gamlingay'. He went on:

The present population is 1,319. The advantages afforded by the waste land in a supply of fuel, and the permission to build cottages on it, have attracted the poor from the neighbouring parishes; and a vast quantity of settlements have been made by the farmers letting their land during a part of the year to be dug for potatoes at high rents. As many as thirty families have been introduced in this way.

Although farmers were providing outsiders with a legal settlement on the Heath in order to get the high rents for their land, the extra burden on the rates was met by all the ratepayers. The consequence was, of course, that the rates went on rising year by year.

The eldest of my informers (all occupiers) remembers the poor-rate amounting to only £50 – that was sixty years ago [i.e., in the 1770s]; the expenditure of the year ending March, 1832, was £1,427.

The rates, therefore, have already approached to very nearly 15s in the pound, and the constant decrease of capital and cultivation threatens a further augmentation. The increase of the last over the preceding year was £100. The disbursements of the last year stand thus:

Aged, impotent and widows	£318
Paupers working for parish	615
Materials, tools, & c.	54
Occasional casual poor relieved for sickness, & c.	316
Medical attendance	54
Law expenses, removals, & c.	17
Bastardies	10

Sometimes there were disputes over the payments, which were settled by recourse to the local Justice. The labourers knew which Justice would be likely to be sympathetic to their case, and used the knowledge to their advantage when they could. Power related an anecdote to illustrate this:

The overseer there told me, that a few days ago he had a difference with several of the paupers about their parish pay, when they summoned him before a magistrate who lives about six miles off [in Wimpole]. On the day of their attendance there, something prevented the case being heard, and they all returned to Gamlingay together. In passing the house of another magistrate [in Hatley], about two miles from home, the overseer said "Now, my lads, here we are close by; I'll give you a pint of beer each if you'll come and have it settled at once, without giving me any more trouble about it." The proposal was rejected without hesitation. I merely mention this to show that paupers have their preferences ...

It also shows they were not as simple as most educated people thought they were. They knew the magistrate at Wimpole would be more lenient than the one at Hatley.

Although this ancient, shambling, rambling system was patently on its last legs, it was only when Power turned his beady eye on the wages paid to paupers working for the parish that he discovered the truly ludicrous side of the picture. He tells us that single men earned about 6s a week from their employers, and married men from 9 to 10s a week. Topped up from the poor rate, single men had a weekly income of about 9s a week, while a married man with four children could expect to receive some 18 or 19s a week on which to keep his family.

Power went on to say that there were now between seventy and eighty men and boys employed by the parish, with an average throughout the year of about forty.

The sole employment is that of collecting stones from the surface of the land, for which they are paid at the rate of 2*d* per bushel, until they have earned the sum allowed by the bread scale, they then do as they please for that week.

Power thought this account 'seemed rather a puzzling one'. He could not understand why the paupers continued to be employed as stone-pickers. Surely they would have run out of stones to pick up sooner or later? Neither could he understand how, with stones fetching 1½*d* a bushel, only just over £11 worth were sold, to be set against the £615 it cost to pay the paupers to collect them.

Power admitted that he was 'not fully satisfied'. It clearly doesn't make sense. But there was a simple explanation, so obvious that I wonder the astute Mr Power didn't realise what it was until later, when he was leaving the village.

I encountered a group of boys and men, eight or ten in number, from the age of sixteen to twenty-five, about a stone heap, busily employed, some with their hands, some with large sticks by way of bats, in returning the collected stones to the impoverished acres.

That's why there were always stones to collect, why it cost the parish so much money to employ the paupers to collect them, and why such a small sum appeared on the other side of the balance sheet for selling them.

As a costly but effective way of providing unending employment, as a way of ensuring the labourers lost all sense of dignity and pride, and as an almost total waste of everybody's time it was an unbeatable system. Someone, surely, must have realised the utter futility of paying one lot of paupers to pick up the stones, and another lot to put them all back again? And the people who devised this system thought the labourers were stupid.

My interview with the overseers (the appointment I had made with them having become known) was voluntarily attended by about six of the other principal occupiers. The external appearance of these men betokened a want of agricultural capital; and they spoke of their parochial burthens in a despairing and almost reckless tone. They could not help themselves. They had in vain attempted several times to share the whole labour of the parish amongst themselves, according to the extent of each man's occupation ...

Apparently, a strong practical objection to dividing Gamlingay's pool of labour among the farmers was that pay night occurred weekly, whereas the rate collector only called fourteen times a year. They had tried to employ the poor in draining the unenclosed fields, but the protests of the ratepayers

who owned or rented land already enclosed and who didn't feel inclined to pay towards improving unenclosed land killed off the idea. Under these circumstances, 'they seemed to have abandoned all thought of mitigating their burthens by a strict and proper administration of parochial affairs'.

At the same time as forking out all this money, the parish officers were defending an indictment at the Quarter Sessions for the 'infamous' state of the parish roads. 'On this point', declared Power, 'I am bound to say that, if the evidence be properly arranged, they must suffer a verdict.' It was, and they did. The parish was fined £150, which it was ordered to bestow upon repairing the roads.

This disgraceful state of affairs, and the misery it brought to the labourers in particular, was summed up by Alfred Power in a judgement with which it is very difficult to disagree. Gamlingay consisted of 'an impoverished race of farmers' who were 'screwing down a miserable, ill-lodged, and ill-fed population to the very letter of the bread-scale, and with difficulty producing their rates'.

It was the farmers who had grabbed the chance to cut wages in the 1790s; who introduced the bread scale; who encouraged so many newcomers to settle in the village for the sake of a quick profit; and it was the farmers who failed to put aside some capital during the boom years of the Napoleonic Wars. It was they who pauperised the labourers, and it was their own selfish greed that was mainly responsible for the appallingly stupid application of the Poor Laws. In the end it was the farmers who suffered – but the labourers and their families suffered vastly more. And it was Parliament that finally put an end to this sorry state of affairs.

In response to the overwhelming evidence of mismanagement throughout the country that reached the Commission, the government took away the independence of parishes and ordered the formation of local Poor Law unions. It wasn't a perfect solution, but at least it removed some of the worst excesses of the old system. From 1835 Gamlingay became part of the Caxton and Arrington Union. After a year in operation the chairman, the Earl of Hardwicke, reported a saving in expenditure of about £2,600 in the first year, although,

> ... it is to be remembered that this reduction has taken place without the aid of a workhouse. We put up a hand corn-mill during last winter, which employed 17 or 18 able-bodied men for a short time, but it was difficult to find hands to keep it at work.
>
> With regard to the condition of the labouring classes, I should say that a visible alteration has taken place in their manners; all farmers I have conversed with, say that they are more respectful and civil in their behaviour, and more regular to their time of work. The parishes in the Union have never been so free from crime.

In Gamlingay 'the saving has been enormous' and the able-bodied had been employed during the winter, generally never having more than about '17 to 20 out of work at any one time', which compared very favourably to previous winters when a hundred men on average were receiving relief.

The introduction of the New Poor Law was, in the main, welcomed among the landed gentry. Emily Shore noted in her diary on 9 September 1836:

> Mr Astell called. Amongst other things, papa and he conversed about the new Poor-law, which seems to be generally approved of throughout the country, although there is unfortunately a considerable opposition arising.
>
> ... Mr Astell, for one, who is high Tory, speaks of it with the highest approbation. He says it has already produced astonishing effects everywhere. In Gamlingay, for instance, the rates are already diminished two-thirds ... If it goes on working thus, says Mr Astell, there will, in a few years, be not a pauper in the country. This Bill is one of the most important political changes which have been made within my recollection, amounting, as papa said, almost to a revolution among the labouring classes.

The poor were not so sanguine. The New Poor Law of 1834 did not attempt to deal with the causes of poverty, but only with the symptom of pauperism. The New Poor Law was much stricter than the old one. If you wanted relief now, you had to enter the workhouse to get it (one was soon built in Caxton). The workhouse was deliberately made to resemble a prison. Families were broken up, the diet was poor, all 'luxuries' of life were excluded and special workhouse dress had to be worn.

The introduction of the New Poor Law was also a signal that the traditional expectations of the poor must be abandoned, and that they should instead conform to the new economic and social ideas brought about by the Industrial Revolution. In rural areas two good harvests following the introduction of the New Poor Law, and the demand for labour to build the railways, together with the removal of the excesses and abuses of the allowance system, largely eradicated the problem of rural pauperism – but not rural poverty.

A year after the New Poor Law came into operation Emily Shore recorded a visit to the Heath. Her family was comfortably off, and she moved effortlessly in a society where her friends and acquaintances were, like herself, the children of gentlemen. Rarely does she acknowledge the existence of a servant or anyone from the lower orders, but we must not be too hard on her, for members of her class seldom acknowledged anyone from below them in the social hierarchy. They did, however, consider visiting the poor an act of charity, and Emily had no difficulty in finding poor people to visit.

August 9th 1835

In the evening I walked to the heath to see some poor people of the name of Betts, whom I sometimes teach a little. They are miserably poor, and live in a mud cottage, built by the man himself, and containing only two rooms for themselves and six children. The man can read, and is tolerably intelligent; the woman is deplorably ignorant, and knows nothing whatever of the doctrines of the Christian religion, so that she requires the very simplest instruction.

The family she refers to was that of James and Elizabeth Betts. He was a forty-two-year-old labourer, probably one of the many brought in from neighbouring parishes by the farmers to work the land. As always with the poor, the wonder is how they managed to survive such abject poverty at all, but survive they did. The alternative was now the workhouse. James himself lived for another thirteen years, two of his children reached their twenties before dying, while his eldest daughter Mary lived to get married in 1838. They were not the only family struggling in such dire straits on the Heath. Emily's diary entry continues:

Another family, of the name of Barford, lives close by; these also I sometimes go to see. They are a very cleanly, industrious, worthy couple; they have just lost a daughter of a decline, whom I used to go and read to sometimes while still ill. She died July 20. I saw her corpse the next day; it was a very affecting and melancholy sight. It was the first I have seen. The deathly pale of the countenance, the whiteness of the lips, and the unmoving look give a dead body a very ghastly appearance.

There were many Barfords in Gamlingay at the time, but the family Emily visited was most likely to have been that of forty-seven-year-old Samuel Barford, labourer, his wife Ann and their four daughters. He was still living on the Heath in 1851, still working on the land, but now a widower sharing his home with his daughter Hannah, who occupied her time making straw plaits.

For agricultural labourers like Samuel Barford and James Betts, the price of surviving to relative old age was high. Betts, don't forget, shared a mud hut with his wife and six children. Both men had witnessed the deaths of their children and their respective wives; they had lived in poverty and known despair; had suffered malnourishment and the pangs of hunger and been treated all their lives as second-class citizens at best and brutes at worst – this in their own country and by their supposed betters – however 'worthy' and 'industrious' they may have been.

While we can forgive Emily much because of her youth, it's more difficult to forgive her class as a whole. Living in comparative luxury they dutifully visited the poor, but only occasionally thought to take some sustenance or

Sketch map of the village fields in 1602, based on Langdon's survey.

Gamlingay wood

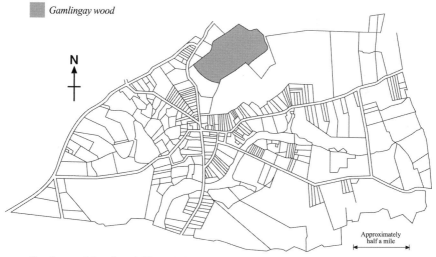

Sketch map of the village fields in 1850.

These two maps vividly illustrate the results of enclosure. The ancient open field parish was a patchwork of irregular furlongs, each with its own descriptive name. After the Victorian Enclosure Commissioners had imposed their rigid geometry on the landscape only the old enclosures around the village core remained.

dole out a few pennies to help people like the Betts and the Barfords. What they needed was nourishment and a decent roof over their heads, but what they got was the Bible pushed down their throats instead. The spectre of the workhouse was to haunt the village labourers and their families for another hundred years.

The period from 1830 until 1850 is the low point in the fortunes of the labourers and, by extension, of the village itself. The bond-peasant of the middle ages was in many ways more free and independent than the cowed and brutalised labourers of the 1840s. At least the medieval peasant had his common rights; the right to graze animals at certain times on the village land, the right to gather fuel from certain places at certain times, and so forth. The labourer of the 1840s had in most villages lost even these rights, although it took until the end of the decade for labourers in Gamlingay to lose theirs.

The reason the labourers lost their rights is very simple. Even the dimmest and most ill-educated villager must have known that the end of commons, open fields and the ancient way of agriculture was in sight. Most of the rest of East Anglia and the Midlands had already been enclosed in the second half of the eighteenth century and the early part of the nineteenth. In Gamlingay, enclosure had been going on piecemeal for centuries. By the 1830s there was almost as much enclosed land in the parish as there was unenclosed arable land that continued to be farmed in the traditional three-field rotation way. It wasn't just Gamlingay that was in dire need of enclosure – there were still 130,000 acres of open fields in Cambridgeshire in 1794, giving the county the reputation (noted by the Board of Agriculture) as 'the worst cultivated in England'.

The trouble with Gamlingay was the old one that had plagued it for centuries. It lacked someone to give it direction, someone able to take on the costs of enclosure: to secure an Act of Parliament, buy mile upon mile of fencing, and so on. The idea had been mooted many times as the answer to the village's problems, not least by Alfred Power, who said enclosure 'would give them great temporary relief, and better them permanently to a certain degree' ('them' being the impoverished farmers, of course, and not the labourers). But there were always objections, from the poor, who would lose their common rights, from Merton College and others who objected to the expense of enclosure, and because of the 'difficulty of arranging satisfactorily to all parties with respect to the tithes'.

Then, following an Act of Parliament in 1836, it became possible to save a large part of the expense connected with enclosure. The need for a private Act was dispensed with, and enclosure by consent was allowed, as long as two-thirds of the interested parties (the landowners) agreed. Merton College, the largest landowner in Gamlingay, after dragging its heels for nearly a century, changed its mind, and the destruction of the ancient village could finally begin.

Commissioners were appointed to parcel out new fields in proportion to the ownership of strips in the common fields. For the first time since Thomas Langdon's maps of 1602, surveyors accurately measured the whole parish and produced a new map in 1844. Langdon's had looked backwards into the medieval village. The Enclosure map looked forward to what was to come. The future was to be large fields with straight boundaries in typically rigid Victorian style, instead of the old higgledy-piggledy medieval furlongs and strips. There was to be a new road (still called 'New Road'), linking the Cambridge and Hatley roads for the first time. Those seventy or so people with common rights and perhaps a strip or two in the open fields were to be granted smallholdings or allotments in compensation.

And so it came to pass. The commons were common no more, save for six acres renamed 'Recreation Ground' and preserved as common ground on the northern edge of the parish. Public roads were clearly defined and given regular verges. Those ancient trackways and strips of pasture known as hadens, deans, ways and slades which ran between the furlongs were either incorporated in the new fields or became 'Private Carriage Roads and Driftways' allotted to the appropriate landholders. Fourteen footpaths became 'discontinued rights of way'. Instead of being able to wander at will over practically the entire parish, villagers were restricted to public rights of way and their own property. Soon they would be confronted with notices painted with the words 'trespassers will be prosecuted' – a legal nonsense, but a sign of the new order of things. It was an enormous upheaval in the landscape, and a millennium of history was swept away virtually overnight.

Blythe Farm in Mill Street illustrates the effects of enclosure on a single farm. It was owned by Clare Hall, a Cambridge College, and their main holding in the open fields was surveyed in 1794. By chance the map that was made following the survey has survived. It shows that the farm's 98 acres were split almost equally among the three great common fields: 33 in Shortwood Field, 30 in Middle Field, and 35 in Potton Wood Field (the names correspond to the medieval East, Middle and South fields respectively). Those acres were made up of more than 130 separate strips, consisting on average of one or two ridges, scattered the length and breadth of the parish, which made it virtually impossible to exploit the full potential of the farm.

Following the Enclosure Award fifty years later, those strips were taken from Clare and in return they were given one large field of their own. The same procedure was followed throughout the parish, landholding by landholding, until the new village was laid out to the satisfaction of all the interested parties, and the Enclosure Award finally confirmed in 1848.

The result was a brand-new landscape of regular fields, each in single ownership. Now enterprising farmers could put into practice new, intensive farming methods. They could drain their lands, fertilise them, and grow precisely the crops they wanted to grow without having to consult or consider

their neighbours. One or two farmers built outlying farmhouses away from the main village, in the middle of their own land. In addition, 700 acres of waste land was now available for use as arable. Enclosure enabled the wealthier landowners to become even more prosperous and grow even further apart from the rest of the village, but in the long run the village as a whole benefited from its effects.

But what of the poor labourers, robbed even of their common rights? Much has been written on this subject by historians, and the effects of enclosure exaggerated by some. The right to graze a cow on the commons was all very well, but you had to own one in the first place to take advantage of it. Few labourers could afford to buy more than the bare necessities to sustain themselves, let alone buy and maintain a cow. Losing the right to gather fuel was, no doubt, a serious blow for some and probably made them worse off than before, until the railway arrived a few years later and brought with it relatively cheap coal.

The most important result of enclosure for the labourers was that without common rights they became totally dependent on the wages they could earn, and even more at the mercy of the farmers. The final act in the demolition of the old village came a couple of years later when the much-resented system of paying tithes in kind to the Church was commuted for an annual fixed payment instead.

The curtain had finally come down on the ancient village. The three great fields hacked out by the first settlers more than a thousand years before had gone. Slowly but inexorably, economic and social forces had changed the villagers from medieval peasants and bondmen into farmers and landless labourers, the open fields into regular, privately-owned ones, and the village from one community into two. Now there were, on the one hand, those stalwarts of the Victorian parish recorded in county directories – the gentry, landowners, farmers, publicans and tradesmen; and on the other, there were those people ignored by the directories whose lives were spent in grudging silence before their betters. In other words, by 1850 there is in operation the fully developed, typically English, class system.

A STORY WITHOUT END

Although the story of the old traditional village ends in 1850, there's no end to history, and since one of the reasons we are interested in the subject is to discover what happened next, this brief chapter is for readers who are curious about what happened to the village and its inhabitants during the succeeding 150 years.

By 1850 a new, modern Victorian Gamlingay had emerged from the upheaval of enclosure. In effect, there were now two villages: the dark, unplumbable one of poverty and hardship, and the 'directory' village of farmers, landowners and tradesmen. Since much of the last few chapters was taken up with the poor, let's take a look at the other village, as seen through the eyes of one of those directories: Gardner's *History, Gazetteer & Directory of Cambridgeshire*, published in 1851.

Eight of the inhabitants listed in its pages are noted separately, and are obviously of superior caste to the rest. In alphabetical rather than heirarchical order they are: Sir Williamson Booth; the Reverend Doctor James, rector; George Heckford, surgeon; William Hepworth; Enoch Manning, the Baptist minister; Mrs Ann Paine; James Paine, esquire, of Brook End House, and William Wilkieson. Booth and Wilkieson both 'reside at Woodbury'.

Then come the farmers – eleven of these – Dews, Paines, Tophams, Woodhams, etc. – followed by the village tradesmen: blacksmiths, builders, saddlers, grocers, drapers, tailor, a milliner and a 'carrier to Cambridge'. Six licensed victuallers are listed at The Bull, Falcon, Chequers, Cock, Oak and Wheatsheaf, whose establishments were used by what it's now permissible to call the middle classes. Beneath them come the nine beer retailers. The names of their humble beerhouses were not deemed worthy of note by the Directory. Licensed for the first time in 1830, beerhouses were used by labourers and others of the lower orders, and were consequently viewed with suspicion as hotbeds of discontent.

The population was rising rapidly. In 1801 the first Census recorded 847 inhabitants; in 1831 there were 1,319; and by 1851 the number had risen

to almost 1,900, more than double the figure at the turn of the century. Yet Gardner's Directory lists only fifty-six people. Even assuming each person named had a family, that shows what a large proportion of the village belonged to that other, twilight world. What of them? Some were servants, employed in the houses of the middle classes or those higher up the social scale. Some were children, some were old, and some were housewives tied to large families. Most of the men and boys worked on the land. James Paine at Brook End, for example, employed thirty labourers, plus a farm bailiff, groom, cook and a housemaid who lived in with him and his family.

A lot of labour was needed to carry on the progressive farming methods which replaced open-field agriculture. Farming was the largest employer of labour in the village, with much extra work of fencing, ditching, draining and so on being necessary following enclosure. A Parliamentary Commission into the employment of children and women in agriculture in 1867/68 heard from the rector that in Gamlingay,

> Persons of all ages from 6 to 60 years are employed in the fields in spring in weeding, seeding, &c; summer, in gathering early potatoes; autumn, harvesting; winter, in sundry field work. The women, however, are much employed at home in straw plait work. The hours of work are from 6 to 6; of those who live at a distance from their work, some are out from 4 or 5 a.m. till 7 p.m. One hour allowed for breakfast, and the same for dinner.

Getting up so early and walking a couple of miles or more to work in all weathers, combined with the hard physical toil in the fields for ten hours a day and the long walk home, took its toll on labourers (let alone on small children). There was little time for leisure pursuits before it was time to go to bed to be ready for the next day's work. Small wonder that men often called in to a beerhouse on the way home, or that some dropped in to one on their way to work, until eventually the opening hours of pubs were regulated for the first time during the First World War. For it's a curious fact that despite the low wages paid to labourers throughout the nineteenth century and into the Depression of the 1930s, most of them still managed to find enough money for their beer and tobacco each week.

Farming, in fact, went through something of a golden age during the thirty years after 1850 when prices were buoyant and the boom in urban development provided a ready and expanding market. Sending produce to these new outlets became much easier after 1862, when the railway eventually arrived. Part of the Oxford-Bedford-Cambridge route, the line was built in a long, gentle curve from Potton through the south-eastern corner of the parish. It followed the course of the brook, and some small embankments and cuttings were necessary before the line left the parish and headed for Cambridge. The

station was built a mile or so away from the village, which meant a long walk for people who wished to use the new facility.

Will Webb, an old man when I knew him, but who as a child had lived on the Heath in the early 1890s, explained how exciting the railway seemed to village children, and illustrated it by relating how he'd somehow managed to scrape together the few pence fare to make his first journey by rail. He walked from the Heath to the station at the other end of the parish, caught the train to Sandy, then had to walk the five miles home again as he didn't have enough money for a return ticket. The thrill of travelling by train more than made up for the hot, dusty walk.

In a subtle way, the arrival of the railway did change rural life. The pace of it quickened and has gone on quickening ever since. Until the coming of the steam train, the fastest you could travel on land was on horse-back at a gallop, and then for only a short distance. Most villagers, if they wanted to visit a nearby village or town, had little choice but to travel on foot. A journey of any length involved travelling on horse-back, or in horse-drawn carts, carriages or coaches. Going to Cambridge and back, a journey of about fifteen miles each way, would have meant an early start and a late return, with an overnight stay thrown in during the winter months. But with the advent of the train, you could sit in relative comfort, travelling at speeds undreamed of by earlier generations, and be in Cambridge less than half an hour after leaving Gamlingay station.

As with all new technology, the snag was that you had to be able to afford it to make use of its potential. Most ordinary people could not afford the fares, which only came within reach of the majority later in the century. To some villagers the railway meant work; not well-paid work, but work nonetheless, and relatively secure. Theoretically, rail travel brought Gamlingay in particular and rural England in general into much closer contact with the rest of the world. Locally, I suspect that most of its real impact was on farmers, by giving them access to new markets in the growing towns, and that it didn't make much difference to anyone else. The steam train belching smoke as it puffed its way along the line slicing through the new regular fields quickly became an accepted part of the mid-Victorian village landscape.

As well as the railway, two other areas of employment opened up in the decades following enclosure. One was in the digging of coprolites (nodules of phosphate of calcium), which when treated produced an artificial fertiliser of great value to progressive farmers. During the 1860s, in a mad scramble of coprolite fever, landowners sought to exploit the new-found wealth beneath the soil, and labourers found lucrative employment in digging them out. There were no coprolites in Gamlingay, but plenty in the Potton and Sandy area. In 1867, the rector pointed out to a Royal commission that the 'coprolite diggings in our neighbourhood have occupied very many of our boys, many of whom earn at them 8s and 9s a week, which is more than the farmers can give them'. It was very nearly as much as the farmers gave their men.

The other, and longer-term, area of new employment was in brickmaking. Bricks had been made in the village from at least the sixteenth century, but most of the best brick-earth was to be found under the Heath, on common land. After enclosure the Heath became available for exploitation, and it was exploited for all it was worth. One of the two brickworks established on the Heath was a smallish set-up which continued production into the twentieth century, but it paled into insignificance in comparison with Belle Vue Brickworks.

By 1912 Belle Vue Brickworks had gobbled up thirty-one acres of land in one enormous pit, surrounded by the attendant plant: kilns of various sorts and sheds with a capacity of half a million bricks. The works produced tiles and pipes as well as sewer bricks, fancy bricks and the rusty-red facing bricks that went into most of the village houses that were built during this period. For sixty years the brickworks provided an alternative to the tyranny of the land, but by 1922 the works were closed, the specially-built railway sidings fell into disuse, and the pit was allowed to fill with water to become a haven for wildlife, fishermen and generations of swimmers.

After enclosure there was a change in the way some of the land was used. Arable farming continued in the new fields, with wheat, barley and oats as the main crops, particularly on the heavy clay, but on the lighter soils many people began to use their new allotments as market gardens. By 1896 fourteen men were earning their living in this way, and some small farmers had split their fields into half-acre strips and were growing market garden crops. The vegetable and salad produce could now be sent to local markets by rail, even to London.

One of the consequences of low wages was the terrible condition of the homes in which so many working people were forced to live. This had been true for a long time, but the Victorians had developed a conscience about many aspects of working life, usually expressed in a flood of Parliamentary and other commissions. They often seemed shocked by what they found. Quite why this should be is difficult to say, unless they went around with their eyes firmly shut.

In 1865, a report by the Privy Council's Medical Officer singled out and comprehensively damned Gamlingay's cottages as being some of the worst in Cambridgeshire. It said the village

> contains some of the most miserable cots met with anywhere. Some of Mr Woollam's are more execrable than any group in the county. They are in advanced stages of dilapidation ...
>
> ... the poorest thatched hovel is sure of a tenant, for it is part of the straw plait country ...
>
> ... a deadly lassitude, a hopeless surrendering up to filth, affects Gamlingay, and the neglect of the centre becomes mortification at the extremities, north and south, where the houses are rotting to pieces ...

£3 is a common rent for a wretched hut, and one not worth £20 was let at £2 15s. Eight and nine people were found in the single bedroomed houses, and in two cases six adults slept in a room with a child or two.

Karl Marx bowdlerised this report two years later in his influential book *Das Kapital*, throwing in his own description of the village as a 'poor rookery'. Many people have since assumed that Marx had been to Gamlingay and discovered the facts for himself. In reality, he came no nearer the village than the library of the British Museum.

These unhealthy, crowded, tumbledown cottages with their communal water supplies and inadequate sanitation were perfect places for diseases to flourish. An outbreak of cholera in Green End in 1849 killed fourteen villagers, who were all (as smallpox victims had been) buried at night. Cholera is a bacterial infection of the bowels spread by contaminated water supplies, and more than 33,000 people died of it in Britain during the summer of 1849. The eldest victim in Gamlingay was seventy-two-year-old Sarah Roberts, the youngest eighteen-month-old Ann Hill. But mere figures only serve to mask individual tragedies. Stephen Cole, twenty-eight, a labourer, buried his sister, daughter, wife and son within the space of ten days, and was left to bring up his four surviving children alone, the youngest a babe in arms. John Waterfall, a shoemaker, and his wife Hannah, both in their thirties, also succumbed, leaving four young orphans. The 1851 census shows three of them living with their pauper grandmother.

The cholera outbreak was followed by one of typhoid in Dutter End in 1851. Typhoid could be spread by contaminated food or water, but fortunately only two people died on this occasion, one an eight-year-old girl. The victims of both outbreaks died as a direct result of the conditions in which their poverty forced them to live.

The same report on Gamlingay's cottages pointed out that the availability of straw-plaiting work meant 'almost every woman can get a living if she will let her house and children take care of themselves, or be taken care of by the men and boys'. Straw-plaiting and making pillow-lace were important female occupations among the lower orders. Pillow lace was produced on a three-legged frame called a pillow-horse. Many women and young girls ruined their eyesight and damaged their spines working at a pillow-horse. Just how vital these occupations were to the income of poor families is revealed by the 1851 Census, which lists twenty-three lacemakers and no less than 152 straw-plaiters. By the turn of the century, pillow-lace and straw-plaiting had declined: changing fashions and the introduction of new machinery killed off these rural industries and only one or two older women still practised the arts.

I have a photograph of Susannah Panter, taken early in the twentieth century, which shows her sitting at her pillow-horse on the path outside her

home. Looking quizzically at the camera through her glasses, she is hunched over her work, her hair in the tight bun fashionable when she was young. Now an old woman (born a mere ten years after the Battle of Waterloo), she was photographed as a picturesque curiosity in Edwardian England.

Where children worked – and the rector reported in the 1860s that in Gamlingay, 'All children are at work from the earliest age at which they are able to work' – their formal education was frequently neglected. The 1870 Education Act set up nondenominational, secular elementary schools managed by school boards, and in 1880 school attendance was made compulsory up to the age of ten. Neither the National School nor the British School survived the establishment of the Board School in 1874 – a large, ugly Victorian building which still provides village children with their primary education (and provided me with mine).

As the School Board Minute Book clearly shows, the chief difficulty the school faced during its first three decades was that parents clearly thought they needed the money their children could earn rather more than they thought their children needed educating. Children's earnings, little enough from such tasks as bird-scaring or light labouring, were nonetheless a valuable source of income. There are frequent complaints in the minutes about irregular attendance, and equally frequent requests from parents for their children to be excused because they have to work.

In 1888, the Board decided to prosecute William Gray because his eleven-year-old son was working instead of attending school, and other parents were threatened for the same reason. Many of the poorest families lived on the Heath, and as late as the final year of the century the Board told the Attendance Officer to 'pay particular attention to children living on the Heath who might be employed in labour & who ought to be attending school'. In turn, the school inspectors often threatened to cut the grant received by the school unless attendance improved.

The inspector's report for 1886 noted that 'the Boys seem to be below average in intelligence and many of them come from poor and rough homes', while the girls 'come from Rough homes and there is much difficulty in giving them a good intonation'. I doubt if having a good intonation was a priority in most poor families. School fees were often remitted in times of hardship, as in 1887 for example, when Mrs Hibbett and Mrs Baxter were excused the fees 'providing their husbands were not employed for more than three days a week'. The same year the inspectors condemned the Infants' class with faint praise by saying it 'fully deserved the mark of fair'.

Poverty became more acute as the agricultural boom turned into the depression of the 1870s. It became cheaper to grow wheat on the vast American prairies and ship it to England than to grow it in places like Gamlingay and send it to market by horse and cart or train. Many farmers, especially the smaller ones, gave up the unequal struggle and sold out. The Victorian

conscience pricked again, and in 1887 another parliamentary enquiry into the state of agriculture found that in this corner of Cambridgeshire the effects of the depression were to make considerable tracts of land virtually worthless.

Even someone as well-off as Octavius Wedd, who lived in Fowlmere, near Cambridge, but who had a farm in Gamlingay, was hard up and anxious for money, as two letters to his farm manager John Dew illustrate. On 24 November 1886 Wedd wrote to Dew, 'Go to St Neots with the Barley & do the best you can with it, if you don't see me on Thursday, *only sell it.*' [My italics.] Four days later he wrote, 'By this mornings Post I heard about my Barley at Cambridge Market yesterday and the Trade was awful. There was no selling ordinary Barley into money; with all the buyers in that great Market perhaps one would make a bid of 4 or 5/- under what he was asked. I wish you would go over to your Uncle's at Caxton before he goes to St Ives and ask him to take it there and *turn it into money somehow.*' [Wedd's italics.]

Fear of the workhouse hung over those who struggled to find work or were too old to carry on labouring (there were no pensions for working people until just before the First World War). It was a very real fear, too. During a six month period in 1870 the Caxton and Arrington Union listed 138 Gamlingay folk receiving assistance. Eighty-three were noted as Outdoor Poor, meaning they were allowed to live at home. Forty-seven of these were described as disabled and were maintained for the whole half-year, receiving amounts varying between £3 and £4 in total. There were other payments to people during times of illness, mostly of a few shillings until they recovered or died, to the long-term sick as well as seven widows with children. Once again, the question is: how did the sick and disabled and the widows with families manage to live on little more than two or three shillings a week? It was scarcely more than they would have got a hundred and fifty years earlier.

No doubt they would all have said they were far better off than their fifty-five fellow-villagers who had been incarcerated within the forbidding walls of the workhouse in Caxton at one time or another during those six months in 1870. These people were not those whom the Victorians thought of as the deserving poor. These were people – and in some cases, their families – who had reached rock-bottom because they were unemployed or old, and could not maintain themselves. Some were noted as having been in the workhouse for a matter of a few days or a week or two, and had managed to extricate themselves from their predicament. Seventeen people had been shut up for the whole period, including eight members of the Norman family.

The reality of Gamlingay and countless other rural villages in the period from the start of the agricultural depression in the 1870s until 1914 was poverty. Even after more than sixty young men of the village had been slaughtered in the carnage of the First World War, the roll-call of the dead full of familiar surnames, the general picture didn't change much and farming continued to be depressed well into the 1930s. My father and others of his

generation, the sons and daughters of farm labourers who were growing up in the years before the outbreak of the Second World War, can still recall the poverty and the pangs of hunger.

The Elementary School, as it was now known, did its best to live up to its name and teach the village children the rudiments of reading, writing and arithmetic, although one of the teachers noted that in 1929 there were four or five boys in her class who could neither read nor write. The teacher in question was Margaret Gardiner, who lived to be 100, and in the many obituaries that followed her death in 2005 she was lauded as a patron of the arts, a friend and supporter of just about every well-known artist and writer of the twentieth century, with an extensive art collection now housed in the Pier Arts Centre she founded in Orkney.

Her father was Sir Alan Gardiner, the leading Egyptologist of his time, and his daughter grew up in culturally privileged surroundings, first in Berlin and then in London. She spent three years at Newnham College in Cambridge, but after the death of her first love she felt she lacked direction, and decided to become a teacher. Her first and, as it turned out, last teaching post was the year she spent teaching Standard V in Gamlingay. Miss Gardiner did not like the village. 'Set in flat, market gardening country,' she wrote in her 1988 memoir *A Scatter of Memories*, 'Gamlingay, with its undistinguished red and yellow brick houses was not, in spite of its romantic name, beautiful.'

She liked her pupils and they seem to have liked her, though she was not, as she quickly came to realise, cut out to be a teacher. She could not control her young charges. 'Crowded in their dark cottages,' she noted, 'often a little hungry and sometimes cold, they were for the most part tough, suspicious and unimaginative.' There was little to stimulate them in what she called 'the ugly village'. She was surprised to learn that some of her class had never been to Cambridge, and when she took a few of them in her car to visit a friend there she was amazed to find that none of the boys had ever seen a house with electric lights. Throughout the visit they took it in turns to switch them on and off, 'with as many oohs and ahs of wonder as though they had been watching fireworks'.

Other than Mr Dalley, the headmaster, with whom she enjoyed an uneasy but friendly relationship, Margaret Gardiner changed the names of everyone she mentions. She described her intense dislike of a fellow teacher, 'Captain Wade,' a First World War veteran fond of telling tales of his adventures in Mesopotamia and equally fond of beating the children with the swagger-stick he habitually carried. My father, who has never forgotten the painful crack across the thighs he received from that swagger-stick, immediately identified the man as Mr Daniels. But Miss Gardiner successfully obscured the other villagers, including 'Mrs Flack, a fat and greasy old woman' with whom she lodged.

During a visit to Berlin in the Easter holidays Margaret Gardiner met the young poet W. H. Auden and struck up an immediate friendship that was to

last until Auden's death. She invited him to stay with her in Gamlingay, a visit which probably raised an eyebrow or two, not least from 'Mrs Flack', who presumably did not know Auden was a homosexual. Auden amused himself while Miss Gardiner was teaching by driving around the countryside in her car, returning on one occasion with a chicken he had run over and killed. When she asked him what the farmer had said, he grinned and replied 'I didn't wait to ask him'. Margaret Gardiner soon put her short stay in Gamlingay behind her, and I doubt if Auden's brief sojourn had any effect on him at all.

There is much truth in her brief pen-portrait of Gamlingay in 1929/30, for the village stagnated during the inter-war years. Despite the crying need for better housing, little building work was done, although a few council houses were built for those who could afford the rent. Most villagers still got their water from the well or from a pump, and used outside earth closets. In the early 1950s mains sewage services were laid on, but it would be another decade before outlying parts of the village were connected. The 1951 census found that out of just over 500 households in the village, more than half did not have piped water, three-quarters were without the exclusive use of a toilet or a fixed bath, while 192 did not even have exclusive use of a stove or sink. I have vivid memories as a child of fetching water for my aunt from a standpipe that served her house and the others in the row, and of the wooden seat with a circular hole over a bucket that was my grandparents' toilet.

The village changed more quickly in the decades that followed the Second World War than in the previous thousand years, but it was the revolution in agriculture, largely unnoticed outside rural villages, that wrought the greatest change. In 1871 William Paine farmed 430 acres in Gamlingay, employing fifteen men and eight boys, with extra help brought in at harvest. There had been some technical innovation, like the introduction of steam ploughing and reaper-binders, but by and large the sweat of men and animals oiled the wheels of agriculture as it always had done. Large numbers of village craftsmen (wheelwrights, blacksmiths, saddlers and so on) relied on farmers for their living.

The situation has now altered so much that the present farmer of Merton's land – some 600 acres – needs only two men to crop and harvest it. Moreover, they produce yields beyond the wildest dreams of men like William Paine. Even sixty years ago, a farmer would have been well satisfied with a yield of a ton of wheat per acre. Now he complains at a yield two or three times bigger. Sitting in his soundproofed, computerised, air-conditioned cab listening to the radio or an iPod, the driver of an enormous, highly efficient combine harvester cuts more wheat in a day than a dozen men could have harvested by hand in a week. Seventy or eighty years ago, a horse and man could plough an acre a day. A tractor will plough twenty-five acres and more in a day, and any weeds that dare raise their heads are destroyed by chemicals as soon as they appear. Virtually any task once needing muscle-power can now be done more quickly

and efficiently by machine. It's the biggest revolution that the countryside has ever seen.

The village craftsmen were finished, and farmworkers left the land in droves as other areas of employment opened up, glad to shake off the chains that had bound them to the soil and perpetual low wages. Many were equally glad to leave behind the deferential relationship between master and man. (I well remember working alongside a retired farmworker in the early 1970s, and being unable to comprehend how he could still refer to the farmer he'd worked for as 'The Master'.) Market gardening, once so important both as a full-time occupation for some and a part-time one for farm labourers, has been killed off by the year-round importation by supermarkets of what used to be seasonal home-grown vegetables.

In the late 1950s and 1960s many women began to go out to work, and the extra income they brought into the family home was often spent on household goods such as fridges, cookers, washing machines and televisions, usually bought on hire-purchase. Some of the drudgery of everyday life disappeared, to be replaced by the new consumerism.

At the same time there was an increase in building, both by the local Council and by private firms, resulting in a large influx of outsiders, mainly from the London area. The census shows the fluctuations in population. From its peak in 1871 when it topped 2,000, numbers fell with the agricultural depression and the closure of the brickworks to a low of just over 1,400 in 1931. Thirty years later in 1961, there were still only 1,551 people living in the village. So rapid has been the increase since then that at the last census in 2001, there were slightly over 3,500 people living in Gamlingay.

In forty years the population has more than doubled, and with that growth there has been a corresponding increase in amenities. There are playgroups, various societies, evening classes of all descriptions, a new community centre, a health centre, and leisure facilities of all kinds, many of them run by newcomers. But at the time of writing there is now only one pub open in the village compared with eighteen in the 1930s, reflecting the changes in how we spend out leisure time.

Education is catered for by the infants' school (the old board school) and a village college, built in 1965, that acts as a middle school. For education beyond the age of thirteen, village children travel by bus to an upper school. The 2001 Census showed that some 1,400 people travelled to work by car, bus or train. Many of them now work outside the village, and some commute to London. Over 300 villagers are self-employed. The average number of people per household was 2.5, with 78 per cent of all households now owner-occupied. People are now living longer: 15 per cent of the residents were over sixty-five years old, with no less than fifty-five people aged over eighty-five.

Alongside these social changes there have been physical changes too, not all of them for the better. During the building boom the village lost two priceless

houses, both at the crossroads: Whitehall, or The Falcon, rebuilt in the late sixteenth century but with a history stretching back seven centuries and more, and Cross Farm, a rambling seventeenth-century farmhouse. Centuries-old barns, home to generations of barn owls, have been flattened without a second thought in the rush to build. The Tithe Barn was destroyed by fire, its ancient beams reduced to ash. Hedgerows, many of them planted at Enclosure, have been ripped up, and the tall and stately elms that were once so typical of the English countryside have fallen to Dutch Elm disease, mourned by those old enough to remember them.

Acre upon acre of farmland has been covered with a sprawl of housing estates, none of them architecturally different from those to be found in any town or village in England. Every spare inch of land is slowly being covered with bricks and mortar. Footpaths have been ploughed up and even Avenel's moat has gone, the last surviving arm filled in to provide a few more square yards of wheat for the farmer.

The railway station was closed in the late 1960s and the railway line torn up. Soon after, a small industrial estate appeared beside the now redundant station, providing more employment in the village. The village has ceased to be an agricultural community and has become a part of commuterland. Indeed, it has almost ceased to be a village and children today are growing up in what is virtually a small town, with as yet no real identity of its own. Modern planners cannot take all the blame, and I am happy to report they were responsible for the correction of one historical anomaly: in 1965 Woodbury, tacked on to the parish for the sake of ecclesiastical convenience in the dim and distant past, but never truly of it, was at last transferred to Bedfordshire, where it belongs. As the modern village grows there has been a corresponding awareness of the historical value of the older buildings which still survive. Several, most notably the old rectory (now called 'The Emplins') and Merton Manor Farm, have been lovingly restored to a perfection they have never known before in their long histories.

Memory insists I spent much of my childhood rambling in Gamlingay wood, ignoring the sign which said I'd be prosecuted and totally unaware of the clues to its longevity contained within the woodbank and ditch that surrounds it. The wood, which Dr Oliver Rackham considers to be 'perhaps the best-documented wood in England', still survives, little changed from its medieval incarnation. It's now owned and managed by Cambridgeshire and Bedfordshire Wildlife Trust, and ought to have a secure future.

Many of the ancient names for the village fields and crofts and lanes are slipping out of everyday use. The field-names are no longer common currency among villagers as so few now work in agriculture, and many of the smaller fields have been incorporated into larger ones in the search for farming efficiency, their names gone forever. Dozens of plots of land have been built over and renamed as roads or closes, usually with little regard for their old

names. And some of the lanes have also received names more appropriate for a modern commuter village: Cow Lane is now West Road. But we must blame an earlier generation of villagers for renaming the hamlet of The Sinks (meaning boggy ground) as The Cinques.

Another loss that's probably not regretted but is worth recording is that of village nicknames. Half a century ago, almost every male in the village was known by a nickname, and the practice may well stretch back centuries – there's simply no way of knowing, as nobody bothered to record them. An exclusively male phenomenon, some nicknames were handed on through families with the addition of 'little' or 'young', in much the same way the Apthorpes had been distinguished from one another. This isn't the place to list the fantastic variety of nicknames or to speculate on their origins, but in losing them the village has lost some of its individuality and character. Equally, the Gamlingay accent, all mangled vowels and glottal stops, became largely confined to the rural working class and has now all but disappeared. It's another symptom of the ebb and flow of social change washing over this corner of south-west Cambridgeshire.

Change there has always been, yet at the end of the first decade of the twenty-first century, during the early stages of what historians will perhaps come to call The Digital Age, we seem to have reached a point where we want to freeze history. We want the present state of the countryside to continue unaltered, and the English landscape, itself almost entirely man-made, to remain exactly as it is, even if we have to pay to keep it that way when there's no economic reason to do so. Our village houses, if they are 'old' or 'quaint', must be preserved as they are. It's as if there was some moment of genesis when everything was created as it is now, when the truth is that it has always been evolving. That young gentleman who visited the Heath looking for specimens almost two hundred years ago taught us that you cannot stop evolution.

It has been said that the study of history teaches us two lessons. The first is that things change much more slowly and over a longer period of time than we imagine; and the second that things change much more quickly and over a shorter time than we think. You may well conclude that both statements are true. But change relates to circumstances, not people. As far back as we can tell human beings have always been driven by the same basic needs and desires – for food and water and shelter; for love and by the need to procreate; above all, by the desire to live. As a species we've always been able to adapt and survive, and whatever the future brings, we probably always will.

NOTES ON SOURCES

The references below are not intended to be a comprehensive list of the sources I have used, but are meant instead as a guide to assist anyone who wishes to research the village for themselves. By far the best starting-point is the Gamlingay section of the *Victoria County History of Cambridgeshire and the Isle of Ely: Volume 5* (pp. 68–87), which is densely packed with references to hundreds of documentary sources. The other books I found most useful – either specifically about Gamlingay or for information on a subject or period – are listed in the bibliography; where I have mentioned them below they are in the form of author and title only. Other references are given in full.

CHAPTER 1

Accounts of medieval life abound. Ian Mortimer's *The Time Traveller's Guide to Medieval England* is an entertaining and informative survey of life in the fourteenth century, while H. S. Bennett's *Life on the English Manor*, the Gies' *Life in a Medieval Village* and G. C. Homans's *English Villagers of the Thirteenth Century* are good introductions to the subject.

The surviving Hundred Rolls are available in printed form, although still in their original abbreviated Latin. The Gamlingay entries are in *Rotuli Hundredorum*, Vol. 2, pp. 529–534. The village's short-lived claim to the record for most variant spellings is on page 96 of *Guinness Book of Records 1984*, ed. N. D. McWhirter (London, 1983).

CHAPTER 2

A draft report of the excavation of the Saxon farm and cemetery appeared as *Excavations at Station Road, Gamlingay, Cambridgeshire*, by Jon Murray

(Hertfordshire Archaeological Trust, 2000). For the etymology of the name Gamlingay, see P. H. Reaney's *The Place-Names of Cambridgeshire* (English Place-Name Society, 1943), who gives the meaning of Gamlingay as 'the low-lying land of the people of Gamela', and *The Concise Oxford Dictionary of Place-Names* (Oxford, 1936), which goes for 'The island of Gamela's people', although I remain sceptical about both definitions.

The Newton charters are in the British Library, Cott. MS.Faustina.A.IV, folios 94–120. John de Seukeworth's journeys around Merton College's properties are recorded in *The Early Rolls of Merton College Oxford* edited by J. R. L. Highfield. The records of Merton College's manor in Gamlingay are still kept in Merton College Library, Oxford. The ones specifically quoted in this chapter are the bailiffs' accounts from 1279/80 to 1361/62 (Merton College Record [MCR] 5342–5411), the manor court rolls from 1340 to 1353 (MCR 5462–5466), and John de Seukeworth's inventory of 1314 (MCR 5370). In order to work out the dates of these and most other medieval documents, C. R. Cheney's *Handbook of Dates for Students of English History* is indispensable.

The villagers' plea of poverty in 1340 is in *Nonarum Inquisitiones in Curia Scaccarii*, edited by G. Vanderzee (Record Commission, 1807). Medieval windmills are discussed in an article titled 'The English Medieval Windmill' by Terence Paul Smith in *History Today*, Vol. XXVIII, Number 4, April 1978, pp. 256–263.

The Black Death was admirably covered in Philip Ziegler's *The Black Death* and more recently by John Hatcher in *The Black Death: An Intimate History*. The rector's dispensation for simony is in *Ely Diocesan Remembrancer*, 1886–1916: Ely Episcopal Register, page 45.

CHAPTER 3

Both Avenel inquisitions are in The National Archives. William Avenel's of 1331 is in Chancery: Inquisitions Post Mortem: C135/28/5; John Avenel's of 1359 is in Chancery: Inquisitions Post Mortem: C135/142/12. A summary of Thomas St George's inquisition to prove his age is in *Calendar of Inquisitions Post Mortem, Henry VII*, (3 vols, London 1898–1955), vol. 1, pp. 384–5. The manorial descents here and throughout the book are in the Gamlingay section, pp. 70–75, of the *Victoria County History of Cambridgeshire and the Isle of Ely: Volume 5*. The manor court rolls quoted here date from 1386 to 1451 (MCR 5467–5477). The reference to 'wranglands' is in MCR 2471.

Colin Platt's *The Parish Churches of Medieval England* and Eamon Duffy's *The Stripping of the Altars: Traditional Religion in England c. 1400 – c. 1580* give the background to medieval parish churches and religion. Walter Taylard's will is in The National Archives, PROB 11/5 Godyn. His wife Margaret's will is PROB 11/6 Wattys, and her graffito is reproduced

in the Royal Commission on Historical Monuments' *West Cambridgeshire* volume, plate 16. John Layer's description of the Taylard's brass is in W. M. Palmer's *Monumental Inscriptions and Coats of Arms from Cambridgeshire*. John Alcock's prayer is quoted in Gibbons' *Ely Episcopal Records*, page 413. The eight banners are listed in the inventories of Gamlingay church books and equipment, dated from around 1278 with later additions and deletions, found in *Vetus Liber Archidiaconis Eliensis* (Cambridge Antiquarian Society, 1917), pp. 128–9. Court cases referring to sanctuary are to be found in W. M. Palmer's *The Assize held at Cambridge, AD 1260* and *Documents relating to Cambridgeshire Villages*. The possessions of the guild when it was suppressed are in *Inventories of Cambridgeshire Church Goods, temp. Edward VI*, edited by J. J. Muskett (reprinted from *East Anglian*, Vol 9) pp. 311–312.

CHAPTER 4

William Hunt's complaint of harassment is in The National Archives, Court of Chancery, C/1/27/13. Robert Otewy's will is in The National Archives, PROB 11/1, f. 110 (he is incorrectly listed as 'Robert Otelby'). William Purchase's long career in the Mercers' Company is recorded in Lyall and Watney's *Acts of Court of the Mercers' Company 1453–1527*; his career in local government is in Orridge's 'Some Account of the Citizens of London and their Rulers', in volume 1 of *The Aldermen of the City of London*, Revd A. B. Beaven, (London, 2 vols., 1908, 1913) and in *Calendar of letter-books of the City of London: 'L', Edward IV-Henry VII* (ed. R. R. Sharpe, London, 1912). The wills of John Norlong (PROB 11/5, ff. 96v-98) and Margaret Purchase (PROB 11/17, ff. 30–30v) are in The National Archives. Purchase's cloth exports are noted in *The Overseas Trade of London: Exchequer Customs Accounts 1480–1* (ed. H. S. Cobb, London Record Society, 1990). His dealings with Edward IV are in *Select Pleas of the Court of Star Chamber, 1473–1509*, edited by I. S. Leadham, Vol. 1, footnote to page 85 (*The Publications of the Selden Society*, Vol. XVI, Selden Society, 1902). His feast on becoming Mayor in 1497 may well be the one described by an anonymous Venetian Ambassador in *Relation, or Rather a True Account of the Island of England*, translated by C. A. Sneyd (Camden Society, 1847), pp. 43–44. The main occurrences during his year as mayor are in *The Great Chronicle of London*, edited by A. H. Thomas and I. D. Thornley. For London merchants in general see Sylvia L. Thrupp's *The Merchant Class of Medieval London*. Chancery records in The National Archives contain Purchase's petition about his arrest in Exeter (C/1/64/167), Michael Dennys' complaint (C/1/64/1123) and a summary of the letters of attorney from Geoffrey Boleyn (C 146/240). Purchase's will is in Canterbury Cathedral Archives, CCA-DCc-Register/F., folios 202–205.

The court rolls quoted in this chapter date from 1461 to 1510/11 (MCR 5478–5491). The Cock is first mentioned in a 1445 deed (MCR 2467), The Swan in the court roll for 1478 (MCR 5479) and the signs in a rental of *c.* 1490 (MCR 5461).

CHAPTER 5

William Slade's unfinished brass is recorded in W. M. Palmer's *Monumental Inscriptions and Coats of Arms from Cambridgeshire*, page 63. Slade's appointment as Justice of the Assize for the Norfolk circuit is in *Letter and Papers, Foreign and Domestic, Henry VIII, Volume 1: 1509–1514*, ed. J. S. Brewer (London, 1920), page 1175. The court case that Edward Slade brought against his fellow villagers is in The National Archives, Court of Star Chamber: Proceedings, Henry VIII, STAC 2/26/336. The retaliatory case against him is STAC 2/26/427. His dispute with John Basse is in The National Archives, Court of Chancery C1/445/14; with Chicheley, C1/889/22; with Thomas St George, C1/672/30. His will is in Northamptonshire Record Office, MW7 Folio 123 N.Will Ed. Slad., and his inquisition in Chancery Inquisitions, C142/75/10(1) in The National Archives. Slade and his family are recorded in *The Parish Register of Rushton (Northamptonshire) 1538–1837*, ed. P. A. F. Stephenson (Leeds, 1930). There's more on Slade and Chicheley in *Victoria County History of Cambridgeshire and the Isle of Ely: Volume 8*, pp. 129–131, and in *Volume 9*, pp. 359–361.

CHAPTER 6

The Prerogative Court of Canterbury wills are in The National Archives, and are now available online at The National Archives website, where you can search the catalogue and purchase copies. The wills of the Consistory Court and Archdeacon's Court are kept in Cambridgeshire Archives, respectively indexed in *An Index of the probate records of the Consistory Court of Ely, 1449–1858*, (3 parts, British Record Society, London, 1994–96), and *Index of the probate records in the Court of the Archdeacon of Ely 1513–1857* (British Record Society, 1976).

Malleus Maleficarum was a popular book (at least with non-witches) and remains so today. It has appeared in many editions and languages since it was first published in the late fifteenth century. It is still in print, and the full text is available online. For information on early furniture the best source is Victor Chinnery's comprehensive *Oak Furniture; The British tradition*.

CHAPTER 7

Eamon Duffy's *The Stripping of the Altars: Traditional Religion in England c. 1400 – c. 1580* and *The Voices of Morebath: Reformation & Rebellion in an English village* give fascinating insights into how the Reformation affected ordinary people. F. G. Emmison's *Morals and the Church Courts* is an excellent study of the workings of and cases to be found in Elizabethan ecclesiastical courts.

The Ely diocesan records quoted in this chapter are kept in the University Library, Cambridge, and catalogued in *A Catalogue of the Records of the Bishop and Archdeacon of Ely*, compiled by Dorothy M. Owen (Cambridge, 1971). The triple excommunication is in B2/9, folio 15v; John Russell being taken in bed with Elizabeth Anderson is in D2/9, folio 28v; Martin Kevell ditto is in D2/9, folio 29; Margaret Person's confession is in D2/9, folio 29; William Flynte and Matilda Wayth 'beinge sewer together' and Thomas Kendricke's punishment are both in D2/9, folio 121. For wife sales see S. P. Menefee's *Wives for Sale*.

John Russell's will is in The National Archives, PROB 11/73, ff. 147–148. Ann Robinson's apology for saying Steven Apthorpe would have had her as his whore is in *Report and Antiquarian Communications No. VIII*, Cambridge Antiquarian Society, (Cambridge, 1858), pp. 7–8.

CHAPTER 8

John Harmer senior's will is in the Archdeaconry of Bedford wills, Bedfordshire and Luton Archives and Records Service, ABR/R11/31. How the Great Rebuilding affected another Cambridgeshire village is explored in Rowland Parker's *The Common Stream*, pp. 135–167, and more generally in W. G. Hoskins' *The Making of the English Landscape*, pp. 134–163, and M. W. Barley's *The English Farmhouse and Cottage*.

CHAPTER 9

The villagers' complaints about Sheffield's enclosures are in Merton manor court rolls for 1510/11 (MCR 5491). The letter from the Privy Council comes from *Acts of the Privy Council, Vol. 30: 1599–1600*, ed. John Roche Dasent (HMSO, London, 1905) pp. 340–341. The collection at Knebworth is recorded in *East Anglian Notes & Queries*, 1897/98, page 227.

The £12 paid to Thomas Langdon for his survey is noted on page 657 in Volume 5 of Thorold Rogers' *History of Agriculture and Prices in England from 1259 to 1793* (Oxford University Press, Oxford, 1866 – 1902).

Langdon's maps are in the Bodleian Library, Oxford, reference MCR 6/17. The accuracy of his maps can be demonstrated by comparing them with aerial photographs such as those on Google Earth. For example, the rectangular field he calls 'Blacklands' has long since merged into the adjoining field, but the boundaries are still very clear from above. Interestingly, the field-name Blacklands is suggestive of ancient occupation, and Gamlingay's Blacklands has within it three parallel wavy lines which are probably prehistoric ditches.

CHAPTER 10

Manor court rolls for 1611 and 1612 are MCR 5492 and 5493. The Churchwardens' accounts and rates are in Cambridgeshire Archives, P76/05/1–79. Among them are the Offertory accounts 1595–1628, P76/5/75. John Lunn's apprenticeship bond to Stephen Apthorpe in 1645 is in Cambridgeshire Archives, P76/14/1/5, along with dozens more, plus numerous settlement certificates, removal orders, bastardy bonds and the like. The poor generated an awful lot of paperwork. The visitation of 1685 describing the church as 'slovenly' is in *Cambridge Antiquarian Communications, Cambridge Antiquarian Society, vol. XVIII 1873–1876* (Cambridge, 1879), pp. 347–348.

CHAPTER 11

The nuncupative wills are scattered among the Gamlingay wills. It's pot luck whether any will has an inventory preserved along with it. Apthorpe inscriptions are in W. M. Palmer's *Monumental Inscriptions and Coats of Arms from Cambridgeshire*, pp. 62–63. Eleanor Apthorpe's 1745 letter is in The Record Office for Leicestershire, Leicester and Rutland, DE1797/1/33.

CHAPTER 12

The remaining manor court rolls run from 1675 until 1713 (MCR 5494–5519). The description of Woodbury manor is from a rental in Cambridge University Library, Doc. 1437. The portrait of Sir John Jacob is reproduced online at the myjacobfamily website (www.myjacobfamily. com/jacobpedigrees/horseheathjacobs.htm, 25 September 2010).

The best Pepys anecdote of the first Sir George Downing's notorious parsimony is related in the diary entry for 27 February 1667. The story of the Downings can be found in Pettit Stevens' *Downing College* (which includes the third Sir George's will), *Aspects of Downing History*, edited by Stanley French, and his *The History of Downing College Cambridge*, the latter volume

featuring portraits of the first and third Sir Georges, Mary Forester and Maragaret Price. The plan of the Gamlingay Park estate with its vignette of the house is reproduced in the Royal Commission on Historical Monuments' *West Cambridgeshire* volume, plate 28.

Jonathan Swift's comments on Mary Forester are in *The Journal to Stella*, letter 27, London, July 1711. An account of the Downing's unsuccessful divorce proceedings is in Lawrence Stone's *Road to Divorce: England 1530–1987*, (Oxford University Press, 1990). The actual proceedings are in *Journal of the House of Lords: Vol. XX: 1714–1717*. The record of Edward Haylock grovelling on his knees can be found in the Cambridgeshire Quarter Sessions Order Books in Cambridgeshire Archives, Q/SO3, page 151. Two copies of Christie's Gamlingay Park sale catalogue are in Lincolnshire Archives, BNLW 4/11/108, one of which is annotated with the prices fetched at auction. Edmund Carter's flattering description of Sir Jacob Downing is on pp. 194–195 of his *The History of the County of Cambridge*.

CHAPTER 13

For the seventeenth-century clergy, see pages 83–84 of *Victoria County History of Cambridgeshire and the Isle of Ely: Volume 5*. The iconoclast William Dowsing's instructions to the churchwardens are in *Transactions of the Cambridgeshire and Huntingdonshire Archaeological Society*, volume III, page 88. Bishop Wren's are in W. M. Palmer's *Documents relating to Cambridgeshire Villages*, page 63. Nonconformists in the village are noted in Palmer's *Episcopal Visitation Returns for Cambridgeshire, 1638–65*. From 1670 Gamlingay's Baptists are recorded in *The Minutes of The First Independent Church (now Bunyan Meeting) at Bedford 1656–1766*, edited by H. G. Tibbutt, until they set up their own meeting in Gamlingay in 1710. From then on their proceedings are recorded in the Gamlingay Baptist Church Minute Book, a typescript of which compiled by H. G. Tibbutt was kindly loaned to me by the late Revd G. S. Tydeman. Agnes Beaumont's own account of her tribulations is printed in *The Arminian Magazine For the Year 1797, Volume XX* (London, 1797), pp. 395–401 and 446–457.

CHAPTER 14

Gamlingay's constables' accounts are in Cambridgeshire Archives, P76/9/1–26, along with the Overseers' accounts and rates, P76/12/1–66; the Overseers' rate for 1629 and the note from John St George disallowing it, P76/11/1; the warrant to distrain John St George's goods, P76/18/3; the Quarter Sessions order to refund John Webb's money, P76/18/5; bribing

John Underwood to marry, P76/12/52; Thomas Tickner's bond to pay for his illegitimate child, P76/15/1. The 1757 Bedfordshire militia riots are described in Eric Stockdale's *Law and Order in Georgian Bedfordshire* (Bedfordshire Historical Records Society, Bedford, 1982) pp. 1–29.

The anonymous overseer's Biblical quotes are from the King James' Authorised version: 'I said in my haste, All men are liars' (Psalm 116:11); '... naked and ye clothed me not' (Matthew, 25:43); 'For ye have the poor with you always' (Mark, 14:7).

CHAPTER 15

The *Cambridge Chronicle* newspapers are in the Cambridgeshire Collection, Cambridge Central Library. Suffolk Record Office in Bury St Edmunds holds files of the *Suffolk Herald* and the *Bury & Norwich Post*, and the British Library has *The Times*.

The proportion of children educated in Cambridgeshire is in *Victoria County History of Cambridgeshire and the Isle of Ely: Volume 5*, page 86. The Revd James' comments on Gamlingay's schools is on page 345 of the *First Report of the Commissioners on the Employment of Children, Young Persons and Women in Agriculture* (Parliamentary Papers, 1867–8, XVII). The growth of nonconformity in the nineteenth century and the turnpiking of the roads is summarised in *Victoria County History of Cambridgeshire and the Isle of Ely: Volume 5* pages 85–86 and page 69 respectively. Vancouver's discussion of the state of agriculture in Gamlingay is in his *General View of the Agriculture in the County of Cambridge*, pp. 114–115. The list of Joseph Triplow's possessions is in the overseers' accounts, Cambridgeshire Archives, P76/12/61, and the survey of Merton Manor Farm in MCR 5/24.

Both the Speenhamland system and the 'Captain Swing' revolt are fully covered in Hobsbawm and Rudé's *Captain Swing*. The maximum wage agreement is in the Overseers' accounts, P/76/12/59, in Cambridgeshire Archives, as is the churchwarden's list of inhabitants 1798–1821, P76/7/2 (I am grateful to Ishbel Beatty for drawing my attention this list and providing me with a copy).

Joseph Saville's will is in The National Archives, PROB 11/1853. Mary Ann Shepherd's counterfeiting case is in the Bedfordshire Gaol Register, Bedfordshire and Luton Archives and Records Service, QV10/3 2236. The quotes from Emily Shore's diary in this chapter and in Chapter 16 are all from the *Journal of Emily Shore*.

For the history of transportation to Australia see Robert Hughes, *The Fatal Shore*. All the Gamlingay transportation cases are in the Cambridgeshire Quarter Sessions Order Books in Cambridgeshire Archives: Baines and Gilbert's trial is in Q/SO17, page 290; Hall Parcel, Q/SO13, page 340; Lewis

Flint, Q/SO19, page 364; Edmund Yourby, Q/SO21, page 450; John Gilbert, Q/SO21, pp. 448–449; James Gilbert, Q/SO22, page 71; Stock Criswell, Q/SO15, page 146; Elizabeth Bartle, Q/SO20 page 263. Also in the Quarter Sessions Order Books is the order that William Birx be publicly whipped, Q/SO9, page 263. The history of the Parcell or Passell family, including Hall Parcell, is admirably related in C. Parcell's *A Passion for the Past*.

After the publication of *Gamlingay*, Ruth Hill contacted me from Australia about the Gamlingay transportees and was good enough sent me copies of many documents concerning them. Among these were the Medical and Surgical Journals and the Sick Books of the convict ships mentioned in this chapter, which are kept in The National Archives: The *Moffat* (1836) ADM 101/55/2; The *Phoenix* (1821/2) ADM 101/59/6; the *William Jardine* (1844) ADM 101/74/9. She also provided me with copies of documents from holdings in Australia, the whereabouts of which are as follows.

The State Library of New South Wales has the record of the deaths of Gilbert and Baines in Convict Death Register 1828–1879, AO Fiche 749–751. The Archives Office of Tasmania holds details of Gamlingay convicts: for Hall Parcell: Conduct Record, CON31/1/34, Description List, CON23/1/3; for Lewis Flint: Conduct Record CON33/1/62, Description List, CON18/1/43, Indent, CON14/1/30; for Elizabeth Bartle: Conduct Record, CON41/1/18, Description List, CON19/1/6, Indent, CON15/1/4.

CHAPTER 16

Somerset Archive and Record Service hold correspondence to the Revd William Wilkieson, addressed to him in Bath, Richmond Hill, Tunbridge Wells and Newcastle as well as at Woodbury Hall, reference DD/SH/66/1–38. The earliest plant-hunting reference I have found is in a letter from a John Wray dated April 28 1662: 'Since my letter to you I have been out again, in pursuit of plants as far as Gamlingay; there I discovered some that I have elsewhere found in England, others that I never saw before.' The letter is printed in *Sussex Archaeological Collections*, vol. X (London, 1858), page 24. The Revd Jennings' account of descending on Gamlingay to collect specimens is in his *Memoir of the Rev. John Stevens Henslow*, pp. 41–42. Darwin's recollections of visiting Gamlingay with Henslow are on pp. 52–53 of the same volume. Anne Plumptre's story of the weeping ash is on pp. 93–94 of her *Narrative of a Residence in Ireland*.

Alfred Power's damning report on Gamlingay's operation of the Poor Law is in *Extracts from the Information Received by His Majesty's Commissioners as to the Administration and Operation of the Poor Laws* (London, 1833), pp. 131–133. His anecdote about the poor knowing which JP would favour them is in *Report from His Majesty's Commission for Inquiring into the*

Administration and Practical Consequences of the Poor Laws (London, 1834), pp. 139–140. Hardwicke's comments on the effects of the New Poor Law on Gamlingay are in *First Report of the Commissioners under the Poor Law Amendment Act* (House of Commons, 1835), page 235.

Copies of the Enclosure Award of 1848 and the Enclosure map of 1844 are in Cambridgeshire Archives, P76/26/1. The estate map showing the Blythe Farm's holdings in the open fields is in private hands.

CHAPTER 17

Gamlingay's principal inhabitants in 1851 are listed on page 329 of Gardener's *History, Gazetteer and Directory of Cambridgeshire*. Hours of work and details of the coprolite diggings are on page 345 of the *First Report of the Commissioners on the Employment of Children, Young Persons and Women in Agriculture* (Parliamentary Papers, 1867–68, XVII). The journey time by train to Cambridge from Gamlingay is taken from *Bradshaw's Railway Guide*, 1910. Details of Belle Vue brickworks in 1912 are taken from sale particulars in Cambridgeshire Archives, 515/SP474.

Dr Hunter's caustic comments on the state of Gamlingay's housing is on page 161 of *The Report of the Medical Officer of the Privy Council, Appendix 6: Inquiry on the State of the Dwellings of Rural Labourers* (Parliamentary Papers, 1865, XXVI). The effects of the outbreaks of cholera and typhoid in the village are obvious from the burials recorded in the parish registers, which are in Cambridgeshire Archives.

Gamlingay School Board Minute Books are in the Cambridgeshire Archives, C/EB45 (1885–1892) and C/EB46 (1898–1903). Octavius Wedd's letters are in private hands. The Caxton and Arrington Union lists of those receiving relief for the half-year ending Michaelmas 1870 are in Cambridgeshire Archives, P76/19/1. For Margaret Gardiner's delightful memoir of her time as a teacher in Gamlingay see pp. 79–94 of *A Scatter of Memories*. Dr Oliver Rackham's statement that 'This Cambridgeshire wood is perhaps the best-documented wood in England' is in the caption to the reproduction of Landon's 1602 plan of Gamlingay wood on page 44 of his *The Illustrated History of the Countryside*.

BIBLIOGRAPHY

GENERAL

Ayres, J., ed., *Paupers and Pig Killers: The Diary of William Holland, A Somerset Parson, 1799–1818* (Sutton Publishing, 2003).

Barley, M. W., *The English Farmhouse and Cottage* (Routledge and Kegan Paul, 1976).

Bennett, H. S., *Life on the English Manor* (Cambridge University Press, Cambridge, 1937).

Cartwright, F. F., *A Social History of Medicine* (Longman, 1977).

Cheney, C. R., *Handbook of Dates for Students of English History* (Royal Historical Society, London, 1978).

Chinnery, V., *Oak Furniture; The British tradition* (Antique Collectors' Club, 1979).

Cressy, D., *Birth, Marriage, and Death: Ritual, Religion, and the Life-Cycle in Tudor and Stuart England* (Oxford University Press, 1997).

Duffy, E., *The Stripping of the Altars: Traditional Religion in England c. 1400 – c. 1580* (Yale University Press, 1992).

The Voices of Morebath: Reformation & Rebellion in an English Village (Yale University Press, 2001).

Emmison, F. G., The *Elizabethan Life* series published by Essex County Council: *Home, Work and Land* (Chelmsford, 1976); *Disorder* (Chelmsford, 1970); *Morals and the Church Courts* (Chelmsford 1973).

Evans, G. E., *The Farm and the Village* (Faber and Faber, London, 1974).

Fuller, T., *The History of The Worthies of England* (London, 1662).

Furlong, M., *Puritan's Progress: A Study of John Bunyan* (Hodder and Stoughton, London, 1975).

Gardiner, M., *A Scatter of Memories* (Free Association Books, London, 1988).

Gies, F., and J., *Life in a Medieval Village* (Harper & Row, New York, 1990).

Gooder, E. A., *Latin for Local History* (Longman, London, 1961).

Hammond, J. L., and B., *The Village Labourer* (Longman, 1978).

Harrison, J. F. C., *The Common People* (Fontana, London, 1984).

Early Victorian Britain 1832–51 (Fontana, 1979).

Harvey, P. D. A., ed., *Manorial Records of Cuxham, Oxfordshire c. 1200–1359* (HMSO, London, 1976).

Hatcher, J., *The Black Death: An Intimate History* (Weidenfeld & Nicholson, 2008).

Highfield, J. R. L., ed., *The Early Rolls of Merton College Oxford* (Oxford University Press, 1964).

Hobsbawm, E. J., and Rudé, G., *Captain Swing* (Peregrine Books, 1989).

Homans, G. C., *English Villagers of the Thirteenth Century* (The Norton Library, New York, 1975).

Hoskins, W. G., *Local History in England* (Longman, London, 1959).

The Making of the English Landscape (London, 1955).

Hughes, R., *The Fatal Shore: A history of the transportation of convicts to Australia, 1787–1868* (Collins, 1987).

Ladurie, E. L. R., *Montaillou: Cathars and Catholics in a French Village 1294–1324* (Peregrine, 1984).

Laslett, P., *The World We Have Lost* (Methuen, London, 1965).

Latham, R., and Matthews, W., eds., *The Diary of Samuel Pepys* (Bell & Hyman, London, eleven volumes, 1970–1983).

Latham, R. E., *Revised Medieval Latin Word-List* (British Academy, London, 1965).

Lyell, L., and Watney, F., eds., *Acts of Court of the Mercers' Company 1453–1527* (Cambridge University Press, 1936).

Macfarlane, A., *Reconstructing Historical Communities* (Cambridge University Press, 1977).

Martin, C. T., *The Record Interpreter* (Kohler & Coombes, Dorking, 1976).

Menefee, S. P., *Wives for Sale* (Blackwell, 1981).

Mingay, G. E., *Rural Life in Victorian England* (Heinemann, London, 1977).

Mortimer, I., *The Time Traveller's Guide to Medieval England* (The Bodley Head, London, 2008).

Newton, K. C., *Medieval Local Records, A Reading Aid* (The Historical Association, 1971).

Orridge, B. B., *Some Account of the Citizens of London and their Rulers* (London, 1867).

Platt, C., *The Parish Churches of Medieval England* (Martin Secker & Warburg, 1981).

Plumptre, A., *Narrative of a Residence in Ireland* (London, 1817).

Postan, M. M., *The Medieval Economy and Society* (Pelican Books, 1975).

Rackham, O., *The History of the Countryside* (Dent, London, 1986).

Trees and Woodland in the British Landscape (Dent, London, 1976).

The Illustrated History of the Countryside (Weidenfeld & Nicholson, London, 2003).

Richardson, J., *The Local Historian's Encyclopedia* (Historical Publications, London, 1974).

Salzman, L. F., *Building in England down to 1540* (Oxford, 1952).

Seebohm, M. E., *The Evolution of the English Farm* (E.P. Publishing, 1976).

Steer, F. W., *Farm and Cottage Inventories of Mid-Essex 1635–1749* (Phillimore, 1969).

Stone, L., *The Family, Sex and Marriage in England 1500–1800* (Pelican Books, 1979).

Stuart, D., *Manorial Records* (Phillimore, 1992).

Latin for Local and Family Historians (Phillimore, 1995).

Swift, J., *The Journal to Stella* (Echo Library, 2007).

Tarver, A., *Church Court Records* (Phillimore, 1995).

Tate, W. E., *The Parish Chest* (Cambridge University Press, Cambridge, 1946).

Thomas, A. H., and Thornley, I. D., eds., *The Great Chronicle of London* (Sutton, 1983).

Thomas, K., *Religion and the Decline of Magic* (Penguin Books, 1973).

Thrupp, S. L., *The Merchant Class of Medieval London* (Ann Arbor Paperbacks, The University of Michigan, 1977).

West, J., *Village Records* (Macmillan, London, 1962).

Whitlock, R., *The English Farm* (Dent, London, 1983).

Wilson, C. A., *Food and Drink in Britain, from the Stone Age to recent times* (Constable, 1973).

Ziegler, P., *The Black Death* (Collins, London, 1969).

LOCAL

Anonymous, *History of Gamlingay and Local Gazetteer for 1902* (Fowler Bros., Gamlingay, 1902).

Browne, D. M., Darby, H. C., Taylor, A., *Early Cambridgeshire* (Oleander Press, Cambridge, 1978).

Bruce, N., Sharpe, G., *Gamlingay, Cambridgeshire: A History In Photographs* (Privately printed, 2001).

Gamlingay, Cambridgeshire: Portrait of an English village (Privately printed, 2002).

Carter, E., *The History of the County of Cambridge* (Cambridge, 1753).

Conybeare, J. W. E., *History of Cambridgeshire* (London, 1897).

Fowler, E. J., *A History of Gamlingay and Neighbourhood* (Fowler Bros., Gamlingay, 1935).

French, S., *The History of Downing College Cambridge* (Downing College Association, 1978).

French, S., ed., *Aspects of Downing History* (Downing College Association, 1982).

Gardener, R., *History, Gazetteer and Directory of Cambridgeshire* (Peterborough, 1851).

Gibbons, A., *Ely Episcopal Records* (Lincoln, 1891).

Gooch, W., *General View of the Agriculture of the County of Cambridge* (Board of Agriculture, London, 1813).

Jenyns, Revd L., *Memoir of the Rev. John Stevens Henslow* (London, 1862).

Palmer, W. M., *The Assize held at Cambridge, AD 1260* (Linton, 1930).

Documents relating to Cambridgeshire Villages (with H. Saunders, Cambridge, n.d.).

Episcopal Visitation Returns for Cambridgeshire, 1638–65 (Cambridge, 1930).

Monumental inscriptions and coats of arms from Cambridgeshire (Cambridge, 1932).

Parcell, C., *A Passion for the Past* (Wylde Green Press, n.d.).

Parker, R., *The Common Stream* (Collins, London, 1975).

Cottage on the Green (Parker, Foxton, 1973).

On the Road – The Papworth Story (Pendragon Press, Cambridge, 1977).

Pettit Stevens, Revd H. W., *Downing College* (London, 1899).

Rotuli Hundredorum (2 vols; Record Commission, London 1812, 1818).

Royal Commission on Historical Monuments, England, *West Cambridgeshire* (HMSO, London, 1968).

Shore, E., *Journal of Emily Shore* (Kegan, Paul, Trench, Trubner & Co., London, 1891).

Taylor, A., *Archaeology of Cambridgeshire Volume 1: South West Cambridgeshire* (Cambridgeshire County Council, 1997).

Tibbutt, H. G., ed., *The Minutes of The First Independent Church (now Bunyan Meeting) at Bedford 1656–1766* (Bedfordshire Historical Record Society Vol 55, 1976).

Tydeman, Revd G. S., *A Brief History of Gamlingay Old Meeting Baptist Church* (Privately printed, 1970).

Vancouver, C., *General View of the Agriculture in the County of Cambridge* (Board of Agriculture, London, 1794).

Victoria County History of Cambridgeshire and the Isle of Ely: Volume 5, The Hundreds of Longstowe and Wetherley (VCH 1973); *Volume 8, The Hundreds of Armingford and Thriplow* (VCH, 1982); *Volume 9, The Hundreds of Chesterton, Northstowe and Papworth* (VCH, 1989).

CONVERSIONS

Many younger readers will perhaps be unfamiliar with both the system of weights and measures and the currency used throughout most of the period covered by this book. The main units were as follows:

1 inch = 2.54 centimetres
12 inches = 1 foot
3 feet = 1 yard
22 yards = 1 chain
10 chains/220 yards = 1 furlong
1,760 yards = 1 mile

1 rod, pole or perch = 5½ yards
1 square rod, pole or perch = 30¼ square yards
4,840 square yards = 1 acre

1 pint = 0.57 litres
2 pints = 1 quart
4 quarts = 1 gallon
2 gallons = 1 peck
4 pecks = 1 bushel
4 bushels = 1 coomb
2 coombs = 1 quarter

1 ounce = 28.35 grams
16 ounces = 1 pound (lb)
14 lbs = 1 stone
2 stones = 1 quarter
4 quarters = 1 hundredweight (cwt)
20 cwt = 1 ton

2 farthings (¼d) = 1 halfpenny (½d)
2 halfpennies = 1 penny
12 pennies (12d) = 1 shilling (1s)
20 shillings = 1 pound (£1)
21 shillings = 1 guinea
240 pennies in £1
1 new penny = 2.4 old ones

Coins mentioned in the documents that may not be familiar are:
Angel: gold coin originally worth 6s 8d, later valued at 10s. Called 'Angel' because it carried the image of the archangel Michael.
Noble: gold coin first issued in 1344, worth 6s 8d.
Ryal: gold coin originally worth 10s. Later revalued at 15s.

The mark was an accountancy term and represented two-thirds of a pound. It never equated to a coin of the realm. Throughout the medieval period until well into the seventeenth century bequests and fines were frequently expressed in amounts that equalled a mark (13s 4d), half a mark (6s 8d) or a quarter of a mark (3s 4d).

It's fruitless to compare prices and money in the past with today's values. The period covered by this book is too long, and prices always depend on whether you are buying or selling. Besides, cash was not as important in the middle ages when payment was frequently made in kind. Even if you can iron out those difficulties, like is still not being compared to like. There's no comparison between the earnings of a thatcher in 1300, when almost every building was thatched and thatchers were to be found in every village, and the prices that a thatcher charges today. Similarly, you cannot compare the cost of buying a horse in the past when they were working animals with the cost of a horse today, when owning one is perhaps something of a luxury.

ACKNOWLEDGEMENTS

Exactly who to thank for their assistance and encouragement during the writing of this book has been a difficult decision to make, for in essence the task has been separated into two distinct phases: the fourteen years it took to research and write my original book, and the time I've spent producing this one.

A further complication is that, sadly, since I wrote the acknowledgements that appeared in *Gamlingay*, several of the people featured in it have passed on. Others no longer occupy the positions they held then, while some of the names of the institutions they worked for have been changed. Such is the passage of time and the tide of history.

Many friends, relations and correspondents who have helped me since I first plunged head-first into the depths of research in 1975 are, however, happily still with us. To thank them all individually would be invidious. I would be sure, unintentionally, to omit someone who did not deserve to be left out. I hope they will all accept my sincere thanks collectively, knowing that without their assistance this book would have been much the poorer.

Similarly, it would be wrong to ignore the contributions from the various record offices, libraries and archive repositories up and down the country I consulted during both phases of my research. I'm grateful to them all for their unfailing courtesy and assistance, particularly the staff of The National Archives, the British Library, and the Bodleian Library in Oxford. I'm especially indebted to the Senior Archivist and the staff at Cambridgeshire Archives (formerly Cambridge County Record Office), who kept me supplied with an almost endless stream of photocopies over a long period, and who have promptly and politely provided every document I wanted to see during my visits to them. The help I received from the Keeper and Assistant Keeper of the Archives in the University Library in Cambridge was equally invaluable. I must also express my appreciation for the assistance I received from the staff of the Cambridgeshire Collection in the Central Library in Cambridge and

the Suffolk County Record Office in Bury St Edmunds. I owe a large debt to Dr J. R. L. Highfield, then the Librarian and Archivist of Merton College, Oxford, who when I first began my research went to extraordinary lengths to obtain copies for me of the College records relating to Gamlingay. Dr Anne Sutton likewise went out of her way to assist me when I visited The Mercers' Company in London to search their records for William Purchase.

Grateful acknowledgements are due to Cambridgeshire Archives and the Warden and Fellows of Merton College, Oxford, for allowing me to quote from the records in their keeping; to the Syndics of the University Library for permission to quote from the Ely Diocesan Records, Cambridge University Library; and to the Reverend James Gilbert for letting me quote from the Gamlingay Baptist Church Minute Book.

Three friends kindly agreed to read this book in manuscript: Neil Thomas and Rex Whitfield read an earlier draft, and Peter Wright read the revised one. Most of the many helpful corrections, comments and suggestions they made found their way into the final text, for which they have my gratitude.

I must not forget to thank the members of Gamlingay and District History Society, who invariably ask me to give them an annual talk (which I believe goes under the title 'We Couldn't Get Anyone Else'). Their support and encouragement and their enthusiasm for the history of the village always serves as a timely reminder that there are others who find the subject as fascinating as I do.

Lastly, there are two people without whom neither this nor my earlier book would have seen the light of day. I should like to record my everlasting debt to the late Rowland Parker, from whose friendship and example I learned so much. He inspired me by writing what is still the best book on village history yet published. He encouraged me, read and criticised my work, and argued with my conclusions. He prevented me making a fool of myself on several occasions, and pointed me in the right direction on numerous others. By taking a fatherly interest in an enthusiastic student of local history he taught me to approach a fascinating subject in a new way. He had my deep and sincere thanks while he lived, and he has them now.

And to my wife, who has unfailingly supported my efforts in every possible way, I'm deeply and humbly grateful.

INDEX

SUBJECTS

PLACES